AMERICAN GROUND ZERO

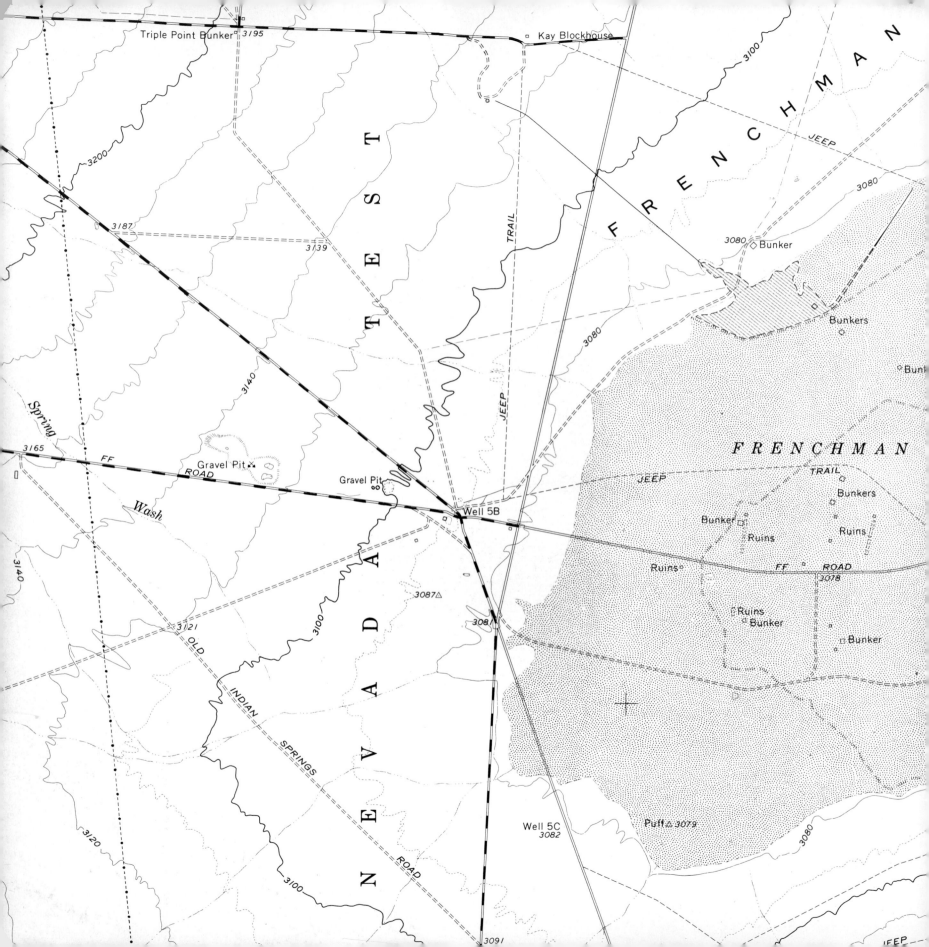

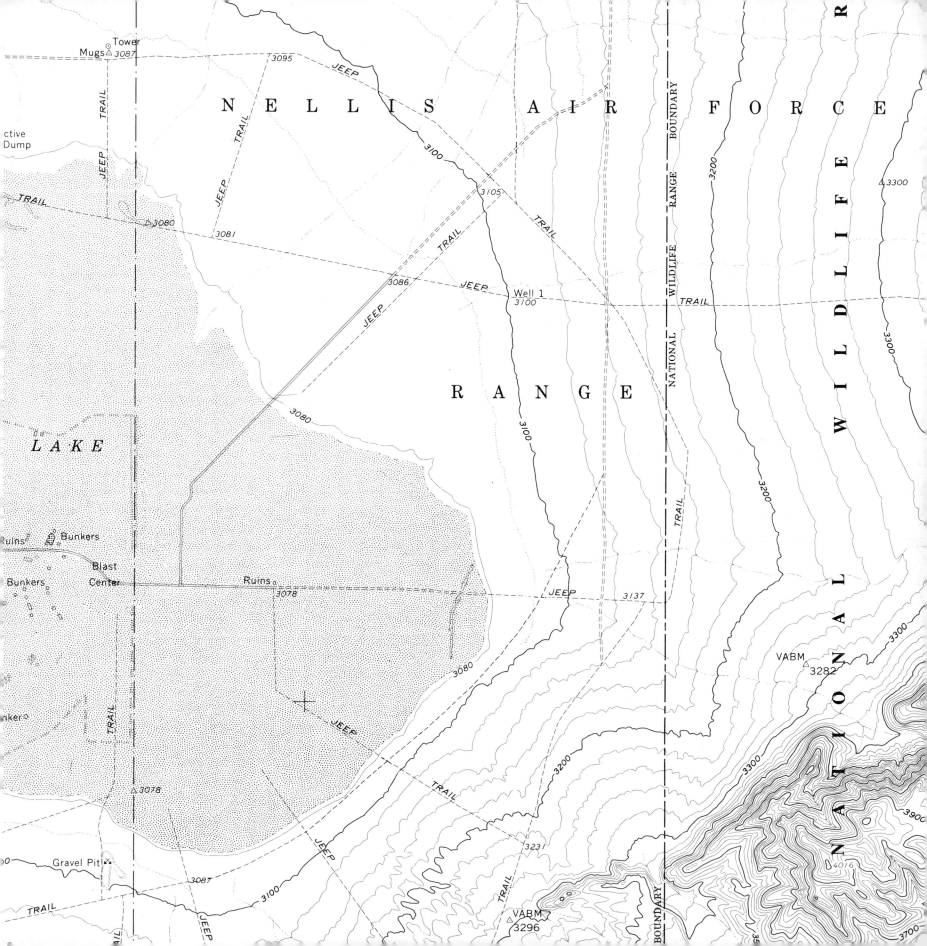

AMERICAN GROUND ZERO

THE SECRET NUCLEAR WAR

CAROLE GALLAGHER

Random House New York

To Caroline and W... H...., with gratitude and love

Originally published in hardcover by MIT Press, Cambridge, 1993.

This documentary was funded in part by major grants from the
Columbia Foundation and the Program for Research and Writing in
International Peace and Security of The John D. and Catherine T.
MacArthur Foundation.

Publication of this book has been funded in part by the Nevada
Humanities Committee, the Fund for Investigative Journalism, the
Columbia Foundation, the Lucius and Eva Eastman Fund, and the
Charles Stewart Mott Foundation.

Grateful acknowledgment is made to the following for permission
to reprint previously published material:

DOUBLEDAY, a division of Bantam, Doubleday, Dell Publishing
Group, Inc.: An excerpt from *The Legacy of Hiroshima* by Edward
Teller, with Allen Brown, 1962.

THE FREE PRESS, a division of Macmillan, Inc.: A fallout map of the
United States from *Under the Cloud* by Richard Miller. Copyright ©
1986 by the Free Press.

PANTHEON BOOKS, a division of Random House, Inc.: Excerpts from
Lying: Moral Choice in Public and Private Life by Sissela Bok. Copyright
© 1978 by Sissela Bok.

Library of Congress Cataloging-in-Publication Data
Gallagher, Carole.
 American ground zero: the secret nuclear war / Carole
Gallagher.
 p. cm.
 ISBN 0-679-75432-6
 1. Nuclear weapons—Nevada—Nevada Test Site—Test-
ing. 2. Nuclear weapons testing victims—Nevada. 3. Nuclear
weapons testing victims—Utah. I. Title.
 U264.4.N3G35 1993
 363.1'79—dc20 92-23128

Text edited by Matthew Abbate
Designed by Yasuyo Iguchi
First Paperback Edition

CONTENTS

Man, that "fickle, erratic, dangerous creature" whose "restless mind would try all paths, all horrors, all betrayals . . . believe all things and believe nothing . . . kill for shadowy ideas more ferociously than other creatures kill for food, then, in a generation or less, forget what bloody dream had so obsessed him."

Loren Eiseley, Man: The Lethal Factor

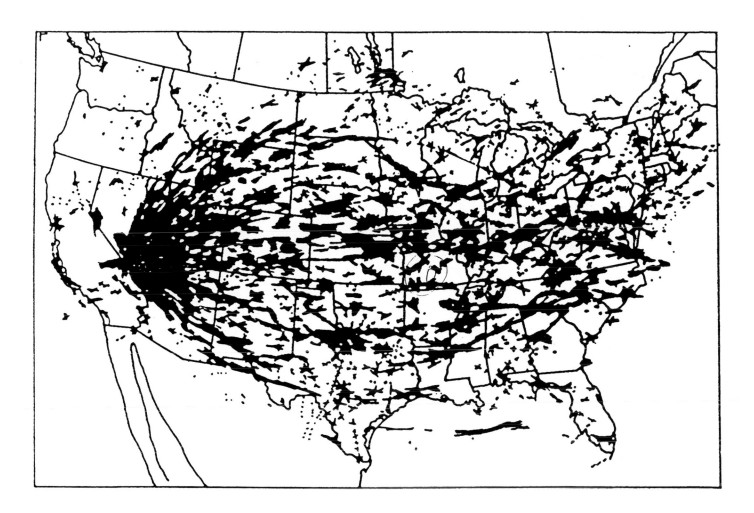

Areas of the continental United States crossed by more

than one nuclear cloud from aboveground detonations.

Photo by Dorothea Lange. "This Is the Place." 1953. Courtesy of the Oakland Museum. This sign placed at the entrance to the gambling town of Wendover on the Utah-Nevada border pokes gentle fun at edicts against such activities by the Church of Jesus Christ of Latter-day Saints. All the casinos are located in the Nevada half of the town. A century before, the Mormon pioneers walked across the plains with their belongings in handcarts, fleeing religious persecution in the East. After an arduous crossing of the Rockies, they looked out from Emigration Canyon into the Salt Lake Valley, and Brigham Young intoned, "This is the place." With his gift for organization and the hard work of his followers, the desert landscape of Utah was "made to bloom like a rose." A century later, the Atomic Energy Commission decided that this "virtually uninhabited" territory of the United States would be the site of a continental proving ground for nuclear weapons.

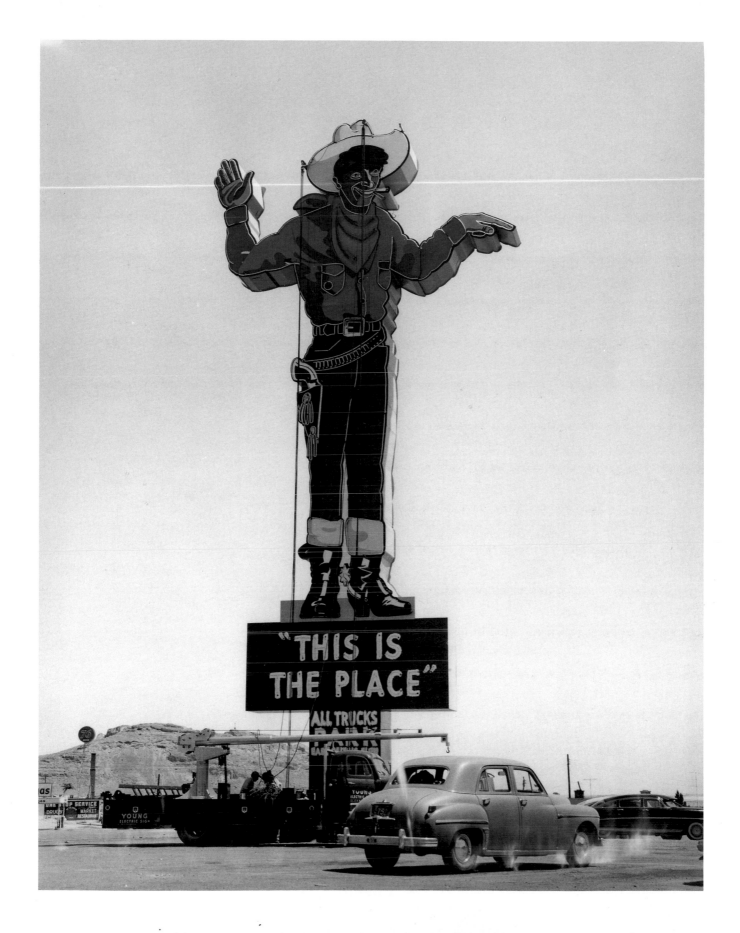

Shot Priscilla, 37 kilotons. June 24, 1957. Courtesy of the Department of Energy. A military film from the fifties titled *The Big Picture*, "produced for the armed forces and the American people," was created primarily to instruct soldiers before they participated in maneuvers on the atomic battlefield. In a particularly stilted segment of the film, a military chaplain calms two soldiers who express anxiety about being exposed (often as close as 2,500 yards from ground zero) to the force of an atomic bomb. He says, "Actually, there is no need to be worried, as the Army has taken all of the necessary precautions to see that we're perfectly safe here. First of all, one sees a very, very bright light followed by a shock wave, and then you hear the sound of the blast. Then you look up and you see the fireball as it ascends up into the heavens. It contains all of the rich colors of the rainbow, and then as it rises up into the atmosphere it assembles into the mushroom. It is a wonderful sight to behold." After witnessing this shot, soldiers returned to Camp Desert Rock bleeding from the eyes, ears, nose, and mouth.

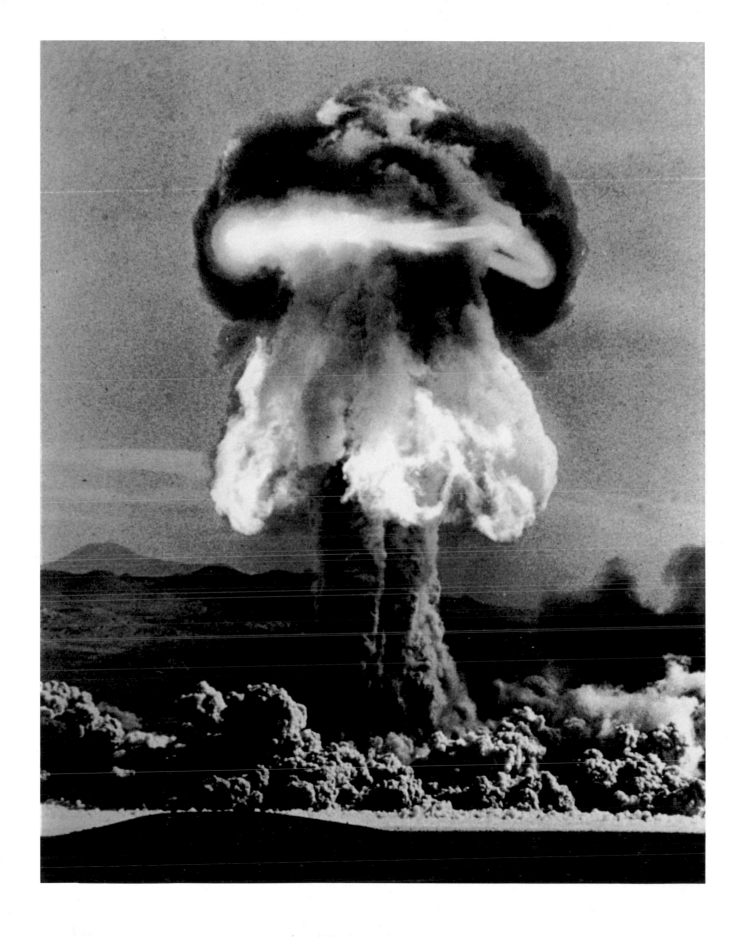

FOREWORD

by Keith Schneider

Minutes before the first light of dawn on January 27, 1951, an Air Force B-50 bomber banked left over the juniper and Joshua trees and dropped an atomic bomb on the desert west of Las Vegas. The flash of light awakened ranchers in northern Utah. The concussion shattered windows in Arizona. The radiation swept across America, contaminating the soils of Iowa and Indiana, the coastal bays of New England, and the snows of northern New York.

Thus began the most prodigiously reckless program of scientific experimentation in United States history. Over the next 12 years, the government's nuclear cold warriors detonated 126 atomic bombs into the atmosphere at the 1,350-square-mile Nevada Test Site. Each of the pink clouds that drifted across the flat mesas and forbidden valleys of the atomic proving grounds contained levels of radiation comparable to the amount released after the explosion in 1986 of the Soviet nuclear reactor at Chernobyl.

The Soviet Union was condemned by the United States for keeping the Chernobyl disaster secret for three days and preventing Ukrainians and Europeans from taking measures to protect themselves from the radiation. In contrast, the leaders of the American nuclear weapons industry waged a secret medical and scientific struggle for 30 years to cover up the contamination of vast areas of North America from atomic blasts at the Nevada Test Site.

These secrets are now public because during the last 14 years formerly classified documents about the atomic testing program were revealed in Federal courts, Congress, and the press. The records disclose a story of cold calculation and doggedly irresponsible behavior by the government's top nuclear scientists and engineers that is difficult, even in this era of national cynicism, to fully comprehend.

According to tests conducted in secret by the Public Health Service and the Atomic Energy Commission, the government's atomic assault in Nevada poisoned milk in New England, wheat in South Dakota, soil in Virginia, and fish in the Great Lakes. Radiation sickened the unprotected electricians and pipefitters at the Test Site who erected the blast towers and cleaned up the radioactive debris. Thousands of infantrymen ordered by the Army to observe the tests from trenches and conduct maneuvers close to ground zero were also injured. Beyond the boundaries of the government's atomic reservation, the radiation killed sheep, burned horses and cattle, and caused men, women, and children to die of cancer in the neat little Mormon towns of northern Arizona, southern Nevada, and Utah.

It has generally been true that the most destructive ideas are those put forward by men who believe that extraordinary times justify extraordinary actions. In the middle of the twentieth century, such thinking formed the ideological foundation of the men who managed the government's nuclear arms industry. To them the atomic bomb went beyond the simple cleverness of science. They thought of it as the supreme scientific achievement of the century, a symbol of technical virtuosity, a kind of explosive magic bullet that would not only protect America and bring the Soviets to their knees but also lead to a new era of secular achievement where science would solve human ills.

In their highly centralized industrial bureaucracy, protected by strict military secrecy, atomic scientists were free to take any risk, conduct any test, and set up any experiment without outside interference. No matter the violence that would occur to the land or the people, the leaders of the Atomic Energy Commission, the government agency that

owned the Test Site, believed their actions, if uncovered, would be justified by history.

Yet the most arresting and bewildering truth of this sad chapter in American history is that in the pursuit of protecting democratic ideals, the Atomic Energy Commission and its supporters in the White House and Congress debased them. Men who had sworn their allegiance to the Constitution fought doggedly to keep this record of violence secret. When confronted in the early 1950s and again in the 1960s and 1970s, the nuclear industry's leaders turned treacherous, shamelessly lying in Congressional hearings, destroying documents in court cases, and conspiring to cover up.

The truth began to emerge in 1978, when President Jimmy Carter ordered the Atomic Energy Commission's operational records to be made public. Two years later a team of Congressional investigators that studied the documents and interviewed participants concluded: "The greatest irony of our atmospheric nuclear testing program is that the only victims of United States nuclear arms since World War II have been our own people."

In this resolute and courageous book, Carole Gallagher introduces us to American victims of the atomic bomb. A decade in the making, Gallagher's book is a striking gallery of the undecorated casualties of an undeclared war. As she prepared this masterwork, she knew she was racing to preserve the stories of desperately ill eyewitnesses to events the government hoped would die with them. The consequence of the government's callousness was an even firmer resolve by the author and her sources. No other work in the growing literature on American atomic arms is so purposeful in forcing the nuclear weapons industry's leaders to confront the human costs of their work.

"I remember in school they showed a film once called *A is for Atom, B is for Bomb*," said Jay Truman, one of the victims who was born in 1951 and raised in Enterprise, Utah, a community downwind of the Nevada Test Site where birth defects and deaths from cancer began to soar in the late 1950s. "I think most of us who grew up in that period, we've all in our own minds added *C is for Cancer, D is for Death*. I think that's what I see for the future. In my own life I try not to think about the future in a sense because . . . the realization comes that you don't really have a future."

"I remember when my boy was born with a birth defect, right after when all this happened," added Ken Pratt, who lived in southern Utah in the 1950s and worked as a stuntman on movie projects. "His face was a massive hole and they had to put all these pieces of his face back together. I could see down his throat, everything was just turned inside out, his face was curled out and it was horrible. I wanted to die. I wanted him to die."

It is difficult to call this record of human injury and ecological scarring anything other than immoral. At least nuclear weapons manufacturing and testing appear finally to be coming to an end. Since Carole Gallagher started work on this book, no other industry in the United States has undergone as much change as the one that makes the government's atomic bombs. In 1983, the Nevada Test Site was one of the 17 principal plants in 12 states that made up the core of the wholly owned government monopoly on manufacturing nuclear weapons. With some 120,000 employees and a budget of $4 billion annually in the early 1980s, the nuclear weapons industry was one of the country's largest and most dangerous enterprises.

Now in 1992 the United States has not produced a nuclear

bomb for two years. Just six weapons plants remain open, including the Nevada Test Site, which will test five or six atomic weapons underground this year, according to public statements by the Department of Energy, the successor to the Atomic Energy Commission. Congress is battling the Department of Energy over new proposals that could end nuclear testing in Nevada. Soon the nuclear weapons industry may consist of no more than two plants assigned the dangerous task of dismantling the thousands of nuclear warheads that took 50 years to design and build.

No one doubts that the collapse of Communism in eastern Europe and the end of the Cold War helped cause the nuclear weapons industry's sudden collapse. Equally important was what the public learned in the late 1980s about the industry's dangerously deteriorated equipment, its poor operating record, and rampant chemical and radioactive pollution. In every state where the industry operated, communities demanded an end to the manufacture of radioactive materials that were no longer needed for a war that would never be fought.

The national movement that forced the closure of the nuclear weapons industry in the late 1980s did not spring up spontaneously. It was born in the desert around the Nevada Test Site and drew strength from some proud and stubborn Mormon people of the Southwest who considered it a sin to challenge the government but did so because it became a bigger sin not to. In 1956 and 1982, these people confronted the government in Federal District Court in Salt Lake City in three historic cases that were the first to pry open the nation's nuclear scandal.

The first two cases grew out of the same incident in 1953, when sheep herders conducting the spring roundup found their ewes and lambs with unsightly burns, lesions in their nostrils and mouths, and so sick that many could barely stand. When the herders got their animals to the lambing sheds in Utah, they witnessed more strange biological events. "The lambs started coming out little spindly pot-bellied lambs," Kern Bulloch, a Cedar City, Utah, rancher told a House Judiciary Committee hearing in 1989. "What lambs did live only lived a few hours."

Of 14,000 sheep on the range east of the Nevada Test Site, roughly 4,500 died in May and June of 1953. The sheep ranchers were convinced the losses were due to radiation from particularly dirty atmospheric atomic tests earlier that year. In 1955, ranchers filed suit in Federal District Court in Salt Lake City, the first to seek compensation for losses from radiation released from the government's nuclear arms industry. In September 1956, during the 14-day trial in Judge A. Sherman Christensen's court, the ranchers never had a chance. When the government's atomic scientists took the stand, their testimony contained hardly anything that was true.

In 1980, the House Committee on Interstate and Foreign Commerce investigated the sheep deaths and concluded that the Atomic Energy Commission had engaged in a sophisticated scientific cover-up aimed at protecting the testing program in Nevada at any cost, including the government's credibility. Internal memorandums discovered by investigators clearly showed that Federal and state veterinarians had, in fact, measured lethal doses of radiation in the organs of dead and dying animals but that the reports had been suppressed by the Atomic Energy Commission.

Moreover, the Atomic Energy Commission had conducted separate studies from 1951 to 1954 at another nuclear weap-

ons plant, the Hanford Nuclear Reservation in Washington state, in which sheep were exposed to the same levels of radiation that had fallen on Nevada and Utah. The results were almost identical to what occurred in Utah in 1953. Sheep developed lesions, their wool fell out, and they died in unusually large numbers. The Government never mentioned the existence of these studies at the trial.

The publication of the House study prompted several of the original plaintiffs to seek a new trial. Judge Christensen, then the senior judge of the court, heard their arguments during four days in May 1982. In August 1982 he handed down a 56-page decision that was a legal landmark. Twenty-six years after his original decision, Christensen ruled that a monstrous miscarriage of justice had occurred and that the Atomic Energy Commission had perpetrated a "fraud upon the court for which a remedy must be granted at even this late date." In granting the ranchers a new trial, Christensen said the government scientists and lawyers had deliberately concealed documents, given false testimony, and withheld information.

In an inexplicable ruling, the United States Court of Appeals for the Tenth Circuit in Denver reversed Christensen's order in 1983. The appellate panel decided that none of the government's witnesses had given false or misleading testimony and no evidence had been withheld from the sheep herders. It was later revealed that before he was appointed to the Appeals Court in 1962, the judge who wrote the appellate decision had worked as a member of a prominent law firm in Santa Fe, New Mexico, that served as counsel to the Los Alamos National Laboratory, the managers of the atomic tests.

The third historic case, brought by 1,200 residents of the Southwest, came to trial in Judge Bruce S. Jenkins's court in Salt Lake City in September 1982. The medical histories of 24 plaintiffs with cancer were chosen as test cases, among them four children who had died and 19 adults, five of them still alive. During the next four months, 98 witnesses took the stand in Jenkins's courtroom. Mothers and fathers talked about the unspeakable pain suffered by their dying children. Sons and daughters described the torment of watching their parents wither and die. Government scientists admitted that they had kept the dangers of testing hidden, but said they remained unconvinced that anyone had been harmed.

In May 1984, Jenkins handed down a 489-page decision that was the first to determine that radiation from the government's nuclear weapons industry had caused cancers. Jenkins awarded ten of the 24 victims compensation because, he said, the government was negligent for failing to warn residents of the potential consequences from exposure to fallout. "The court finds that as a direct and proximate result of such negligent failures, individually and in common, defendant unreasonably placed plaintiffs or their predecessors at risk of injury," he wrote.

Again, the Tenth Circuit Court of Appeals in Denver reversed the decision. A panel of judges ruled in 1987 that conducting atmospheric tests was a policy judgment protected by the Federal Tort Claims Act, a 1946 law that gives government officials broad discretionary powers to carry out vital Federal programs whether or not they cause injuries. In 1988, the United States Supreme Court decided not to consider the case and the court challenge ended.

Far from being demoralized by the higher court decisions, the national movement to compel the government to face up

to its responsibilities gained new momentum. Using the Jenkins decision as a guide, class action lawsuits seeking compensation for medical injuries and environmental harm have been brought against the Department of Energy's nuclear weapons plants in ten states. In 1989, in the first successful case, the residents of Fernald, Ohio, were awarded $78 million by the Department of Energy for harm caused to their property by radioactive contamination from the Feed Materials Production Center, a uranium processing plant there.

Judge Jenkins's decision also added new authority to efforts by Congressional lawmakers to compensate victims of the atomic arms industry. In 1988 Congress directed the Department of Veterans Affairs to provide disability benefits to atomic veterans who had participated in atmospheric testing in Nevada and suffered from any of 13 types of cancer. And on October 15, 1990, after years of intensive lobbying by two Utah lawmakers, Representative Wayne Owens and Senator Orrin Hatch, President Bush signed the Radiation Exposure Compensation Act to apologize for the government's behavior in the Southwest and establish a trust fund for the injured.

American Ground Zero: The Secret Nuclear War is a surpassingly careful recounting of human turmoil and official indifference. It is part of an American tradition of oral history and documentary photography that transcends other art forms in keeping alive bruising political eras. Just as Mathew Brady documented the Civil War, Walker Evans chronicled the Great Depression, and modern photojournalists reported on the civil rights movement and the Vietnam War, Carole Gallagher has brought us face to face with the victims of another painful chapter in American history. The consequences of the nuclear arms industry's contamination of America will linger for centuries. Here is a document of extraordinary craftsmanship by one journalist unwilling to let this tragedy go unremembered.

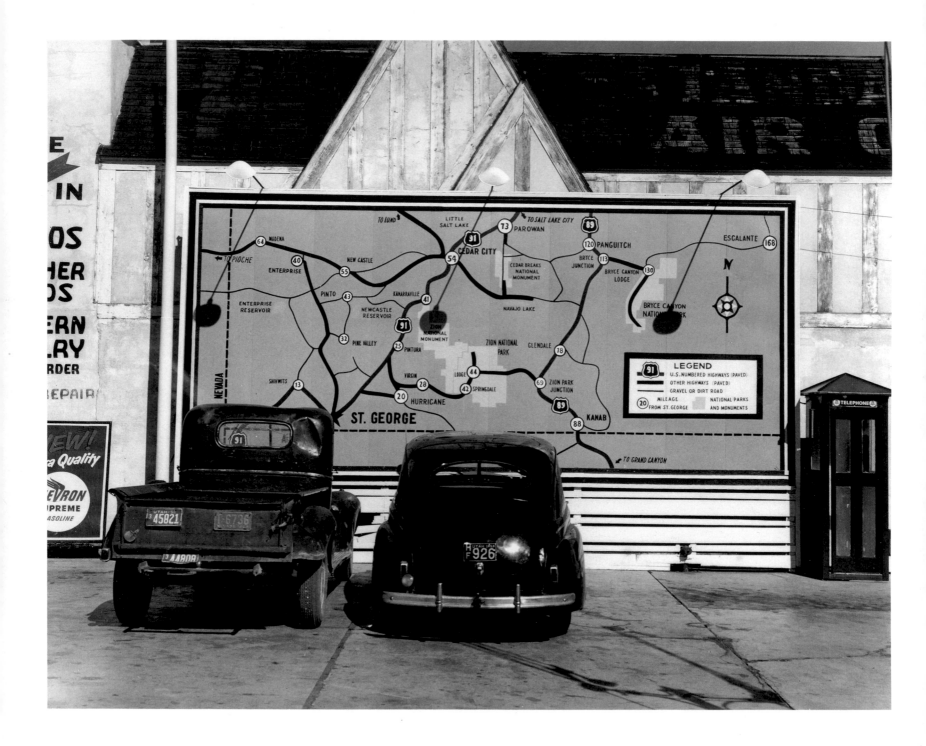

T H E R E I S N O D A N G E R .

Atomic Energy Commission

At times, those who govern . . . regard particular circumstances as too uncomfortable, too painful, for most people to be able to cope with rationally. . . . Deception at such times may seem to the government leaders as the only means of attaining the necessary results. The perspective of the liar is paramount in all such decisions to tell "noble" lies. If the liar considers the responses of the deceived at all, he assumes that they will, once the deceit comes to light and its benefits are understood, be uncomplaining if not positively grateful. . . . Thus Erasmus, in commenting on Plato's views [in the *Republic*], wrote:

. . . He sets forth deceitful fictions for the rabble, so that the people might not set fire to the magistracy, and similar falsifications by which the crass multitude is deceived in its own interests, in the same way that parents deceive children and doctors the sick.

Some experienced public officials are impatient with any effort to question the ethics of such deceptive practices. They argue that vital objectives in the national interest require a measure of deception to succeed in the face of powerful obstacles. Negotiations must be carried on that are best left hidden from public view; bargains must be struck that simply cannot be comprehended by a politically unsophisticated electorate. A certain amount of illusion is needed for public servants to be effective. Every government, therefore, has to deceive the people to some extent in order to lead them. These officials view the public's concern for ethics as understandable but hardly realistic.

Sissela Bok, *Lying: Moral Choice in Public and Private Life*

PROLOGUE

In 1981, two phrases I came upon in my readings made a fortuitous connection that changed the direction of my life, and just in time: a decade of unprecedented American greed and political duplicity was in its infancy. While studying a biography of the American photographer Dorothea Lange, I discovered she had always pinned to her darkroom door a thought by Francis Bacon:

The contemplation of things as they are,
without error or confusion,
without substitution or imposture,
is in itself a nobler thing
than a whole harvest of invention.

By then I had been researching the nuclear military-industrial complex for some years, and had found recently declassified Atomic Energy Commission documents from the 1950s both riveting and deeply disturbing. In one "top secret" AEC memo, the people living downwind of the Nevada Test Site during the atmospheric testing era were described as **"a low-use segment of the population."** The shock at such callous bigotry fused with the ideal of clear seeing expressed by Bacon. It was that illuminating but painful moment which eventually brought me to the West to research, investigate, contemplate, and document the effects of nuclear testing on the land and on three groups of people: those who lived closest to the Test Site, the workers at the site, and the soldiers exposed to the bomb at close range by military fiat. I dropped out of life as I had known it.

Truth being stranger than fiction, I rented a basement room in the home of two polygamous Mormon widows in St. George, Utah. More than once after settling in to work in Utah I had been told I was, well, let's put a good face on it, not much more than an East Coast city slicker. Horrors. There was much to learn about the ways regional prejudices divide and conquer us as a nation. First of all, I stopped telling people I was from New York, the city America loves to hate. Knowing a bad thing when I heard it, I had exterminated my New York accent by taking speech lessons in high school, but realizing that even my appearance might be alienating to rural Mormon people so different from myself, I changed it. I grew my hair, abandoned trousers, put on longer skirts and modest blouses, often covered myself further with a vest or jacket, took the ebullience and assertiveness out of my voice, and toned down everything about me. Dorothea Lange had much good advice for documentarians, all of which I followed, but my most useful adaptation was to wear "the cloak of invisibility." I wanted to become a blank slate upon which the stories and images could be written, but to do this I had to lose my own needs and history for a while. Perhaps at times I became too lost for my own good, but a new life in a virgin landcape can yield fresh and heartfelt photographs, new ways of thinking. Muting one's own voice for some years to listen to the stories of others can be a golden path to understanding. In his book *Mormon Country* (1942), Wallace Stegner had characterized Utah Mormons as unfriendly, even downright hostile to outsiders, and this is largely true, but once I arrived for an interview and was given the once-over, the people I visited realized they had nothing to fear from me. I was dusty, haggard, out of my depth, and just barely coping with the Bomb, now a living entity to me. I had no detachment in my repertoire. Perhaps my very evident vulnerability was the best calling card.

Utah, Nevada, and Arizona are unarguably some of the most beautiful territories on earth. Cowed by the land, I was completely unable to make any images of it at first, feeling it would be arrogant even to try. Once again, it was my reading that unlocked me when I came upon a phrase in a publication from the 1950s called *Armed Forces Talk*. Used to instruct soldiers before they would attempt their atomic maneuvers at the Test Site, the magazine described this part of the West as **"a damn good place to dump used razor blades."** This typified the attitude of the decision makers toward both the land and the people, as it does to this day. Since the federal government retains 68 percent of the land and air rights in the West (despoiling it with nuclear and biological labs and test sites, toxic and nuclear waste dumps, electronic warfare, missile silos, bombing and strafing test runs, and, most recently, projected open-air testing of nuclear-powered rockets), it seemed appropriate in the final pages to include images of the land as well as its people at work and at rest. I had hoped that the beauty of the land as seen through my lens could provide the reader some healing and restoration from the preceding tragic segments, although it should be kept in mind that the hidden secret of each and every one of these landscapes is the presence of radioactive toxins that are certain to be there. All of these photographs were taken in areas shown to be heavily dusted by fallout, according to declassified AEC maps, some isotopes remaining deadly for 250,000 years. Certain experiences I had during two days photographing within the borders of the Test Site, particularly at Frenchman Flat, the ground zero for 27 detonations, surely bestowed upon me an honorary doctorate in denial, thus drawing me closer to understanding the culture of the downwinders. Nevertheless, I am sure it was my solitude

enfolded in other, less obviously lethal landscapes of the West that gave me the grace and strength to go on. As I listened to the oral histories of people in Utah, Nevada, and other places further to the north, east, and west, it was apparent that these areas referred to as "desert wasteland" by the AEC were a common comfort and cure for all of us, despite their covert radioactive mysteries. The stunning beauty of the land had the power to lull us into a passive contentment. How could something this lovely be dangerous?

In the following pages you will hear the voices of people long silenced, and by their portraits, icons of the atomic age, you may understand that their tragedy is universal. (There are 45,000 sites highly contaminated by radiation in this country alone.) As a way of reaching back in time to show you the good and gentle people that were being victimized, I have included some photographs taken by Dorothea Lange in 1953 while she was on assignment in Utah. Although many states in the West were severely affected by the fallout clouds from atmospheric tests of nuclear weapons, I believe that Utah serves best as the bellwether state for this atomic drama, an environment of fervent beings, the progeny of the Mormon pioneers, who considered themselves more American and more patriotic than anyone. The term *bellwether* here (literally, the belled male sheep that leads the flock) contains a wry irony. During 1953, one of the dirtiest and most dangerous years of the tests in Nevada, many flocks of sheep in Utah were decimated from grazing on the fallout-dusted range. Since the sheep ranchers most affected had been in this business for generations, no one was really fooled by the Atomic Energy Commission's assertions that the sheep loss was due to "mismanagement, malnutrition, and perhaps poisonous plants on the range." They had first been told by

their county agricultural agents and public health officials that the beta burns their animals had on their muzzles that extended right down their alimentary canals and through their intestines were caused by radiation. Ewes aborted. Lambs not stillborn lived for a short while, some born with their hearts beating outside their chests. The animals' wool fell off, in much the same way that the Japanese lost hair after being poisoned by radiation in Hiroshima and Nagasaki. Despite the fact that the public health bureaucracy and AEC scientists camouflaged the consequences when they realized that a public uproar over the potential health effects from the fallout might force them to close the Test Site, there wasn't a person alive in southern Utah, then or now, who didn't fear that the deaths of those lambs and sheep were a precursor of a shared destiny.

The people in this book have been selected from the hundreds interviewed to represent most kinds of radiogenic health effects (cancer, heart disease, neurological disorders, immune system–related illnesses, reproductive abnormalities, sterility, birth defects, diseases from genetic mutation that would appear in later generations) and as many different life situations and political points of view as possible. The relationship of these illnesses to radiation exposure has been confirmed by both independent and government-funded scientific studies. The Test Site workers were often migrant laborers from other states where the economy had yielded few jobs, and their work by far the highest-paid employment in Nevada outside of organized crime. The atomic veterans were then, as they are now, members of those classes of citizens who always serve, many just out of high school, with very few of the nation's insulated elite in their ranks. I had hoped to represent various exemplary people living in as many of the small towns of Utah and Nevada as possible, as well as other representative cases from northern Arizona, Idaho, and the northmost point in my documentary travels, South Dakota. These are the "downwinders," but as I was told during an interview with an Air Force colonel who flew radiation monitoring missions, "there isn't anyone in the United States who isn't a downwinder." One might also include Canada into this nuclear drama at least, and the whole earth at most, since there are more than five metric tons of plutonium, the most toxic known element, in the atmosphere as the result of global nuclear tests by those in possession of the Bomb. Several *pounds* of plutonium, which remains deadly for 250,000 years, if evenly distributed and ingested inhaled, or absorbed into the bloodstream, would kill everyone on the planet.

Oral histories of a number of scientists of the atomic age have also been included, in particular two who originally participated in the Manhattan Project. Dr. John Gofman's testimony exposes the nuclear-protective mentality of federally funded cancer studies. For more than 40 years and at the cost of many hundreds of millions of dollars, the results of these studies have consistently downplayed the effects of radiation. Stewart Udall, former Secretary of the Interior in the Kennedy and Johnson administrations and an attorney for the downwinders, refers to this as "the fox guarding the chicken coop." Some federal scientists even came up with the concept of "hormesis," I was told by Dr. Gofman, "an Orwellian rewriting of history—they claim radiation might even be good for you." Gofman, who codiscovered uranium 233 and isolated the first milligram of plutonium for J. Robert Oppenheimer during the Manhattan Project, was later asked to study the effects of radiation as an associate director of

the Lawrence Livermore Laboratory. "All we want is the truth." Gofman was told by Nobel laureate Glenn Seaborg, then chairman of the Atomic Energy Commission. "I guess I had a lapse of cerebration," Gofman said of his acceptance of the position. When he delivered an address titled "Low Dose Radiation, Cancer and Chromosomes," which eventually led to his ejection from federally funded science, he revealed that the risk of cancer had been underestimated by at least a factor of 20, and that if the population received the "permitted" dose, there would be 16,000 to 32,000 extra cancer deaths per year in the United States. His $3-million-a-year program was shut down and Gofman was effectively gagged. "They're smart. They learned something the anti-nuke people never knew, the lesson of Joseph Goebbels. He had it right. Tell a lie. Tell a very big lie, and you'll be believed if you tell it often enough. . . . Look at the large number of scientists they produce, a whole stable full, from their brothel. People think they're giving a scientific opinion. Baloney! They're giving the opinion that will guarantee that their job continues, or their scientific research grants. . . . The history of whistleblowing tells you that you'll get clobbered."

Dr. John Willard, Sr., a chemist from Rapid City, South Dakota, worked on the Manhattan Project at Hanford Nuclear Reservation in Washington state, where enriched uranium and plutonium for atomic bombs was manufactured. Years later he hosed down the streets of Belle Fourche, South Dakota, dumped the local milk, and burned the hay after fallout from tests at the Nevada Test Site rained out over the area. He also notified the Civil Defense and local Health Department authorities of the emergency, which brought him an FBI-escorted summons to the AEC offices in Las Vegas and a severe reprimand. "The AEC were really threatening me with Leavenworth, that I had no authority and I had identified a test that was highly classified. I did. I took some of the damn stuff back to the laboratory. Every radioactive material has what we call its own fingerprint. I relayed that to Denver and to the Air Force out here. Boy, they were going to nail my hide to the barn door. They had me under house arrest. They told me what a traitor I was. Even the head of the Atomic Energy Commission in Washington got on the telephone." He still believes that the less "the people" are told, the better, although when his home town was directly exposed he was extremely concerned for the safety of his neighbors.

Dr. Billings Brown of Provo, Utah, seemed bowed but not entirely beaten in his attempts over the years to alert the northern sector of the state to the fallout that heavily dusted its mountains and rangelands, although he now admits to a cynical realism. "When the government doesn't want things out, it suppresses them with vigor. . . . They put enough money into lawsuits and cover-ups so they always win. It's them against us."

In Utah there is a prevalent Mormon saying: "All is well." It is a remnant of the pioneer era when they walked across the plains with their belongings in handcarts, fleeing religious persecution in the East, and these fearless companies of Latter-day Saints would sing such hymns to keep up their spirits and endurance. As Sheldon Johnson explained to me, "There is a philosophy that Latter-day Saints have, that all will be well, no matter what. . . . In spite of all the things that will happen, everything will be okay, the end will be all right." Yet such trusting mindsets that are appropriate in one century may not adapt so well to the more complex problems

in the next. The darker side of "all is well" is its capacity to disguise reality. A more fitting adage for Utah today might be "all is not what it seems" in a state that rarely admits that there could be anything wrong, and whose citizens really do think of themselves as Saints right from the moment of conception, before even being tested.

Utah is a living, breathing hyperbole of Americana, yet visitors will remark that they feel as if they have crossed the border into a foreign country and a much earlier decade. Capable of believing almost anything they are told as the God's honest truth, perhaps only trusting Utahns could have elected the redoubtable Senator Orrin Hatch, a wily carpet-bagger far too slippery and dangerous to be so successful in his native Pennsylvania or anywhere else. Utah has chosen him over and over since 1976. It was Orrin Hatch who introduced legislation to compensate the downwinders (part of Senate Bill S.1483) that, had it actually been passed by Congress, would have helped few if any of them. The radioepidemiological (probability of causation) tables upon which compensation would be decided were drawn up by scientists formerly associated with the AEC and/or presently funded by the Department of Energy, National Institutes of Health, or National Cancer Institute, the foxes guarding the chicken coop. No independent (unbiased) studies were involved. This Compensation Act provided enormous loopholes and escapes from liability, it freely applied concepts that understated the probability of causation, and many radiation-induced cancers would not have been compensated. "Absolute lies" was Dr. John Gofman's opinion of this bill, which most downwinders would have accepted from Hatch without question or protest.

That legislation, and even the slightly more favorable Radiation Exposure Compensation Act later introduced by an attorney for the downwinders, Rep. Wayne Owens, with Senator Hatch (enacted by Congress in October 1990, Public Law 101-426; amended November 1990 in Public Law 101-510, Sections 3139–3141), includes only the counties in southern Nevada and Utah and in Arizona only north of the Grand Canyon. It completely ignores other territories in the western states that were pummeled with fallout clouds directly or exposed through documented radioactive rainouts. It also excludes from compensation many cancers and other illnesses that are radiation-related. There is no account taken of the legacy of cancers and birth defects in generations to come as a result of chromosomal damage from radiation, what Dr. John D. Little and his colleagues at the Harvard University School of Public Health call the "delayed mutation effect." Preliminary studies of such delayed genetic phenomena have been ongoing since the 1950s, when the AEC first began such radiation research and experimentation. Wiser about the foolishness of trusting government officials about fallout in the fifties, but not any smarter about eliminating from power those culpable for equivalent betrayal today, most Mormon downwinders are steeped in an unblinking political naivete. There is still much to lose.

In Utah there is no substantial difference between church and state: 92 percent of the state legislature and all of its Congressional representatives are Latter-day Saints. With an unarguable ability to mobilize large numbers of the obedient faithful on short notice, this unusual religion is the single most formidable political force in the American West, yet any efforts made to stop the atomic bomb tests were as fruitless then as now. Neither was there any call forthcoming from the hierarchy for a life-saving migration away from the

open-air atomic blasts, which, given the lesson of Hiroshima and Nagasaki, could certainly have been considered as lethal as the religious persecution a century before that sent the pioneers walking across the plains and over the Rockies with their possessions in handcarts. Nor were any attempts made to set up an adequate medical facility in southern Utah where cancer could be diagnosed and chemotherapy administered, forcing downwinders to attempt a day's travel to Salt Lake City in the most dire of circumstances, vomiting from chemotherapy all the way home. Such a situation was referred to as "an insult" by many downwinders, yet one interview question that was least likely to be answered by the faithful with any reaction but a blanched expression was: "If your church opens a ward house or temple costing at least a million dollars in some part of the world each and every day, why didn't they open a branch of the LDS Hospital as a cancer center in St. George? Wasn't one of Jesus Christ's primary teachings to care for the sick and the dying?"

The Mormon church teaches that worldly wealth is a sign of God's blessing, and so it is no surprise that the top levels of the hierarchy are composed mainly of successful corporate executives and small businessmen of the most orthodox wing of conservative politics. There is little academic theological training involved in their ascension to power, and their service to the church is, for most, a part-time effort. A disproportionate number of Mormons hold highly respected positions in government, particularly in the FBI and CIA, valued for their unquestionable patriotism, trustworthiness, and wholehearted devotion to American family values. Ezra Taft Benson, the present "Prophet, Seer and Revelator" of the church, was the Secretary of Agriculture in the Eisenhower administration during the height of atomic testing.

Even though a revered and respected Latter-day Saint was a member of his Cabinet, with many other Mormons in potent positions within the administration, when confronted with the dangers that atmospheric bomb tests imposed on citizens living near the Test Site, Eisenhower is alleged to have said, "we can afford to sacrifice a few thousand people out there in the interest of national security."

Throughout the testing era to this day, the Mormon hierarchy has remained silent, officially, on the issue of testing. With the Cold War over, local politicians who belong to the church still maintain that the testing must continue "in the interests of national security" even though so many believers, friends and neighbors, have suffered and died as a result of it. In fact, some of the officials who changed their minds about the cause of the sheep deaths in the fifties were local Mormons, and to this day some DOE bureaucrats at the highest levels of authority at the Test Site are members of the church. My research offered reasons to contemplate the darker possibility of a quid pro quo between the government they believed to be "divinely inspired" and the Mormon church. Turning a blind eye to nuclear experimentation in the LDS heartland in the interest of national defense would provide enormously lucrative federally funded scientific studies at local universities and a potential economic boom in two of the poorest states of the nation. I preferred not to investigate further. An inquiry into that kind of Cold War church-state alliance would require a book of its own, and another decade of research into a church whose secrets have always been shut tight as a tomb and into government agencies that had been shredding the evidence for decades. I have tried here, instead, to hold to the method of the anthropologist, to examine the culture itself in as detached a manner as

possible, without accusation or censure, and thus discover the roots of how and why this tragedy could happen here.

In the Beehive State, the element of control and blind obedience is basic to the Mormon church organization. Above all, the Saints do what they're told. Even to differ overtly in opinion is to be shunned. During interviews, the sense of intellectual and emotional isolation of the dissenting few was palpable, almost tragic. As Wallace Stegner wrote in *Mormon Country*,

It takes courage for a Mormon to dissent. One gentleman who rose in the tabernacle a generation ago and asked for an accounting of Church funds was unceremoniously thrown out and disfellowshipped.

Those Mormons obey because their whole habit and training of life predisposes them to obedience. . . . They will defend their system militantly, because by and large it has been good to them. By and large it has been responsible, despite its assumption of power over the individual. Call it a benevolent despotism. It is not a democracy, even yet, except in terms of state and national politics, and its essentially fundamentalist hostility to free thought has driven a good many of its sons and daughters into something like exile, but it cannot be called either deplorable or unwholesome any more than any other fundamentalist faith can. After all, it satisfies its people, or most of them.

Once nuclear testing began, this strict regulation of acceptable behavior and thought was a prescription for disaster. As Jackie Maxwell reminds us in her interview, the Church of Jesus Christ of Latter-day Saints teaches that the Constitution and the creation of the United States were divine in origin. Some devoted Mormons I interviewed would perceive radiation-related illness and death as a punishing act of God, since it was their divinely inspired government that thought fit to bomb them. This, combined early on with a sense of futility in trying to make sense of what was happening and the personal devastation of illness and death, created many cases of clinical depression, mostly untreated. Others found in this doctrine a reason for denial that anything unusual was actually happening. After all, they were told regularly by government officials that there was no danger. Cancer was such a rarity that when a cluster of leukemia deaths struck the small towns of southern Utah and Nevada a few years after testing began in 1951, even the doctors had no idea what this illness could be. One nine-year-old boy who was brought to the hospital in St. George was diagnosed as diabetic by a physician who had never seen leukemia before. This child died after one shot of insulin. Mortician Elmer Pickett, who would later lose sixteen of his immediate family members to cancer, had to learn new embalming techniques to prepare such small, wasted, near bloodless bodies for burial. Enormous concern and fear were voiced by the families of the dead, yet every vehicle for denial was firmly in place that would keep those most directly downwind of the Test Site from, as Don Cartwright put it, "making a fuss."

"I was raised in a Mormon family, raised always to be patriotic, always to be obedient, and never to question at all," recalled Darlene Phillips, who as a teenager sat herself down in the hovering fog of an orange-pink fallout cloud near Bryce Canyon to paint for a few hours. "And so when we started testing bombs out in Nevada I was excited about it. . . . We would always be notified when there was going to be a blast because it was patriotic hoopla to get out there and watch them. . . . You would see the whole sky light up as if the sun were coming up backwards, and even the shad-

ows of the trees would be wrong, casting their shadow in the other direction. And I should have known then that the world was upside down, that it was wrong, but I didn't."

Darlene Phillips, a writer as well as an artist, was one of the most articulate of all those I asked about the dangers of blind obedience. "I am not Mormon now. . . . I chose a different way. . . . Having asked [as a young woman in the 1950s] for some guidance about the issue of fallout and political issues related to it, [I was] told 'We're just good citizens and we're lucky to have these tests near us, and we should be honored. This is our chance to prove that we are loyal citizens of the United States.' I feel that everybody in Utah has paid for that. I think Utah was the one state where they could have done this." Even after a group of about a thousand scientists led by Dr. Linus Pauling had issued a warning about the health effects of radiation in the mid-fifties and there were small demonstrations against the testing in Utah, when Phillips wanted to join the protest she was forbidden to do so. "I asked my bishop what was the proper role for a good Mormon woman to take. He said, 'No, you stay away from it, those people are Communists,' so I didn't go. To Mormons, the first law of God is obedience. We were more able to be victimized. Utah is rather well known for fraud, and it's because as a structure, as a society, Utah is filled with people who will believe just about anything."

It was extremely painful for me to comprehend the responses of the Mormon downwinders in Utah. What they were told, they believed, and whatever they believed had made these good and gentle people fearful, suspicious, enormously resistant to interviewing, and, in most cases, extremely passive once confronted with the tragedy of radiation-induced cancers. (This was definitely not the case with the Test Site workers and atomic veterans or their widows, who always welcomed me with great warmth, very anxious to speak up, and who would immediately push enormous stacks of scientific papers, legal depositions, and magazine articles on the subject into my hands.) Caught in a real catch-22, many downwinders in Utah would tell me that they felt it would be disloyal and unpatriotic to speak up "against the government," much less act. There were, however, the rare few who thought to examine the other side of this coin, to speak up forcefully for themselves and for the health and welfare of their families, often at the cost of being perceived as eccentric, or worse.

Many downwinders testified that the Public Health Service officials told them that their "neurosis" about the fallout was the only thing that would give them cancer, particularly if they were female. Women with severe radiation illness, losing their hair and with badly burned skin, were even clinically diagnosed in hospitals as "neurotic." Other severely ill women were diagnosed with "housewife syndrome." Duplicity was also evident in military propaganda films shown to soldiers before they were exposed at very close range, often less than three miles from ground zero, to the force of an atomic bomb. They were reminded that "the sun, not the Bomb, is your worst enemy at Camp Desert Rock." There were those who, once confronted with their own illnesses, knew there was absolutely no "neurosis" involved and preferred to think things through clearly, but often at a great price. "When I left the Mormon church I claimed back for myself the right to make my own decisions, even if they were bad ones," Darlene Phillips remembered. "My parents were angry. My mother disowned me. My sisters wouldn't speak to me. My neighbors wouldn't have anything to do

with me. It was not an easy decision, but I chose life over tyranny."

The dormitive forces created by this authoritarian system were not so evident in other western states where the Mormon church was less rigidly entrenched. Ruth Cole Fishel of Belle Fourche, South Dakota, was vigorous in investigating the cause of the deaths of her calves, conducting crude autopsies with her husband, calling in local officials, and collecting as much scientific data as was available. Other interviews collected in Rapid City, South Dakota, were evidence of an active community network that served to alert the public health authorities of a radiation problem. Streets were flushed by local fire departments, milk dumped, and other means taken to minimize the danger. Yet shortly after milk samples from Utah were tested in St. Louis by AEC scientists, the levels of acceptable radiation were raised to suit the findings. Nobody questioned. And no one ever hosed down the streets of St. George.

The phrase "nuclear numbing" was coined by Dr. Robert Jay Lifton, a psychiatrist whose definitive studies of the emotional health effects of nuclearism (beginning most notably with the interviews of the *hibakusha* of Hiroshima and Nagasaki for his book *Death in Life*) have been a major part of his life's work. His writings suggest that the passivity, the numbness that I witnessed may have been a natural by-product of both the trauma of atomic bomb tests conducted so close by (near enough for the shock waves to throw people from their beds) and the cover-up, the web of lies in which the downwinders were tangled. To cope with the psychic damage from their betrayal, perhaps it was necessary to avoid acquiring further information that would make their vague

fears specific enough to require decisive action. In this warping of awareness and crippling of grass roots political potency, the downwinders were the Cold War bellwether of an increasingly unquestioning nation. They were the unwitting casualties of an American nuclear jihad: the Cold War against Communism. Each society produces its own slaughter of innocents, of those who are most expendable in dangerous times, whether the danger is falsely manufactured to achieve a political end or truly exists. "My country right or wrong": the issue of blind obedience to authority is germane to all societies that value abstract ideals above life itself. The active or passive role of religion is as important and powerful as the role of the state. The most extreme penalty for such absolute repression of individual choice, by either a government or a religion, seems to be a repetition of the human holocaust syndrome, genocide. And at the heart of this planetary misery is a manipulative net of what Erasmus called "deceitful fictions for the rabble" reaching back into recorded history, with which the powerful few of both the church and the state control the lives of the many, always for their own good.

By virtue of the near-invisibility of the deadly radioactive toxins and a well-orchestrated government cover-up, this was a secret war. The fallout debris scattered over a 350,000-square-mile area, creating many hot spots that in one hour could irradiate any interloper with sufficient exposure to kill. Those involved, living downwind, working at the Test Site, or conducting military exercises on the nuclear battlefield, were consistently told "there is no danger," a duplicity that continues to this day throughout the nuclear military-industrial complex. In the lingering aura of a previous Holocaust

concluded not even a decade before testing began, these nuclear experiments made "forgotten guinea pigs" of "a low-use segment of the population."

Primo Levi, a survivor of Hitler's genocide of the Jews, wrote that "silence is complicity." So few of us know that until recently nuclear tests were conducted twice a month in Nevada under the moonscape that is Yucca Flat. Each test costs the taxpayer between $50 million and $100 million. Many if not most of the devices exploded are ten times the size of the bomb that destroyed Hiroshima. Fifteen percent of the more than 760 announced nuclear explosions have leaked radioactivity into the atmosphere, and so they are only detonated, as they always were, when the wind is blowing toward Utah. Death by geography. Who decides who lives and who dies? Glenna Orton's protest, "I'm as important as anyone else," is a truth that was lost in the race for global nuclear superiority, as in any tyranny.

After I moved 60 miles north from St. George to Cedar City, I would occasionally go to the dreaded K-Mart for batteries or soap and feel the horror of seeing there four- and five-year-old children wearing wigs, deathly pale and obviously in chemotherapy. The landlord of my apartment on North Main Street was Carl Bradshaw, who owned the hardware store on the ground floor. His wife had died of leukemia in her thirties, and one of their sons was born with only one hand. Isaac Nelson lived a few blocks away, and I would often walk over to keep him company while he spent a half hour twice a day as a school crossing guard. More sick children, and always the memory of hearing Isaac's story, my first interview, describing an ordinary night when his wife, Oleta, went into the bathroom to wash her hair. "All at once she let out the most ungodly scream, and I run in there and there's about half her hair layin' in the washbasin! You can imagine a woman with beautiful, raven-black hair, so black it would glint green in the sunlight just like a raven's wing, and it was long hair down onto her shoulders. . . . She was in a state of a panic." Once I became sensitized, the Bomb's deadly harvest was before my eyes everywhere I looked. Years afterward I appeared at the offices of the Department of Energy in Las Vegas after an accident at the Test Site released radioactivity into the atmosphere. I interviewed Public Affairs officer Barbara Yoerg about the incident. Aware that I was a photographer on a newspaper assignment, she mentioned that she too had a master's degree in photography and then elaborated that she was only working at the Test Site so she would have enough money to support her work as a photographer. . . . Now that the news of an accident and radiation release had been admitted to the press, I inquired about the AEC/DOE's practice of waiting until the wind blew toward Utah before testing bombs or venting radiation in order to avoid contaminating Las Vegas or Los Angeles. Unabashed and unconcerned, she actually said, on tape, "Those people in Utah don't give a shit about radiation."

In this decade as a documentarian and up-close witness to the health effects of nuclear testing, I've had to admit this candid Test Site official could be right, but not only concerning Utah. When it comes to matters nuclear we have come to resemble the fish of the deep, pale beings who have lived so long in darkness that the eyes have become vestigial. We believe what we're told, if only to quell anxiety. During the eighties the nation stopped questioning altogether, leaning back into the comforts of consumption and greed while

taxpayer dollars spent on metastasizing the nuclear military-industrial complex hit the $2 trillion mark, ballooning the deficit rather than paying it off. Lack of vigilance and control of the weaponeers played a large part in bankrupting the economies of not just one superpower but two. We have entered the second nuclear age, one of burgeoning radioactive waste with no safe burial ground, one of proliferation and terrorism. Now anyone, anywhere, can build and detonate a nuclear bomb. Deadened by fifty years of nuclearism, we may have mutated into a nation of "good Germans" unwilling to see.

**The contemplation of things as they are,
without error or confusion . . .**

Out of this blind silence, a brief whisper of the voices of the living and the dead can be heard rising from these pages. The nuclear war that claimed their gentle lives is no longer a secret. They leave their memories to us as a warning.

Those who profess to favor freedom,

and yet depreciate agitation

are men who want crops without plowing up the ground.

They want rain without thunder and lightning.

They want the ocean without the awful roar of its waters.

Power concedes nothing without a demand.

It never did, and it never will.

Find out just what people will submit to

and you have found out the exact amount

of injustice and wrong which will be imposed upon them.

These will continue until they are resisted

with either words or blows, or with both.

The limits of tyrants are prescribed

by the endurance of those whom they oppress.

FREDERICK DOUGLASS

August 4, 1857

THE NEVADA TEST SITE WORKERS:
TAKING RISK AS IT COMES

In honor of Ben Levy

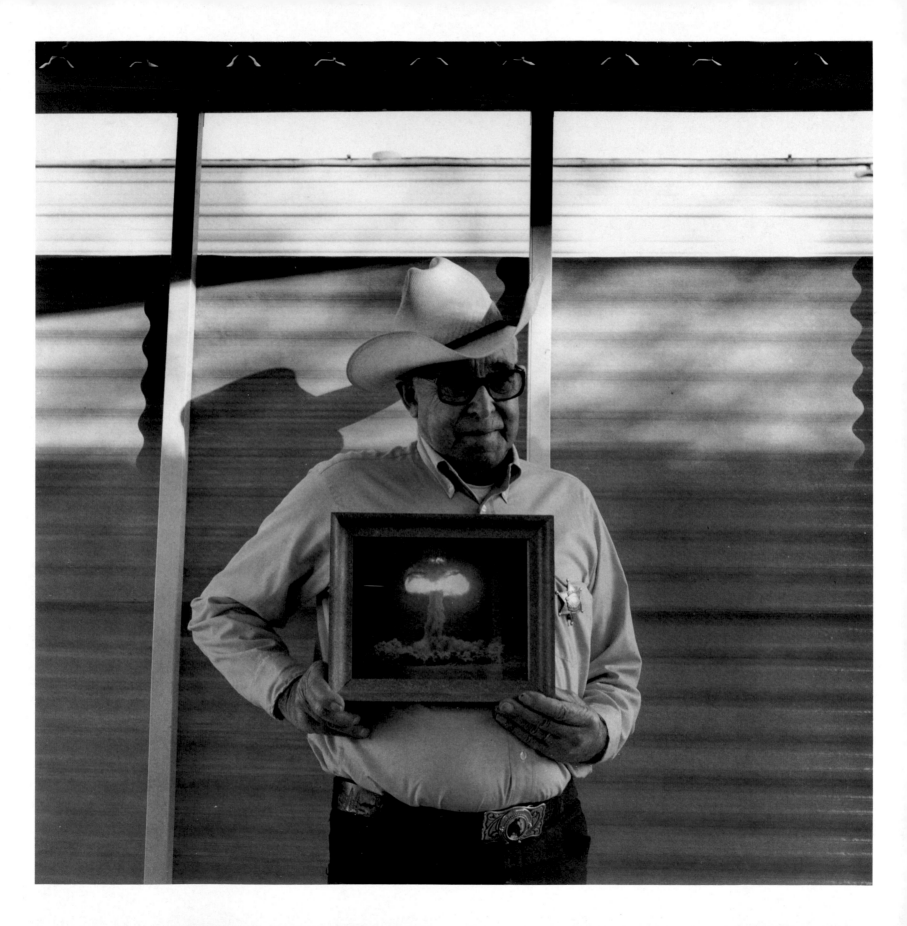

KEN CASE

January 1984

North Las Vegas, Nevada

"They've tried every shot they can think of, over and over and over and over. Rabbits would run across there, and they would be on fire."

Ken Case had the dubious distinction, he thought, of being called the "Atomic Cowboy," both by his fellow workers at the Test Site and by the press. Hired on a horse as a deputy sheriff by 1954, he literally became a cowboy for the Atomic Energy Commission, riding a herd of cattle and horses over ground zero after a nuclear detonation so that the effects of radiation on wildlife could be measured by scientists at Los Alamos. This series of animal experiments continued for seven years. He showed me yellowed photographs from the fifties of himself in that capacity, the complete Marlboro Man, in the saddle and holding up a cattle branding iron with AEC initials measuring almost a foot high. There would be no mistaking a radioactive cow on the range with a 12-inch brand burned into her hide. In another testing era photo he pointed to himself on horseback, and particularly to the dust raised by both horses and cattle. "They got cancer and we got cancer," he said, "only the animals were so much closer to the ground that they died faster."

Case himself had many feet of his intestines removed, and his spleen, and at the time of his interview the cancer had spread through most of the organs of his body. His wife was also dying of cancer, and she had also endured for years the fusion of the disks of her spine, another health effect of high radiation exposure. They both lived in a trailer in North Las Vegas, and among the bric-a-brac hanging on the wall were photographs of two atomic bombs that Case had witnessed at close range, among many others, while he worked at the Test Site. One hung above a plate with a poem "To Mother" on it, glazed with pink roses. He was a kindly bear of a man, and he and his equally endearing wife were, as religious Mormons, preparing themselves for Eternity—they knew they hadn't long to wait.

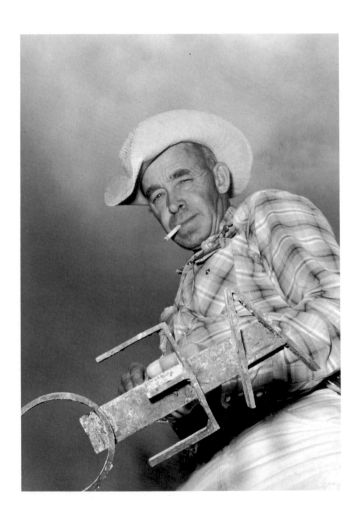

Ken Case, the "atomic cowboy." 1963. Courtesy of Reynolds Electrical and Engineering Company and the Department of Energy. This photograph of Ken Case holding a foot-high AEC cattle branding iron adorned the cover of the *Test Site News.* One of Case's duties was to herd cattle over the atomic range, particularly over the ground zero areas, in an AEC animal experimentation program, whose existence is denied to routine visitors to the Test Site.

Your job was to herd cattle on the range. Were you close to the ground zero area?

Went right through it a lot of the times. I had ridden the range all the time on horseback, all the area, checking for feed and water. To start with, in '55 and '57 they brought in 27 or 37 big helicopters, the kind they call the banana type, the big sway-nose with the double props. I think every mission, in the chopper, the pilot and I would be the first ones in ground zero. We were monitoring.

Did the geiger counters go off-scale? How close to the ground were you, and what did it look like?

We would get over [ground zero] and bang, off-scale. When we went back over about 30 feet off the ground, the sand, it would be melted just like glass. Those ground zeros in the spring, you look out, they bleed a big circle in the snow around ground zero. After a shot and it's cooled down, then they monitor all that area and what's left of the tower [on which the bomb was detonated]. They just melted that tower down. They had a few aerial bombs that planes came in and dropped. They would have just so much time to get away from them. If you happened to watch the plane, it would rock the plane. As quick as it went, the area around the outside of that circle would be on fire. All the weeds and grass, and if there were trees, they were on fire too. Rabbits would run across there and they would be on fire. It was something.

How long were you monitoring from the helicopter, how many shots?

About 15 or 18 aboveground shots, and I was in every one of them. We took samples of the cattle all the time, twice a year, so many out of each herd. I think that as far as having to do that first for results of radiation, they have been wishing away their money for the last ten years. They had all the data they ever needed, had it for a long, long time. They've tried every shot they can think of, over and over and over and over. It's just a way people spend a lot of money.

Many years after this interview, in 1989, I took a "public information tour" of the Test Site that is available to anyone who requests it in advance. The Department of Energy even solicits visitors at conventions in Las Vegas and at old age homes, and so the bus was filled with senior citizens looking forward to a day "out of the city" as well as people from other countries who were just plain curious. No photographs were allowed, and no tape recorders. The tour guide knew who I was and became flustered when I asked about the animal cages still left standing on Frenchman Flat, the site of 27 atomic bomb tests. She denied they were cages. Thinking also of Ken Case, I continued to inquire if there had ever been a program of animal experimentation at the Test Site, say in the fifties, before they knew better. "Oh, no, we wouldn't do that."

What were the viewing conditions when an aboveground detonation would take place?

They had a big crowd out at the observation point, lots of people there and cars. They had gone through and told everybody that before the shot time, they would furnish the glasses like goggles, to wear them or turn their backs to the shot, not to face it. There were a few of them that tried to be smart and try to look without them. They were blinded for quite a while. The bombs were powerful enough that you could turn your back and it would burn the back of your neck from the heat. That was about five or six miles from ground zero from where we was at.

Did you witness what the atomic vets experienced? How many of them did you know?

About two hundred. A bigger share that I knew personally while I was out there, I don't think there's four or six alive today. They were all over. Camp Desert Rock had a lot of them, of course. They went out with machines and dug trenches for them to get into. So many feet or yards away from ground zero. I forget how close. The first ones were pretty close, closer than a mile away. It was where it was hot. There wasn't hardly any of them at that time that didn't get sick. They tried to keep them to say it wasn't, but it was, the effects of it. A lot of it depended on the type of shot it was, what chemicals they used in the device itself. [I've lost] eight or ten friends that I knew quite well.

When I first started getting ready for the shots out there, when they started their series in '55, the only shot I wasn't near was from Control Point, and they had me go out on the highway, patrol the highway from Lathrop Wells to Indian Springs. The winds had changed and brought [the fallout cloud] right back over Control Point. The patrol car we were using was an old Plymouth sedan. They took it into camp later and washed it down. I had a little breakfast, then asked them if it was ready and they said yes. I got partly back to Control Point and my arm started burning. I rolled my sleeve up and I was burned from my hand to my elbow a strip about that wide [about two inches]. There was radiation in the felt pad on the window, because it was wet where they washed it down. We got hold of who was supposed to be the head guy and told him what happened. He said, "Go back to work, nothing to worry about." He wouldn't even look at my arm. That's the way they operated out there. It's a fright, it's terrible.

I've had eleven surgeries. Tumors. The Test Site, as far as I'm concerned, is just nothing but a place for them to spend a hell of a lot of money foolishly.

Ken Case died on July 5, 1985, and his wife, Woody, followed him shortly thereafter.

KEITH PRESCOTT

November 1984

Kamas, Utah

"They gave us the attitude that we weren't to complain and if we did, we would lose our jobs. In the tunnels they had a quart bottle of aspirin sitting there by the water can. In two shifts that bottle of aspirin would be gone."

Keith Prescott and his family have always lived in the small town of Kamas in the Uinta Mountains, 40 miles east of Salt Lake City. For the entire time he worked at the Nevada Test Site, 1961 to 1968, he was only able to spend weekends at home, living during the work week in a trailer right at the Test Site and traveling 1,200 miles each weekend, round trip. This commute is not unusual in the West, where the economy has forced many to travel long distances for work. His job involved underground construction, the digging out of tunnels in which nuclear tests would later be conducted, and as the operating engineer he would also haul dirt out after a blast with his mucking machine. Twice he was asked to recover instrumentation from near ground zero inside the tunnels, and during the atmospheric testing era he had also witnessed many aboveground detonations. As if this were not enough exposure to radiation, he and his family lived in the fallout path downwind of the Test Site. When Prescott discovered he had multiple myeloma, a radiogenic cancer of the bone marrow, he decided to sue the Department of Energy and the Test Site. His case represents the grievances of all Test Site workers, opening the way for the remainder of them to begin litigation. The federal government sought to dismiss the lawsuit, arguing that actions and decisions chal-

lenged in his lawsuit involved the performance of a "discretionary function or duty" necessary to preserve "national security."

Prescott was clearly under the strain of great pain from his illness when I interviewed him, and would occasionally burst into tears from the struggle with his physical suffering and the pathos of the story he was remembering.

We would be working in the tunnels when they had an atmospheric shot, then everyone would have to come outside. They would give us a pair of dark glasses to wear and we'd sit there and watch it go off. If there was any chance of radiation we'd wear a film badge. We just accepted it because we thought they were taking whatever steps was needed to protect us and you were allowed 5 rems [of radiation] a year.

It was scary, you bet. Something amazing, something you didn't think you'd ever see in a lifetime. When the bomb would go off, you could see the ledges fall off those mountains, and dust. Then you could see somewhere near where the blast was, and it looked just like a tidal wave coming. The ground would go right to you, it was visible. The ground was moving, just like a wave in the water. You could see fissures in the ground and then the dust would spew up from the cavities, maybe for 10 minutes.

Tell me about your recovery missions to ground zero in the test tunnels.

After they blast and get all the muck [interior bedrock] blasted, then I'd go in with the mucking machine. It had a dipper on it and you'd go in and pick the muck up and put it in a conveyor onto cars, haul the cars outside and dump it. This one shot in the B Tunnel we had masks, respirators,

rubber booties and coveralls and gloves that you tape to your wrists and ankles. At this one particular shot there was poison gas of some kind. We had oxygen masks and the hoses running up. I remember this one time the hose caught on a piece of steel, and the fitting came loose. Chuck Taylor, he's the one that took care of the hoses and stuff for me, he got the coupling back together, and I remember Glen Clayton, he was my shifter at the time, said if I would have breathed any of that air, it would have killed me right there. I assume it was radioactivity, too. This one shot, of course, was in sand, and it would get so hot. You could see the steam coming out of the sides and the awfullest smell, just burnt, just nothing you could ever describe. Burnt dirt, burnt sand is what it smelled like. Just real hot, maybe 153 degrees or hotter. They had Rad Safe [the radiation safety team] in there because it was real hot with radiation too, and they'd change our film pads twice a day at noon and at the end of the shift. No one ever said what it would do to you.

Why did you stop working at the Test Site? Was that in 1969?

Well, about a year before that, I got feeling real bad. I knew something was bad with me but I didn't know what it was. Then, when we'd get on the buses to go to work, my sides were hurting and I thought it was my kidneys, just pain. It hurt so bad I couldn't sit down in the bus, and it went on for a long time. I could still work. I could run my mucking machine but I just couldn't lift. I could push, pull, and it just seemed like the muscles were affected. I went to a specialist in Las Vegas, who said it was the type of work I was doing— he said lots of women who scrub floors have the same thing I have from bending over! The people at the Test Site were

of the attitude, "don't make any waves, don't come in and complain." That makes you feel bad, because you knew something was wrong with you and nobody believed you. In the tunnels they had a quart bottle of aspirin sitting there by the water can. In two shifts that bottle of aspirin would be gone. There wasn't anyone there with enough ambition or guts to complain of the conditions we were working in. They gave us the attitude that we weren't to complain and if we did, we would lose our jobs. That's the words they said. Men were sick from no ventilation. Just dead, stale, stinking air and gas from the rock. A lot were nauseous, headaches. They had 300 men working a shift down there.

There were precautions they could have taken that wouldn't have cost them a dime. Like taking your diggers [work clothes] home to get washed. Just take them home and put them with the family wash and wash them, then take them back to work Monday and wear them till Friday night. We didn't even think about it, taking the radiation home. The cuff of your pant leg, walking in that dust, you've got to have radiation in it in certain amounts. We had dosimeters that would read up to one *rem* and if the red line was up at the top you'd go and check with Rad Safe. They'd always say it was not working, something wrong with it, throw it away and give you another one.

This one night we were working the graveyard shift and we quit to eat our lunch. I was having a cup of coffee and my throat got sore, and by the time the shift changed, another four hours, I could hardly breathe, my throat was so swollen. So I got in my car, to show you how scared I was, I practiced putting my finger in my throat to get air because I didn't think I was going to make it. I got to Mercury [a small town in the southeast corner of the Test Site] and went in to talk to the

doctors. They didn't do anything but give me aspirin. Then they said, "Now you go back to camp. If you don't feel better, why, you come back." I told him, "I can't get to camp. I was damn lucky to get down here. I'm not going to go back because I can't make it." I got in one of the beds and when I woke up I was in a Las Vegas hospital.

I don't know how much later, we were going to work one morning and I had just stepped on the back of a muck car to ride into a tunnel, and I had a battery light in my hand. I dropped the light into the bottom of the car, so I just bent over to pick it up and put my weight on my chest on the edge of the muck car, and I heard it pop. I heard a noise in my chest and I got nauseated and I couldn't walk. I couldn't do anything. Of course my shift boss was hollering that I wasn't there ready to work, screaming and hollering. They weren't concerned. I went out, I don't even remember if I went to Mercury. I came home. They diagnosed my multiple myeloma and they told me the bones in my chest had shattered just like a windshield in a car, in a million pieces. My whole chest had shattered. The doctor said I had pulled something inside my rib cage, and the diaphragm broke loose. Through this multiple myeloma I also had six disintegrated vertebrae, but I was working. I had lost three inches of my height through these crushed vertebrae. That was in October of 1969.

Did you ever have the feeling that you were expendable?
Yes! Very! When I worked down there, I never doubted them. The government's name was made serious. When you worked on the job that involved the government, you didn't have any worry, they'd take care of you. I think ninety percent of the people that worked there felt the same way. You were allowed five rads' worth of radiation a year. If you hadn't been exposed to radiation they'd take you in a hot place and work you right up to where you almost had five rads. Once they had a shot at noon, and the graveyard shift came in at midnight. When we came on at eight the next morning, the shifter was telling us how sick his men were. They don't know what it is so most of them are outside the tunnel. That shift went out and as soon as they went through the gate at Mercury [which measures the radiation on the workers] the alarms went off—they flew the guys up to Livermore Radiation Center. They never called *us* to Mercury or checked us over, that's what got me. One guy said, "This recovery [of instrumentation for measuring the bomb's size and effects] is so important to the United States government, the consequences don't mean anything. We're going to get that stuff out of there regardless." It wasn't long until they sent us in to recover.

Keith Prescott's daily life in Kamas is a struggle to conquer pain. He is trussed and corseted to keep his fragile bones in place, and even sitting still in a chair is often a challenge. When I asked him what kept his spirits up, however, his eye had a twinkle. Somehow he was able to walk down to the barn, and he pointed to a very young colt that was romping in the corral with its mother. "All I want is to watch him grow up," he said, and taking a small camera out of his pocket, he started to photograph.

All these years later, Keith Prescott is still alive. His lawsuit against the Test Site contractors and the government is landmark litigation that has been battled in the courts for a decade. There has not yet been a decision.

BEN LEVY

January 1984

Las Vegas, Nevada

"**Everything I tell you I can substantiate with documents.**

I'm going to prove to you our government is lying and

covering up."

Benny Levy was very ill, incapacitated by fits of coughing on the day I first met him, but he was determined to show me his considerable collection of declassified papers, photographs, old magazines, and books as irrefutable proof of the dangers of working at the Nevada Test Site. In 1980 he had organized a large group of workers and an ever-growing contingent of their widows that met monthly to talk over the progress of litigation they had begun against the government and the Test Site contractors. Among them they had collected their "bioassays," Test Site records of their estimated radiation exposure. When men who had worked side by side over the years compared records, it was clear that the estimates had been manipulated. Rarely had they worn badges, dosimeters, or protective gear, so where had the numbers come from? I looked over eight years' worth of Benny's dose estimate papers. All that time he had done the same job in the same places. The numbers made no sense.

Everything I tell you I can substantiate with documents. I'm going to prove to you our government is lying and covering up and not telling the truth. They say the Test Site is not a hazardous place to work, okay? There are 49 radex [high radiation] areas in the Test Site and I've worked in every one of them.

This is my radiation exposure in 1957, 3,850 millirem. 1958, 3,760 millirem. I want you to pay special attention to the '60 to '65 years. I come up with a zero reading. There's *no way* you can come up with that when you're working out there where there's plutonium, and I was into it pretty heavy. When I requested a second opinion, they found out I had a few more, so they gave me 10,110 [millirem]. That's only by film badge, that's external, but they never gave me any reading

of my internal, what I inhaled or ingested. They have no record of that. [All records of exposure kept by the AEC/DOE are for external dosage. Ingested or inhaled radioactivity has never been estimated or even studied.]

I worked at the Nevada Test Site for twenty-seven and a half years. I worked there when they exploded the first bomb, the 27th of January 1951. We worked during the atmospheric era, when they shot the bombs off the tower. We built the towers, and then we cleaned the towers up and cut them with a torch. That was all contaminated metal. When that bomb went off, it was formed like an umbrella. The fireball came back down to earth and enveloped all that debris from the melted tower [and the earth below] and that's what the fireball carries with it. As it dissipated that dust started to come back down to ground zero. We went on reentry thirty minutes to an hour after they were detonated to recover instruments when the ground is still smoldering hot. We would go in and clean up after they cooled. We breathed the air out there. We were exposed more highly than the people that cleaned Nagasaki or Hiroshima because everything fell right back to the Nevada Test Site. That's my problem today but they'll never admit it. Lung problems, started a couple or three years ago. I'm just taking it as it comes. I never wore a mask the whole time I was out there. That's why I say the Good Lord had His arms around me all this time, because all these guys I worked with are dead. There are very few left.

One time they were going to fire me, lay me off, because I was too hot, I had had too much radiation. 1957. I know they haven't checked none of the people who were contaminated that have died of cancer, they haven't pursued the investigation of anyone's health status. They haven't checked me once. I've paid for my own checking. The Nevada Test Site does not have any compensation for any radiation-induced illness. If you get cancer that's radiation-induced, you pay for it yourself.

You asked me why I got into this, disputing the government? In 1956 I lost three very good friends in a mishap, the safety experiment test [at Frenchman Flat] they were conducting to see if a nuclear device would be detonated by crash landing the airplane it was on. It went nuclear on them. On the reentry in the recovery is when they got contaminated with alpha radiation, plutonium. They weren't protected for alpha radiation. Oral Epley was sick for days afterwards. He died from a cerebral hemorrhage in the hospital three days after he recovered the instrumentation and his family had to come from Oklahoma for him. They asked the family if they could hold the body over one day, and for permission to hold an autopsy. They removed all his brain tissues and his soft tissues. The guy that transported the organs to Mercury to put them on a plane to Los Alamos is a friend of mine. The family was never provided with a death certificate. I got one from Vital Statistics which said there was an autopsy performed, but under "Consent of the Family" it said "NO." Our attorney, Larry Johns, went on to find out what happened to the organs and Los Alamos said they have no record of them. The other friend, Joe Carter, is dead from the same thing.

So that's how I got where I am today: that's what started the government to lie, in 1956. Do we have justice? No, we don't. What they're doing is that old stalling game, wait for everybody to die so nobody will be compensated for it. Then they'll have nobody to testify. They would send these men in to recover regardless of the consequences. They would not

warn the people of the potential dangers, just go in and not tell them. The government doesn't give one red nickel for a life. All I can say is it's going to catch up with them. The truth is going to come out.

Eight years later when I visited Benny again at home, his exposure had caught up with him. A changed man greeted me at the door, too thin, too frail, almost unable to speak, walk, or even stand steadily but quick to cry. Over the years he had made great progress in his struggle to expose the truth of working conditions at the Test Site, eventually winning the Karen Silkwood Award from the Christic Institute for his courage as a whistleblower. Most of the Test Site workers he had arranged for me to interview, and their widows, were dead, and the remaining women were embittered, often clinically depressed and living in poverty and isolation. One of them had lost everything, including her home, while trying to pay off her dead husband's medical bills, and was forced to live in her car for a year. In March 1992, the 9th Circuit Court of Appeals had denied the government motion to dismiss the Keith Prescott case, the bellwether case upon which the remainder of Test Site worker litigation would be based. The truth was beginning to come to light, despite the costly, decade-long efforts of government agencies and their military contractors. With glacial slowness the wheels of the justice system had ground down many of the obstacles placed in the way of worker compensation by the Atomic Energy Commission and its equally wily spawn, the Department of Energy, but it had pulverized the remaining victims also. Some very small progress had been made, but for the most part "that old stalling game" had succeeded all too well.

WALTER ADKINS

May 1984

Las Vegas, Nevada

Walter Adkins was exposed for five hours to the fallout cloud of an underground test, Baneberry, that vented. "It sounded like a clap o' thunder . . . ka-POW!!! And that turned our coffee cups over, we thought the mess hall was comin' down. A big red flame and black and smoke was going up just like during the war at Iwo Jima. They just ruined my car. Steamed it for nine weeks. Yep, that's how they got the radiation out of it."

When the United States and the Soviet Union signed a partial test ban treaty in 1963 that banished the atmospheric testing of atomic bombs, an anxious public was lulled into the belief that it was now safe from fallout. Baneberry, an underground detonation of a nuclear warhead at the Nevada Test Site, was an explosion gone awry in December 1970, one of at least forty tests in the sixties and seventies that vented massive levels of radiation. The device had been placed in a vertical shaft 900 feet deep and 86 inches in diameter, but when it vented it cracked a fissure in the desert floor that was at least 300 feet long. This dynamic venting continued for over 24 hours to emit a radioactive cloud of more than 3 million curies that slowly drifted over Nevada, Utah, Wyoming, and part of California. Part of the fallout cloud was absorbed into a winter storm system, creating highly radioactive snowfall over popular ski areas near Salt Lake City, as

had a test code-named Schooner two years earlier. In a hearing eight years later on the potential dangers of underground testing, Admiral Hyman Rickover, the father of the nuclear navy, reminded a congressional oversight committee that "the significance of just two-thousandths of a curie is that the radiation to which people are potentially exposed . . . is equivalent to about six or seven chest X-rays." Rickover was respectful of the toxic power of the split atom. When the navy began fueling their submarines with nuclear power, he had hung an adage over his desk: "Where there is no vision, the people perish."

By Rickover's estimate, people living or working directly downwind of Baneberry would have received billions of chest X rays from that test alone. Walter Adkins, at that time a bus driver at the Test Site, owed his physical condition to his experience of fallout during that incident. He developed a tumor on his larynx, then had a cancerous lung removed. Skin cancers had developed all over his body. Months before I interviewed him in May 1984, he found it difficult to breathe at all without a portable oxygen unit; he would carry a tank of oxygen with him wherever he went to survive with his one sickly lung. He showed me a photograph of himself taken in the late sixties when he first began working at the Test Site. He and his wife, Marvel, had moved in an economic crunch from Oklahoma to Las Vegas so he could work there; they lived in a tiny trailer on the Boulder Highway, then on the outskirts of Las Vegas.

When Baneberry went off, I went back up there [to the medical outpost at Mercury] and the doctors went over me with a fine-tooth comb. My hair, my eyes, my heart—a cardiogram. They were saying there wasn't a thing wrong with me, and I was strong! I went to work there in '61, off and on. Work was

slack, and they'd call me back, then laid off, up until Baneberry went off. Then I worked for a while after Baneberry, and then we got laid off. I don't know if it was because I was loaded with radiation, or what it was. They knocked me out of my union pension, and I went to goin' down. A downgrade after they laid me off . . . seemed like it took all the sap out of me. I didn't have no more energy. Or nothing. I'd get to burnin' inside the skin. Seemed like I'd start to ache, and my bone would burn down inside me. [He pointed to the skin cancers all over his body.] You can see right here where it burnt me a little bit. Just kept breakin' out all over me, right around the hairline and all over. [This is the characteristic manifestation of heavy exposure to radiation: a severe, burning rash, intense lethargy, and body pain, followed years later by numerous skin cancers on exposed body parts.]

I'll tell you about Baneberry for a minute. Now that's where I got my big load of radiation. I went down to the mess hall with my bus to take a load of men to work and bring 'em back that morning, and I'll swear it seemed like it was seven, or before eight o'clock that the bomb went off. I had to go take the men up to T-Tunnel [one of the access tunnels to the underground excavations where the nuclear bombs are detonated]. I was sitting there drinkin' my coffee, waitin' for the boys to get through eatin' and git on the bus. We was sitting in the mess hall, up on the mountain, and down on the flat here not quite six miles we was from it, it blowed plumb out of the ground.

Boy, it *shook*. A blast, sounded like 40 sticks of dynamite went off. It popped! I mean it sounded like a clap o' thunder . . . ka-POW!!! And that turned our coffee cups over, we thought the mess hall was comin' down, and we run outside, and look right down the hill, and a big red flame and black and smoke was going up just like that bomb did during the war at Iwo Jima. Just like that! And so they made me take that load of men, get a load of men on the bus, and go on up to T-Tunnel, and I had to go right down there towards where the bomb went off! We went up and the men said, "Go into T-Tunnel and stand by, and let the men go in. We don't know what we're going to do yet. We'll call you . . . you stand by." So pretty soon it seemed like I was there about 30 minutes. I was sitting on the bus. I never did go into the tunnel . . . 'cause they told me that radiation would never hurt you, back then. It was comin' over, boy, it was thick.

It came comin' over, and pretty soon they called to say, "Bring the men back to [Area] 12." I took 'em back, and they stood around there, and everybody went crazy! They didn't know what to do! They just went screwy! We were just covered up out there, standin' there waitin' for them to make up their minds what they were going to do. I could just see it, on my hands. Pink, kind of pink-lookin' stuff. Like a pink dust, my car inside was just covered with it. The 18th of December, 1970, that was the Baneberry.

So they took us up to the bathhouse, and it was snowin'. When we got there, that guy run that monitor over me? And it like to flew out of the box! "Oh, man," they said, "get out of that car, and get in that bathhouse!" And I went in there, and the damn hot water had broke down. We all had to take baths in ice-cold water. And I'd step in there and take my bath, I'd step out, he'd run that [geiger counter] over me and shove me back in there to take another one, till that happened nine times. I took nine of them, and I still don't think they got it out of my hair. The thing would just keep a-clickin' when I'd step up and I thought I was going to freeze to death in the ice-cold water. That's enough to kill a man, right there! In the winter time and snowing!

They just ruined my car. Steamed it for nine weeks. Yep,

that's how they got the radiation out of it. After they did all that, anyway, they took us out to Mercury. Had medics up there, and they tested us until four o'clock in the morning. I'm not kiddin' you. They just kept coming. We was settin' on the bus there and they'd run us in, and test us, test us, test us all night. And finally they sent us home with a pair of coveralls, paper coveralls on, and paper shoes. At 4 or 5 the next morning we got home.

Two years after Baneberry, Walter Adkins still suffered from a dry, hacking cough: "I always thought I had a cold workin' on me." Since the accident, he always noticed that anything he drank would be "foaming a bit" when it hit his windpipe, which set off a coughing fit. "I thought I had a cold all the time, but it was that tumor workin' on me. Then I went to breakin' out with skin cancers." Indicating tumors and growths on his arms, legs, back, nose, in his nasal cavity, in his ears and eyes, he continues, "All that stuff on me since the Baneberry blew off up there. Can't you see I got one right here in my eye?"

He has had a malignant tumor removed from his windpipe. A heart bypass was performed to allow for the future removal of his lung. Three weeks after the bypass operation, Adkins coughed up a cupful of blood, and was immediately hospitalized and a tumor excised from his lung. Two months later his entire lung was removed. He died in the autumn of 1988. For years Adkins had attended the monthly meetings of the Nevada Test Site Workers Radiation Victims Association, accompanied by his wife, Marvel, and a portable oxygen unit. He was, in body size, two-thirds of himself in the photo he showed me. In it, he is seen cutting the hair of a fellow Test Site worker in the warm Las Vegas air, before "the Baneberry."

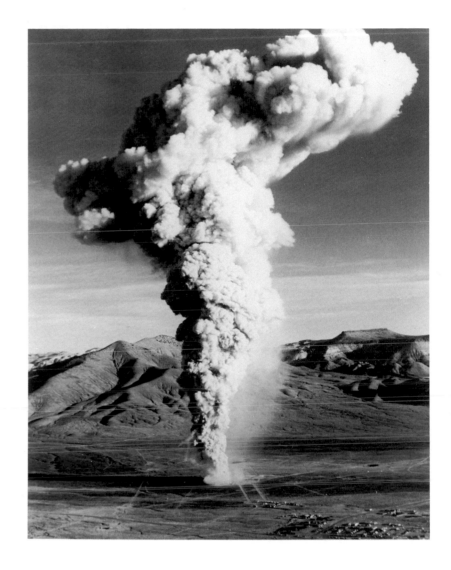

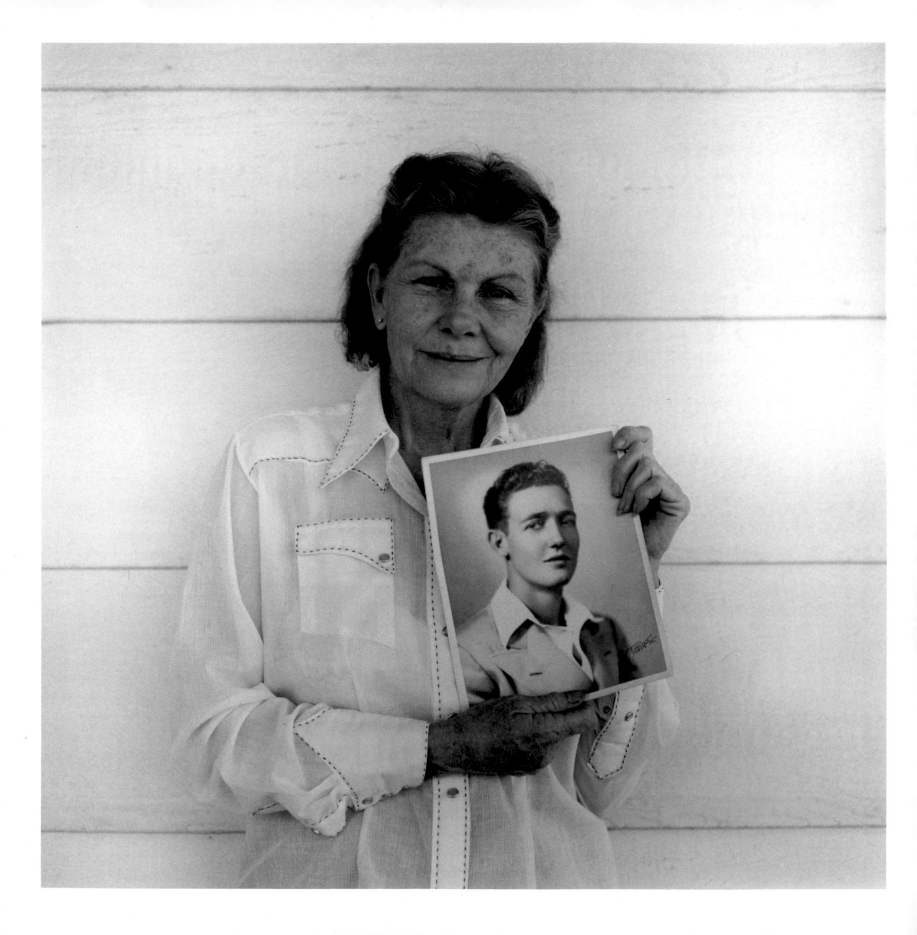

RUBY DAVIS

June 1986

Las Vegas, Nevada

"It's been proven what this radiation can do. No amount is safe to any human being. His tongue swelled out so badly before he died so that it burst out of his mouth and covered his nose. It was a horrible sight. Nobody could stand to look at him. I think the government killed my husband and ruined my life."

I had met Ruby Davis at a meeting of the Nevada Test Site Workers Radiation Victims Association at a steelworkers' union hall in a poverty pocket of Las Vegas. In fact, we had met a number of times at various radiation victims conferences around the country. She is a striking Irish woman with bright red hair, and I've watched her change from imperious to worn in the time I've known her. Life has not been comfortable for her since her husband died, weaving through spells of acute clinical depression. She shares her home with 150 large turtles, and she cares for them with great tenderness. Certainly it was a startling sight to drive up to in 115-degree heat, turtles just everywhere in the white-out glare of the desert sun. Once inside the cool of the house, I was shown a photograph of her husband Jack, and was touched by the sweet innocence of his face.

When my husband died, I locked the house up. I rented my house in Henderson for just enough money to make the payment on the house so I wouldn't lose it. Our insurance went out. At that time we didn't have heart disease or cancer coverage on our insurance with the union and in 13 months our insurance ran out and we owed so many thousands of dollars. I took him against his will to a veterans hospital in Long Beach. It didn't cost me anything except my rent and what I ate and that wasn't much. I stayed that year with him, and I was right there anytime he called. Right towards the end when I was out in the smoker I would watch the light up front and when the light went on it wasn't for the nurses, they just totally ignored it. It was for me because they couldn't do anything with him.

He lost his voice, he lost coordination of his hands, he couldn't write notes anymore. He hung onto life to the very

last minute. He would not give up, he was going to get well. It was better than three years then but he was actually in the hospital 26 months. He weighed 86 pounds three weeks before he died. We had to turn him over with rubber gloves because his skin was pulling off the bone. I couldn't cry, I could not let him see me cry. I could choke to death, I couldn't even cry behind his back because he knew when I'd been crying. We were only married eight years. We were together four years before and we were married eight, the happiest and the saddest.

We started going out together in '56 and we got married in 1960. He had worked up there a long time before that. The guys all worked together and the gals were all friends. We didn't think anything of it either. They were bringing home a good paycheck. Everybody needed the money. At various times Jack would come home and he would be restless, and he would tell Jim, "Let's go for a ride, son, I want to talk to you." "Why don't you talk to me too," I'd say. "I don't want to talk to you about work, I want to talk to Jim about work." He'd take Jim to a bar and they'd sit down and have a beer and he'd tell him, "I really got a dose today. I got a bad dose today. You're never to tell Mom this, never to worry Mom."

His last boss died of cancer six years ago. He devoted 16 years up there, straight years, never missing a day's work, never missing an hour's overtime, worked as a general foreman. He got sick and they told him he was getting old and couldn't remember anything and they fired him without any dignity of what he had given to that Test Site or anything. Five years later his wife died of colon cancer. We've all [the wives] been through a situation with cancer because I had cancer. There have been a number of the women that I know have contracted cancer. The men would come home in these dirty clothes, dusty clothes, faces are ashy dusty, their helmets are ashy with dust. Radioactive dust.

The last few months of Jack's work there his boss, Zeck Simmons, came and told me, "Ruby, I'm going to have to pull Jack off the job." I said, "Why?" "He's going down in the hot holes for recovery and he can't make it back, we have to bring him out. [Hot holes are the underground tunnels and vertical shafts at the Test Site in which nuclear tests have been conducted since the 1963 Atmospheric Test Ban Treaty.] He's choking to death in the hot holes. He can't breathe anymore, he's choking to death. I'm going to have to do something." I said, "Fire him. Fire him right away." The last time they pulled him out of a hot hole was the last time he worked.

They were going to remove his voice box and his tongue. They didn't. The tongue was too far gone and the voice box, they scraped what they could get. His tongue swelled out so badly before he died so that it burst out of his mouth and covered his nose. It was a horrible sight. Nobody could stand to look at him.

When he died he was 49 years old. He had death rigors all day long. I helped hold him in the bed. I would not let the doctor restrain him. I held him in the bed and the last rigor he went into I had both arms around him and he grabbed my hands and he died that way and he wouldn't turn my hands loose and I wouldn't turn him loose. So they had to come in and lay him down and take my hands out of his. It was an experience that made me a much better person. It helped me to understand there's hope, there's life after death.

Didn't your son also work at the Test Site?

Yes. His health is deteriorating now. He's worn out all the time. He can hardly hold his head up. He's totally worn out. He's told me sometimes that he can't think anymore, he's too tired to think. He's so tired and he's only 43 years old. He went to work up there when he was 18 as a summer apprentice. Now Jim's legs are bothering him real bad. His back is bothering him real bad. He's dizzy, he's real tired, he can't see, he can't focus, and he's going from one doctor to another trying to find out what's wrong with him. I asked him if he remembered Dr. Stewart saying it may take twenty years for it to show. He said, "Yes, I've thought about that." [Before testing began in Nevada, Dr. Alice Stewart of Birmingham, England, conducted a ground-breaking study on the dangers of low-dose radiation that indicated that women exposed to X rays during pregnancy had a very high rate of birth defects and cancer in their children. As venerable and vigorous as ever in her late eighties, she continues to do radiation effects studies to this day.]

So, Ruby, have you any thoughts about your government, and its part in all this?

I think it stinks. I think the government killed my husband and they ruined my life. Until I die I will fight this thing and I will do it. If I can just help prove that they killed our men as surely as they sent them to slaughter in battle, and they did and I believe that . . . We've kept everything under cover here actually. Many men that have died right here in Las Vegas from one local union [steelworkers]. I can go to our local union hall and show you every man on this big bronze plaque who has died of cancer. I knew every one of them. There are a lot of them that didn't belong to their local that I know died of cancer, thousands. The Department of Energy here in town knows that we know better. And the people in Utah are just like we are.

It's been proven what this radiation can do. No amount of radiation is safe to any human being. This should make everyone stand up and take notice.

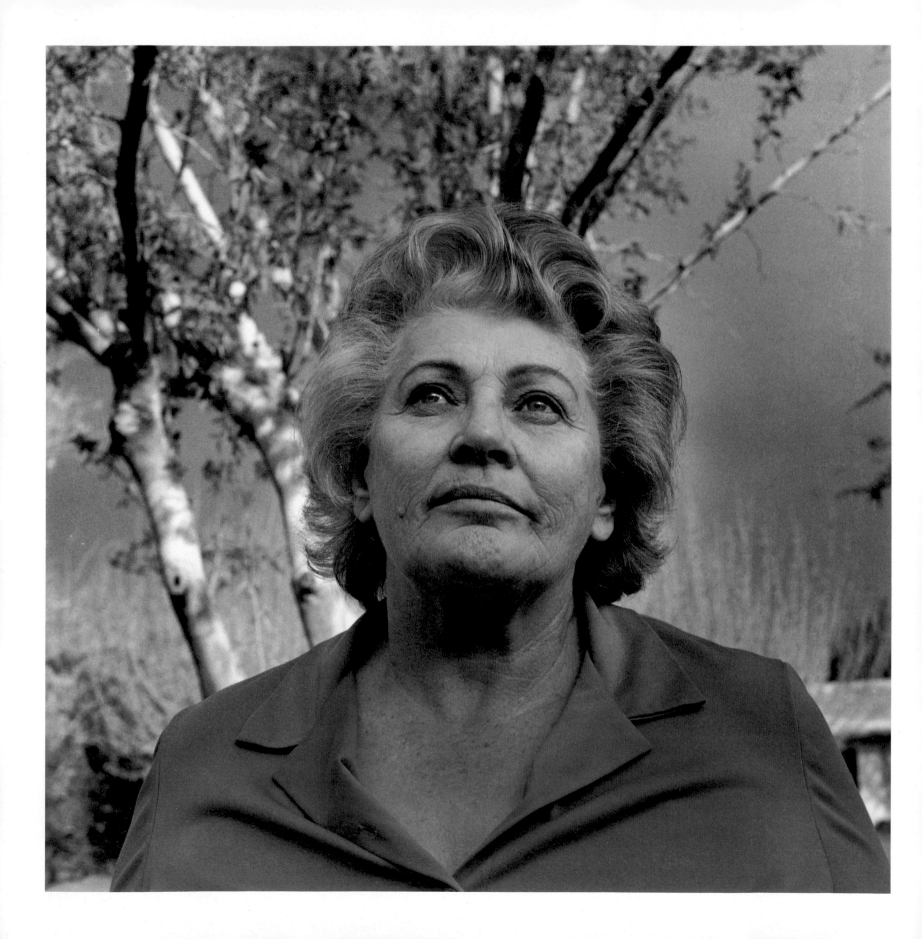

JUNE RIDGWAY

February 1984

Las Vegas, Nevada

"Everybody I used to talk to who worked at the Test Site is dead. It's like a bunch of ghosts out there. They keep recruiting. Yeah, they keep recruiting, but we know what's going to happen to them, don't we?"

June Ridgway is the widow of John Chester Ridgway, who worked as a supervisor of the Manhattan Project at Los Alamos. He was later the director of his department during the Titan II Missile Project at Lawrence Livermore Laboratory, the AEC/DOE's nuclear think tank near San Francisco, and was considered "indispensable" by his colleagues at the Nevada Test Site.

I had barely entered the door of her home in Las Vegas when she pushed an enormous, bound deposition record into my hands. John Ridgway had entered this testament as evidence during his lawsuit against the Nevada Test Site. After we were seated and comfortable, June Ridgway showed me a photograph of her family while "John Chester," whom she also called "Daddy," was still alive. They were an extremely attractive couple: she was a former model, and her husband bore a distinct resemblance to Oppenheimer, although Ridgway was by far the more handsome.

Everything she said to me during the first twenty minutes of our interview indicated a strong need to let me know that the men and women connected with the Test Site were normal, patriotic, and hardworking people living normal daily lives, who needed these jobs to keep their families going despite the horror of the bomb. Three years after her husband's death, she believed in a "strong defense" and that the Test Site is indispensable because "Las Vegas needs it for jobs." The only change she felt necessary was to equip the workers with "adequate protective clothing," and she asked with singular incredulity why the government would "buy space suits for astronauts but not for Test Site workers."

So, you see, people do live here. They work here. They go to school here. And they die here. Yes, they die more than they should.

Everybody I used to talk to who worked at the Test Site is dead. It's like a bunch of ghosts out there. They keep recruiting. Yeah, they keep recruiting, but we know what's going to happen to them, don't we?

Here, let me have this deposition, and I will show you what my husband said in black and white. They told him that he would be sterile. But he wasn't, honey, because he was the only man I've ever slept with, and he was the father of Jeff. They didn't tell him he could have cancer; they told him he would be sterile and he said "that's all right" because Sean was 19 at the time and that's our baby, and we really hadn't planned on any other children. But, as I say, when you keep house, you know what happens!

And there was no training for radiation or anything. No protection. He worked out there ten years. Their treatment for radiation was showers. That's all they did. Eight hours of showers. He had to leave his clothes out there because they were contaminated.

I've got pictures of him that would scare you to death. My husband weighed 79 pounds when he died. I can show you. He looked like hell, and you can see here [pointing to family portrait] that he was a very nice-looking man, to me anyway, and he had a nice figure. He wasn't skinny but he wasn't fat. I got very heavy when he got sick, I think because I had to lift him. See, Daddy couldn't walk, and if he had one kidney that wasn't on a tube [he had lost a kidney and a colostomy had also been performed] I would have to lift him to the bathroom. He couldn't talk. I'd have to give him his water in a teaspoon, in his mouth. He would hurt so bad . . . "Momma,

come and pray for me," and I'd take my hands on his bare stomach, and pray to God for him, to help him get well. Yes, my dear, it was a horrible experience, when you live with somebody . . . 41 years . . . most of my life. [June Ridgway married her husband when she was 14, and he 23.]

I never want to go through it again. No way. When my father died, it hurt me terribly. And I lost a little boy. But not like my husband. That just about killed me! And I had nightmares. I just had another one last night! I can't help it. He'll be dead three years on June 27. He's been gone . . . about 31 or 32 months, and I'm still having nightmares, it was so horrible. He had a HELL of a death! And for those bastards to say, "You're expendable!" I just can't help it, I wish they were in those circumstances. I don't want 'em to die, I just want 'em to be in those circumstances for one day. They would never do that to another person.

That's not mean of me, is it? I don't mean to be vindictive. But I can't help it when I hear my husband, he kept hollering, "Momma! Momma!" He didn't want to die! At that hospital, they remembered it two years later. He hollered and he thought that if I was there, he wouldn't die. But I was so tired by ten o'clock, and the doctor, he says, "June, you either go home or I'm gonna put a hospital bed in his room for you." And he died one hour later. I promised him I'd be with him when he died.

It was a happy marriage. I was lucky. I won't say it started out happy, because it didn't. Nothing that is for real and worth having comes easy. But the last 25 years, nobody had a better husband than I did. He was very considerate, and a wonderful father. Not only my loss, but those young men right in this town that says, "Auntie, why did Uncle John have to die? We need him." He started these kids in their apprenticeship. He

would help anybody. You ask any neighbor in this neighborhood and they will say, "John Ridgway, he was A-OK." Now he wasn't a saint—he had a temper—he was just a man. But he was a good man, and he didn't gamble and he didn't drink, and as I say, he was a good man. And you wonder why this had to happen and why he had such a horrible death! I can't help from wonderin' why.

What is your feeling about the people at the Test Site who send the men into these contaminated areas?

I think they should be in John Chester Ridgway's circumstances for one week, they should go through the hell. I'm not asking God to take their lives. Put them in the same circumstances, the same hell as John had for one week, and there would never be another person settin' in radiation. Now I'm talkin' about the big boys. I'm not talkin' about we little people. I'm talkin' about the big boys, the ones who say, "You go in. You're expendable!" If they went through just one week of what John Chester went through, there'd never be another person without protective clothing.

He had a constitution and he wanted to live. And you could talk to those nurses in the hospital, they still remember. He fought to live, and the doctor told him, "John, you're dying, you'll be gone in three . . ." And he'd just lay down on the couch in that waiting room, and pounded that couch and said, "It isn't fair! I went through your surgery, I went through 23 radiation treatments over at Southern Nevada Hospital, I went through your gamma treatments, those big ones down in Loma Linda. I took your chemotherapy, I went to Mexico for laetrile, and I'm still dying?" That's why I don't have a damn thing done to mine. What's the point? Go through all that hell for nothing? All that money, for nothing? There's not a thing I can do!

June Ridgway was suffering from cancer of the pancreas, inoperable and terminal, and she lived alone in a house with barred windows in Las Vegas, Nevada.

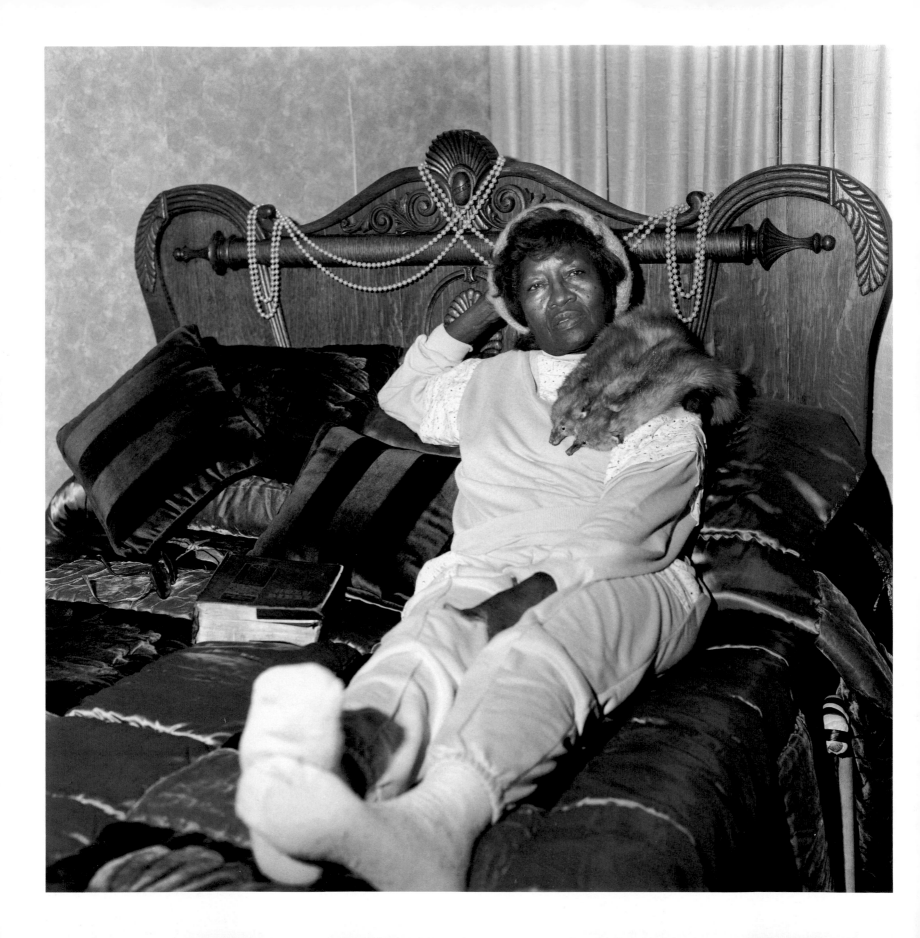

MAPLE HALL

November 1988

North Las Vegas, Nevada

"I said, 'Daddy, why do they give you jobs to do all that kind of stuff?' and he said, 'I don't know. We have meetings sometimes and they tell us, whatever you do you've got to do it if you want to keep your job.' I'm not a very good talker but it doesn't keep me from thinking. Thinking is my thing, so I could see how they had abused him."

Rumor was, around the circle of Test Site worker widows, that Mark Hall had been abused by the Test Site, sent on missions that others knew better than to tackle. The widows had all packed their husbands off each morning to Mercury, Nevada, 60 miles northwest of Las Vegas, the gateway to the Test Site. Each had a similar story: a husband with multiple myeloma, lymphoma, cancer of any and every organ, impotence, sterility. After years of attending meetings of the Nevada Test Site Radiation Victims Association, the widows were losing hope of financial recovery from the expenses of the cancers. Unknown to his wife throughout his illness, Mark Hall had taken out health insurance from the Test Site, which she never used, paying all his expenses out of pocket and in cash. Maple Hall apologized:

I was so dumb and willing to do my part, I didn't think about the money and I didn't know we were going to be so broke later on. I had to pay the hospital each time, and then I had to pay different people to come in and assist me with him. All these things happened, and I wasn't really aware. I paid it all out of my own pocket in cash. I wasn't thinking of the insurance that he already had taken out at Mercury, and that money still belongs to me.

He loved Mercury. He had the license to me but he was married to Mercury. He really dedicated his life to Mercury but he was a beautiful husband to me. He was very Christlike and I'm sure everybody liked him on the job. And he was really clean and neat. A very ambitious person, he was such a jewel. We ain't got no college but we was *good people.*

A lot of abusing things that they did, I don't know if they did that because he was a black person. They said, this fool will do whatever we tell him to do . . . They knew how clean

he was and swift. I noticed how his hands had swollen up. I said, "Daddy, why is this so big, as big as two of your fists?" Then he started crying, "They had me dig and find the heavy duty power line down in the ground. When I found it, it threw me up on the house, and then I fell off the house and I still had the shovel in my hand." They knew he didn't have any better sense, he'd just go there and just be digging as fast as he could dig. So they knew that if anybody was going to find it, Mark would find it, and he did. Then he had to go through a lot of surgery.

I was as dumb as he was, in a way, because I was kind of young-like. I said, "Daddy, why do they give you jobs to do all that kind of stuff? They see you don't really understand," and he said, "I don't know. We have meetings sometimes and they tell us, whatever you do you've got to do it if you want to keep your job." He thought that if he was to keep his job, he had to do everything, and they messed his whole life up. I'm not a very good talker but it doesn't keep me from thinking. Thinking is my thing, so I could see how they had abused him.

He was sick off and on for about 15 years. He was such a jewel. He was still wanting to go to Mercury. Then I could see where his flesh was deteriorating. Daddy sat up and cried many times. His flesh was cracking open. He was going from bad to worse. He'd lose his hair and scars would come to his head. He urinated red blood. I was beaten up in my heart. As time went by his flesh came off the bone and his hip bones came through the flesh. One day, like when a young cow is going to have a calf, his stomach blew way up. This rotten flesh had blocked his water and he couldn't use the bathroom. Daddy's stomach busted loose and his penis was larger than a horse and swollen up with all that corruption, and the flesh had been rotted and had come from the bone because he inhaled too much of that radiation. A lot would happen, like blood would come out of his eyes because there was such a pressure inside. He was down to dying then because he didn't have anything to survive off of.

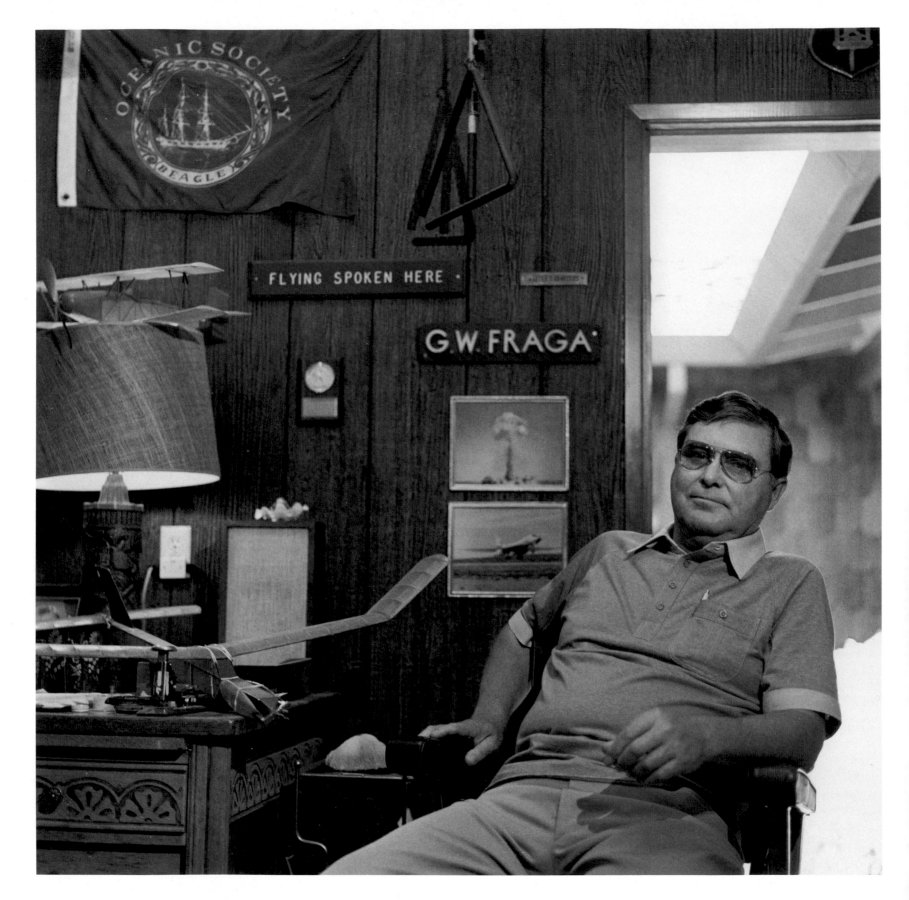

GILBERT FRAGA

August 1986

Sacramento, California

An AEC radiation monitor, Gil Fraga distributed radiation badges even in the local brothels. "There was a little number that was not only peroxide, but she had a green tint in her hair. Lucky's business shot sky-high: sheepherders, ranchers, and miners come from miles around to do business with the girl that had the film badge. She never took it off, that was the gag."

As a radiation monitor for the Atomic Energy Commission, Gilbert Fraga came into contact with all manner of people in Utah and Nevada while chasing fallout clouds in his Plymouth Fury. Frequently he would stop at one of Nevada's ubiquitous whorehouses for a cold beer and a chat, dropping off a few radiation badges in the process.

The farther up you'd go in the hills, the more friendly people were. You might wonder how I know the madam at the Big Four [brothel]. My supervisor says, "Fraga, we're supposed to get a cross section of the indigenous population. That means nurses, school teachers, that kind of thing. Have you ever issued a film badge in this business? You better get down there and do it. You ought to have at least one girl with a film badge." I knew he was kidding me, so I called his bluff, and I went down there and introduced myself to the madam. Girls with little frilly things were up and down the bar and I told her I was going to issue a film badge to one of the employees. "Oh, why sure, good idea! I'll get those that aren't gainfully employed in the back room and have them assemble out here." So she sent them all out. "You go ahead and make your choice." There was a little number that was not only peroxide, but she had a green tint in her hair. Her name was Lucky. Lucky's business shot sky-high: sheepherders, ranchers, and miners come from miles around to do business with the girl that had the film badge. She never took it off, that was the gag.

People knew who we were when we come driving up, Atomic Energy Commission on the car and everything. Nobody brought up talking about the bomb. It was just a fact of life, I guess. It was the psychology of the day. Nobody expressed any worry. I ran into a lot of school teacher ladies

out in Nevada and Utah that showed no concern. The bombs went off every day. We'd come in and collect the film badges from time to time. I'd say, "You're not saying you're concerned about radiation and the mushroom clouds floating over here, but how do you feel about that?" She said, "I don't care at all. It's my parents back in New York that are calling me up every time they hear a bomb goes off." At the time they were probably more concerned on the East Coast.

It was either shot Smoky or Hood that was a terrible mess, one of the worst I'd ever seen. I was called down to drive two reporters from *Life* magazine up to Newsmen's Knob. Here's all the troops lined up, not all of them in trenches, and some of the officers standing and facing the tower without goggles. You had to have goggles. It would burn your retina when you're close, and we were close, three miles. There's a blinding flash. There's a big shock wave that booms against your chest, almost knocks you down, but not quite. After five seconds a boom reverberates all over the canyon. This mushroom cloud is always supposed to go up and disperse and then blow to the east, out towards Utah. The weather report went wrong . . . the cloud starts coming right over us. There were hundreds and hundreds of people up there. Here's a funny thing. Here's the cloud right straight above me, and it's just like a rain cloud where it comes down. This is a moving cloud. Then it falls out, so the fallout pattern, it's like rain. I started getting 1,500 millirems, 2,000. I thought my instruments were wrong so I was changing from one to another. No, they're working okay. So I called headquarters. I said, "It's hotter than hell up here." "Hey, Fraga is up there saying it's hotter than hell." "Tell him his instruments are wrong." Boy, I took off running. We had to pick up to 80 miles an hour on both lanes. That cloud kept on coming, just kept on following us. That cloud went down through Death Valley, then north over Beatty, Warm Springs, Carson City, rained out over Reno, went out to sea at Fort Bragg, California. That was a dirty one.

Visualize the bomb tower and the thing is detonated and the whole tower is vaporized right down to the concrete block supports. The floor is pushed down in a basin and burned to a crisp. Sand is melted together in a black glob. We took off one time to monitor one of these sites. We had our geiger counters out and it was hot. It had been two weeks since the bomb was shot, and it was still darn hot so we couldn't stay there very long. The truth of the matter is, we shouldn't have been there anyway, it was too hot for anybody. We worked there a while and went back a week later to a whole row of houses that had been built for testing purposes right on the flat. Wood frame, cinder block, different things, all furnished with mannequins all dressed up, sitting around a dining room table. Then, the bomb. We went into those places. The mannequins were just cut to shreds by the glass from the windows blowing in. Shards of glass were stuck along the opposite end of the dining room.

We had a sweep of territory. We had parts of California, all of Nevada, parts of Arizona, and parts of Utah, all divided into zones. It was about 3,000 miles a month at 90 miles an hour in a Plymouth Fury to get to all of these places, four of us. We were so stretched out that we had one tin building, a hut in Las Vegas, and all the radiation film badges, they had to come in there, change them every two weeks. We gave them to people and fence posts and at the front of schools and churches. You went down miles and miles of lonesome valleys to collect a film badge. We had tons. The truth of the story is, hundreds and hundreds got thrown in the pail be-

cause we didn't have time to read them all, no better than 40, 50 percent. I had my own badge. It didn't work well enough. They were worthless.

We also had to respond to damage claims, beta burns on the cattle, sheep, people. I remember running into an American Indian that had World War II gunnery medals. He was 17. This poor old Indian had sheep, and he got to crying one time, talking about how badly his sheep were doing on account of beta burns. Tears came down his cheek. He opens up his pocket, and this really got to me. I almost cried. He brings out his air medal, he had about four medals wrapped up in toilet paper in his shirt pocket. He said, "I was a good Indian and I was a hero then, but now they treat me pretty badly." It was confirmed, beta burns.

This was '57. I was 23. Two years later I went back to Berkeley for my graduate studies. I started to get awful migraine headaches. After two years they went away, all of a sudden. Then I started developing dizziness. This gradually kept on getting worse. Got to the point where I couldn't pilot an aircraft anymore because I was blacking out. I had what you call vertigo and I still have it. Weave a little bit when you walk, short-term memory problems, nausea quite often, tired. It would get so bad that it was difficult to sleep. Some days are so bad I just can't get out of bed. Bladder cancer surgery. Something wrong with my circulation. Two heart attacks. You know what emasculating means? When a man can't drive his car, it's emasculating. It makes you mad. Living below the poverty level, not a whole lot of fun. We applied for social security disability. For three years we fought the dirty beggars and they turned me down. They said, "Mr. Fraga, you can't prove that radiation caused you to be sick." I said, "You can't prove it didn't."

You see movies about atomic bombs going off, or hydrogen bombs. People try to describe it. By golly, it's nothing like seeing one yourself, being right there. It's such an enormous doggone power, it will never leave you.

SARAH HAYNES

June 1986 and December 1991

Las Vegas, Nevada

Adam and Sarah Haynes. "He was out in the middle of nowhere, watching plutonium balls. They wanted to find out if an atomic blast would set them off. He was as-signed to an area which was so inaccessible that I don't care how ardent a communist a Russian might have been, they wouldn't have come through these gates because it was so hot. They used to put the geiger counter behind his ears and it would set that thing off. He threw up for six solid weeks without a stop."

FOR OFFICIAL USE ONLY March 29, 1955
From James E. Reeves, Test Manager.
RE: OVEREXPOSURE OF SECURITY GUARD, EUGENE D. HAYNES

On the morning of March 1, 1955, Mr. Haynes proceeded to Tesla shot area after H-hour to provide surveillance over plutonium spheres until they could be recovered, after exposure to the shot Tesla, by the Project Recovery Party. He proceeded to within 1/4 mile of Ground Zero. He was in the contaminated area a maximum of 20 minutes. The dosimeter reading was off scale, and the film badge, when developed later that day, indicated a total exposure of 39 Roentgens.

He was 36, an ex-Marine, when the "accident" happened. The Atomic Energy Commission admitted that in 20 minutes he received ten times the amount of radiation then thought to be the maximum "safe" dose over a year. The *Las Vegas Review Journal* reported, "The fear of his wife's wrath worries Eugene Haynes more than that of any ill effects he may have received. 'Knowing her as I do, I'd just as soon be back in California. She's kind of nervous and it will upset her. She may blow her top. Otherwise, I feel fine, and don't see what all the hullabaloo is about.' " Years later his brother Wilbur, also a security guard at the Test Site, would grow red in the face with rage at the callousness of the managerial personnel, who were the culprits in Gene's exposure: "They used to make experiments. He gave him this stupid assignment, for no reason at all. At this particular time someone was exper-imenting with plutonium balls. They were placed in strategic places. They wanted to find if an atomic blast would set them off, or how they would react. Sergeant Crane said, 'After the shot I want you to go over there and make sure

nobody bothers those plutonium balls.' Now that is ridiculous. There's nobody there to bother them! The minute the shot goes off Gene is cleared and he goes out. When he went through on this road, instead of the fallout going the way it should, he drove right through it. It was so intense that it blocked his radio off from contacting headquarters. [More likely, the electromagnetic pulse of the bomb had made his radio and other electronics temporarily useless.] Gene had only worked there a couple of months and he didn't know anything about this stuff. He went on through and got in behind the plutonium balls. They finally got in contact and asked him where he was. He told them and they said, 'Get out of there!' I was told that if he would have stayed there five minutes more, he would have been dead, the heat was so intense."

Eugene Haynes drove to within a quarter mile of ground zero moments after 7-kiloton shot Tesla was detonated, right into the atomic dome, where he remained for 20 minutes. His brother remembered: "I brought him into headquarters and we found out that the vehicle he was driving was hotter than a pistol. They wanted to make tests on him because *he* was supposedly hotter than a pistol. Before long he wouldn't be able to keep anything in his stomach. The Surgeon General came out [from Washington]. They used to put the geiger counter behind his ears and it would set that thing off. He was breaking out in boils and having a lot of problems eating. The Surgeon General came out a second time. He was never allowed back into the Test Site after that, so they got rid of him, which is what I get a kick out of."

His widow Sarah recalled their years before the Test Site, when they were chicken and produce farmers in Cotati, California.

We had a polio epidemic in our community. He had polio and couldn't work for months. He was completely paralyzed, the only thing he could move was his head. I was polio mother of the year in 1952, my husband and my oldest son. He couldn't really hold a job that was physically hard, so his brother said, "Why don't you come to Las Vegas and get a job as a guard at the Test Site? We make great money, and there is no hard physical work involved." So this is the start of the story. I still didn't understand all this jargon, "ground zero" and "the mushroom." We didn't read, we didn't care about Hiroshima. I was having my own problems, I'm in over my head and I didn't care what the atom bomb did to Hiroshima or Nagasaki. I knew nothing about the work that Gene and Wilbur did out there.

He was assigned to an area which was so inaccessible that I don't care how ardent a communist a Russian might have been, they wouldn't have come through these gates because it was so hot. Until recently it wasn't told what Gene was watching, in the middle of nowhere watching plutonium balls. They said he would have fried in another ten minutes. They burned his jeep right in front of all the men. They burned his clothes, and sent him home! They didn't have to tell him to stay home, he couldn't go to work, he was throwing up. He threw up for six solid weeks without a stop, a weight loss of about 40 pounds. Blood tests every day. He had to go to Dr. [Ross] Sutherland, who was the joke of the whole camp. This was the most ignorant human being God ever put on the face of the world, honestly. "There's nothing wrong with you, Gene. You're just nervous, that's why you're throwing up. Everything is fine." They decided that there was nothing wrong, patted him on the back. All of a sudden, in the seventh week, his whole body, from the tips of his nails to the tips of

Eugene Haynes being tested for radiation effects at the

Nevada Test Site in 1955 after an incident that exposed

him, officially, to 39 rads. The Atomic Energy Commis-

sion/Department of Energy later claimed to have no rec-

ords of his employment. Photo courtesy of the Atomic

Energy Commission, 1955.

his toes, broke out in boils. Boils and red-purple splotches through his whole body and face and back and neck. He couldn't wear clothes. He would scream if anyone touched him. It was vicious, okay? Apparently there was a ruckus from Hiroshima at that time with this type of lesion. There were photographs of the burn victims. They kept denying it to the very end that there was ever anything wrong with him.

The media asked Gene to come to the downtown [AEC] office to interview him. Reporters were coming from all over the world. He signed a letter before that interview to withhold certain facts—if he didn't withhold these facts he'd be liable for treason. If he would take the blame that he was in his jeep and made a wrong turn, if he would tell the media that it was his fault, they promised him a lifetime job in town [in their offices rather than at the Test Site]. A woman from Sweden asked him, "How can you be so stupid as to go down the wrong road?" He just broke down and cried, he couldn't even answer her. They closed off the mikes then. After all the pictures in the magazines, in *Life,* in *Liberty,* Gene worked about a month and they let him go. Gene asked, "What about the promise of a lifetime job?" Captain McIntyre said, "Prove it." I'm talking about callous men, not men with compassion. Things quieted down, Gene was no longer news, the tests were going on, other people were irradiated. We were never right. They were always right.

After the accident, Gene was sterile for many years. After he went in for a hernia operation, they said it couldn't happen . . . apparently it did happen. I became pregnant. I was concerned about the radiation. My doctor was from Japan and he was concerned too. With Adam I wanted an abortion. It was illegal then. Adam is a little slow, there is a problem there. He has no power of concentration, he's a very big

asthmatic, all kinds of sicknesses. This is my worry now. This is my heartache. That's why Gene and I had no money, because Adam was in and out of hospitals. That's why if I smoke myself to death and I don't have to face the future, I'll be happy. Everything seems so futile.

[Near the end of his life] Gene was gasping every day and coughing every day, the red spots were prominent. Here I see this hulking man shrieking in front of my eyes, I mean literally shrieking. I put Gene back in the hospital. Dr. Qureshi looked at me with his sad eyes and said, "Mrs. Haynes, your husband has adenocarcinoma of the lungs. There are only two ways of getting this type of cancer. Did he ever work around asbestos?" I said, "Never, a produce man all his life." "There is only one other way you can get adenocarcinoma and that is through radiation." He also said that the splotches were very reminiscent of radiation cancer. Gene went into the hospital exactly thirty years from the day he was irradiated.

Sarah Haynes loved her husband in a wild, passionate, and often loud way, and his death unlocked a rage in her that soon diminished her health as well. In the years after burying him, she underwent 13 surgeries for her failing heart and, unable to bear the financial strain of caring for herself and their genetically damaged son, Adam, she succumbed to periodic bouts of clinical depression. Adam, a gangly teen-ager who was devastated by his father's death, burst into tears when I asked him about his dad, his best friend and constant caring companion. "He always used to call me his trusty sidekick." When Test Site workers and widows launched their lawsuits against the government and weapons industry contractors, she began to collect evidence in support of her case, writing to various government agencies for her husband's radiation dosage records. Despite daily blood and urine collections for weeks after his exposure which were sent to Los Alamos for analysis, when Sarah Haynes utilized the Freedom of Information Act in 1985 to obtain documents regarding his exposure, the Department of Energy's written reply was: "The determination that our Master File contains no records for Mr. Haynes constitutes denial of your request."

There were many years of courtroom ping-pong, with judicial decisions in favor of the Test Site workers and widows appealed and won by the government. In late spring 1991, a new wrinkle developed.

The government wanted depositions from all of us, especially the first five or six of us who are going to trial. Justice Department wanted depositions from us. So everybody goes to give a deposition, they take three or four hours. Me, I'm there for two days. *Two days.* My daughter was there half a day. Keith [Prescott], myself, Alma [Moseley], five or six, I really can't be sure. We're all under the Prescott case. A strong man, but he'll never live to see the case settled. Judge Foley felt that we should have our day in court. The day before we got a call from our lawyers that the trial was postponed indefinitely. The attorneys got a last minute appeal from the Ninth Circuit Court to squash our court appearance. They were all new attorneys, and they "didn't have enough time to go through all our records," and so they wouldn't understand what we were talking about. It was a last minute ditch attempt to stall.

Worse still, after the deposition, we get a phone call from [our attorney] Larry Johns; the judge had called him into

chambers and said that the government wanted an autopsy. Did you know that? Okay, that's something you didn't know. Okay, I'm telling you all. That's all we're hung up on right now—they want to perform five autopsies. Keith [Prescott] is alive, so they don't have to do Keith, right? But they want to dig up Gene, and Alma's husband, they want to exhume four bodies, and that's what's in court right now. That's what the trial is being held up for.

In the first years after testing began, abduction of body parts by the AEC had been standard procedure. Then it was sheep, now it was humans. It had never gone quite this far, however, the desecration of graves, the removal of bodies for autopsy. Like the autopsied organs remembered by Ben Levy, such bodies might never be returned, might be conveniently "lost" and all evidence of government culpability destroyed forever.

We each had to write a letter to Judge Foley begging him not to let the government do this to us. I'm telling you, little by little I'm beginning to withdraw. From the world, from the case, everything. The autopsy, parts of his body will go to Livermore, parts will go here, parts will go there, to many labs in the country. That's where we stand right now. When we wrote our letters to the judge, he threw up his hands and said, I don't want to handle the case anymore, that Judge Foley. He threw it to the Ninth Circuit Court in San Francisco. So that's where we are: the exhuming of the bodies is what the government wants, and we're fighting it. At first, Larry told me I couldn't tell anybody, he said there was a gag order. I said, Larry, the courts can't gag me. Number one, they haven't sent me a notice. Number two, the hell with the

courts. I just don't give a damn. What are they going to do, hold me in contempt? Throw me in jail? Great, I'll have free meals, I won't have to clean the house, who cares? At my age, who cares?!!!

I'm bitter, I'm suspicious, I've never been this way. I try to be rational, but I'm too old to be rational now. I'll be 65 in June. I'm out of money. I'm in a desperate situation. My back is against the wall, and I don't know where to go for my next month's rent, Carole. There's tears running down my face because I'm out of money now, and I have a child to support, who can't get work. He can't even get work at McDonalds because he doesn't present a normal picture. You saw him today. He's shy and backwards, he pulls back, and I have no place for this boy. I don't know what's going to happen to him, I have no money to leave him. I don't mean to cry, I'm sorry. I'm just feeling sorry for myself, and there are times that I have to, I suppose, because I've been keeping this all in.

My tears aren't new, they're not just for Gene. My tears are for everybody, for the ones I don't know and the ones I know. Long before Gene had adenocarcinoma, I cried every time I read a report of a child dying in Utah, and when Gene's colleagues would die. This is man's Armageddon: you don't even have to go into a nuclear war for man to die off. I think radiation is a killer and it will always be a killer. From the bottom of my heart, I do know they die from exposure to radiation, I really do.

GRACE SWARTZBAUGH

January 1984

Las Vegas, Nevada

> **"A couple of days after [my husband's] funeral, two men came and they showed me badges from the Atomic Energy Commission. They burned everything that was in that desk, even my stuff. Things they had no business touching. And they just walked out . . ."**

Grace Swartzbaugh's husband worked at the Nevada Test Site right from the day it opened for business. Previously he had worked on the Manhattan Project at Los Alamos, and his tenure in the nuclear industry lasted from the early 1940s to 1968. By 1958, health effects from radiation exposure became evident and a cancerous kidney was removed. In 1968, during a vacation in Hawaii with his wife, he found that he could no longer walk the distances he was used to and was constantly exhausted. Despite his malaise, after their holiday he returned to work at the Test Site. One day some weeks later, he called home to his wife, "See if you can get me into a hospital." Diagnostic work began but there were no conclusive results. Exploratory surgery found that "his whole insides looked like the inside of a tree—just solid. And it just looked like rings around all his organs. It just looked like it all came together, just looked like a big bowl of solid Jello. There was nothing they could do for him. But, as I say, he only lasted from December 18 to January 18."

Grace Swartzbaugh has no evidence left that her husband ever worked for the Manhattan Project, at the Nevada Test Site, or at the Marshall Islands atomic test site at Eniwetok.

("He had his hands pretty badly burned at Eniwetok.") She cannot sue for his illness or death, having no papers to submit in litigation. "I do not have one single thing to prove that he worked at the Test Site. And when I sent in a letter to ask them for the radiation that he got, they wrote back and told me that he didn't work there." In his last years, he worked as a coordinator of underground nuclear testing. One of his jobs was to recover instrumentation from ground zero shortly after each blast.

A couple of days after the funeral, and everybody was gone, two men came and they showed me badges that they had from the Atomic Energy Commission and said, "You know that your husband handled secret work for the Atomic Energy Commission and we have to come in and get his papers." Well, they came in and I said, "Well, all the papers he has are on that one side of the desk." I showed them where that one side was. He said, "Well, he had briefcases. We need the papers out of the briefcases." So I went to the bedroom and got the briefcases and brought them. While I was getting the briefcases, they took all the things out of the drawer and burned them. When I came back out, I asked, "What are you doing?" and he said, "Well, you know, we have to destroy these before they get into some hands of somebody it doesn't belong to." And so when they had everything completely burned, and left, I went to the desk to close the drawers, and they had burned everything that was in that desk, even my stuff. Things they had no business touching. I had income tax papers and other personal papers. Everything was gone. And they just walked out . . .

BONNIE McDANIELS AND MARJORIE LEASE

June 1986

Las Vegas, Nevada

Bonnie McDaniels and her mother, Marjorie Lease, with a photograph they took of their father and husband, Hap Lease. "I remember Hap said that there were some areas up there that was infected with plutonium so bad it will never be fit for anything."

Bonnie McDaniels and her mom, Marjorie Lease, were hard at work making a dozen apple, lemon meringue, and pumpkin pies when I arrived at their home. I had known them both for quite some time, encountering them at the yearly meetings of the National Association of Radiation Survivors, and survivors they were. Bonnie's deportment was that of an Annie Oakley, a hard-talkin' straight shooter who would curse and holler at any Congressional oversight hearing in Washington, making sure the concerns of Test Site workers were heard. Her mother, more retiring by nature but just as enraged, balanced the effect somewhat. To remind me of their years tending "the man of the house," Hap Lease ("his nickname was Happy"), they rolled out a very large photograph of him, taken as he lay dying. Any thought of a piece of warm pie quickly disappeared with one look at the poor man's neck, a seething mass, half the size of his head, of open ulcerated tumors. "It don't bother me to talk about it," said his widow, Marjorie, lips pursed in a thin, hard line.

MARJORIE: The cancer started in his throat, it was real sore. We went to our own doctor, who said, "You have a sore throat, I'll give you antibiotics." He took them for six weeks, but didn't seem to improve any. We went to a throat specialist. He said, "All I can tell you, you sure have a sore throat. I'll give you some antibiotics." We told him we already had some, but he said, "Well, try them three or four weeks longer." It kept getting worse and worse. Finally, desperate, I looked one up in the telephone book. We went in right away and he said, "I sure don't like what I see. I want you in the hospital tomorrow morning for a biopsy." After the biopsy we went to the UCLA hospital and they took out his larynx. They took his whole head off almost. When he came out of

surgery he looked like a mummy, he was so wrapped up. He didn't come to for a few days. Bonnie [a nurse by profession] quit her job to take care of him and she literally did intensive care for seven months.

He worked at the Test Site for fourteen years, since 1962. He was a monitor so he was one of the first guys in [into the test tunnels to recover equipment and check radiation levels] after these shots. I remember Hap said that there were some areas up there that was infected with plutonium so bad it will never be fit for anything. Nobody dare go in there because there is so much plutonium. There has been so many guys die that worked up there.

B O N N I E : I worked out there too in 1963 and 1964. I was a secretary and bookkeeper for Rad Safe [the Test Site's Radiation Safety team] so I knew a lot of what he was doing. He was a draftsman so he made all the drawings for all the maps of the entire Test Site. He was on every road there was, on every piece of ground, measuring, right in the middle of all the shots. He was in the clean-up of Baneberry [an underground test that had a massive venting in 1970] and had to give people showers and feed them beer and give them paper clothes. Cars were buried in big ditches out there because they were so contaminated they couldn't clean them up. In the cafeteria everything was contaminated. He was one of the front ones up there. They had one of these T's to hang onto, a pipe in the ground with a crossbar to hang onto when the ground shook. The day that Baneberry took place, they were all standing at these certain spots [the T's] for the shot. It *really* shook because it ruptured. When the smoke and dust or whatever it is came out, that cloud, Hap was right on top of it.

M A R J O R I E : Area Twelve was the place where he told them to get out. They said, "No, we can't. Our supervisor said we can't go." Hap said, "Get the hell out of here, it's too hot!" They didn't go, Roberts and Nunemaker. Four years later they were both dead from leukemia. Later on he told me how they kept these people on the bus and took them for showers, showers, showers to try to get that stuff off. Feed them beer, any kind of liquid to get them to urinate and get that stuff out of their system. He said he never saw people take so many showers in his life.

B O N N I E : They told me when I quit that I can't go out there again because I have too much radiation. I would go from Mercury and take time cards and paychecks out to all the guys no matter where they were. I was all over the Test Site. I was out there when they were doing shots and everything. I never dressed out [in protective clothing]. They would have a shot and it didn't matter where we were. They didn't know where I was, I didn't have a radio in my truck. I'd just jump in it in the morning and take off. If they had a shot, they had a shot. I never knew where. I didn't know radiation from anything else. They said it didn't hurt you so you went along and did your thing. I had a little counter, they always left a geiger counter in the trucks. When it goes off in the truck you're sittin' in you *know* it's contaminated.

M A R J O R I E : Hap was told different times when they had visitors up there from foreign countries to turn it off. She got a lot of radiation up there. After that, she had another child, Sean, he's eighteen now, and he was born with a cleft lip, and there's something wrong with his stomach muscles.

BONNIE: He has no stomach muscles. His bladder is backwards. He has lots of things wrong with him. He had four operations on his lip. His teeth were laying sideways so he had to have them pulled. I think right now he has more pain than he wants to admit. He has a bad temper because he doesn't know what to do. Doctors tell him he shouldn't have kids because of all the chromosome damage. He's pretty much decided that he's going to self-destruct. He's started drinkin' and drivin' crazy all within the last year. He's decided he's going to go nuts. His older brother [conceived before she worked at the Test Site] is just fine, a happy-go-lucky kid.

And you know, at the warehouse my office was in, they would bring in soil samples, wood samples, little animals, all kinds of stuff, so radiation was coming through all the time. I worked out of two offices. Right across the hall is where they did all the badges [which measured workers' exposures]. They'd run the badges through the counters and a lot of times I'd hear the guys say, "This one's too hot" and "Let's ditch this one; get a new one and give it the same number." Many times they'd put them in the fire and burn them up, actually burn up the badges.

They made us sign things that we would never ever say anything or tell anybody what we did up there, about what went on. When we quit we had to go through a debriefing. They sit there and talk to you and find out how much you know. I just played like I didn't know a thing. I walked out of there and thought, "You fools." Everybody thought it was neat to be employed by the government. It was the kind of job you don't say no to. When they say to do something you go do what they tell you to do.

MARJORIE: I think they can't be trusted.

BONNIE: The government stinks.

MARJORIE: All they do is please themselves.

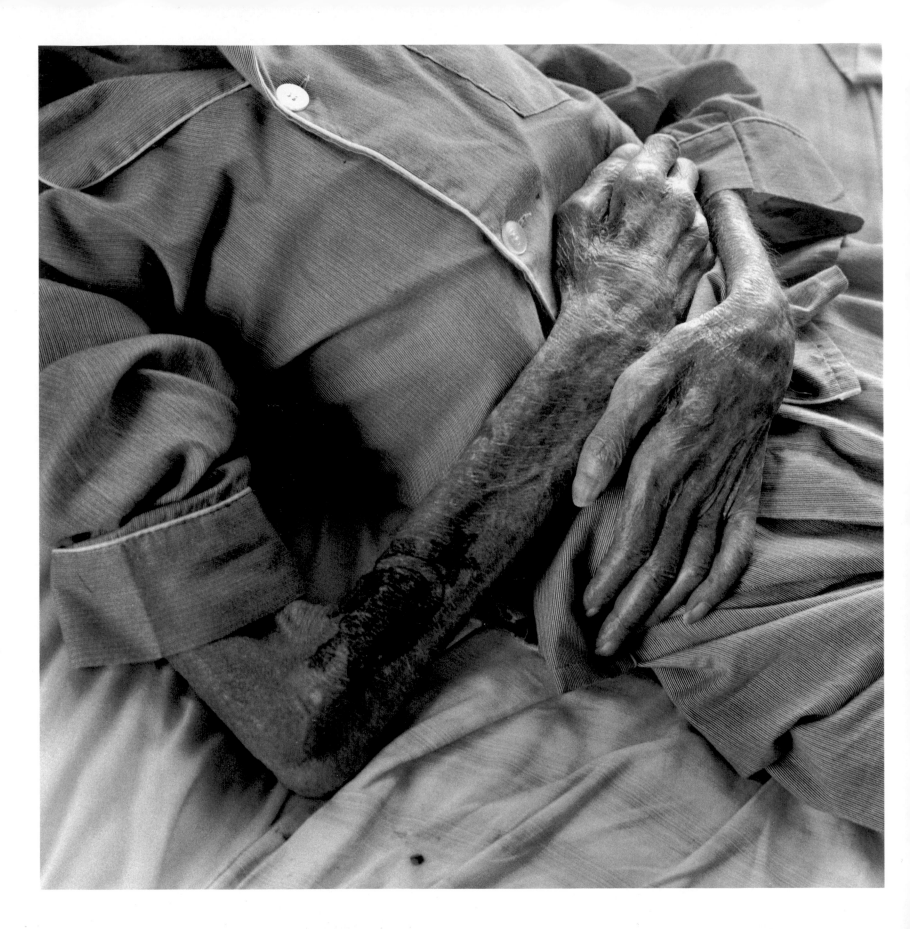

MARY AND HERMAN HAGEN

June 1986

Henderson, Nevada

| **"It was a good living . . . it was a great living!"**

Herman Hagen was a member of the pipefitters' union at the Nevada Test Site. A rather impressive fellow of 227 pounds in his prime, when I visited him in June of 1986 his multiple myeloma (cancer of the bone marrow) had whittled him down to 98 pounds. He had been bedridden for three years. When he sat up, the light from the window behind him revealed through his thin pajamas the silhouette of a body as narrow as a child's, but attenuated by his six-foot height. It was so painful for him to keep himself upright that this shocking vision lasted but a few moments.

By his wife's description and those of his fellow workers, Hagen was unabashed in his machismo at the Test Site. He would dip his arm up to the elbow in radioactive wastewater and say, "See, this can't hurt you!" Even lying on his death-bed, Herman Hagen found it hard to admit that the radiation he ingested at the Test Site could have caused his illness. He kept on repeating, "It was a good living . . . it was a great living!" His wife Mary was much more negative. "It's a subject we don't get on because they made him a good living, but he forgets that it's killing him. They make a good living while they work there, big deal. After 55 I practically became a widow and he lies in bed. In fact, my friend and I used to say, 'he's the oldest young man we know.'" She was much more willing to talk about it than he was. When he died a year later, he weighed only 60 pounds.

Everybody went out to watch the bombs in the morning. I remember the very first one that went off. We were lying in bed one morning and all of a sudden every window in this house was rattling. We didn't know what it was. Was it an

earthquake? We had a horrible feeling. We were in bed and it was just like the ground was shaking and the house was moving. Anything in the house that could swing was swinging.

Then later on when we knew there was a bomb going off, golly, everybody would get up and go to wherever they could see the bomb really well and watch that thing go up. Many times we saw that mushroom cloud in the sky. After a while it loses its novelty.

I remember when Herman first started to work there. His great aunt in Norway wrote a letter and said, "I hate to see you work at the atomic test site." We wrote back, "There's nothing wrong with that. Our government wouldn't let us work there if it was harmful." We really felt that. Now our government would do anything, I think. How can they do that to their own people? They figure they're all dispensable, why not use them, that's the feeling I have. He started working there in '58. I think he wasn't allowed to [talk about his job] but one time he slipped and he got the funniest look on his face. What he slipped and told me was that he was on recovery. I didn't know what that was and when he told me I nearly died. They go in the tunnel a day or so after they have a shot. They suit him up, ha, ha, and send him into the tunnels for recovery [of the instruments which measure the radioactivity from the nuclear blast].

Then I found out that he had walked on hot ground. The areas that are hot are supposed to be roped off, and this wasn't roped off. Herman started to cross it and somebody hollered at him to get out of there. It's on his medical record that he's been exposed to radiation. He never would have admitted it because he thought that as long as he had a good paycheck . . . but that's a lot of bull.

He'd been ill for a long time but we didn't know. We were living in Pahrump [a very small town about 25 miles south of the Test Site] and he had just slowed down and was not interested in anything. I was 42 when we moved out there, so he was 44. It was really unusual. It was after ten years of living there that we noticed it. I would ask him what was wrong. "My hands hurt so bad. Whenever they get cold they get so painful." Then it went from his hands to his feet. He mentioned one day that he had fallen down. He had a terrible time. If he didn't have help, he wouldn't have been able to get up. We made an appointment at Loma Linda and they discovered he had neuropathy [deterioration of the nerves]. He kept on going back to have that checked, then they would do more and more testing. It will be three years in July when they put him in the hospital for three weeks and discovered everything. Before that I would say a good four years he's been really bad, but he would come home from work and just sit. On the weekends all he'd do is sit. He would *struggle* back to the bus at work.

Right to the end, Herman Hagen maintained that the Test Site "paid the best salary in the state, outside of organized crime." When I suggested that it might actually be organized crime, the laughter that shook his disintegrating bones soon changed to a grimace of pain. So thin and frail, with tattooed arms like reeds, the hands stretched across his pelvis were larger than the wasted pelvic bone itself.

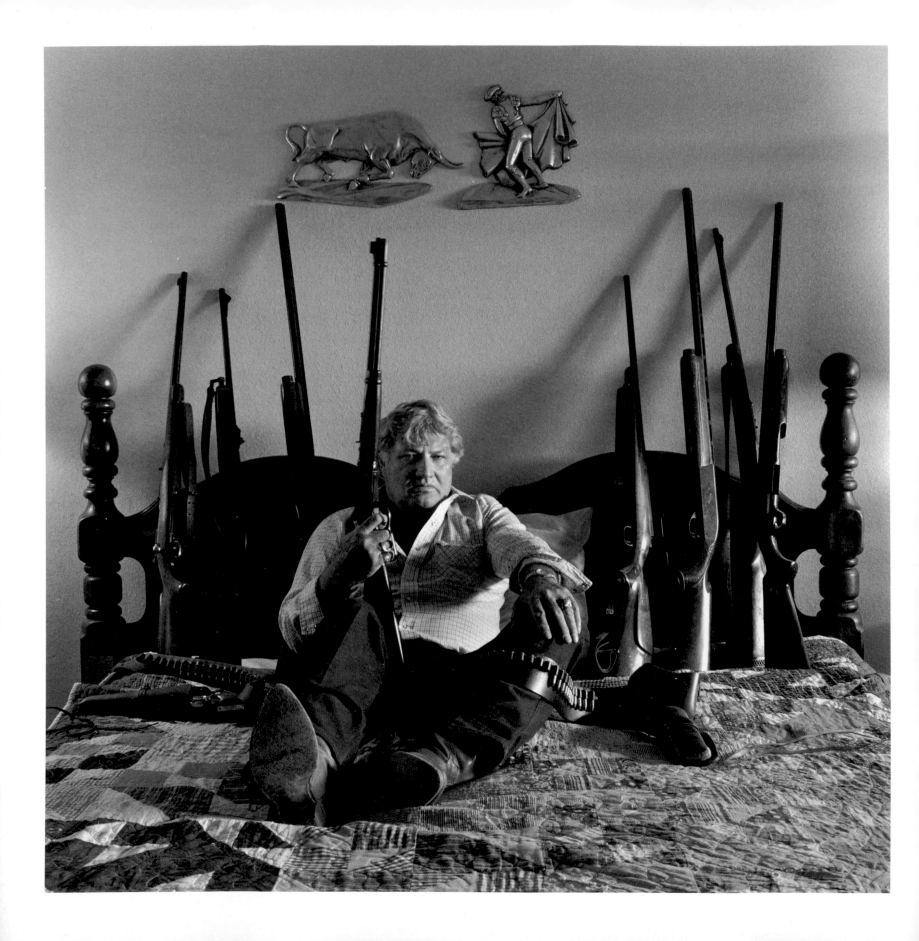

REX TOMLINSON

May 1988

Las Vegas, Nevada

A former life as a mercenary and his work at the Nevada Test Site "both paid well." In pursuit of the dollar, Rex Tomlinson takes risk as it comes.

A striking fellow with a powerful physique, a former mercenary in Central America and a 20-year veteran of the Nevada Test Site, Rex Tomlinson declined to be interviewed on tape for fear of losing his job. He would drive an enormous lemon-yellow Cadillac to a park-and-ride point on Interstate 15 to catch the Department of Energy bus to Mercury, 60 miles northwest, put in a hard day's work at the north end of the Test Site, another 40 miles, and come home ready for a beer. Half Cherokee, half Irish, he had hair as yellow as his car, and his eyes were celadon green. It took a few weeks and many beers with Rex for him to say even the least thing about the Test Site, this fear-of-God loyalty and pride being the hallmark of even the most macho of workers there. Many have told me that they actually sign agreements with their employer never to divulge the content of their work at the Test Site. Others allege that they are also forced to sign a release stating that they will never sue the Test Site, its contractors, or the government for any illness they think may be due to their work there. Although Tomlinson was worried about his gushing nosebleeds, fainting spells, and other precursors of things to come, he showed a curious bravura about his working life. When I asked him what were some of his favorite things, he mentioned his gun collection, which he kept stored in a beautiful wood and glass cabinet in his bedroom. The quilt on the bed was made by his Cherokee mother, whom he called "the squaw" and kept out in a trailer behind his very large house, which he shared with his sons. She only came in to cook and clean for them. The sheets she had put on the bed were . . . pink!

Why run weapons to Central America and why face the perils of radiation day after day at the Test Site? It all seemed so dangerous. "They both paid well." In pursuit of the dollar, Rex Tomlinson takes risk as it comes.

ATOMIC VETERANS:

"WE WERE EXPENDABLE"

In memory of John Weik Grifalconi

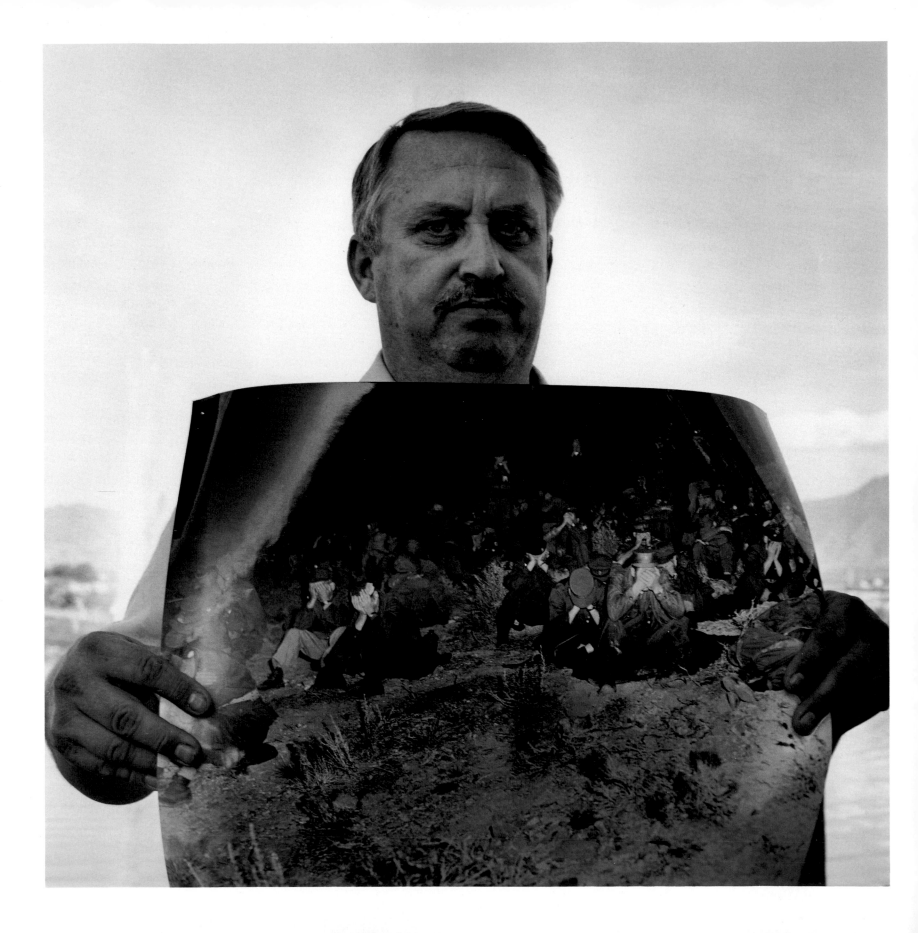

ROBERT CARTER

October 1988

Taylorsville, Utah

Robert Carter holds a photograph of his platoon of soldiers taken moments before shot Hood was detonated on July 5, 1957, at 74 kilotons the biggest atmospheric shot ever in Nevada. "I was happy, full of life before I saw that bomb, but then I understood evil and was never the same."

He was a blue-eyed 17-year-old from a small town in Utah, shy, a loner, and so scared that he threw up twice into a tin can ashtray during his pre–A bomb orientation in Operation Plumbbob at Camp Desert Rock, the Nevada Test Site. Thirty-one years later, a depressed and angry man stood before my camera, holding a photograph of his squad of Air Force buddies crouching in the desert sand in the dark, hands over their eyes, waiting for the bomb to explode. Bob Carter was the only youth whose eyes looked out toward ground zero, unshielded, and he was biting his lip. It was July 5, 1957, and he was about to witness shot Hood. The device was suspended 1,500 feet above the desert floor from a lit striped balloon, and at 74 kilotons it was by far the largest atmospheric nuclear detonation conducted within the borders of the United States.

It had hurt Bob Carter to get into my truck, to walk around with me near the Jordan River while searching for the right spot for his portrait. At 49, he had already endured for many years the deterioration of his spine and debilitating muscle weakness, forcing him into a wheelchair on most outings, and had had two small strokes. Carter's two sons, both in their mid-teens, are abnormally small for their age—the younger measuring only 4 feet 8 inches. Carter describes himself and one of his sons as clinically depressed.

I was happy, full of life before I saw that bomb, but then I understood evil and was never the same. I was sick inside and it stayed with me for a year after. I seen how the world can end. This world is a really thin sheet of ice between death and this happiness I had known all my life. There's a thin line between total destruction and peace and quiet and happiness.

I'm just a little skinny guy in there, 140 pounds. [Carter pointed to himself in the photograph seated among forty other strobe-lit men near the press area, News Knob, just before dawn, before the bomb exploded. They would soon be marched much closer to ground zero, where they were not even protected by trenches but stood out in the open, more vulnerable than they had ever been in their lives.] When the countdown came close I was scared to death. I thought, "Well, I'm going to die or maybe I'll be lucky and won't." The explosion went off, and I remember feeling the confusion that just blew me, it just blew me forty feet into the mountainside and all these men with me. I felt elbows, I felt knees, I felt heads banging, I felt my head hit the ground. I felt dirt in my ears, my nose, it went down my throat. I had a bloody nose. I felt all these terrible things that you don't want to go through in your whole life. I remember the ground so hot that I couldn't stand on it, and I was just burning alive. I felt like I was being cooked. After the shot my coveralls were cracked and burned, there was so much heat.

The stunned soldiers then participated in a field exercise, a march toward ground zero where they would simulate battlefield maneuvers devised to calculate their physical and psychological responses after witnessing the blast. Little did they know how intensely radioactive their activities would be. Ground zero was radiating 500 to 1,000 roentgens an hour, more than enough to kill a man. And, contrary to a gentleman's agreement among the weapons scientists, the government, and the military never to explode a thermonuclear device on American soil, shot Hood, "the dirtiest atomic explosion in the United States,"[1] was a hydrogen bomb.[2]

I had a huge sunburn, and I remember being in a lot of pain going back to the base on the bus. The doctor told me that he thought I had radiation illness because I was nauseated, dizzy, disoriented. They didn't know what to do. They don't do anything for radiation illness, they just watch you die.

After the test, some men in the platoon had more reason for shock and dismay. While sweeping the area during their maneuver some of them had seen cages and fenced enclosures. Some contained animals burned almost beyond recognition. When Carter told me the others held humans in handcuffs chained to the fences, his credibility came under suspicion. I knew that a clinical aspect of severe depression was paranoia, and perhaps he had even undergone a psychotic episode after the detonation. Perhaps this had been a kind of mass hysteria on the part of men under such severe physical and psychological stress.

Over the next three years, however, I came across the same story again and again from men who participated in shot Hood. The account of Marine Sergeant Israel Torres,

published in the *Washington Law Review* in a legal brief by attorney William A. Fletcher, was identical to Carter's. In fact, when soldiers spoke of seeing the burned and shackled remains of humans on the nuclear battleground, they were submitted to the same psychiatric "deprogramming":

[I saw] something else horrible . . . out there in the desert after we'd been decontaminated and were in our trucks. We'd only gone a short way when one of my men said, "Jesus Christ, look at that!" I looked where he was pointing, and what I saw horrified me. There were people in a stockade—a chain-link fence with barbed wire on top of it. Their hair was falling out and their skin seemed to be peeling off. They were wearing blue denim trousers but no shirts. . . . Good God, it was scary. While I was in the hospital I told my nurse what I'd seen. The next day when [the doctor] looked in on me, he said, "The nurse told me a most unusual story. What about those people you say you saw at the test site in Nevada?" [Torres was questioned on two occasions during the next two days. He thought that one of the questioners was a psychiatrist.] . . . They took me to the Balboa Naval Hospital in San Diego [where four men questioned him at length]. I told the story of the people behind the chain-link fence. They told me I imagined I saw those people. One of them called me a liar and forced a large pill down my throat. I must have been kept drugged for days, because I woke up back at Camp Pendleton in the hospital. The day I left to return to my unit a doctor told me not to repeat the "bizarre" story about the people I'd seen. He said if I did, he'd see to it I was thrown out of the Corps.[3]

After some time under observation, Carter was returned to George Air Force Base, and found that his hair was beginning to fall out in clumps. By that winter, after a transfer to Newfoundland, his health had deteriorated so badly that

he was hospitalized. At that time he, like Torres, mentioned his ordeal at the Test Site to the doctor and a nurse.

They immediately brought me back to the States to Colorado, where they locked me up like a criminal for three days, like in a psychiatric place. They told me the only way I could get out of there was to go through a reverse brainwashing type thing. Nobody knew what we knew. You know that if you tell anybody it's like treason, you'll be hung. They were doing something with the top of my head. I thought it was needles stuck in, but I couldn't see. I thought, why am I being locked up here where they are screaming at me and yelling at me and telling me that my friends all wear skirts? They were trying to break me down, telling me I was not to reveal anything I know. I was really upset. It's unimaginable.

If Bob Carter and other soldiers like him were treated to questionable psychiatric practices, it is a certainty that they never received any practical therapy to help them cope with the emotional trauma not only of being exposed at such short range to a hydrogen bomb, but also of the enormously distressing revelation that their government might be conducting the human experiments they witnessed. The physical disability that now consigns him to a wheelchair is coupled with a clinical paranoia that keeps him housebound. He fears he and his family have been and will be harmed in retribution for his very vocal activities in defense of atomic veterans.

That cloud was like a big ball of fire with black smoke and some red inside, a big, monstrous, something almost sickening. Something that would scare you. It left me really sad,

real apprehensive about life. My dad said I left home loving life and I came back, and I had no love for life any longer . . .

How would you feel if you sent your kid, 17 years old, to watch a 74-kiloton explosion? It's destroying the human species. That's what it's done to me. That explosion told me I was part of the most evil thing I have ever seen in my life. How can anybody use it as a deterrent to a war? I'd rather go fight the war. Wouldn't you rather go fight in the war than destroy the world?

1. Richard L. Miller, *Under the Cloud: The Decades of Nuclear Testing* (New York: The Free Press, 1986), p. 266. Statement of Frank Putnam of the National Academy of Sciences on January 24, 1978, under interrogation by Congressman Tim Lee Carter at a meeting of the Subcommittee on Health and Environment.

2. Thomas H. Saffer and Orville E. Kelly, *Countdown Zero* (New York: G.P. Putnam's Sons, 1982), p. 47. In a letter to atomic veteran Thomas Saffer dated July 7, 1980, Col. William J. McGee of the Defense Nuclear Agency revealed, "It was a thermonuclear device and a prototype of some thermonuclear weapons currently in the national stockpile."

3. Saffer and Kelly, *Countdown Zero*, pp. 248–250; also William A. Fletcher, "Atomic Bomb Testing and the Warner Amendment: A Violation of the Separation of Powers," *Washington Law Review*, 65, no. 2, April 1990.

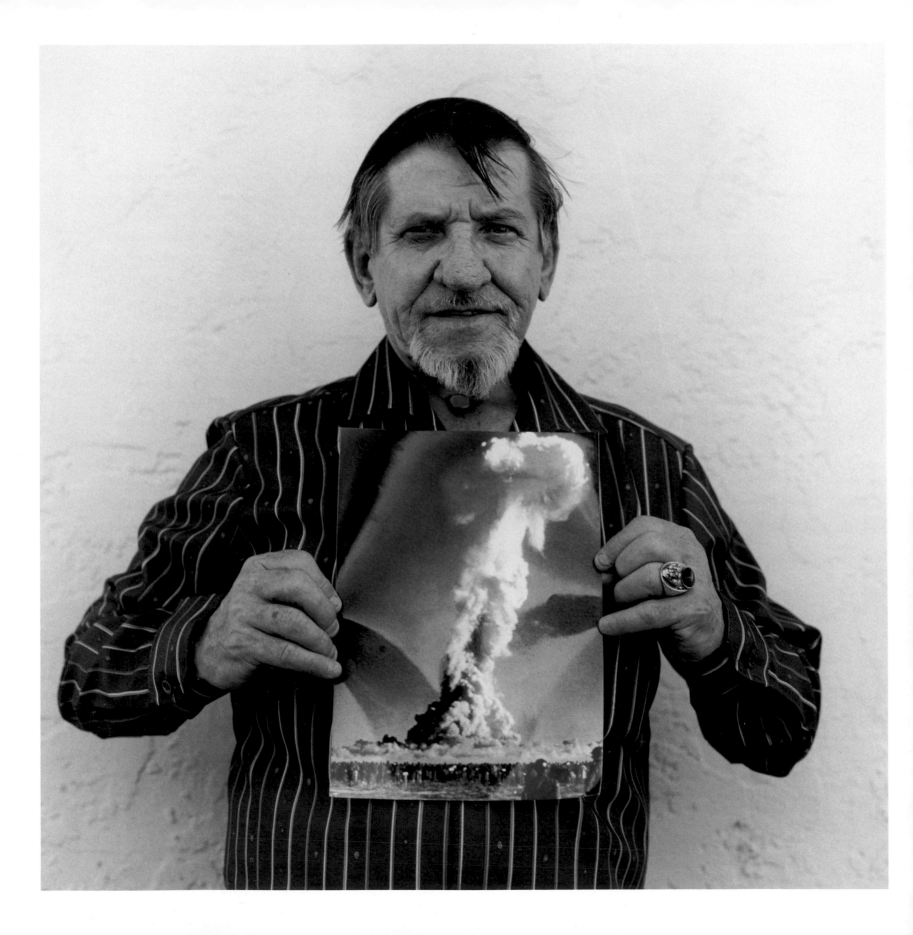

TED PRZYGUCKI

July 1986

Las Vegas, Nevada

Ted Przygucki had collected photographs of atomic soldiers and the bomb, and was particularly proud of this one, a test in which he participated. "I think if they would have come out and said that it would hurt you in the years to come, I would have gone AWOL. The AEC and the Department of Defense, they have been dodging the public for so damn long that people are just fed up."

Ted Przygucki doesn't have all that much to say because it's so hard for him to say it. He has no voice box. The written material he brought with him spoke volumes. There are lists. Lists of illnesses and lists of operations. Lists of the 22 atomic bombs he witnessed between 1952 and 1956. "After you've seen so many, they all look the same." But he did see things. He saw mannequins and animals—pigs, chickens, rabbits, donkeys—all "burned to a crisp." He was the army truck master of Survival City, described by the Associated Press in May 1955:

Immediately after the blast, a vast cloud of dust welled up from the desert floor, covering the test town like a brown shroud. White fire seemed to jet soundlessly from the dirt you were staring at. Civil defense experts prodded into the shredded wreckage of this atom-blasted town and learned where and how you would die—or survive—in a nuclear attack. C[ivil] D[efense] workers started probing into basements of damaged and destroyed buildings to see whether mannequins left in bomb shelters would have escaped. Ripped and crumpled debris made clear that none would have lived. The mannequin families in them "died"—to a man. In the two flattened homes, four shelters were uncracked. Out of a makeshift bathroom shelter came two cheerful tail-wagging witnesses for survival. They were dogs. Photos showed a two-story brick house on Doomsday Drive, 4,700 yards from Ground Zero, in a shambles. This was the Darling family home.

I was a master sergeant. I was about 28. The officers in charge, they said that all the safety precautions were taken to prevent anything from happening to us. From the trenches we looked at the damage that was done to the mannequins dressed in military uniforms with steel helmets. The equip-

ment at different distances from ground zero was burned and obliterated and tossed for quite a distance. What I saw was just mannequins that were dressed, sitting in a motel complex that was made out of rock and some wood and steel. They had mannequins sitting by a table with food. The blast or the heat did damage to the interior and exterior. A lot of dust and ashes would get on us after the shot, from the fallout. When a shot went off you could hear the blast. Then the heat went over us and you could feel it on your arms and on your ears and neck. It was like a furnace. Then the shock wave, you would be knocked off your feet even from the official observation point, and this was probably seven to ten miles from ground zero. It would knock some of them on their fanny if they weren't graceful.

Number one, they didn't know what the hell we were getting into because the military officers told us to take it face value. You see, you didn't question them about safety because twenty years down the road, not even your scientists who developed the A-bomb really knew what damage radiation might do. The main object was to see how our troops would react in case, in a war, our enemies dropped the A-bomb on us. See how they would react, what type of visible injuries we would receive, or burns, but never internal radiation from the fallout. Some got sick from headaches. They didn't pay attention that headaches were caused by the radiation. My teeth fell out about 1956. I could pull them out myself. I went to the dentist and they checked me out. They said, "For your health's sake, we're going to pull all your teeth out." And every year after I would get a bad case of laryngitis until 1976. The doctor took a biopsy and said I had cancer of the larynx.

Veterans told me that when they go for a check-up at the VA, and they tell them they are atomic veterans, they just give them a normal physical. Then they call in a psychologist to try to talk them out of the idea that they are sick. I wouldn't trust them. I don't even go to the VA for treatments. They'd just tell me I was wacky. When I told them I was exposed to radiation, it was "so what."

Sergeant Ted Przygucki has a visible hole in his throat, the hallmark of a laryngectomy. In it is a little metal button with a screen to let air in and keep dust and water out. "If I get any water in me I would drown, because I haven't got the strength to cough water up, or liquids." And his buddies from the Nevada Test Site? "Most of them are dead." Przygucki is a diminutive man who never married, and whose cancer took him by surprise.

I was all by myself here. I just saw it as a challenge. I wouldn't be a dummy. I'd learn to talk. I thought about all them tests and all those auditors telling us about the safety precautions they were taking. Trying to understand why somebody didn't tell us, like, ten, fifteen, twenty years down the road something may happen to you. I think if they would have come out and said that it would hurt you in the years to come, I would have gone AWOL, I know. The AEC and the Department of Defense, they have been dodging the public for so damn long that people are just fed up with their silly tales of "it's impossible," "nothing will happen," and "it is safe."

The front page headline of the *Las Vegas Tribune* on May 5, 1955, blared: "SAVAGE A-BLAST WHIPS 'CITY,' SPARES PROTECTED WATCHERS." There is some truth in this, but only the scientists and important government officials were protected. For the atomic veteran crouched in a trench two miles from ground zero, as in the photographs he showed me, it was the big lie displayed in Cold War column inches: "On the opposite side of the shot tower—which vanished in the twinkling of an eye as unearthly heat vaporized everything near the explosion—was an atomic battleground, like that which may await soldiers on some tomorrow. Awed, dazzled, with hearts thumping, they experienced a prime lesson of atomic war—that adequate shelter and knowledge can often save human blood and life."

R U S S E L L J A C K D A N N

October 1988

Jean Dry Lake, Nevada,
on the set of the film *Nightbreaker*

Russell Jack Dann chums with the extras on the set of *Nightbreaker*, which was based on his experience as an atomic veteran. 1988. "It's like the Holocaust. But the government, they're simply playing a waiting game. We are becoming an endangered species, the atomic veterans, and the longer they wait, hell, we'll all be dead. All they have to do is simply bury their damn mistakes."

The first shot, Smoky, was August 31, 1957. It was [the equivalent of] 44,000 tons of TNT [44 kilotons—Hiroshima was 13 kilotons]. The tower seemed so close, and you could count the light bulbs on it. It was a 750-foot tower. It looked like a Christmas tree, and then there was an elevator going up and down. Nobody knew how big the bomb was. We wore no protective clothing or anything, no gloves, no gas masks. We were in completely open space, right on the top of the hill, like a bunch of dummies out there. At 3.8 miles the heat and the light is instant. First of all, when the bomb went off the light was like a thousand suns and the sound was like a million cannons. Then we saw this tidal wave of dirt and dust and sagebrush and rattlesnakes and wires coming after us, it could have been any damn thing out there, but it was coming and [the sergeant] hollered, "Hit it!" We went down like damn bowling pins. First of all, you could see right through your arm as if it was an X ray, the sound was just earth shattering and deafening and a tremendous roar. The wind was blowing at 150 miles an hour, peppered the hell out of us and everything went flying, everything you could hold on to. There was nothing to hold on to.

The stem was straight up about 65,000 feet to the top of the mushroom. With Smoky, the stem was really, really dirty for some reason, long like a stovepipe and deep purple in the center. And really scary-looking, but it was dark, it was black on the outside. It was awesome standing there and looking up and seeing how high that thing was going. That bomb was four times the size of Hiroshima and Nagasaki and here we were standing out in the damn middle and watching it like a bunch of turkeys.

Right afterwards, they marched us off the hill, down to see what the tower looked like, and it was a pile of . . . nothing,

nothing left of it, just vaporized. Tanks were melted and turned over, the houses were blown away. There was no crater. The ground was crusty. Now whether it was glassy or whether it was crystally, I have absolutely no idea, except that when you get a hundred and seventy troops marching in columns, there's a hell of a lot of dust. The man with the radioact meter came on and hollered, "Be sure to get out of this area because it's getting pretty hot." Radioactive-hot hot.

Before we boarded the trucks to go back they simply used whisk brooms to get the dust off us, alpha particles, and that was the end of the decontamination. When we got back to camp, we showered with our fatigues on, then we had to throw them away.

The next day Russell Jack Dann was treated to another, smaller nuclear detonation, the 9-kiloton Galileo, at Jackass Flats.

We were just facing the shot, laying on the ground. It was a real distinct crack, just like time stood still, just like a thousand bullwhips in your ear, and the brightest, most magnificent, beautiful bomb you have ever seen in your life. Every color in the rainbow. It had pure white, it was absolutely fantastically beautiful. The area was pretty hot with radiation so they ordered my squad out.

Dann was immediately affected with radiation sickness, which continued after his 82nd Airborne Division returned to Fort Bragg, North Carolina. Doctors denied that he was ill, and said that they had never heard of the atomic maneuvers: "They couldn't find any records that I had served at Camp Desert Rock, but I didn't know that the Pentagon had retained them as secret, so I had nothing to prove." Meanwhile, he vomited green bile, was increasingly unable to stand steady on his feet due to violent attacks of dizziness, and was losing clumps of hair. Within a year his teeth became loose and fell out, his skin lesions had not yet disappeared, and his doctor found him to be sterile. The dizziness persisted and grew worse until one day, while doing construction on his home, he fell from his ladder. The fall broke his neck and put him in a wheelchair for life. The subsequent amputation of his leg, Dann remarked cynically, was "nothing unusual for a quadriplegic." He has fought unsuccessfully for compensation for his service-connected disability for many years, as have thousands of the 250,000 veterans exposed at close range to nuclear tests in Nevada and in the Pacific.

I did not remember falling and really getting busted. Anyway, it was a story and a half, busted my neck at the seventh level, so as a result, I'm paralyzed from the neck down. To me, the government has used us. We fulfilled our mission, now it's their turn to fulfill their mission. We did our duty and served the army, we did it well.

[The atomic veterans will] win this damn thing someday, somehow, but I don't know if I'll see it before I die. Someday this will all end but the hell of it is, girl, by the time this will have blown over, it will be forgotten about. It's like the Holocaust: it will always be around, naturally. But the government, they're simply playing a waiting game. We are becoming an endangered species, the atomic veterans, and the longer they wait, hell, we'll all be dead. All they have to do is simply bury their damn mistakes.

REASON "FRED" WAREHIME

April 1988

Riverdale, California

Fred Warehime sports a two-foot-long scar around his torso from the operation he endured to remove a cancerous lung. "[After witnessing the detonation of the bomb] we went straight forward, which put us in really high radiation. The sand had kind of melted into a glaze, like a brown glass. Then we got a sunburn, and the guys all started throwing up, sick as dogs, all of them."

Fred Warehime, who enlisted in the Marine Corps with a phony I.D. when he was 16, was a participant in the Allied occupation of Nagasaki shortly after the second atomic bomb dropped on Japan ended the war. He pointed out that there weren't too many other teenagers in what he sarcastically called "the clean-up brigade," but his cynicism could not mask the awe he felt at the sight of the bomb's destruction.

It was leveled. I've never seen anything like it. Funny, the first day we didn't see anybody. Nobody. Everybody hid from us. We were camped by what was left of the railroad station—you could tell because it had all those tracks coming in. The Marine Corps engineers were in there cleaning up with bulldozers. Of course, all that dust didn't bother us one bit. We'd wake up in the morning with dust on us a quarter inch thick.

We had seen two wheels of a bicycle sticking out of the rubble. We dug it out, and there was a skeleton on the darn thing. You could see, well, at the time we didn't realize they had been people that had been vaporized, but you could see whole outlines of a shadow on a wall, even with a dog, or a person.

Eight years later Warehime was assigned to the Camp Desert Rock atomic maneuvers in Nevada, participating in the 43-kiloton shot Simon in 1953.

It's been decided since then that nobody out there knew what they were doing. The fallout in this thing went all the way to New Jersey. It was one big goof-up, supposed to be a 23-kiloton bomb, twice the size of the one at Hiroshima. When it went off, they're saying it was 51! When the thing went off you felt you were in a vapor, like a vacuum. It's really quiet—

everything was still as death—and then this real bright light for a few seconds. It was so bright I had my hands over my eyes closed, and I could see all these bones like you were looking at an X ray. Then this earthquake. Everything is so dusty you can't see a thing, and a deafening roar which feels like something crushing your head.

Then a guy stands up and hollers, "Get up and look at it," so we stood up. The fireball was right straight up above our heads, I mean *right* over our heads. To see that fireball you had to put your head back to look up. We had to be in the stem of it.

We were only 300 yards from ground zero. I told my men to get out of the trench and move out. Our sand bags were all on fire, and I had a sack lunch sitting up there that burned down to a piece of charcoal. We went straight forward, which put us in really high radiation. Mainly we noticed when you get out closer that a lot of the sand had kind of melted into a glaze, like a brown glass. Then we got a sunburn, and the guys all started throwing up in the truck going back. The guys in that bunker in front of us were sick as dogs, all of them.

Simon's fallout cloud, with a reading of 300 roentgens per hour, spread its nuclear debris in a band 80 miles in width as it approached Utah. Roadblocks were set up and buses were stopped on their way to Las Vegas. Cars approaching St. George, Utah, from the south or west were checked with geiger counters and washed off before they could proceed into town. The cloud drifted slowly northward through the West Desert of Utah and hovered over the Cache Valley on the Idaho-Utah border, one of the most productive dairy areas in the West, killing cows in their tracks within hours. It was still dangerous when it reached New York state, where it rained out over local milk farms during a thunderstorm. At the Rensselaer Polytechnic Institute in Troy, students noticed the laboratory geiger counters clicking when they came to class. The puddles outside were radioactive and the tap water's count was 2,630 times higher than normal. Data regarding the rainout were quickly classified. It was neither the first nor the last time that high levels of fallout would visit the East.

Weeks after the test, Reason Warehime began to lose his hair.

It started every time you put your comb through your hair, you come out with a big gob of hair. It would have been three years later when they finally had to pull every tooth in my mouth because they had all turned black and came real loose. Let's face it, I was 28 and that's not the time you lose all your teeth all of a sudden. And I was sterile after the shot. That's in my military records.

By his thirties Warehime had developed radiation cataracts, and osteoporosis and muscle deterioration were also becoming a problem. In 1982, a malignant tumor was discovered in his lung. He didn't spare me a gruesome show-and-tell description of the operation. "They cut you all the way around, pry your ribs apart 14 inches with a vise, then take the lung out. It's the toughest operation you could go through." He peeled off his shirt and lifted his left arm, revealing a two-foot-long, sickle-shaped scar that stretched from his sternum around to and up his back. It was all far too graphic, and Fred Warehime laughed at me as my knees wobbled at the sight and thought of it. I had not yet developed any skills of detachment, but he was a Marine head to toe, and tough as nails.

ROBERT MERRON

February 1991

Santa Lucia (Big Sur), California

"It had been a crystal-clear day in the desert, but now all you could see was fire. I don't know how long we stood there, sobbing and weeping with no shame at all, every single guy. We looked out at ground zero, and it was a vast dish and there were all these fumes and smoke rising out of it, green-black-purple fused into one solid big bowl."

Big Sur is the geographic cliché of the dropout generation, and Bob Merron lives not far from its epicenter, Esalen. Working as the caretaker of an estate in Santa Lucia perched above the ocean's rim, he has transformed its garden into a profusion of tropical flowers, and its large pond shimmered with leaping fish and with sparks of colored light as the sun sank closer to the horizon. This pastoral environment was the antithesis of Merron's experience as a young soldier, when the experience of shot Hood, at 74 kilotons the most powerful bomb ever exploded in the Americas, destroyed his peace of mind, and his health, forever. He would laugh compulsively throughout our conversation, defending himself with a gallows humor, but this was a sad man, and a kind and humble man. He felt, he said, that the only way he could redeem himself was to retreat into the deep sensuality of nature, creating beauty to combat the catastrophe of his past and the fear of his future.

When shot Diablo misfired, they kept us in the desert to witness the next scheduled test [in test series] Plumbbob, which was on a balloon. [This was shot Hood.] It looked like [shot] Plumbbob. I could see it from the trench. They said it was 3,500 yards away, which . . . [laughs nervously] was *close*. They had dummies right above our trenches with Marine Corps gear on, clothing, and they went instantly on fire. By the time we got out of the trenches, everything was gone before the trenches, there was no brush, no lizards, no bunny rabbits, nothing. Incredible.

How did they prepare you for the test?
We had a couple of classes at Camp Pendleton before we left for the desert to tell us, to try to let us know what we were

up to or what we were in for. They didn't know. What they really did tell us was that they didn't really know what was going to happen. They likened it to dropping a drop of water on a mirrored surface, the exact same amount of water—every time it strikes it'll splash differently. It was the splash pattern that they couldn't tell. It'll blow three miles this way, or six miles out here. So they don't really know.

What was the feeling of the guys in the class, did you talk about it?
NO! We were not supposed to. First of all they get everybody cleared for secret clearance, and then they did some other kind of thing, really investigated. And we weren't to talk, we weren't supposed to say anything to anybody. Once we were informed that we were going to do this, they cut our liberty, and we weren't allowed off the base. We were really excited about it.

You didn't have a negative feeling about it?
At 20 years old, nobody ever gets to see one of those things. They told us, of course, that we were privileged to have been chosen to do this, and you naturally believe it. You *want* to believe it. You want to believe that you are the best of the best of the best. But there was a certain amount of trepidation just when they told us they didn't know, we began to be a little uneasy. If they didn't know, then how do they know that 3,000 yards is far enough away? So, anyway, they took us, I think, about 90 miles north of Las Vegas. I remember driving, going in through the area—we passed 20, maybe 30 towers, hard to say but it really impressed me, the number of towers, with blackened things underneath, the ground right underneath them, and in various stages of melt or disintegration.

Some of them not so bad, and some of them right down to the ground with the ground blackened. They tested and tested and tested. At any rate, they told us that they were able to control the radiation contamination. They called it a "clean" device. [Laughs.] Well, you don't have to be a rocket scientist, y' know . . .

So, they marched us out there into the desert in the middle of the night to get into position in the trenches, and they had the countdown. When Diablo fired, I thought, "What happened—are we dead now?" Five, four, three, two, one, nothing, and then he started to yell over the loudspeaker, "Misfire, misfire, hold your places." They had us there in the desert, prepared, and so they decided to hold us there until the next scheduled device. Device. I always liked that word: Newspeak. We spent, I think it was, three weeks, if I recall. We spent all the time just marching out into the desert, half a day out, half a day back. All these troopers, and nothing to do. You could go walking out there in the desert, and it was full of life. Desert turtles, all kinds of reptiles, so it's a living desert.

What did those old ground zeros look like?
They were blackened, it was obvious there was a tremendous explosion. The thing was, it was different. They compared it to thousands of tons of TNT, and that doesn't even say it. You can't even compare them, it's like comparing two completely different things. They took you out there and it was dark. You couldn't even see anything. We'd get down into the trenches, six-foot-deep trenches, and they said do not look to the east, which is where the bomb was. The day before the actual test, they took us into the Test Site in trucks, and there were countless pieces of military equipment of every

description, jeeps, tanks, trucks, artillery pieces. They were just stationed and scattered out in a vast, vast area to the south and east of the actual ground zero, and we were to the west. And they had this town, and you could see it shimmering in the sun. What I understood was that they built a housing tract. They had tables, dummies, food, windows, everything, just made it up for the time of morning when people would be getting up, eating breakfast, going to work. There was enough light in the east for me to discern that balloon, and I could see it clearly, like *Around the World in Eighty Days,* a balloon with a basket hanging under it. It was tethered to the earth. I *had* to look.

We'd been told what position to assume at what point in the countdown. They begin the countdown, and you're in the trenches an hour before. You get down on one knee and brace yourself against the sides of the trench. It's like a grave, is what it is, just one L-O-N-G grave. At the point of detonation, I could feel the heat, felt like someone had run a hot iron over the whole of my body, and I could see the bones in my elbow. I'm looking with my eyes shut, and it was just as clear as could be. So first, it's the light and the heat.

One of my buddies wore his watch, and you weren't supposed to, and his field jacket sleeve only covered a part of it. It burned the face of his watch a brown-black, except for where the hands were, that's how hot it was. It's either heat or radiation or light, or a combination, but what's the difference? Does anybody know? So, the light comes up, and then it fades and fades and fades, and it goes almost to red. Everything is dark, but it's red. There were two distinctly separate sounds of detonation, the second one was the shock wave. Then the ground starts to move, and it's caving in, and literally your whole world is coming apart. I remember

only seeing two guys ahead of me, and the trench was snaking so violently, zigzagging, curving, and caving in. Once the light and heat is gone, they tell you to get out of the trenches or you're going to get buried. We were having to pull guys out.

By the time we get out the dummies are burning and there are brush fires behind us, and you're not looking anywhere but straight up, and the fireball is every color of the rainbow, green, blue, red . . . *directly* above us. It obliterated entirely the sky. It had been a crystal clear day in the desert, but now all you could see was fire. I don't know how long we stood there, and I was just sobbing and weeping, with no shame at all, as was every single guy there. It was just . . . how can we do this?

After watching this whole thing, we got loaded into armored personnel carriers and they just drove around the desert to occupy time. Then we were taken to another area, given gas masks, and we were going to go back into the area we had been in the day before to view what had happened to all this equipment. It was an atomic exercise. We were supposed to be playing war. I promise you that you are rendered incapable of doing anything warlike or otherwise.

You can't understand the forces it takes to accomplish what was accomplished by that thing. It blew some things completely apart, it melted other things. A truck here and a jeep there, one of them doesn't even have any tires on it at all, and everything is bent and twisted, and right next to it one with tires, but the whole body is melted. It moved a tank. We looked out at ground zero, and it was a vast dish and there were all these fumes and smoke rising out of it. It was green-black-purple, and just fused into one solid big bowl.

Having seen it once, nobody can ever explain to me how

they continue to do this. I've always thought that they should take all the people who are so very interested and think that it is serving a purpose to test them, take them into the desert, and put them in a hole in the ground, and get in it. Give them a shot if they like to play with that shit, give them a firsthand experience. None of this sheltered stuff with their bunkers and protective gear, and they know for sure their asses are safe. "We don't know what it's going to do to the troopers, but we know we're okay. Because we've got to consider our studies." I can't believe they're still blowing those things off, and now they're doing them underground, which may even be worse! It's just got to stop, it's insane. Let them go through that experience just once and I promise you that they will put away those things so fast that it'll be history. I'm still convinced that if it ever happens again, I don't care whether it's by OOPS! or if it is used against mankind, then we are finished. I think God will just . . . well that's it for the human race.

What was the feeling in the camp that night with the guys, just having seen this thing?
Complete deflation of spirit, and I mean to a man. You didn't want to talk to anybody. There was no joy associated with the experience whatsoever. No talking, no nothing, I just want to be with my own thoughts. I was 20 years old, and probably the youngest guy there may have been 18. It was just before my twentieth birthday. I don't know how many of us are left. At some point in the not too distant future I would suggest that they will be able to count us all on just a couple of hands.

Have you had any health problems along the way?
Ten years later, in 1967, I had six feet of intestines removed, colostomy—eviscerated at 30 years of age. I went on, then a fibroid the size of an orange was removed from my gut ten years later. I've got fused disks in my back, two blown disks. I think it did more psychological damage to me than anything else. It's something that isn't ever very far out of my consciousness. You can't tell anybody about it, or talk to anybody. I've met very, very few people who even knew that that kind of stuff went on. To know, to have that experience and then to realize that nobody really understands when they're talking about the nuclear confrontation, they don't understand what the hell they're talking about . . . It just gets too unreal. An experience like that forever forbids even the threat of using one of those things. Everybody that I knew at the time, and the two or three guys that I met since, when we talk about it, all feel that way. It might somehow have been a benefit to me personally because it humbled me so. It's not for the common experience. It's an impossible idea to ever think of using that as armament. It's too, too dangerous to everything. I just can't understand how they're still doing it.

I've met very few people who even know that all that stuff went on. And that's wrong, I mean, Jesus, it's *dangerous,* I promise you! If that can be done, and then suppressed to the point where it's not common public information, then there's danger in exposing it to public awareness. There are vested interests in seeing it continued to be under wraps. "You don't say anything about this to anyone at any time." There was always an implied punishment. "If there's a breach in our security and you're responsible for it . . ." And in the Marine Corps, if they tell you something like that, there's an implied

threat in it. You can bet that they would keep their word on it. In the Marine Corps, threat is the primary motivating force.

Do you think that the experience made you into a much gentler person?
Oh, I know it did, I *know* it.

HERBERT HOLMES

July 1991

Clarksburg, West Virginia

"The plane was crackin' and poppin'. The explosion blew us up about 4,000 feet, the shock wave hits and blows you another 2,000 feet. Straight up over a mile, this plane weighed well over 100 tons and it was like we was just a feather. We had a postflight debriefing and the doctor said, 'Gentlemen, I've read your dosimeters. You've received half enough rems of radiation to kill you.'"

I was an electrician gunner, what they called an E-gunner. I called myself an engineer's troubleshooter. If anything went wrong, it was my job to fix it while we were airborne, say the bombs wouldn't go? It was my job to kick 'em out of the bomb bay. U.S. Air Force, airman first class. I was 27 years old at my first test on the seventh of March 1955. Turk, a 43-kiloton bomb, was the first one that went through the atmosphere clear out into outer space, and shot Met afterwards. Tracking that cloud, it went down into Arizona, come across the southern part of the United States, and come up the Ohio Valley. Of course it bathed the East Coast. Every inch of the United States has been bathed in nuclear radiation, every inch of it.

A week before, we won the bombing competition of the Strategic Air Command. We were the best in the nation as a crew, hittin' the target and doin' what you're supposed to do. It was an honor! So what does the Air Force do? They say, "Since you won the bombing competition, you *will* participate in the atomic tests." They wanted the best. Our home base was Carswell Air Force Base near Fort Worth, Texas. We made an electronic bomb run on the 500-foot-tower that held the bomb. At bombs away we were in exactly the same spot as if we had dropped it. We were at 26,000 feet. You would detonate it at 1,000 feet, say, above Moscow to get the maximum destruction sideways. If it were a hydrogen bomb, they might detonate it at 2,000 feet. Back in the fifties, they estimated that with a hydrogen bomb everything 80 to 100 miles away would be flattened from the shock waves, and up to 20 miles away, everything would be melted. Absolute, complete destruction.

We had what you call preflight briefing. You get your instructions, are advised of weather conditions, how long the

flight will be, all the specifics. This particular flight we had a flight surgeon give us a briefing, the first medical briefing I ever had. He said, "Gentlemen, this will probably affect you in later years, but there's nothing I can do about it. You've got to go." The hair kind of goes up on the back of your neck and you say, my goodness, this is serious. But you're young, so you think, hey, you're going to live forever, just a bunch of young guys having fun.

Before bombs away, we were instructed to black out the bombers like a dungeon, three-quarter-inch-thick curtain pad with aluminum foil on the outside that fit in the window, called blisters, and we put a little nylon pillow, four inches thick, about a foot square, over our shut eyes. At bombs away it was brighter than any sun, you couldn't imagine how bright it was in there, just startles you. I could see the bones in my fingers through my closed eyelids and the pillow! One of the eeriest things that ever happened in my life. Ghostly, really. You don't believe what you're lookin' at. Almost immediately there was a river of water running down my nose. If you had poured five gallons of water on top of my head, there wouldn't have been any more, the sweat coming out of me, that's how hot it was, and smoke was flying off all of the electrical connections. After half a minute at the most, they said to remove the curtains. I looked around, there wasn't a man who wasn't lookin' at everyone in there. Their eyes were *big*. If you hadn't been there, it's awful hard to believe. We had to go into a tight right turn to get out of there, to get away from as much of the radiation as we can. Of course, we didn't get away from anything. The explosion blew us up about 4,000 feet, the shock wave hits you and blows you another 2,000 feet. Straight up over a mile, this plane weighed well over 100 tons and it was like we was just a feather.

We were in such a tight right-hand turn that the plane was crackin' and poppin'. You could see like a pot a-boilin' right down there on the ground, black smoke and fire all mixing together. It has this uniform-lookin' stem, from the air it looked like about 150 foot across, the whole thing just alive goin' up there, that stem. We're flying under this *tremendous* mushroom cloud, boiling up and just spreading out, huge. That was carrying all kinds of radiation—that test was one of the largest bombs ever put off out there, 43 kilotons [shot Smoky].

There wasn't a sound from anyone. We were trained—you had to be cool or you wouldn't be there. We were all thinking, "What in the world is goin' on?" We knew there was trenches full of men down there. You didn't realize that you were going to get just as much, maybe more, radiation. That's how young men think. We didn't have geiger counters; we had dosimeters, one on the lapel and one on the pant leg. When we got back they landed us on the remote runway and we went down to a bath house, dropped our dosimeters into a barrel there for them to read. Took a bath, discarded the flight clothes, underwear and everything else, and came out with brandnew clean clothes. We had a postflight debriefing with the same doctor and he said, "Gentlemen, I've read your dosimeters. You've received half enough rems of radiation to kill you."

What it did to me, if you want to know, is that my teeth come out by theirself, no blood. One time I was dozing off to sleep and my tooth jumped out on my tongue and it startled me. The gum had rejected it, it just popped out. I put it in a little envelope, and a little bit of time later it had deteriorated to powder. That doesn't happen with teeth. They dig up teeth that are millions of years old, right? I started coming apart

at 43. My eyes, my nerves, just bingo, overnight. One day I have 20/20, I could go to bed tonight and read the Bible, the next day my signature is blurred. I thought I had a stroke in my sleep. My arms were numb, and I lost the strength of my left arm. I couldn't open a door. I went to the VA clinic, and six doctors examined me. I didn't mention radiation to them because I didn't think of it myself! They sent me to Wadsworth in LA where there's modern equipment to test me. I was out there about three years, every day of the week for tests. Near the end they had an auditorium full of doctors, me up on the stage, everybody asking me questions. They hung me by my heels, rows of television cameras around, a guy snapping the X rays, an hour and 45 minutes, a myelogram. Weeks later the doctor said, "Herb, sit down. You're wasting my time and I'm wasting yours. Medical science can't do anything for you." He knew by then I was claiming nuclear radiation did this to me. I really believe this, that when they quit lying they will decide it gives you cancer of the nerves.

And another thing, that plane was never washed down. We flew that thing the rest of the time I was in the air force the same as if it had never been in an atomic test. You can't make me believe that every man who worked on that plane wasn't irradiated because it was *hot,* you couldn't get away from something like that. That thing was dangerous as a cocked cannon. I think they did all this to the airmen and the navy and the army just to see how long it took us to die, the reaction, the medical problems. I think we were a scientific study to further the cause of the atomic age. It was an ego trip for a bunch of atomic scientists.

I think our government was using us for human experimentation. They had less respect for the humans, the airmen, than for the money it took to train us. We were told that at a SAC survival course. The officer on the stage said, "First of all the reason you're here is because it cost $40,000 to train you this far. We don't care about *you,* there's plenty of *you* out there." We all laughed, we were young, we thought he was making a joke. But he wasn't kidding—he *meant* that. We were nothing, expendable. They could always get more young men, but it would cost more money to train them. I'll never forget it as long as I live. Anything that the government wants to hide, or cover up, or be devious about, they classify it "secret" or "top secret." We had to be cleared for "secret" before I could be a member on that bomber. We were trained to be tough boys. You were a man, you couldn't be a momma's boy, you took it all in stride. You didn't rattle us very much. I wouldn't have batted an eye if I was told to go blow up Moscow. You did whatever you had to do. You're trained for that, just second nature. But after that atomic test our tail gunner did say something afterwards, eyes wide open: "Well, we fly the *heavies!*"

I love my country. I'm probably as patriotic as a human being can be, and I *know* it's the greatest country on earth. But it's the old adage, one rotten apple will spoil the whole barrel, and it keeps building momentum. Satanic bureaucrats fleecing the taxpayers, can't even look you in the eye, and the general public sits back, the silent majority.

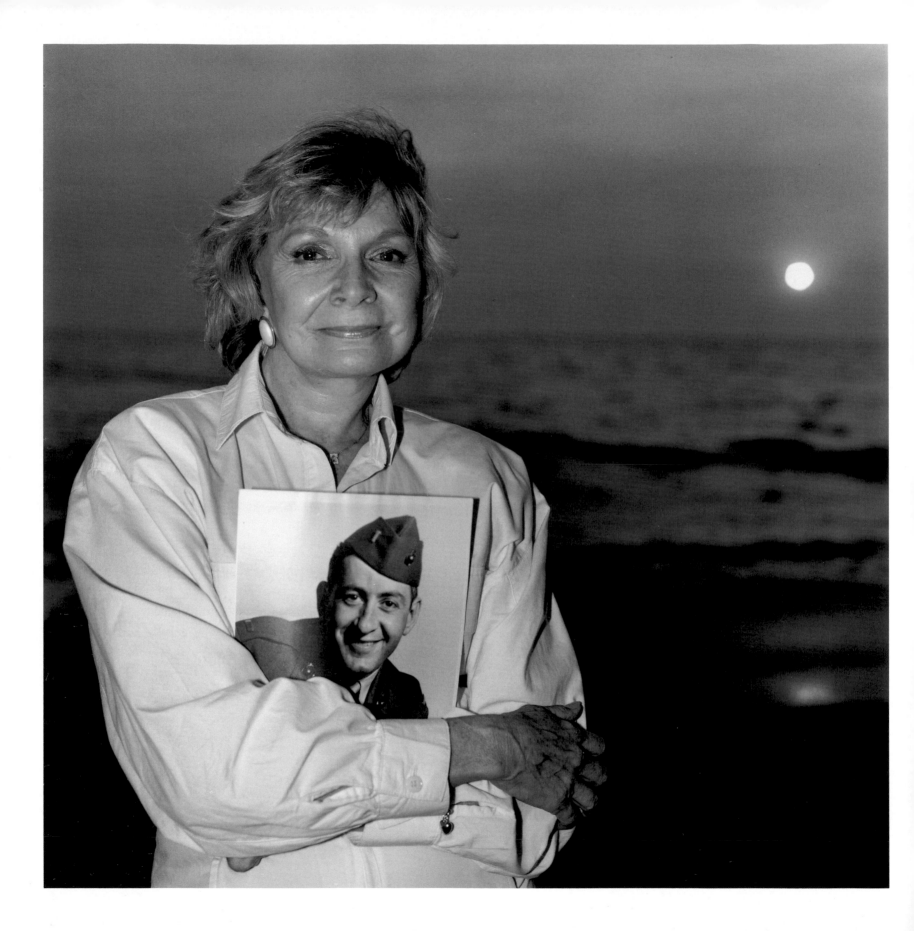

PAT BROUDY

October 1988

Laguna Niguel, California

"They shredded documents, and this all came out during the trial. The government admitted finally that they had known the dangers of radiation since the early forties. They knew it caused cancers, they knew it could cause birth defects, but they felt it was worth the sacrifice of a few men for the good of the country."

It was 1950. Pat Broudy was on a vacation in San Francisco, hoping to recover her spirits after her failed marriage had ended.

I met this charming, handsome guy who was a pilot, attending radiological defense school. In one particular class he was being sent aboard the target vessels in the Bikini tests, which had been towed back to San Francisco, to decontaminate them. They were learning how to chip the paint off, which raises radioactive dust and debris in the air, and they were inhaling and ingesting all this, living aboard for three days. I learned this later from documentation I got under the Freedom of Information Act. Anyway, he proposed to me the first night I met him. It was very romantic. We bought a house for six thousand dollars in the middle of a peanut patch in South Carolina, where we were stationed. We were in love and we didn't care, it was great fun. He was a career marine, enlisted in 1940, so he had ten years under his belt at that time. Chuck later went to Korea, flew his fifty missions, got his five air medals and his distinguished flying cross, and came home.

We moved back here in March of '56. The first shot he witnessed was Priscilla, June 18, 1957. The one he went out there for was shot Hood, which was 77 kilotons [listed by the Department of Energy as 74 kilotons], the largest bomb ever detonated in the atmosphere of the United States. It was supposed to have gone off on the Fourth of July, so that they had this great big firecracker going off and it made headlines. Eisenhower flew out. He called me on the Fourth and said, "Well, it didn't go off," which means the winds were blowing in the wrong direction—they were blowing towards California instead of St. George. Next night he called me and said, "It's going to be detonated in the morning. I want you and the

kids to get up and go out in the driveway and face east. You'll see it." We were 400 miles from Las Vegas. We got up at 4:30. It was like a huge sunrise. It came up very quickly and then slowly disappeared. It was seen, according to newspaper articles, by pilots that were flying over the Pacific. He came home from the test and never mentioned it again. Never ever spoke of it, and we forgot about it.

They were sworn to secrecy; they were brainwashed. If you know anything about the Marine Corps, they were brainwashed. He had top secret clearance and there was no way he would talk to me about it or anyone else. Everything I've learned I have gotten from government documents, and through the Freedom of Information Act I found out exactly where he was when he was there, and what he did, from the Defense Nuclear Agency. When they marched toward ground zero after they left the trenches, they marched through the ground zero of another test too, Wilson. It had been detonated a couple months before and it was very highly radioactive, of course, with plutonium. When they got to within 400 yards of the Hood ground zero, they inspected the tanks and the trucks, Japanese houses, and whatever, then marched back through the searing heat, the wind that was blowing constantly, helicopters churning it up, the plutonium embedded in the top inch of the soil. The wind blew it right up in their faces and they breathed it, ingested it, inhaled it. It was estimated that he had received 75 rads of alpha emitters.

Nineteen years later, she was on a vacation in Hawaii with Chuck, now 56.

I noticed that his feet just swelled terribly. We couldn't figure out why. They were just these two big blobs, and he could hardly walk. He was so fatigued, he just could hardly move. They were bright red and so sore. We had only been home a few days when he raised his arm up, and here was this huge lump that came up overnight. The surgeon called me about two days later. I was here by myself and Chuck was at work. He said, "It's cancer," just like that, "lymphoma stage 4B." "What does 4B mean?" He said, "It's terminal." Here I am all by myself, and I was hysterical. I called my mother. She was a big lady and she pulled me on her lap and I sat there like I was a little kid and cried.

Within the next six months it got to the point where his legs were so swollen that when he stood up he would pass out. The Veterans Administration people who interviewed us didn't even know how to spell lymphoma, we had to spell it for them. We had to tell them why we thought it was service-connected and they just laughed at us. We filed a lawsuit. Not only did we feel just absolutely crushed by his illness, but he also felt that the government had dealt us a very bad hand. I was very bitter about that.

It hit the papers. People called me and said, "I was there too and I've got cancer," and that's when it all started. It was amazing how many of them had developed cancers within that time frame. Chuck died, and my lawsuits were dismissed and my appeals were denied. And so we started working on the legislators. We thought, well, what the hell, let's form our own organization, and that's when atomic veterans [or, more and more, their widows] got together and formed the National Association of Radiation Survivors.

This organization now represents 250,000 radiation-exposed soldiers, weapons complex workers, and civilians across the nation, and the downwinders of many nuclear installations

including the Nevada Test Site and Hanford Nuclear Reservation in Washington state. Broudy's wrongful-death lawsuit became landmark litigation for radiation victims. In fighting her appeals the government lawyers reversed their position and admitted that they knew since the time of the first nuclear tests that the radiation could be dangerous, but were not responsible under a "discretionary function" clause—a "king can do no wrong" or sovereign immunity theory that would protect the government from prosecution.

They shredded documents, and this all came out during the trial. The government admitted finally that they had known the dangers of radiation since the early forties. They knew it caused cancers, they knew it could cause birth defects, but they felt it was worth the sacrifice of a few men for the good of the country.

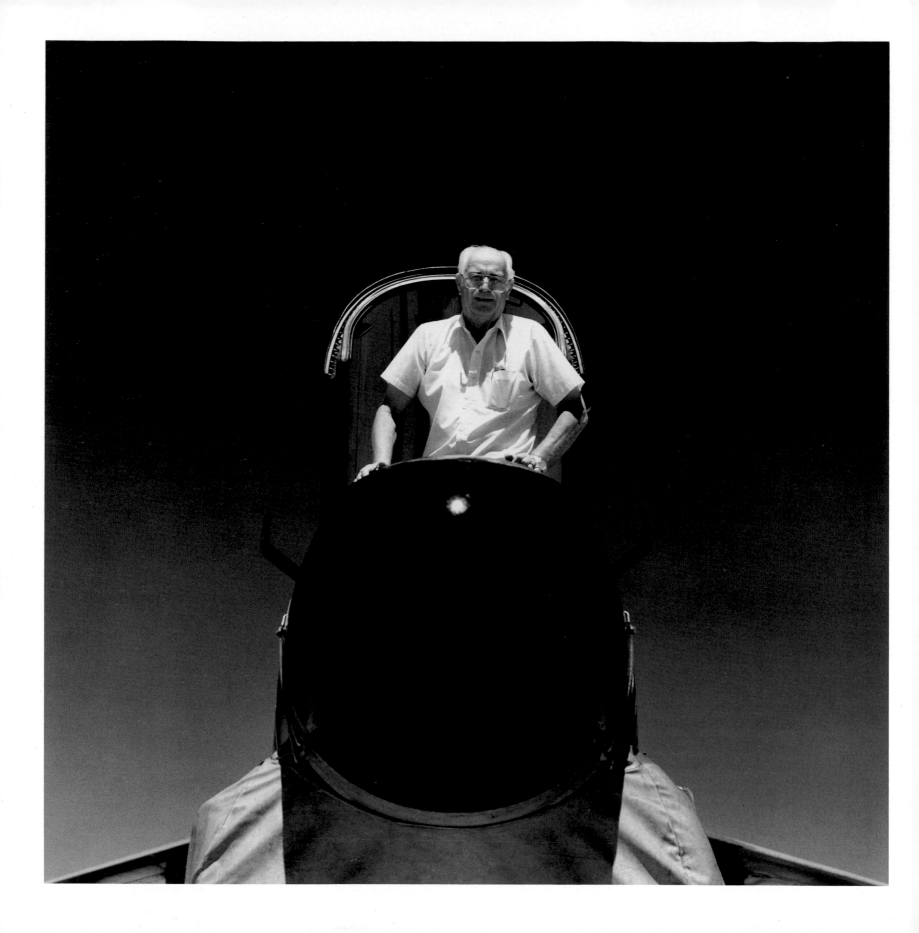

COLONEL LANGDON HARRISON

July 1989

Albuquerque, New Mexico

"There isn't anybody in the United States who isn't a downwinder, either. When we followed the clouds, we went all over the United States from east to west and covering a broad spectrum of Mexico and Canada."

If the secret nuclear war had its own top guns, perhaps the air force crews of the 4926th Test Squadron qualified for sheer machismo. Their mission was to sample the radioactive by-products of the atomic mushrooms that sprouted over the Nevada desert and the atolls in the South Pacific during the testing era. "Long before we went through those tests," Colonel Harrison recalled while flipping to a page he had marked, "Oppenheimer had warned that 'above all the pilots dropping the bomb must avoid at all cost reentering the cloud, as it is very radioactive and quite dangerous to the human body.' They knew that before sending us in." At the time, Dr. Harold Plank, an AEC scientist from Los Alamos, had high praise for the air force men. "I'm prejudiced in their favor. From my viewpoint the 4926th has consistently delivered more than one had a right to ask. This mission has inherent elements of risks and of personal devotion to duty which are not normally required during peacetime."[1] Langdon Harrison's duty was to pierce the heart of the atomic bomb cloud fifty times, even sampling those that China and Russia detonated when their fallout passed over Japan, but there was a hefty price to pay. Years later, after a cancerous bladder and prostate had been removed, the Veterans Administration would deny his claim for service-related disabilities as a matter of policy.

I don't know why they want to avoid it. It's there, we can't sue them, we're in the service so they might as well tell us what we've got and why we're sick and why an inordinate number of us are getting cancer. I don't believe the air force is trying to avoid it, it's the Defense Nuclear Agency and the AEC. I say, gee, I'm dying of cancer, I'm leaving my wife and

kids, they should be compensated because I went through the atomic clouds because I was *ordered* to. I didn't volunteer to do it!

Sampling is the only way that the scientists can learn about the efficiency of a nuclear weapon, by collecting the debris and testing it to see how much of the plutonium was burned up in the explosion. This denotes whether it's a "clean" weapon, or effective or ineffective. The air force is made up of people who want to get the job done, and the scientists want the information, and they're not correlating the dangers between the two of them. The scientists don't care. And the air force doesn't say, "Hey, are you out of your cotton-pickin' minds?"

The thing that gave us so much radiation was that the scientists wanted us to get our [collection] tanks 75 percent full before we left the cloud. Sometimes it took a great deal of time. If we could have just flown through and be done with it, that would have been fine, but we had to circle in them ten, fifteen minutes. To watch your dosimeters swinging up to 150 roentgens of radiation while we're floating around inside this thing, it's not very good. Sometimes we'd go in fifteen minutes after the detonation. We had some lead vests that covered the frontal part of our body but left the sides and back and the rest of the body open to radiation, not very effective. And film badges aren't worth a hell of a lot. When I landed my dosimeter showed I had 10 or 12 roentgens of radiation, but it was worn *under* the vest!

I was mission director of the Redwing [series] at Eniwetok [the tests of hydrogen bombs in the Pacific] and then I was operations officer at Plumbbob [series] in Nevada [the continental nuclear tests]. At Eniwetok we were told not to let our crews get over 15 roentgens of radiation, so about a third

of the way through the tests all my pilots had over 15. I reported to the commander that all my people were grounded because they had exceeded their dosage. He wired back that he got permission for us to go to 30 roentgens. Then I reported all of our group had over 30 and he got it up to 45 roentgens. That's where we left it, at 45.

You haven't seen an atomic bomb until you've seen one of those down in the Pacific. You'd wipe out the entire state of New York with one fell swoop. It stretches out 125 miles across, a realization of man's insanity. In Nevada the clouds got only a couple of miles across, little firecracker ones by comparison. We would fly through the cloud, then we would land, and they'd send fork lifts out. We would step up onto the fork lift from the airplane without touching the sides of the aircraft, then lower to the ground, get in a van, go to a complex of showers. We took our uniforms off, we kept our helmets with our boots, but our suits were buried or burned. Then they checked us with geiger counters and they clicked like a son of a gun. We'd go through shower after shower and they'd check us again and they'd still be clicking, and we'd shower some more and wash our hair. Usually there was a lot of residual radiation in hair areas, and it didn't clean up as well. We'd get down to something like a roentgen of radiation, then put on our flight suits and go about our business.

The aircrafts were very hot and were left at the end of the field. The ground crew went out there and scrubbed them with soap and water, but since engines are oily by nature, they never did get the radiation out. They'd leave them out there for two or three days and then bring them back into service, emitting radiation like there was no tomorrow. We'd crawl into those things and fly through the cloud again. The

mission kept using the same aircraft over and over. They should have been burned along with out clothes. We were in hot air places, getting hotter and hotter through the series of tests. It's very dangerous, very careless, and very callous.

We had other things that weren't too good out there [at Eniwetok]. We had a shot called Tewa during Redwing that was set off over Bikini and the cloud immediately came directly over Eniwetok where we were living. We discussed evacuating the island, but the test force commander said, "It would scare the rest of the people if we evacuated," so we had to stay. The thing dumped all the material on the island, in the sand, and everywhere. Of course, we lived on this island for the rest of the time we were there, five months, after it had been highly irradiated.

That's what war is, a calculated risk. You know somebody is going to get killed, and that's what the military was facing. Some may die of cancer, some may be all right, we don't know. No one's ever done it before but we'll take the risk for the evolvement and improvement of that weapon system. The information was withheld either purposely or accidentally, but I have to say purposely because we wouldn't have had the tests if we would have known the results and the danger we were placed in. The whole thing was fraught with peril and danger and they knew it was, and this I resent quite readily.

There isn't anybody in the United States who isn't a downwinder, either. When we followed the clouds, we went all over the United States from east to west and covering a broad spectrum of Mexico and Canada. Where are you going to draw the line? Everyone is a downwinder. It circles the earth, round and round, what comes around goes around. We're not the only guilty party. We had China and Russia setting off atomic bombs, and the French. I think the whole thing should be stopped. It has to be and it should be outlawed and abandoned as soon as possible. We're human animals. Sometimes I wonder if we are intelligent animals. We're always killing each other. We've never been without a war.

1. *ARDC Newsmagazine*, March 1957, p. 14.

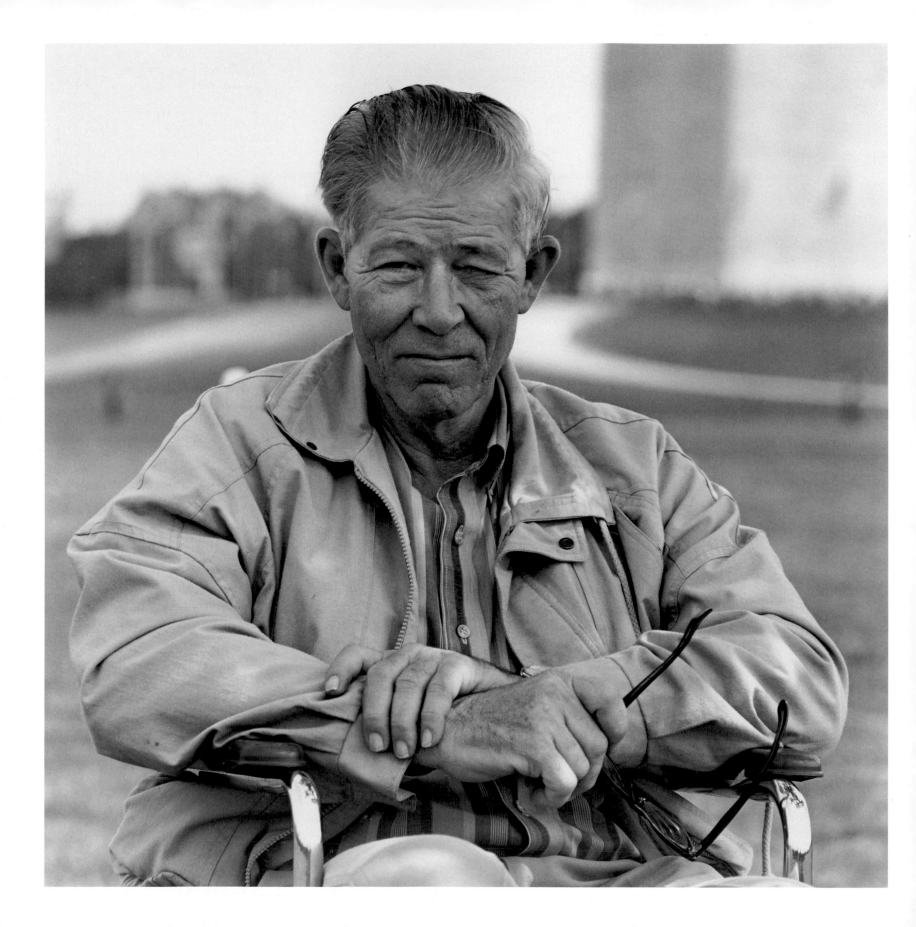

LARRY PRAY

September 1988

Loveland, Colorado

"I keep everything at arm's length, kind of like 'Star Trek,' you know, like Spock. I put up shields. That keeps you from feeling. But things kind of creep in. Once in a while, things sink inside."

Larry Pray was an 18-year-old boy from Loveland, Colorado, when he participated in the series Tumbler-Snapper nuclear war games on May 1, 1952. Shot Dog, a 19-kiloton atomic device air-dropped on Target #3 of Area 7 at the Nevada Test Site, was described by Gladwin Hill, reporting for the *New York Times*, in an article titled "Marines Get a Taste of Atomic Warfare": "A gray-black, massive and dense [column] surged up instantly and persisted as a solid 'stalk' for many minutes. The rolling, red-orange fireball following the initial flash was visible for the unusually long period of ten seconds, and the cottony white radioactive cloud that developed soared quickly to four or five miles before it was caught by the wind and attenuated southward."

When asked his nationality, Larry Pray answers "just American." At 54, never married, never even close, he lives in Loveland with his 87-year-old mother, who has taken care of him ever since doctors discovered his brain tumor in his late twenties. He had always kept us amused with a lengthy repertoire of jokes at every radiation victims' conference, undaunted in his performances by a noticeable slurring of speech, one of the aftereffects of his surgery. "You keep in pretty good spirits?" I asked. "Yes, you can't do anything else. I keep everything at arm's length." Months after his interview, he telephoned me in a low moment and confided, "It's kind of like 'Star Trek,' you know, like Spock. I put up shields. That keeps you from feeling. But things kind of creep in. Once in a while, things sink inside."

The bomb went off on May Day, 1952. I came to camp and they had indoctrinations about what radiation does. They stressed the fact that the sun was the worst enemy, not the bomb. You feel the bomb first, you felt the heat. It seemed

like a thousand flashbulbs went up behind you. Then the ground rocked. When that was over, you jumped out of the trenches and formed up in tactical maneuver, and then the shock wave hit. Some guys actually lost their footing and fell down. People were advised not to open their mouths until the shock wave passed, because you'd get a mouthful of really [radio]active sand. It was time for the troop to march down towards ground zero. The equipment down there had been thrown around and destroyed, some overturned tanks, fused and torch-melted down. You're just a soldier, you really don't care about it, you really don't pay any attention. It didn't affect me at all. After all, they said we were safe, why worry about it? They're the leader, they should know.

I had loose teeth and bleeding gums, supposed to be an aftereffect [of a large dose of radiation] shortly after in 1956. [In 1961, when the tumor was discovered in his brain,] it all happened so fast, I didn't have time to think about anything, just a severe headache. I was legally blind for a while, then I got [my vision] back gradually.

Once the tumor was removed, Larry Pray began his life sentence confined to a wheelchair. His sense of balance had been destroyed by the operation, and neuromuscular problems had also made his legs useless.

At the time that shot Dog was detonated, the nuclear testing program in Nevada was 16 months old. Already thousands of soldiers had been exposed to radiation and thermal blast during their tactical maneuvers, but top military officials were pushing to move their troops closer to ground zero than the 7-mile limit imposed by the AEC. In a Defense Department letter from Air Force General A. R. Leudecke to the director of the AEC's Division of Military Applica-tions, the director, Brigadier General K. E. Fields, was assured that the military would be "prepared and desires to accept full responsibility for the safety of all participating troop units and observers." The heat on the ground below the burst was estimated to reach between 5,400 and 7,200 Fahrenheit, and at a 2½ mile distance anything, plant, animal, or human, would be scorched by the heat. The desert sand, regarded as "thermally nonideal" for its tendency to absorb the radiation and heat from the fireball, created enormous risks for soldiers placed within a 7-mile radius of ground zero, and nobody knew in those early days what would happen to troops in foxholes exposed to the blast and its surge of heat and radioactivity.[1] It is estimated by the Defense Nuclear Agency that between 250,000 to 500,000 soldiers were exposed to nuclear bombs at close range. Despite that letter forty years ago that promised "the safety of all participating troop units and observers," despite lawsuits by many thousands of atomic veterans, fewer than 500 of them have collected any service-connected disability benefits for radiation-related injuries or illness. "There are others that are a lot worse off," reflected Larry Pray, fortunate, at least, to have the care of his mother all these years, "but now I get downright hostile when someone lies to me."

1. Richard L. Miller, *Under the Cloud: The Decades of Nuclear Testing* (New York: The Free Press, 1986), pp. 138–139; Samuel Glasstone and Phillip J. Dolan, *The Effects of Nuclear Weapons*, 3d ed. (United States Department of Defense and the United States Department of Energy, 1977), pp. 289–291, 125.

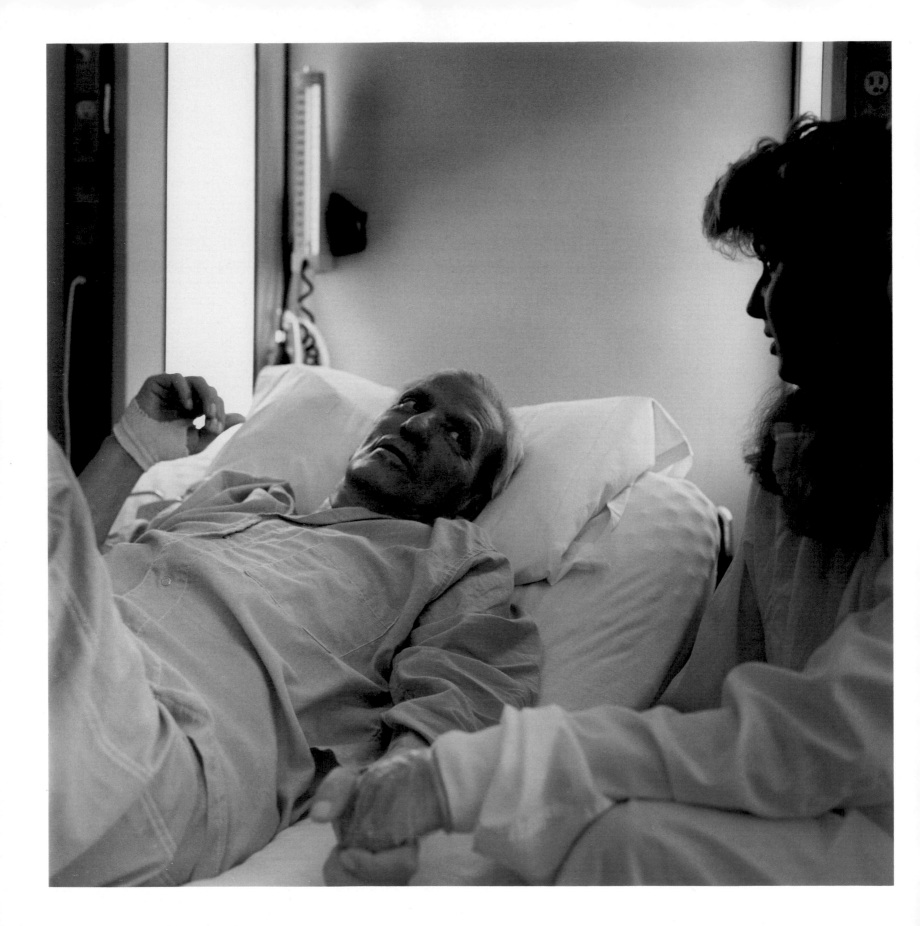

JACKIE MAXWELL

March 1992

Menlo Park, California

Al Maxwell with his daughter, Robin. 1987. "Out of those 24 guys that were exposed with him, 18 of them died of multiple myeloma, and that's only one-eighth of all the cancer. I've got the letters from [the Veteran's Administration] to prove they were calling him a liar. I wanted him vindicated. He believed and I used to believe that there was Godliness and cleanliness in the government. It took him an awful long time to wake up to the fact that we were just being used as guinea pigs."

A story within a story, the saga of Al and Jackie Maxwell and their six children is transitional between the experiences of the atomic veterans and those of the downwinders. During World War II, Al Maxwell was a prisoner of war who survived the Bataan Death March and was later whittled down to 89 pounds in a concentration camp near Hiroshima. During the days after he witnessed the first use of an atomic bomb in war until Japan surrendered to the Allied Forces, Maxwell was utilized with his fellow POWs as a clean-up crew in what had been the city of Hiroshima. His route of return to the United States also took him through Nagasaki just days after it had been leveled. Unrecognizable at first as the 225-pound, 6' 3" soldier who left Utah to serve his country, after a few years Al Maxwell felt sufficiently healed to put it behind him and try to live a normal life by beginning his family.

Oh yes, we were right there in Utah all during all that mess, the testing. We lived in Ogden, then moved to Logan. Al was a car salesman and then a real estate salesman, and out of doors a lot. That's what he loved about it. Our state was so stupid, they wouldn't even admit the damage it was doing, I'll tell you, until later on in years. I did a lot of work in the hospitals and we kept seeing case after case after case of leukemia. I asked the Dr. Powell why, did they just not report leukemia before? He said, "No, we've never seen anything like this." When you have leukemia so many times higher than any other place in the world, it's just ridiculous. Even so, they would not connect it with testing, they're so afraid to go out on a limb, anybody in the medical community. We were hyper-trusting because we are taught to trust authority figures. Another section of the country might have ques-

tioned a lot more. I've never known anyone more patriotic than Al, but he said if they have to do it, why do they have to do it here? Why can't they do it in the middle of the Gobi Desert? Al was a conformist, it took a lot of mind-searching and changing of his whole personality for him to come to that. He believed and I used to believe that there was Godliness and cleanliness in the government. It took him an awful long time to wake up to the fact that we were just being used as guinea pigs.

There was nothing normal about life in a fallout zone, especially for a man already heavily exposed to the radiation of Hiroshima. Of the six children conceived by Jackie and Al Maxwell, only one daughter, Robin, has survived to this day. Any fetus or infant already at risk due to radiogenic birth defects was mortally susceptible to the radiation from downwind fallout, but since Mormons believe that big families are truly a gift of God, the Maxwells kept on trying. Utah during those years was the living and dying proof of "the survival of the fittest." Perhaps this is why many downwind mothers of children with birth defects now believe they live in a "national sacrifice area."

I was pregnant six times, lost one, miscarried at five months and had five babies. The fetus I lost, it was so abnormal they couldn't even tell what it was. It took me three days to miscarry, parts of it coming out a piece at a time. It just disintegrated. The doctor couldn't even see anything you could identify. My first little girl, Paulette, had four different abnormalities in the four heart chambers. She was also hydrocephalic, and she had a misplaced rectum which they had to correct surgically. If there's one anomaly there's usually more than one. She lived for thirteen months, a darling girl. Paulette weighed about seven pounds but looked about five or six pounds, tiny, dainty, like a little China doll.

The second one was a little boy, Michael, and he was exactly the same medical diagnosis, but he was a husky little guy. He had his dad's build, a little chesty thing, but by the time he was three months old they could tell he was hydrocephalic so they operated on him and corrected it. He had the same type of heart condition, and one undescended testicle. He lived to be five. Michael didn't talk for so long that we were really worried. He couldn't walk until he was three, he just wasn't strong enough. His coordination was just terrible, but once he did walk he wouldn't walk, he'd run, just run everywhere. When they operated on him they put a catheter in to drain the fluid from the brain off, and we knew they'd have to go in and do that over again eventually. And during the first year of his life he had 17 bouts with pneumonia. But that little guy, he made everybody just absolutely adore him. He could only speak just a few words until he was four. He really didn't talk until right before he died. He looked just like Al, which was really hard on me after we lost him, because every time Al would look at me and smile I would just die, these big deep dimples and that great big grin and a happy disposition, he'd hardly ever cry. There have been fifteen boys in our family and friends named after him. He was just that type, you'd never forget him.

The third baby was Michelle, and she was just perfect all over, absolutely perfect, but she had an atelectasis of the lungs, another anomaly. She only lived 40 hours. She just smothered to death, a problem with the lining of the lungs. The same with my number six child, Rebecca, they were exactly the same, lived the same number of hours, weighed the same, 5 pounds 14 ounces. The fourth child was Robin,

never ever a problem with her at all. And the fifth was, as I said, a miscarriage.

After Paulette was born, they told us it was just one of those things and it couldn't happen again. Right after Michael was born the way he was, in 1950, the doctor asked us both to come to the office. He wanted to talk to Al, trying to find out what was causing the birth defects, what childhood diseases he had had, and so forth. He talked to him for the longest time, and asked him where he was while in the service, and Al told him. The doctor said, "And you were a prisoner of war?" Al said yes. "Were you anywhere near Japan?" "I was two years in a prison camp there." "Were you there when the bomb was dropped?" Al said yes. "Were you anywhere near it?" Now this was 1950, and the doctors back then didn't think anything about this. In fact, the whole medical community just said it was a whole lot of bull, but in any case he questioned him and Al said he was out on detail at the Hiroshima clean-up. "Did you eat anything there?" "Whatever there was. We had a little rice, and water, and fish juice." "You ingested it right there?!" All of a sudden he just threw the file on the desk and just leaned back and said to Al, "Well, there you have it." "What? There I have what?" "You're not going to believe what I'm going to tell you, but I'm going to tell you anyway. Then you're going to do what you want to do because I know you and Jackie want more children, but I'm going to tell you one thing. If you were to have ten children, nine of those children would have anomalies." I was just stunned. I said, "What are you saying?" "I believe that he's been exposed and that radiation has affected him, and his sperm. In the first place, his body was in such a state of malnutrition that he would be affected even more. No other doctor's going to agree with me, and you're going to say you want children, but I know what this is going to produce."

Perhaps it was fortunate that Al and Jackie Maxwell had a family physician who had some experience with radiation, if only for moral support and truthfulness. While a medical student at Columbia University, Dr. Wendell J. Thomson came down with mononucleosis and was at home, bedridden, when his class was irradiated during a serious accident.

"Just to give you a frame of reference," Dr. Thomson remembered, "five of my closest friends from the class got leukemia within five years. Three of those five had children with deformities, all the sets of kids were affected by it. Within ten years all those friends were dead. Believe me, it gave me a healthy fear of the atom bomb. If X rays can do that, imagine what that atom bomb has unleashed." The doctor said, at the time, that about one percent of the medical community believed that radiation could hurt you. "But I'd be willing to venture a guess that within 19 years from now you're going to have some kind of cancer in your body, I'd suspect leukemia. I want you to be prepared, be on the lookout and take good care of yourself." I kept going back to him because he was a good doctor, our family doctor. It turned out Dr. Thomson was right, almost to the day. He was one of the best diagnosticians I've ever seen in my life, a brilliant doctor. After Al got sick he'd just break down each time I'd see him and say, "Oh, Jackie, I just prayed I'd be wrong, all the time."

It was September of 1969 when they diagnosed Al's multiple myeloma. At first they thought it was leukemia, though. His white blood count was up over 150,000. They gave him 52 blood work-ups. It took three months. The whole time Al had these sores on the back of his legs, big black spots and gray spots, two kinds. His skin was gray. He'd try to get up to go to work and he'd just collapse back into a chair and say, "Jackie, I just can't. I'm just too tired." Then Al started

to feel better, and the doctor told us his blood count was down to 9,000. "I don't know what the hell it is," the doctor said, "it's a probability this will reoccur, not a possibility. For three months I thought he had leukemia, but it's a blood disorder." At the top of Al's chart he wrote in big red letters, "Feel like this entire episode was caused by Al's exposure to atom bomb." Later, when we tried to get his records from that VA hospital, they were all gone, probably because he wrote that on the top. All those medical records, the 52 blood tests, and everything was gone.

Al said in his diary that he thought his prisoner of war camp was 160 miles from Hiroshima, and they took him in to work there in an open-bed truck. They were sent in to Hiroshima on the day that Nagasaki was bombed. From the way he described it, he said there were a lot of rivers, and a railway that went in a complete circle around the city. They were clearing all the debris so people could get to the hospital, but they didn't realize that the hospital was almost at the epicenter. They'd see rooftops lying on the ground. They'd see places where he thought bodies had been, but he didn't realize that the bodies had been burned into the ground. Outlines of the bodies, they thought that's where they had been and had been removed, but it was the actual body burned into the ground. When they were released from prison camp, they came back through Nagasaki. They said he had never been there. He was picked up in the port there by the hospital ship *Hope.* The veterans board said it didn't exist.

Did the feds tell you that he had never been in Hiroshima?
Oh, yes. They said he was never there at Hiroshima, and that he just imagined he was in a prison camp. And the radiation levels they were basing all their summaries on were not taken

until 100 days after Al was exposed. It was the only time I heard him swear in his whole life. He just threw the letter across the room and said "Damn, call Gordy, I'm going to join the lawsuit." [Gordon Erspamer was an attorney for a number of atomic veterans.]

Did he write in his diaries that he had seen or heard the bomb go off in Hiroshima?
Oh, sure! They saw the mushroom cloud. The Allies had really been bombing the coast of Japan, up and down, but this one morning they found particularly loud. Now if you're on the water, sounds carry, and they heard this reverberation, and they all rushed to look. All of a sudden they saw a humongous cloud facing them, and he said he couldn't imagine what in the world it was. Then about an hour or two later they had a terrible storm, just terrible, and it was all black. So what was it? The black rain. It was all over where they were. [The black rain had occurred when radioactive debris from the atomic bomb was sucked up into an approaching storm front. The residue rained out over Japan during the afternoon following the nuclear attack, heavily contaminating wherever the isotope-ridden showers fell. This was even more deadly than a fallout cloud because the radiation could be more concentrated in liquid than in air.] He and his friend made a buddy statement about that, had it notarized and put it into the request for veterans' benefits too. But they didn't give any credence to anything.

Did he see the Nagasaki bomb also?
They left early that morning that day, before light, to go to Hiroshima. The guys in the camp said they could feel it. They said you can't 200 miles away but that's baloney. You could feel it in Salt Lake City when they set them off in Las Vegas,

so I know darn well you could feel them on the ground. They knew something terrible was happening. They did an awful lot of clean-up of debris and in his diary he said, "I can't believe this devastation here. Nothing natural could have caused this. I've never seen such devastation in my life." They worked from dawn to dusk. The thing that really got to him, well, he thought it was because they had been out in the sun all day working, but he had the worst sunburn he'd ever had in his life. Of course, it wasn't a sunburn. They laid down to rest and got this gray dust all over them, and that's what it was. He had a rash from that time on until the end of his life. The doctors never knew what it was, they called it "etiology unknown." It would swell up like you had put a waffle iron on it, so high it would look like it was going to burst. So whatever it was, he really got it.

When did the multiple myeloma actually start?
They diagnosed it in 1980 and he lived seven years after. Characteristically, it's supposed to run for fourteen years. They felt like they had gotten it fairly early until I reminded the doctor about that predisposition since 1969 and he said, "Oh Lord, Jackie, if it's been in his bones all this time it has probably affected every bone in his body from the head on down." Multiple myeloma is to the bone what leukemia is to the blood. You have no immunization whatsoever, so many die with pneumonia and since they don't bother to do autopsies, they never know. You can have multiple myeloma and never know you have it until it's too late. It's insidious, almost like osteoporosis, a silent killer. It has a habit of settling wherever there's been trauma, and he was so severely beaten across the small of his back and across his kidneys by the Japanese that when they'd X-ray his back they'd say, "My gosh, you look like you've been hit by a truck," and he'd say,

"Well, you might say that." That's all he'd ever say about it. But it was injured so badly that that's where it hit. They put him through the CAT scans and that other machine that it takes five hours to do, and when it finally hit that portion of his back it lit up and the bells rang and his doctor stood out in the hall and bawled.

As has been the case with thousands of other atomic veterans, the attempts of Al and Jackie Maxwell to seek compensation and medical care for his service-related radiation injuries were rejected by the Veterans Administration, which accused Maxwell of fabricating his stories of being on the Bataan Death March, in a prison camp near Hiroshima, or having seen the devastated city during the days he was on a clean-up detail. In order to prove her husband's accounts, Jackie Maxwell transcribed his war diary over eight months in preparation for a claims hearing.

I've got the letters from them to prove they were calling him a liar. I wanted him vindicated. Out of those 24 guys that were exposed with him, 18 of them died of multiple myeloma, and that's only one-eighth of all the cancer. His diary was terrible about the Bataan Death March, very graphic. And the funny thing is, he never wrote anything that was maudlin or pathetic, they were just bold statements. He'd say, "So many of the guys were bayoneted." On the march, they didn't have too much water. They were trying to conserve all they had. His friend couldn't go any further and he just sank to his knees. Al bent over to take his canteen off to give him a drink and as he was straightening up the guard was just pulling the bayonet out of his friend. He wrote that something in him died right then. He said, "Maybe it was meant to protect me but from then on it was just like a moving picture around me,

it was happening but it wasn't happening. It was unreal." He'd say, "The fences look like a puppet show," and I'd ask him what that meant. He told me they'd just bayonet them and then hang them up over the wire fences by their chins all up and down the line. His nose got broken three times during the beatings and instead of saying how bad it was he'd simply say, "I've got a schnoz on me like Jimmy Durante." He had a sense of humor about it, even as bad as it was. It took me eight months to transcribe these diaries and I just bawled every day. I asked him, "How in the world could you have lived through this? I couldn't stand to even write about it. How could you live from day to day?" He said, "You don't live from day to day. Or from hour to hour. You don't think about the minutes that pass or the minutes that are coming forward. You just think about the minute you're in. That's it. It passes."

What Al Maxwell had learned about mental and physical pain and suffering during the Bataan Death March served him well while he was in treatment for his cancer, but myeloma was more of a torture than the daily beatings he had received forty years earlier.

When he was at the Veterans Hospital in Salt Lake, I guess it was an accepted procedure for them to insert these tubes into the lung to drain it out when he had pneumonia. The thing is, they should have anaesthetized him. It wasn't just a tiny little catheter, it was the size of a man's middle finger. Instead of making a little hole and anaesthetizing the area around it, they pushed it right through the skin and then through the ribs and cracked a rib doing it. As I came down the hall I could hear this screaming. In all the pain he had ever had nobody ever heard him scream, not once, or even make a sound in all his agony. The nurses were just in fits and came running down the hall towards me saying, "Oh, my God, you're here, go get that screaming stopped!" They had been ordered out of the room by the intern who was doing it, and then he ordered me out. I just hit the ceiling. Finally I got the head doctor who was just fit to be tied. Finally they anaesthetized him and put an even bigger catheter in, and he was like that for months. They never did get all the fluid out.

Robin was so upset towards the last when he was dying. She just broke down and sobbed, "It's not fair, I hate it, what the government is doing to you." And he just said, "Honey, I wouldn't trade my life for anybody's in this whole world. I have had such happiness I'd go back and do it all over again." She just howled, "Even what you went through in the prison camp and all this?" He said, "I would go through it all again to have your mother, and our kids, and you. Believe me, this country is worth dying for. You may not agree with what's going on, but this Constitution is divinely inspired. It's not administrated very well at times, but all you have to do is be a guest, now I mean a guest not a prisoner, in some foreign country for three months or so and you'll come home and kiss the ground you walk on. Don't you ever forget it. I wouldn't change that for anything, not anything."

He loved his country first to last. After he died, everything went by in a blur for Robin, I guess, but they had the most beautiful military salute for him, with the twenty-one-gun salute, and I was holding her little son Hunter on my lap. When it was all over he looked up at me and patted my face and said, "Nana, the guns went pop-pop and Poppy Al went up to heaven. Now we're happy. Don't nobody cry anymore."

DOWNWIND:

"A LOW-USE SEGMENT OF THE POPULATION"

In memory of Jeffrey Snow Montague

Photograph by Dorothea Lange. 1953. Courtesy of the

Oakland Museum. Mormons at Sunday worship, southern

Utah, designated by the Atomic Energy Commission as

"a low-use segment of the population" in formerly clas-

sified top secret documents.

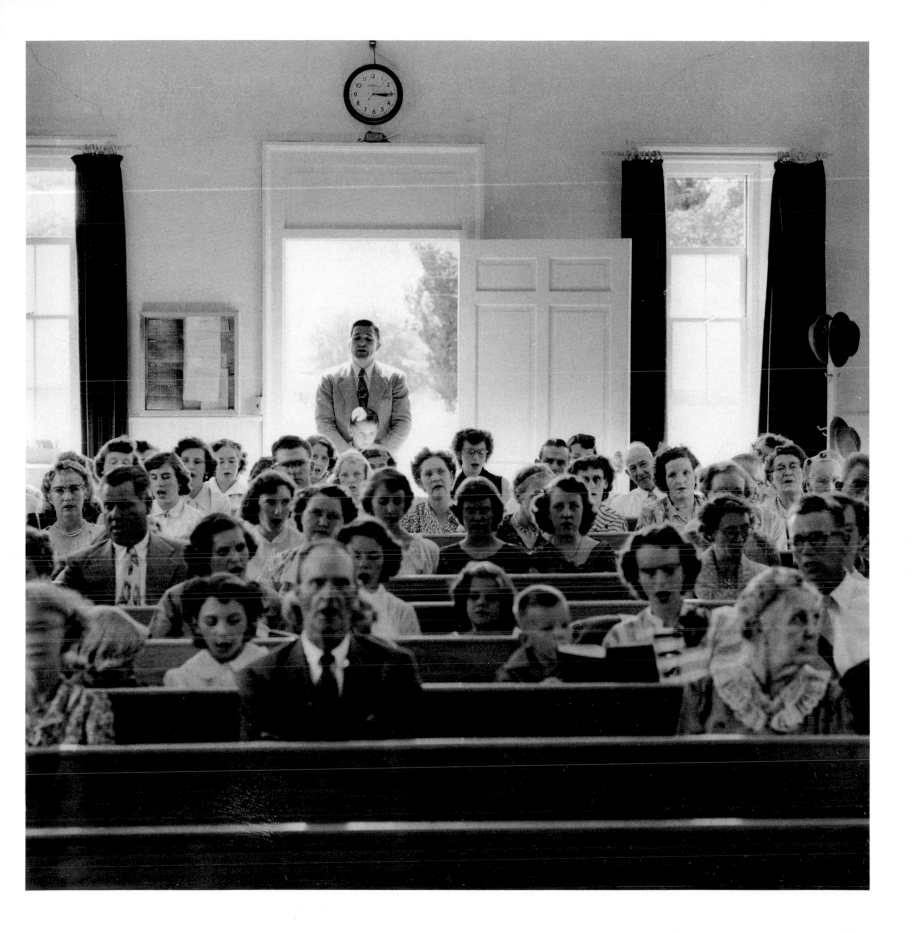

MARTHA BORDOLI LAIRD

November 1988

Carson City, Nevada

Martha Bordoli Laird holds photographs of her children and friends at their one-room schoolhouse and the fallout cloud approaching it in Twin Springs, Nevada. "They still won't say yea or nay, but they know. Why did they choose this area to set these bombs off and wait for the wind to blow in the 'right' direction, to carry it to us? If it's so safe, why couldn't they drop it in the middle of LA?"

I feel that we were used more or less as guinea pigs. The forgotten guinea pigs, because guinea pigs they will come to the cage and check, which they never have. To this day, they have never checked anyone in my family or anyone I know of from the fallout of these bombs. At no time were we ever called upon or talked to or told about the effects of radiation, what it could do to us or anything else. There is only one time that I ever received a notice from the government that they were going to set a bomb off, and that was in 1958 *after* we had sold the ranch and moved to Carson City.

Martha Bordoli Laird never really knew exactly how far away ground zero was from that ranch in Twin Springs, Nevada. There were two main testing areas, Frenchman Flat at the south end of the Test Site and Yucca Flat to the north. The radioactive fallout from each test blanketed the area of Twin Springs and Warm Springs.

We figured it out by the flash of light at the time that we were probably 80 miles away, but sometimes I'm sure we were much closer because we could see when they shot the cannon. We could see the big ball of fire in the sky. We had no idea down on this ranch because they would never tell you. Even if you asked them, they'd lie to you. You'd be sleeping in the morning. The flash was so bright it was like the sun would come out right in your face, and then it wasn't long after that you could hear it coming. This was louder than an earthquake and you could hear the ground rumbling. Then when it got to you, you had the shock and it blew our front door out a couple of times. One time it broke one of our windows, just from the blast.

They never did at any time come to our ranch and warn us. The only time they came was after my little boy died and

Fallout cloud approaching Twin Springs, Nevada. 1953.

Photo courtesy of Martha Bordoli Laird and Joe Fallini.

I had written a petition for all the ranches to sign to see if we could quit it. I guess I was the first one to really rebel against it. They promised they'd get back to me. Well, 29 years later and I still haven't heard from them. One time my sister got burns on her eyes. During this time our cows got white spots on them and cancer eyes. At school, children broke out with rashes from the radiation.

We had three cows at the time that we milked, we drank all the milk, which is one of the worst things, and then, of course, I made butter and sometimes cheese. I always raised a big garden and we ate our own meat, so we had it all, and there was no way of getting away from it. But they never came and told us not to do this, so we lived right under it. I have pictures here that prove it. There's a big cloud coming in. You could see where the cloud was coming in with the radiation of a blast.

Four years after atmospheric nuclear testing began in 1951, Martha Bordoli's seven-year-old son Butch developed stem cell leukemia. It was a long ten months until he died, and most Nevada doctors who saw Butch had never before treated leukemia. It was a very sparsely populated area of rural Nevada, where everyone knew everyone.

I could name about a hundred people along that line where someone, somewhere has died of cancer. I mean, right around this area of Warm Springs, the circle of people who lived there at that time. I've got the names of I don't know how many people who have died of cancer. I will always believe that fallout had a lot to do with it. No way, in my mind, will they ever erase that. We are the forgotten guinea pigs.

Had they come here and bought out the ranches of a few of these people on the land which they call "virtually unin-

habited," or come and warned people, or told them, so they could get out of it, it would have been a hell of a lot cheaper for people than the way it turned out. They still won't say yea or nay, but they know that it did it—why did they choose this area to set these bombs off and wait for the wind to blow in the "right" direction, to carry it to us? If it's so safe, why couldn't they drop it in the middle of LA?

There was one time they shot a bomb off, and I'm sure it was the one they called Smoky. I don't know whether they shot if off in coal or what not, but you couldn't see a block away, it was that dense when it came to the ranch. [Mrs. Laird's assumption was corroborated in an interview with Test Site worker Ben Levy, one of the ironworkers who built the towers on which the bombs were exploded, and who had seen the coal piled all the way up to the bomb platform.] You could not see. The smoke was so black, just like it comes out of a train. I had to go to Tonopah that day. I went into the newspaper office, I think it was the Crandalls running the paper, and she put the geiger counter to my hair. Well, the needle went right over to the pin, click, click, clicking, it was so heavy. There was one of these smart-ass monitors over there, and he said, "Never put oil on your hair because that's the first place any of that will click. Just wash your hair and it will be all right."

Martha Bordoli's children had no margin of safety against the bombs, nor did her husband. After Butch was born, she became pregnant once again.

I never say much about it. The baby was born and buried in Ely. It was a little boy, and from the hips down the legs were all shriveled up and black. It lived for a couple of hours. It

would have been completely paralyzed in the legs, or they would have had to take them off had it lived. That was a seven-and-a-half-month baby. It was 1953.

Three years later, seven-year-old Butch died of leukemia. One daughter has had her face continually carved, losing major portions of her lip and forehead to subskin and muscle cancers. "Now that she's had this problem the doctors watch her quite close." The other daughter has had fainting spells, an inactive thyroid ever since testing started in her childhood, and will remain on medication for the rest of her life. Martha Laird's husband developed cancer and heart trouble.

And that's why we sold the ranch and moved, because we knew the government wasn't going to do anything, and my husband wasn't well. And we didn't want to expose the two girls to any more radiation. So we just got out from under and moved. We sold our ranch for a song. My husband was only fifty-something when he died. I get so upset with this government because they use people. They just lie, lie, lie. I was pretty bitter, and it's something you're never going to get over. You can't. You can cry a bucket of tears but it don't bring them back.

In 1957, one of the rewards of seeking justice for the death of her son was a thinly veiled accusation in a letter from her senator, George Malone, which stunned her:

Recently the newspapers in this country have carried stories that make it appear that a large segment of the scientific world is in disagreement with the government's nuclear testing program in regard to the harmful effect of fallout resulting from atomic explosions.

This has resulted in a fallout scare throughout the United States. The President has questioned these reports coming from a minority group of scientists, some admittedly unqualified to comment on nuclear testing, and as he has said it is not impossible to suppose that some of the 'scare' stories are Communist inspired. If they could get us to agree not to use the only weapon with which we could win a war, the conquest of Europe and Asia would be easy.

Martha Bordoli had become active after the death of her son Butch, and circulated a petition signed gladly by 75 people living downwind, and sent it right to the top, the Atomic Energy Commission. In part, she wrote,

We, the residents of the area immediately adjacent to the Nevada test site, which the AEC has designated as 'virtually uninhabited' feel that the health and welfare of our children and ourselves have been seriously endangered by radioactive fallout from the atomic tests. We believe further that it is both undemocratic and un-American to subject one group of citizens to hazards which others are not called upon to face, particularly when the adverse effects may be reflected in future generations yet unborn. We are not excitable or imaginative people, most of us coming from rugged ranch families, but neither are we without deep feeling for each other and our children. Having with our own eyes seen tragedy strike among us from 'radiation associated' causes, we feel that official recognition of our plight is long overdue. We, therefore, petition that the atomic tests be suspended, or that some equally positive action be taken to safeguard us and our families.

A letter in reply from the AEC's director, Lewis Strauss, contained the seeds of United States nuclear policy for at least the next forty years: ". . . the Government decisions

regarding nuclear testing have not been made lightly. The possible risks from continued weapons testing have been carefully evaluated by competent scientists. In essence they conclude that the risks from the current rate of nuclear testing are small, exceedingly small in fact when compared to other risks that we routinely and willingly accept every day. I appreciate your concern and hope that my reply has been helpful." In another letter, he rebuked her, "Let us keep our sense of proportion on the matter of radioactive fallout." Quoting President Truman, Strauss used a phrase that became the strategic byline of Cold War excusemaking for the domestic nuclear tragedy that was just beginning to unfold: "Of course, we want to keep the fallout from our tests to an absolute minimum, and we are learning to do just that, but the dangers that might occur from fallout in our tests involve a small sacrifice when compared to the infinite greater evil of the use of nuclear bombs in war."

DIANA LEE WOOSLEY AND LaVERL SNYDER

April 1989

Reno, Nevada

> "I had my first surgery at six months old. I had a neuro-blastoma tumor in my chest, located somewhere between the heart and lungs. All this is because they didn't warn the people. They just took our freedom of choice right away."

The most poignant aspect of arranging an interview with Diana Lee Woosley was the childlike sound of her voice during our first telephone conversation on a snowy February afternoon. Her story seemed so enormous and so malevolent, yet it was spoken by one who sounded so tiny and so tender. A 30-year-old mother of two girls stood before me months later. Diana Lee was 4 feet 5 inches tall. She had a round "moon face" from taking Prednisone for her ever-present pneumonia, and she apologized for her appearance. Her very sparse hair was tucked back into the tiniest of ponytails, and she wore a cheery pink T-shirt decorated with dancing tennis shoes. Diana Lee's mother, LaVerl Snyder, soon crossed the street to join us.

LaVerl Snyder and her family loved to camp in the mountains and desert close to their home in Ruth, Nevada. She was pregnant with her third child in the summer of 1958, a year when atmospheric tests were at a zenith at the Nevada Test Site, and when Cold War tensions with Russia matched the bombing of the West in fury. She recalled one camping trip that changed her life and the life of her fetus, then five months in utero.

I remember seeing lots of clouds. Different clouds. I broke out in a rash, my whole body. Burns and blisters, little ones like water blisters, spread up my arms and on my face, soon my entire body. I was sick a lot, nauseous all the time. They took me to Holy Cross Hospital in Salt Lake City. Nobody knew what it was. [Mrs. Snyder revealed that the doctors finally diagnosed heat exhaustion, sunstroke, and neurosis.] My toenails fell off and some of my fingernails fell off, and I lost a lot of hair. It almost killed me. I thought I was a goner for a while. Diana was born real early, about three weeks

early, and only weighed 3.2 pounds. The rashes kept coming back, and more than a year later my teeth were falling out. The dentist couldn't understand it. My gums were perfectly healthy but my teeth were falling out.

Her baby Diana Lee wasn't quite so lucky: she was born with cancer. "I had my first surgery at six months old. I had a neuroblastoma tumor in my chest, located somewhere between the heart and lungs." Diana pulled out a file of medical papers dating back to 1959. Her mother had taken her to a hospital in California for surgery and radiation therapy, the only treatment for cancer in the early days, little understood and crudely performed. The beam of radiation that enveloped Diana's chest during therapy was not well focused, and she was exposed to 6,000 rads at the tender age of six months.

Back then they didn't localize the radiation, and that's why I got a lot more than I needed. It caused damage to my heart and lungs. My right breast didn't grow, bones, everything on the side where they shot the radiation, and it caused scoliosis and kyphosis [severe deformation of the spine] which curls you like a pretzel.

LaVerl recalled that the treatment's immediate effects caused her daughter to have "constant vomiting spells from the radiation therapy, and then for years afterward she would have vomiting spells for days at a time until she was throwing up bile." The horror of Diana Lee Woosley's early childhood grew in intensity as she matured.

I had rods put in my back to straighten it out. In January 1979 [at 21 years of age] I was diagnosed with heart disease and lung disease. I had congestive heart failure and pulmonary hypertension, and the right lung doesn't function at all. I've had four breast implant surgeries. Then I had to have kyphosis surgery. They said I would die within three years if I didn't have it, but the fatality rate of the surgery was 85 percent. I had the surgery done for the kyphosis because my spine was crushing my heart and lungs, but the orthopedic doctor who did it said that there was so much radiation damage to my disks that if I didn't have the surgery done, my back would have collapsed within a year. Before the surgery I was going to try to have a heart and lung transplant, but there wasn't enough room in there.

Diana Lee's mother described the procedure.

We didn't know until afterwards, but the nurse told us we would have died if we had seen how they did the surgery. They had four posts, with straps around her wrists and ankles, and they had her suspended in mid-air to these posts. The posts moved as the doctors did the surgery. They cut her here and they cut her there. They had to break her whole back. What makes me mad is, I heard on the news and in the papers that Eisenhower knew that these tests could affect people and said it didn't matter if you could suffer to save the country, to make these tests. And that was bad enough, now these people are trying [through litigation, the *Irene Allen et al. v. United States* lawsuit] to get money. She could use money so desperately for her medical needs, and to make her life a little easier, and they just won't come through with five cents. I'm not talking about millions of dollars, I'm just

talking about helping. I don't have enough faith in the government even to vote. I hate it.

Diana Lee's husband, Joe, is a heavy equipment operator. They married when she was 19.

In the last two or three years we've had a lot of marriage problems and I know it's medical because I've been sick and had surgery. He won't admit that it's medical but I know that he's probably tired of me being sick, and I understand that. So we almost got a divorce several times and we're still having marital problems, and I know that it's because of my illness. When we first got married, I wasn't as bad. We used to go camping and I just can't do that any more. Oh, I *am* angry. I guess I've just learned a lot of coping skills, especially with kids. You can't just sit around being depressed all the time with kids. That's what's gotten me through everything. But I'm bitter, definitely, 'cause all this is because they didn't warn the people. They didn't say, "We're going to do this, if you want to leave you can, if you don't we don't know what kind of danger there is." They just took our freedom of choice right away. If they would have said that, my mom would have taken us right away. My life now, I'm only 30 years old and I have to wear oxygen, be in a wheelchair most of the time, and it affects my time with my kids. When we go anywhere I have to take oxygen and breathing treatments. When they put me in the hospital this last time, the pneumonia was real bad, so they had to put me on high doses of Prednisone, and I got diabetes from that. It may go away when I'm completely off the Prednisone, or it may not. But I could be a lot worse off than I am.

CLAUDIA BOSHELL PETERSON

October 1988

St. George, Utah

"Right now it's in our life everywhere we turn, like it's snowballing. Oh, I'd just like to stand up and scream, 'Do something, you dumb people, they're killing us!' I see what they've done. I see I've lost a child. I've lost my sister. She's got six little children that don't have a mother. I see people dying young from brain tumors and leaving families, and the sorrow, and the suffering. On our own behalf, they are killing us for their own purposes."

I was probably three or four. My brother and I were outside and we were on the swing. There was this great big red ball that came up on the horizon and I thought, "It's a flying saucer." I was really impressed. We could see a mushroom type of thing and it was so bizarre. It came up over, there was a cloud, so then we knew that it wasn't a flying saucer. I remember my mother saying, "I want you to stay in today," and she wouldn't hang the clothes on the line. We lived out of town on a little farm [just outside Cedar City near Hamilton Fort].

I think the first time I ever became aware of it was when the sheep died. I was old enough to go over to the sheep-herders' when they were lambing and everybody was talking. We always heard the livestock men talk about the sheep that had died, but we never thought they were really doing anything to us because they told us they weren't. And we were so patriotic. My father was in the war, and when the flag goes up your heart pounds and swells, and a lot of people don't get that. We thought they would never do anything to hurt us. They kept telling us, "It's fine. The sheep died but we'll find out why." Two-headed lambs, and there would be piles of dead lambs that were born dead. As a child, I didn't know what it was. We just thought that was life, that they would be born without legs and two heads.

But when I was in sixth grade one of the little boys that was a year behind us died of leukemia. Then when I was in eighth grade one of my friends had his leg amputated from cancer and died a couple of months later. When I got older in high school, my best friend's mother was dying from cancer, and then my sister, Cathy, had melanoma, and we started to wonder why. That's when you started to hear people talking about the fallout. I think it's peaking now. I know it's what

caused my child's death and my sister's death. Being a logical person I know there is a percentage of people who are going to die from cancer, but not like we're seeing. There is one block in Cedar City where there are seven people on one block dying from cancer. I guess I just lived in a fantasy land all my life. I just didn't think that this could happen to people. Stomach cancers in young people, and pancreatic cancers and brain tumors in young people, just bizarre things. It seemed like everywhere you turned somebody was going through a crisis. I don't think there's a family in this area that hasn't been affected. Right now it's in our life everywhere we turn, like it's snowballing.

When I was in fourth grade, they came to school with geiger counters. The only reason I remember this is that they came up to us and when the geiger counter was near my face it just went bananas, and I said, "What does that mean?" He said, "It means you've had dental X rays." I knew that I had never had a dental X ray, my mother being a nurse all my life. My sister said that every day when they left the school they would pass out a big brown pill to them. I guess it was the iodine pills, but we never did get that. It's so frustrating to me to even think about it, because I remember we would get up in the morning and go out and play all day long. We would climb fences and climb trees, pick apples and eat them and play. We'd go our way, watch the sheep and play. It was such a good childhood. We were raised so patriotic and so happy. I still feel blessed, but in the same respect I see what the government is doing to us, and on our behalf they are killing us for their own purposes.

Claudia Peterson's story of her daughter Bethany's illness was a litany of doctors' identical patronizing pontifications: she was always "overreacting." The diagnoses of the first three physicians in St. George, confronting her screaming three-year-old with a stomach tumor the size of an orange, were: "constipation—give her an enema," "she's a little anemic," and "I think it's just growing pains." Feeling helpless in the face of such incompetence, Claudia and her mother took Bethany to a hospital in Salt Lake. It was a six-hour drive she would never forget.

My mother and I drove in her truck all the way. I went to the emergency room at Primary Children's Hospital. I had to carry her, she was listless by then. They said they were worried it was neuroblastoma. I said, "Give me some books, I want to know about it." I went down to the hospital library. The only little paragraph on neuroblastoma says, "fatal." They called me back upstairs to her room. I get up to the end of the hall, and I'll never forget this . . . I've never ever done this before or since . . . it was like my whole body was being altered. It was like I was being sucked down a tunnel and there were fifteen doctors standing there waiting for me. I said, "I don't want to hear it, I don't want to hear it!" I curled up on the bed and put the pillow over my head, and rocked back and forth and screamed. And it was just like he was screaming it in my ear, "She's got stage four neuroblastoma."

Then my sister got sick and was in the hospital. Melanoma. She had gone through hell: liver tumors, bone tumors, breast tumors, brain tumors, tumors in her lungs, but she was coping with it. Here she was, going to have a baby in two weeks! After, she was having chemo and determined that she was going to make it, but she was bleeding internally. All Cathy wanted to do was be a mother and a wife. She thought I was radical and making waves, but I think she really didn't think

it was going to happen to her. When Cathy died, it really scared Bethany. We spent a lot of nights talking about death.

Bethany lost all of her hair. She had a bloody nose that just wouldn't heal. We'd drive up Sunday night to Salt Lake and she'd get her chemo, and then she'd vomit all the way home, just sit there in the car and vomit nonstop.

What she went through! When she started feeling a little bit better she'd go off to play and take her little pan. She'd puke in the pan and dump it in somebody's grass, then she'd go on her way. Later, when they diagnosed her with leukemia and told her she couldn't go to school, she was broken-hearted. She was a real socialite and loved kindergarten. One day I came home and she wasn't here and I panicked. I went to her classroom, and the teacher said she'd been down seeing all her teachers. I went up the street and she was walking with her little boots on, and little wool skirt and sweater, and her little backpack and she said, "I just had to go to school one more time." To see this child that wanted to live so bad! The week after she died, every morning the dog would get her shoe and hit me in the back of the leg with it. I would take the shoe and throw it back in her closet, and then he'd get it again and follow me.

We're living with a big cloud over our heads. We're all trying to hang on to survive. Oh, I'd just like to stand up and scream, "Do something, you dumb people, they're killing us!" They knew after they started what they were doing to people in this area, they knew, but I think they justified it in their own minds thinking, this is a small sacrifice. Back then they probably thought, here are these isolated communities of Mormon people who are patriotic and hard workers, they don't drink, they don't smoke, they go about their business, they don't make waves, they just do their thing. Who else?

They're not going to protest, they're not going to get radical. I think we were just sitting ducks for them because Mormons don't cause trouble. It's not like we're going to get into politics . . . we're not going to protest. But I see what they've done. I see I've lost a child, I've lost my sister. She's got six little children that don't have a mother. I see people dying young from brain tumors and leaving families, and the sorrow, and the suffering.

Then I see them saying, well, this is technology, we need to do this. They spend $80 million a test down there and we've got people starving to death in America. I don't care where the money goes, I just hate seeing it blown up in the ground. It's all money and politics.

WINONAH SHAH

June 1986

Las Vegas, Nevada

Winonah Shah holds photographs she took of her son-in-law Jim and grandchildren Donny and Mike at the funeral of her daughter, Therol, who died of leukemia at 24. "My husband died three years after Therol died. I don't know how I made it through. I wanted to die, I didn't want to live."

We lived in Caliente, Nevada, in 1950. My husband went to work for a mining company, Lincoln Mines in Tempiute. That's why we moved out there, in 1951. I remember when they first started the tests. We used to go on the county summit and drive up there, everybody did, to see this big mushroom cloud. We went out there two or three times to see this before we moved to Tempiute. Everybody in the whole town would go down in the valley and line up on this bench. We'd sit and watch this big old thing go off into a big old mushroom cloud. Sit there and watch it, big show. It lighted the sky lighter than the noonday sun, so bright. We were cautioned never to look towards it, never look towards the flash. We never missed a time when they set a blast off, and after a while it got commonplace. We lived there from 1951 until 1957.

My husband was 42. He was out a lot, right out on top of the mountain there. He worked on the compressor right at the mine where they pump the air down in. Later he went to work as a government trapper, right out in the dirt, right next to the Test Site. He saw a lot of ulcerated cattle. There was quite a uranium surge going on. Everybody was prospecting and had their geiger counters. We went to test some mining claims with the geiger counter and everywhere we went it was busy. We thought we had some uranium. Later we got some rocks we had at the house and the counter went wild. We turned it on in the house and everywhere we went it was hot. The counter would go just wild.

We talked about it all the time. Neighbors would get together and say, "They're just using us as guinea pigs." We were all curious but knew nothing. They always said it's not going to hurt you. Then we heard all kinds of rumors that

scientists said that people will never know for twenty or thirty years what the fallout would do to us. We never heard of fallout. We didn't even know what it was.

It was the spring of 1953. I do remember the one day that it seemed like everything was so close, seemed like pressure. I knew they had warned us to stay inside. That was the same day my daughter walked over the mountain and got an eruption on her face. Therol was in the eighth grade, 15 years old. The AEC had this in their files, of her walking over the mountain. Men stationed there with the Health Commission, with the AEC, came by and said not to let the children go out to school because there was heavy fallout and it was headed for our area. She'd already gone when we got this message. I had gone outside to get the kids in. My little boy was playing under this old cedar tree right in front of our house. About 11 o'clock he came in the house just dragging his feet. He came in so tired and wanted to lay down on the couch. I fixed him some lunch and I couldn't even wake him up, he wouldn't wake up. He slept all day long. Finally, about 1 o'clock, he woke up in the middle of the night. It was strange.

I went down to the post office the next morning and the lady that worked there had a rash on her face and neck. I looked and there were little tiny lines, like veins. She had it on her arms. That night after school my daughter came home and I looked on her to see, and she had it on her, the same kind of little lines. As time went on she later got crusty-like splotches on her face, reddish. She would keep on getting these red spots on her face for a long time after that. There was one other lady out there that said she got the rash. I looked on myself and I had it too.

I had faith in my government. I couldn't believe they would do anything that would hurt us. They wanted information.

They had heard about Therol being subject to this fallout and they wanted me to write up an account of it and I wrote it for them. It's in the files of the AEC. When the guys came to the house I said that my other little daughter was getting the rash too. They said, "It can't be anything worse than chicken pox."

Therol was only 15 years old and she wanted to get married. She was madly in love with him. They moved to the mountains in California. She got pregnant with her first baby and lost it. It seemed like she got more than one miscarriage. Then she had two little boys. One night she woke up in the middle of the night and she was strangling. Jim took her to the doctor. He said she probably had goiter. Mike was seven and Donny was five. It was in the later part of the summer of 1962, she began to get kind of thin and broke out with big ulcers on her face and other parts of her body, too, mostly her face and arms.

She would be sick a lot and they would take her to the hospital. It was just before Christmas in 1964 that Jim called me from Flagstaff. The doctor had said she had acute leukemia. Twenty-four years old. That was the biggest shock I ever had in my life. I almost folded up. I didn't know too much about leukemia but I heard it was incurable. I don't like to talk about it and I do like to talk about it. Whenever I do, I burst into tears. Everybody in the hospital thought she was just fantastic. People asked what was wrong with her and she'd say, "I've got leukemia." It bothered everybody when they heard that word. I couldn't help but admire Jim. He was so good to her and those little kids. After she died we went way up in Idaho, and he was clear down in Arizona. And he kept those little boys with him. How he did it, I don't know. They were so close, Therol and Jim. He was lost. He hung onto his little boys. He had no one else to hang onto.

All three of my girls had thyroid conditions. My oldest daughter, they thought she had cancer. The doctor took her thyroid out and she was put on chemotherapy for some time. She never would file a claim, no way. She just figured she had to be a victim, just happened to be a victim of it. My husband died of lung cancer three years after Therol had died. Yes, it was real hard. I don't know how I made it through. I wanted to die, I didn't want to live.

ISAAC NELSON

December 1983

Cedar City, Utah

Isaac Nelson holds the image of his wife, Oleta, to his heart. "She'd gone to the bathroom to wash her hair. All at once she let out the most ungodly scream, and I run in and there's about half her hair layin' in the washbasin! You can imagine a woman with beautiful, raven-black hair, so black it would glint green in the sunlight just like a raven's wing. She was in a state of panic."

Both my wife and I were born here in southern Utah. I was born in Cedar City in 1915 and my wife in Parowan about 20 miles north of here in about 1924. In 1941 we got married, and in 1943 I left for the South Pacific and served in the navy on a destroyer at Okinawa. A troop transport came in bound for Nagasaki, and they assigned our destroyer as an escort. So I seen the devastation and misery that those Japanese people underwent and it isn't pretty, I'll tell you. I got to see some of the Japanese people down on the docks—they wouldn't allow any of us off the ship—and they were dressed in pantaloon type garments and sandals, with nothing above the waist. I noticed that there were quite a few of them that were really scarred up and burned. Badly disfigured, and it was really pathetic to see. These were people who were probably on the outskirts and hadn't suffered like those who were in the immediate vicinity of the blast. Some of these workers had black sores, or boils, all over their body on any exposed part I could see. They were the size of a fifty-cent piece and there were so many of them they almost interlocked into a solid mass of black.

Later on I was discharged from the service, came home, and resumed employment at the Cedar Hardware and Lumber Company. There was a salesman by the name of John Crabtree that used to come visit with us about every two weeks, show us different lines of hardware. John's territory was from up to Fillmore, 115 miles north of here, all the way down to Las Vegas, and out west to Panaca, Pioche, and Caliente, all those little communities out in Nevada. During this time, he developed leukemia, and kept getting weaker, and the employees in the shop would comment, "He's going downhill." One day he said, "Would you like to see something?" I said yes, thinking he'd show me a new line of hardware. He just

took his shirt off, and he was covered exactly with those black splotches like I'd seen on those people in Nagasaki.

After 1951 they were going to start the testing in Nevada, and everybody was really excited, and thought maybe we'd get a part to play in it and show our patriotism. We wanted to help out what little we could. My wife and I and a hundred or so residents of Cedar drove out to see the first one. We huddled up, our blankets around us because it was cold, so early in the morning before daylight, and we were chattering like chipmunks, so excited! Pretty soon, why, the whole sky just flared up in an orange-red flash, and it was so brilliant that you could easily see the trees ten miles across the valley, and if you had a newspaper you could have easily read it, it was so bright. Quite a unique experience for us hillbillies here in a one-horse town to go out and see something like that.

Later on in the day, you'd see these fallout clouds drifting down in Kanarraville, and up through Cedar, and if you'd ever seen one you'd never mistake it because it was definitely different from any rain cloud, kind of a pinkish-tan color strung out all down through the valley there for several miles. They'd float over the city and everyone would go out and ooh and aah just like a bunch of hicks. We was never warned that there was any danger involved in going out and being under these fallout clouds all the time I lived here. I do recall hearing over the radio a time or two that there'd been a test, and they were stopping cars down in St. George and hosing them down, and we wondered why.

Along about 1955 a cloud came over Cedar, and my wife and I, the kids and the neighbors stood outside looking at it and talking about it. Later on towards evening, my wife, her skin, her hands, arms, neck, face, legs, anything that was exposed just turned a beet red. I thought probably she had a sunburn, but Oleta wasn't the type to develop a sunburn. She was an outdoors girl—she had real dark hair and a dark olive complexion. She got a severe headache, and nausea, diarrhea, really miserable. We drove out to the hospital, and the doctor said, "Well it looks like sunburn, but then it doesn't." Her headache persisted for several months, and the diarrhea and nausea for a few weeks.

Four weeks after that I was sittin' in the front room reading the paper and she'd gone into the bathroom to wash her hair. All at once she let out the most ungodly scream, and I run in there and there's about half her hair layin' in the washbasin! You can imagine a woman with beautiful, raven-black hair, so black it would glint green in the sunlight just like a raven's wing, and it was long hair down onto her shoulders. There was half of it in the basin and she was as bald as old Yul Brynner to about halfway back, the hair had just slipped right off! She was in a state of panic, and I did the best I could to comfort her, but that hair never did grow back. She'd work her hair back over and cover up the best she could, but anytime she'd ever go out in public she'd always wear a hat.

Whereas we'd been very active, used to go square dancing, chase all over to Phoenix and Salt Lake and Vegas, after that she kept getting weaker, and listless, and she didn't even have any desire to go out in the garden to work with her flowers. The doctor said she was going through change of life, but she was only 34 at that time. This went on and on, but finally in 1962 I prevailed upon her to change doctors, and after three more doctors one of them called up to LDS Hospital in Salt Lake for an appointment. She was so weak we couldn't drive clear up and had to stop overnight in Provo. After three days of tests, they couldn't figure it out. Finally

they said it looked like a large tumor in her brain, and they operated and removed a tumor about the size of a large orange or softball, but they couldn't get it all out, it was too embedded in the brain tissue. Oleta lived two years or so after that operation. She started going downhill from 1955 and died in 1965 at 41.

The helplessness that the family feels in not being able to do anything, to see them slowly but surely grow weaker and slip out of your grasp is the hardest thing I've ever undergone. And when the young boys and girls developed this leukemia, dropping off like flies, a regular epidemic around here, nobody seemed to know. They were holding three or four funerals a week and that's a lot for a small town like this. If the government had informed us, if there had been any information of the danger when they started this testing, if they had just said one word, I would have gotten out of here so fast it would make your head spin. The leaders of the Department of Energy and Defense looked upon the people of southern Utah and Nevada as expendable. "We've got to conduct these tests, so if a few old Mormon farmers get killed, so what?" They just kept saying, "Don't worry, there is no danger, there is no danger."

JOSEPHINE SIMKINS

May 1988

Enterprise, Utah

> "I feel like we were really used, and I'll never trust our government again."

Hers was a house "not in town," as Josephine Simkins described it, "town" being a thousand people not very far down a dirt road, tiny, spartan Enterprise, Utah. A varied collection of diehards, these were the children of the children of the Mormon pioneers who had lived on the rim of the Great Basin at the Nevada-Utah border all their lives. "You have to be tough to live here," she would say. There was a picture of her husband, June, on the piano, a very handsome man with eyes notably bright blue and full of light. He worked in the granary with his brother, chaffing wheat from the local fields. The house they had built and everything in it was country-style, Americana . . . stark white, starched, frilly curtains, a spinning wheel, a fireplace she made from stones she had rockhounded from the land, the walls covered with wood from trees he had cut down himself. Josephine Simkins had just one constant companion after his death: a cough that every few moments contorted her frail body into spasms, disrupting any continuity in speech. Her joints were swollen to many times their normal size, making it difficult for her to walk. "Allergies," she commented when she could catch her breath, "and it gets my feet, legs, hands too," a complaint common to everyone in her family since testing and to others living downwind, where radiation has diminished their immune systems just as Linus Pauling and thousands of his colleagues in science had predicted it would 30 years before.

I feel like we were really used, and I'll never trust our government again. I don't think they're truthful. President Eisenhower made the statement that they could sacrifice a few people in this area for testing. I think we sacrificed greatly. We didn't know what they were doing to us. We had no idea.

People who talked about it were considered eccentric, something was wrong with us, or we were imagining it. We

were just naive. They haven't just killed my husband, my brother-in-law, and all these other people . . . how do we know when our children and grandchildren are going to suffer? They keep testing and maybe they're still contaminating us. It took everything I had to pay his doctor bills and get him buried, and I didn't have a thing when I got through. It was hard. Cancer of the stomach, died at 62. He lost 30 years of his life. His brother was only 46 when he died, and he lived in Nevada at Pahrump, just south of the Test Site. We had three cancer deaths in our family and I had to help take care of all of them.

We heard they were setting those tests off, and we didn't know there was anything wrong with it. We'd get up to watch it and hear it, and watch the pink cloud go over. We thought it was something to see, something great.

They never did warn us. Most of it went a little bit west of here, that's where we could see the cloud the most. A lot of it came right over us, but the heaviest part went a little west, farms, our reservoir that waters our fields, right over them, some ranches, and our cattle range. There is some longleaf pine along the reservoir but the cedars, you could look over them just like a line, they would turn white and just die, all at once. Mrs. Reed Pollock's mom and dad lived right in the worst of it, on a ranch up there. Their ranch was just a piece of heaven. His wife used to say, "If they don't quit setting those bombs off, it's going to kill me. I get deathly sick when one of them comes over," and people would just poke fun of her, and thought she was eccentric. She always said she felt sick to her stomach and her head bothered her, kind of dizzy. She died of cancer of the liver.

One time, and I didn't dare tell anyone because they'd call me eccentric like they did her, but the south wind was just like some hot specks. Burned into the south windows of my kitchen, just tiny little specks that burned into the glass. When I'd go to wash them, the cloth would stick on them. It took years and years for that to wear off. Radiation from your windows!

It wasn't a heavy thick cloud. It would be round on the front and then kind of trail out. Sometimes I would look out this window and I couldn't see the top of it, it would be that big. It was kind of misty-like by the time it came down. Sometimes it would just drift along, spread out going down. It would be like you'd see a cloud, one big thunder cloud, and gray as it came down to the ground, only it would be a pinkish color.

My husband's brother took his vacation down here and was going to find uranium. It was when people were going to get rich with uranium. He bought a geiger counter, he called it a geeger counter, and he sat it down here on our flagstones and it was really a-bouncing. He put it on some others and it did the same thing. He sat it out in the driveway and the reading was still the same. Everywhere he went with his geiger counter it read high, it was picking up the fallout. My husband had sores. He wore gloves and his shirt sleeves would work up when he worked in the grain, that was the dustiest. They were purplish sores, they weren't like anything I've ever seen before or since. They didn't heal for a long time. That's the same time his eyes were getting sore, so sore that sometimes he could hardly see. It never did bother him except when he was out after those fallouts and in the dust. A Japanese doctor asked me if my husband had sore eyes. Some of the victims of Hiroshima did.

Those clouds went over our farm. There was one year that our sheep had lost their lambs, and had dead lambs, just

dozens of them. About a third of our lambs had defects. They were the most horrible-looking things. Some of them would have just half a face and some no ears, and some had only two or three legs, or no tails. And no eyes, some of them. Some didn't have any wool on them. It just made me sick to look at them, they were so deformed. We lost a lot of money that year. I remember my son James backed up into the corral and just loaded those lambs clear up to the top of the pickup bed to haul them off. We never had that in our sheep before. They had blisters. The wool would come loose in spots. A lot of range bulls died. We went to the county agent about it, and he said the ewes must have eaten some poison plants. But they were right there on our farm and we'd never had anything like that before. They hunted all over for poison plants but they never found any.

We had a little mentally retarded lamb, and [my sister] Ruth used to hold it up, and oh, it was so cute. We called it Butch. She babied it and it grew up to be a nice fat lamb, but it was just mentally retarded, the way it acted, dumber than usual. Here in Enterprise three or four years ago there were three Down's syndrome babies born in one year, children of adults who were children during the testing.

The Atomic Energy Commission used to come and ask us if we had milk cows. They found everyone in town that had milk cows. They came back every two or three years to check if we had cows and what feed we were feeding them. They didn't say anything about why for a long time. So finally, the later part of the testing, they told us that if we had any fallout on us, they would tell us so we wouldn't use that milk, but they never did. They finally did come and test thyroid, and a lot had bad thyroids. Quite a few of the women have had thyroid surgery, the older women.

One little girl, born and raised here, is dying of brain cancer now. One little girl had bone cancer in her teens. There's others that died of leukemia. A couple here brought their newborn baby out of the hospital in St. George that day they stopped cars and washed them. They told them to stay in the hospital. They didn't, thought there was nothing to it. Their child died of leukemia. I wondered if they felt guilt about taking him out after they'd been warned not to. Then the other cancers started showing up. Lots of breast cancer. They've realized now that nearly everyone that died for years died of cancer. There are hardly any other deaths in town besides cancer. Leukemia, lung cancer, liver, and stomach. We thought we were being real careful of what we ate. We had our own milk and meat and eggs, and raised our vegetables and what fruit we could, even our own wheat. I ground the wheat and made my own flour. We should have been healthy. We didn't realize that when we drank our own milk we were drinking radiation. We thought we were really having a healthy diet, but it turned out that we weren't.

It's amazing to me that the government could lie that thoroughly. What angers me so much, they've kept lying and they finally admitted that they caused these problems. They say that the government doesn't have to pay us for it. We have no right to collect anything for it. It bothers some but still they don't do anything about it. We were really used. I don't know, I guess we're still patriotic, in a way, but I don't trust my government.

INA IVERSON AND HER DAUGHTER TRUDIE BALLARD

October 1988

Highland, Utah

"Trudie wasn't able to have any children for ten years.

Then, the molar pregnancy. She didn't quite feel right

about it. They said she had gotten pregnant but it never

developed into a fetus, the cells went crazy. He said it

was just like a bunch of grapes."

Ina Custer Iverson was 11 years old when her family moved from San Francisco to a ranch in Veyo, Utah, 25 miles northwest of St. George, and she started going to school in the nearby town of Gunlock. By the time testing started in 1951 she was 21 and the mother of two small daughters, Vickie and Trudie. She had a miscarriage in 1952, and in 1953 her daughter Ida Jane was born. Both Trudie and Ida Jane, once grown and married, also had "funny pregnancies," according to their mom. What grew inside of them rather than a fetus was a hydatidiform mole, which doctors describe as a gelatinous mass resembling a bunch of grapes. This was an all too common experience for the native women of the Marshall Islands in the Pacific Testing Range after being exposed to the fallout from the detonations of hydrogen bombs, who lived in "by far the most contaminated area in the world."[1] Great pains were taken by the Atomic Energy Commission to differentiate between the domestic atomic tests in the kiloton range and the multi-megaton hydrogen tests in the Pacific. A meeting of the AEC's Advisory Committee for Biology and Medicine in 1956 heard a pre-Nuremberg type of rationalization for using the Marshall Islanders in these radiation research experiments: "While it is true that these people do not live, I would say, the way Westerners do, civilized people, it is nevertheless true that they are more like us than mice."[2] The effect of large doses of radiation was much the same for all women in the Pacific and the western United States once they matured to childbearing age.

We had two little girls that were born in '47 and '49. They were the ones that experienced the fallout. I had a little book that the government passed around down here, yellow and

four by five inches.[3] I read through it. They said after the fallout has passed to go out and hose down your roof and yard. I was suspicious. Other people went out and watched this fallout. We had big windows on the side of our house to the west. You could see those clouds and they would be kind of pink-looking. They would scare me to death. I used to say, "You kids aren't going out and Mama isn't going out, nobody is going out of this house." One winter at school the kids were out playing at recess when the cloud came over. The school had told the parents that they would take them down to the basement but they didn't. They claimed they didn't get notification quick enough.

I remember being worried because they said the cows would eat the hay and all this fallout had covered it and through the milk they would get radioactive iodine. We quit drinking milk to avoid any problems. My sister and brother-in-law had a little girl and she had her thyroid swell up. They hadn't tried to shield her like I did mine; they just took the government's word that there was nothing to worry about. They had their own cow so this little girl got the swollen thyroid. They sent a team of doctors in to test the kids. It seems like she grew up all right but since she's been married she had a terrible time every time she got pregnant. Finally the doctors told her, forget it, we're tying your tubes or you and the baby might not come through the next time.

You never used to hear of all these funny pregnancies. I was so normal before this fallout with my first two pregnancies. Then my thyroid started giving me problems. In 1955 I had a son born with asthma and I put on 40 pounds within six weeks after he was born. My next pregnancy I lost weight all the time and nobody even knew I was pregnant. When I was about 35 we moved north to Pleasant Grove, and Dr.

Webster couldn't figure out what was going on either. In 1967, I had a biopsy of my uterus and they said it was cancer, the cervix was cancerous too. He recommended surgery, and radiation therapy, this was before there was chemotherapy, and I said, "Phooey on this, that's exactly what I'm afraid of." My sister got cancer of the uterus and my mother too . . . they just put a cobalt capsule in hers. It took her three years to die and I'm telling you, I hate to see anybody go like that. There was no history of cancer in our family, none, so they can't tell me it's hereditary. Nobody had any problems until we went through the fallout.

Trudie wasn't able to have any children for ten years. The doctors couldn't explain why. Then they adopted a little girl and then after she had a little girl of her own, and then the funny one I told you about, the molar pregnancy. She didn't quite feel right about it. When she would bend over something solid would fall in her uterus. They never did hear a heartbeat. They said she had gotten pregnant but it never developed into a fetus, the cells went crazy. He said it was just like a bunch of grapes of different sizes, larger ones and small ones.

T R U D I E : From four months to about six months I kept a-wondering because I hadn't felt any kicks. Then I started spotting and I thought I was going to have a miscarriage. I hadn't progressed to the size of a normal pregnancy and the doctor gave me a sonogram. He couldn't see any form of a baby and so he said I had a molar pregnancy. He did a D and C. My husband was there and he showed him what he had taken out of my uterus. There were little grapelike cysts. My husband said it looked like a bunch of peeled grapes. He couldn't give an explanation of what caused it. There was a

girl from BYU [Brigham Young University] studying to be a nurse who called me and she said she had a couple of them in a row. She was doing a thesis on it. I guess she got my name from the doctor.

I N A : All of a sudden everybody we knew or somebody they knew or were related to was having miscarriages at five or six months along, or their babies dying on them and I said something has got to be going crazy here, it's just not normal. I thought they put something in the water! It was all through the valley here, a strange, widespread thing.

I think it was really dirty politics. I used to get so mad. They'd talk about the Russians but I thought, heck, they experiment on our own people. What chance do you have? I feel like they did it deliberately. I guess you knew about them sending the soldiers out there on the flats, how they could see each other's skeletons when the bomb went off. Those guys must be dead by now. And very vaguely you heard a little tidbit about how cows died or sheep died, they tried to keep it so quiet down there when it was happening. Most of the people I talked to definitely felt it was undercover experimentation. I get so mad because nobody stands up and says no. They evade the problem, an "if I don't see it, it's going to go away" attitude. The people here, anything political and they stick their heads in the sand.

1. U.S. Atomic Energy Commission, transcript of 54th meeting of ACBM, January 13–14, 1956, New York, pp. 231–232.

2. Ibid.

3. Atomic Energy Commission, "Atomic Test Effects in the Nevada Test Site Region," January 1955.

KAY MILLETT

March 1988

near Cedar City, Utah

Baby photographs of Sherry Millett, before and during leukemia, with 1957 Atomic Energy Commission propaganda booklet. "We can expect many reports that 'Geiger counters were going crazy here today.' Reports like this may worry people unnecessarily. Don't let them bother you."

Kay Millett lived north of Cedar City, Utah. Her home was one of a cluster of tract houses very near but not in the town of Enoch, on the road to Minersville. In small-town Utah, it is important to stress these geographic particularities due to the rivalries that often arise between the towns. Solidly Mormon Enoch, for example, was usually described by others as "too pure," an indication that people there were too self-righteous for their own good. Since pioneer miners were usually not Mormon, Minersville was definitely considered the underclass, although I found the town quite touching. In such an austere economy there had always been competition for tourists' dollars between Cedar City and St. George, a competition that could occasionally grow quite nasty. The fallout from Nevada made no such distinction, however, its equal opportunity poisons seduced only by the power of the winds. After a few turns down the wrong dirt roads, my truck's bald tires spinning up clouds of redrock dust, I arrived to find Kay Millett leafing through the family album, looking for pictures of her daughter Sherry, who died of leukemia at five years of age after a two-year struggle to live.

We really didn't take a lot of pictures back then. We were too poor to buy film and get it developed. That first picture there, she was three almost. It was the summer before we found out she had leukemia, but she had started to have those bloody noses lasting quite a while. It wasn't a normal bloody nose, it gushed from both sides. This was [taken on] the Fourth of July. Her sister was in the parade, and they both had cute new dresses on. She got a nosebleed watching the parade and she ruined her dress. She couldn't eat. No appetite, no play, no nothing. She got so white and peaked. She got these little black bruises all over her legs and buttocks,

not like a normal blue, yellow, greenish bruise. They were definitely just a black bruise . . . I don't know how to explain it on that transparent skin. Of course, the doctor didn't know what was causing it. He couldn't get her blood anywhere. He had to take it out of her neck. They weren't that familiar with leukemia. It was something he said was really rare. He had only known of one case of leukemia in all his doctoring years here in southern Utah. I was in the doctor's office, reading this magazine there, and it's talking about the rare disease of leukemia. Here I am, ready to have another baby, and in the back of my mind I'm thinking, "No, this isn't the leukemia I've read about, it's too rare. That wouldn't happen."

When he got through with the tests he came out and said, "I want you to take her to Salt Lake first thing in the morning. I'm not sure but I'm pretty sure. It looks like leukemia." It was so traumatic. He said, "You can't go," because I was due to have the baby that day. I left anyway. She was really sick on the trip [which is almost five hours by car]. She must have been in pain. I held her all the way up there and then I had to sit for hours through all these doctors wanting her history. Finally, after blood tests, they told us it was acute leukemia and they would have to do some blood transfusions, and that they could make her well for a little while. They were really concerned about me having a baby, so they told me who to contact if I went into labor. They gave me a sedative and I went to a motel.

I came back the next morning and there she was, sitting in her little chair and she was all pink. They were experimenting with all these new drugs at this time. That's what made me think we were just guinea pigs, they knew this was going to crop up and they were coming up with drugs they were trying to test on patients that would come in. There was a hundred little kids with a rare disease called leukemia going to that hospital for treatment. We didn't know until we went up there that there were that many kids suffering with it. All of a sudden this rare disease wasn't rare anymore. It was just raging inside of Utah. In fact, I seen patients come in there from Wyoming and Idaho. It wasn't only leukemia, there was Hodgkin's disease and brain tumors all of a sudden. One day I just sat down and thought, "All these people, there must be something causing this for everybody to be getting cancer."

I asked the doctor up there, "Would it be the fallout that we are getting from the testing in Nevada that could be causing this? I have gone over in my mind a million times what could possibly be causing all this." "Oh, no," he looked at me like [I'm] some kind of a nut, "your government wouldn't do this. They're taking precautions." He just thought I was funny. He intimidated me like I must be stupid to even think that. I didn't dare say anything like that to anybody for fear they would think I was awful because I would even *think* the government would betray us. I didn't dare talk freely to anybody about it for fear they would put me in a nut house or something.

We weren't aware there was any problem. They never told us to stay indoors or have water tests. No precautions whatsoever were given to us. I noticed our dog had puppies and they died, they weren't healthy. Our rabbit had rabbits and they died. I had grown some tomato plants in the house to put out in the spring, and it was February, a nice sunny day and I thought, "I'm just going to set these tomato plants out and let them get sun." An hour later I went to those plants and they were white, crusty-like and laid over, gone for no reason. That year when we raised the garden we noticed the squash and tomatoes would get this light stuff on them, the

leaves would get white and crusty and the squash would be all yucky and the tomatoes did the same thing. It kind of spread around the garden. We ate them, the ones that were good. That was 1957 or '58, because Sherry was just a baby then. They were doing tests all the time.

I think back to when they were talking about fallout shelters for if we had a nuclear attack. They had all these signs where we could go for a bomb shelter in case of an attack. What to do with your vegetables if we had a nuclear attack: you would wash them and peel them and then you could go ahead and eat them. With all this stuff they were telling us about how to take care of ourselves, and I got thinking about that. Gads, we've been under nuclear attack so many times it's not even funny. We've had that nuclear fallout on us for *years* . . . and nobody knows it! We were being showered with it all the time. We went out and watched the bomb in science class. Our teacher said we were going to do something really special, watch this atomic bomb blast, and watch the mushroom cloud and see it come over us. We sat out there and thought it was really something. After I had a rash come on me that was unexplainable. The nurse didn't know what it was and sent me home from school.

You think about this. The government certainly didn't say "There's been a nuclear attack." We're a trusting people. We are really naive about people who try to do harm. We try to look at people as we are, that love people and wouldn't want to harm them. We're just starting to experience the wickedness of people. You hate to think people can be so cruel and mean and wicked.

We took Sherry up there [to the hospital in Salt Lake] every week for treatment and transfusions, whatever they thought she needed. She could hardly wait when we got home, she'd say, "Let's have lamb chops, mashed potatoes, and beets."

Gosh, I couldn't believe how she started eating and playing and feeling good and just happy, feeling her own self again. Her little cheeks were so pink. But not for long.

Kay Millett began to look through her photographs and mementos once more. In her photo album was a small yellow booklet that seemed ubiquitous throughout Utah and Nevada, an Atomic Energy Commission publication called *Atomic Testing in Nevada*. Countless people I have interviewed over the years insisted that I take a look at their copy of it, a few of them furious about being portrayed by the government as stupid cowboys or as simpleminded children, ready to do anything they were told on blind faith. There was also a photograph of Sherry at four that was unrecognizable, taken after Prednisone had affected her weight.

She wanted to go down to have her picture taken, but she was too sick. I said, "Sherry, I don't think you can even sit there to have it taken." "But I want to," she said. She was in awful pain sitting there. When she saw these pictures, she didn't like them, she didn't think they looked like her. She took one look at them and she could definitely see that she was sick. You see that hollow look from not feeling good. She'd go to Sunday school and the kids would tease her because she was bloated up. One day she said, "Momma, am I going to die?"

Government people I don't trust anymore, I don't trust them at all. It is organized crime, that's what it is, and it is something you can't do anything about. I really do believe that they cover up. I know that the government is so deceiving, and things we don't even know about they just sneak around and do. How do you fight it, how do you fight the government?

ELMER PICKETT

February 1984

St. George, Utah

Elmer Pickett, who lost 16 in his family to cancer, with his panoramic view of Snow Canyon, site of many Hollywood westerns. "John Wayne's two sons I got to know real well. Susan Hayward's twins, we took them fishing, we took them hunting. Susan came over and spent evenings with us. They were here in 1954 on that film called *The Conqueror*. As you know, that cast, the majority of them died of cancer."

Elmer Pickett was a mortician for many years before the onset of the atomic tests, and so he sensed there was something very wrong in St. George before most did. In the mid-fifties he was shocked by a sudden surge of deaths from leukemia, and he had to teach employees new embalming techniques to prepare the small bodies of the wasted children brought to them. During the Upshot-Knothole series of eleven atmospheric tests in 1953, 252 kilotons' worth of nuclear fission products descended upon the people living downwind of the Test Site. Thousands of grazing sheep were killed immediately, but the radioactive legacy of human devastation would strike in different ways at different times during the next fifty years or more. The downwinders were becoming anxious, and to quiet their nerves the Atomic Energy Commission launched a new campaign of propaganda. They sent their operatives into the small communities to live, and instructed them to blend in and be helpful to their neighbors: fix a broken tricycle, help change a tire, show the AEC movies in local high school auditoriums, to increase the trust and relieve the anxiety of south-state Utahns. They even asked the small town people if they would like to play starring roles in newsreel films about the atomic tests. Elmer Pickett became one of the actors.

During the time all of this was going on, of course, the AEC were doing all they could to convince everyone that everything was safe. They published a little book called *Atomic Test Effects*. This was put out in January of 1955 just before they had a real bad one. The worst one of all was Dirty Harry in 1953, did a terrible amount of damage. In this book they were trying to convince us that everything was fine, there was no danger, gives a record of past tests. They had a

certain number of people who'd come around every once in a while who put these little badges on. They claim they have lost the data. There was one place in here that I wanted to read to you, talk about lies. "These reports show under controlled use in Nevada there has been no significant fallout anywhere in the nearby region. . . . Fallout levels have been very low, slightly more than normal radiation which you experience day in and day out where you may live." This whole book is full of falsehoods because they knew. Guys running their monitors here are now testifying that their machines went clear off the scales. They frantically called, and they told them to calm down and to quiet us down. Don't let anybody get excited, shut your mouth. As long as they were working for the government, they couldn't say a word. They knew what the fallout would do, they very well knew. They had data from what happened in Japan.

The first one we lost was my mother-in-law. All the time when the sun was warm she'd get out and exercise, so she was out all the time. She died quite fast in 1954. She was born in 1900. Then others around here started getting leukemia all at once, started blossoming out. We were getting nervous. That's the reason the AEC put that book out, and they produced a film, strictly a propaganda film. I was in it, and a lot of other people here, quite a bunch. They showed me in my store listening to the radio about the fallout. Remember the milkman and the police? They had a housewife and a sheriff, and the director of civil defense. Out of the bunch that was in that film, two-thirds of them died with cancer.

They tried to make us feel like it was an exciting time. We better go out and watch it, which the majority of the people did. I was one of them. Early in the morning, before daybreak, we watched the big flash in the western sky. A few moments later, the rumble, then an hour later there would be a big red cloud come over. The dust just followed it.

Elmer Pickett sold his mortuary business in the mid-fifties and bought a hardware store on the Boulevard, volunteering to train the new owners until they became adept at handling cancer victims. As we stood in his office, he pulled a sheet of paper from his wallet. On it were printed the eleven names of those who had died in the Pickett family so far. (Years later when I visited, another five names had been added.) In a splendid gold frame hung a five-foot-long antique photograph of Snow Canyon, a place much beloved for its beauty since pioneer days. The smooth black domes of the extinct volcanos pepper the steep red- and cream-striped escarpments, a perfect stage set for Hollywood westerns in the fifties, and the Picketts became personal friends of the children of John Wayne and Susan Hayward, who rented homes down the street.

Kiddingly the town called it Hollywood and Vine, our corner. John Wayne's two sons I got to know real well. Susan Hayward's twins, two boys, we took them fishing, we took them hunting. Susan came over and spent evenings with us. When they were making the movie, I was in it. They were here in 1954, early in the spring until way late summer on that film called *The Conqueror*. As you know, that cast, the majority of them died of cancer. Susan, brain cancer. Moorehead, something similar. Wayne, he died of [stomach and] lung cancer.

Going back in our records, I find very, very few cases of any kind of cancer. Leukemia and Hodgkin's disease was

relatively unknown. All the years I worked in the mortuary till this started, only one case of Hodgkin's and not over four leukemias in all that time. Very, very few. In my town there was not one single case anywhere in our family history as far back as we can go. Not one case till this, then . . . bang! I lost eleven people in my family. My wife, my sister, my niece, sister-in-law, you name it. I myself have some problems, a thyroid problem they still can't figure. Huge sacks of gelatin-type stuff across my thyroid, and nodules. They tested the kids about 1960, 1961. I have a son, he was one at high risk for thyroid. He was under close watch, although at this point nothing has happened yet. He's 28, born in '55. So we're all wondering what's going to hit next.

We were had. Many of our family and everyone else. My wife just loved to work around the shrubs and flowers, and she was outdoors a good share of the time, more than she was inside. At first she got Hodgkin's disease. Hodgkin's is a terrible death. Takes about two years. It deforms. We fought it for a year . . . she was in Salt Lake most of that time. I was going back and forth, burned up a lot of rubber and gas. All at once she got leukemia, and it took her in a week. She died in 1960, December. Six kids.

All of my family were very long-lived. Late nineties, hundreds. They were pioneers on both sides, came in here with the old original settlers. Those who were sick, and a lot of them died, were fighting with themselves, they got stirred up. We're getting more stirred up all the time because of the way they're manipulating this thing. I understand the attorneys that were handling the trial up in Salt Lake a year ago made a statement that no one lived to ever see these things happen. That's a pretty bad commentary on the government, it really is. If they would have quietly settled, there wouldn't

have been a stir, it would have been taken care of and everyone would have felt good. They wouldn't have spent as much money as they've already spent. They're spending millions and millions and millions fighting this thing, for what purpose? They've committed fraud, perjury, you name it, right down the line. My personal feeling is that those people who are responsible for this are absolutely criminal. Responsible for heavens only knows how many thousands of lives, and they're getting off scot-free when they knowingly made us the human guinea pigs. They bombed Utah and we're paying the price. They done to us what the Russians couldn't do.

BETTY ENCE, FOR HER DAUGHTER TONI

February 1984

Ivins, Utah

"One day a man came to the door and asked me if [Toni] had been outside, and I told him yes, and he told me to wash her hair very thoroughly, immediately. She was about three. In her twenties a gynecologist did an exploratory operation. He told her that her female organs are like an infant's. We tried to get her to date and go out. She wouldn't. She would say to me, 'Nobody would want me because I can't have any children.'"

When the fallout cloud from Dirty Harry passed over Ivins, Utah, Betty Ence was in the garden with her three-year-old daughter, Toni. A month later she would conceive her son Kerry. As they grew older, neither developed functional reproductive organs, a calamity of major proportions to Mormons, who believe that very large families are a blessing from God. Young girls are soon taught, and usually believe, that having children is the primary if not the only reason for being alive.

In the papers and radios they would say to go out and watch. We were watching history. I used to watch the bomb clouds come up over the hills. My children were with me most of the time. One day a man came to the door and asked me if she had been outside, and I told him yes, and he told me to wash her hair very thoroughly, immediately. It was early summer because we were out in the garden picking peas. She was about three. When she got to be in her twenties she went to a gynecologist and he did an exploratory operation. He told her that her female organs are like an infant's. He said what little bit of ovaries she has, she might as well say she doesn't have any.

She's grown up with the idea that nobody would want her. We tried to get her to date and go out. She wouldn't. She's a real shy person. She would say to me lots of times, "Nobody would want me because I can't have any children." It has had an effect on her life. She doesn't say a lot, except she'll say, "I'll just have to work on my life because I won't have anyone to help take care of me." She was cut out to be a mother and that's all she's wanted to do. When they were little, she was

the doll player and my other daughter was playing football with the boys. She's the one who has the children. It doesn't seem to be fair the way things work out sometimes.

My son can't have any children. He was born in 1954. He produces no sperm whatsoever, nothing, so there's no way he'll ever have any children. He was really upset. He was going to sue everybody. He said that the first doctor he went to, when he first started to take his history, asked him where he was born. He said he didn't want anything to do with him— "I can't afford to get mixed up with you"—so he went to another doctor. Kerry is really worried that he'll get cancer. I feel lucky that it hasn't happened to us yet.

At the time they were dropping these bombs, there was fourteen families in Ivins. Out of those fourteen families, I have a brother-in-law that has a daughter who isn't able to have children. The boy she married is also from Ivins—they said there was something wrong with both of them. His sister lost a four-year-old girl to leukemia, and now his mother is having cancer. My neighbor died of bone cancer a year ago, just 59 years old. She told me that the doctor in Salt Lake told her that she's a victim of radiation but he wouldn't sign a letter stating the fact. The others that lived there at the time, they're practically all gone now.

There was no damage or harm, nothing to worry about, they'd say. I decided, no sense in worrying about it. We didn't know enough to worry. My father-in-law died in his early sixties of cancer of the liver. At the time this was going on we raised turkeys, so he and my husband were out in it all day. We have our own cows and we milked the cows that ate the grass, probably had all this stuff on it. I know we didn't get sick and feel nauseated like a lot of the others did. They did test the children for nodules in school in the sixties. They did find some in some of the students, but mine they didn't. I received a letter about a month ago asking me about the three of them and if they could come and interview me to see how things are now. They were wondering if we were in the same place, if I was still alive.

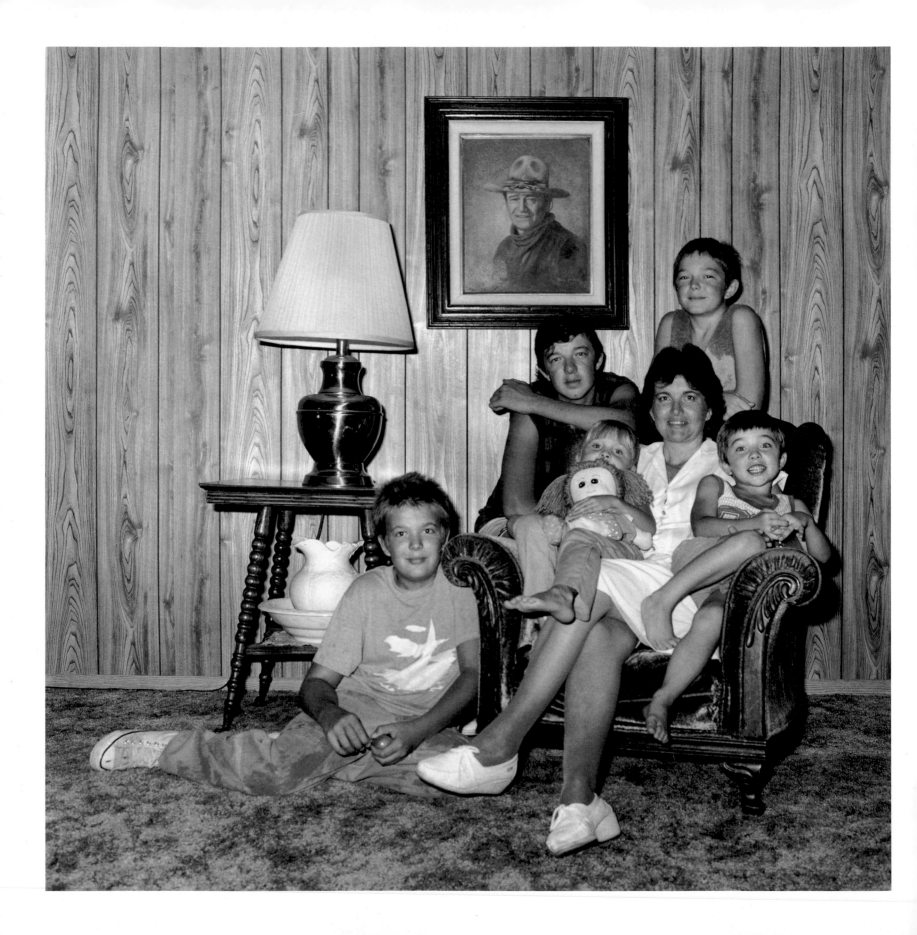

DIANE NIELSON

June 1986 and August 1987

Henderson, Nevada

> "After a bomb, there it would be, the fallout. We would play like that was our snow. It would be thick enough you could write your name in it. It would burn your fingers and you would have to wash your hands."

Our family was economically low. We didn't have indoor plumbing. We didn't have a telephone. We did all our entertainment living in the hills outside of St. George [Utah]. We had our little huts on the hillside, played in irrigation ditches. It was a great way to grow up. After a bomb, there it would be, the fallout, fine like flour, kind of grayish white. We would play like that was our snow. We never had snow there because it was a warm climate. Then we would go out and write our names in it. It would be thick enough you could write your name in it and see it. It would burn your fingers, it would irritate you, and you would have to wash you hands. I can remember I was little enough that I came up to the edge of the fender of the car. I would climb up on the bumper because I wasn't tall enough to see over the top of it. I was born in 1952.

My dad had a geiger counter that he would go and check things with. He would come in and be really upset because it was reading radioactive. Verbally upset. I remember my dad several times going outside and walking around with that thing and having it go ratta-tat-tat. We would tag along with him and watch it—it would go up. I do remember the dial going up and down and hearing it click-click-click. My dad would say, "Clean off, don't get it on you, wash up good. Don't play in it." Of course, kids are going to go and do the opposite, and we would. We'd sneak out and dig in it and have a good time.

I can definitely remember the ash, and it was on everything. Sometimes it would be big pieces, like burnt pieces of paper, like if you burn a bonfire. Other times it would be real fine. Sometimes there was stuff in it. I can remember that because I remember going outside and shaking it off the blankets that we slept on. We didn't think too much of it. We

had one little mulberry tree we slept underneath, but basically we'd be out in the open. My mother made Levi quilts, took patches of old Levi's and made quilts to protect our beds. That way we could jump on them and play on them.

I always had a sore throat. I think I was born with a sore throat, never had anything else. I can remember as kids in school, kids being taken for tests for their thyroids but it was all hush-hush. It was very secretive, nobody said anything. When we asked them later about it on the way home from school on the bus, they were not allowed to tell us anything. They would not talk. I had a girlfriend that lived about four miles from us. My dad told me that she had her thyroid removed.

We didn't think anything of it. When you're a kid, you don't. I remember wondering why my dad would get so upset because physically I couldn't see anything hurting us. My dad was very upset when he was talking about his pigs—lost a whole batch of newborn pigs. He was hollering, "I'm losing money!" They were like somebody had burned them, all wrinkled and shriveled. Dad was saying, "Get out of here, you don't need to see this, go in the house." I was about seven years old. My dad was gruff and real macho, but when it came to something being hurt or suffering, he was really quite sensitive, really tenderhearted when it came to his animals. He was never educated in school, but he was self-taught and did a lot of reading, and would follow stuff quite closely. I remember my dad coming inside and dusting his coat off, being angry. He knew what was wrong and what the effects of it were. He was the type that felt that they weren't telling the public what they could be telling them.

I was about eight. It was when you started to think, "I'm going to develop like my older sister, this is exciting." When I first found it, I was sleeping outside. We would have our beds out there, and I remember laying there and thinking, "I get to grow up like my sister and she has a cute shape." It was something kids in grade school were talking about. I felt across my chest and there was a little lump like a little hard pea. Just on my one side. Then when I grew up, it was the side I was having trouble in, the same location. They were kind of flattish, but yet they were hard. They weren't normal, but I thought they were. So I never really developed. I kept on thinking, this is not fair. Just basically flat-chested, and it was really traumatic. After I had my babies I never nursed on my right side, the babies wouldn't have anything to do with it.

When I finished nursing school and started this self–breast exam, I found my lumps again and thought, that's no big deal. The next month I did it and they had really started changing and growing. Between August and October it went from the size of a little pea to about the size of the palm of my hand. They did a breast resection, they just cut off half of the breast. I had to go back in for check-ups. The last time I went I had lumps on the other side. I was 25.

I think it's really a shame that they play on people's ignorance. When we realized that things were not right and people confronted them, they treated them as if adults are like children. "There's nothing going on, it's your imagination." People became very aware of it and asked and questioned. That's the fraudulent part of the whole thing. They never tell the truth.

They are counting on people to be passive, that's the pathetic part of it. Everyone was so trusting. So much so that when I was little, I thought it was an everyday occurrence. When our family started popping out with these medical prob-

lems, that's when I myself became angry. My dad has a lot of growths, my brother has them, I've got them. They start out like a little cell that burns, and when it quits burning it will form a hard spot and start to grow in a month to the size of a walnut. My legs always looked like they had been beaten—I get bruises real easy, have a hard time with bleeding, a slower time at clotting.

Diane's reproductive system also suffered—her twins cost her $30,000 in birthing expenses. During delivery she had a stroke and spent a year in recovery before she could even dial a phone number. At the onset of puberty, her two older sons developed "pigeon chest," an abnormal pointed growth of bone from the sternum. Teachers in Wyoming have told me that they have noticed unusual numbers of teenagers with the same problem in their schools. "Cal just looks at it and says, 'Gol, Mom, I'm getting a lump like Chad.'" All three older boys had scoliosis since puberty, which is rampant in Diane's birth family as well. Her mom, her sister and brother, and she herself developed it at the same time, when she was 12, with no previous history of it in their genealogical records. Most of the downwinders I've interviewed have related similar difficulties with scoliosis in their extended families. Diane Nielson's sister has also had a severe thyroid condition since childhood.

The western skies, which were at the heart of so many camp songs of Mormon families since the time of their forebears, the pioneers, had brought them pink clouds of deathly snow. The bombs' ashes fell on handmade quilts, made of cowboys' worn-out jeans and farmers' overalls. It burned the paint off the hoods of trucks, leaving behind the names scrawled by children who would eat and breathe the bone-seeking radioactive isotopes of strontium and cesium, whose hormonal systems would remain forever damaged by iodine 131. Their progeny would be genetically distorted, often growing misshapen bones and sprouting tumors, succumbing to leukemia detected shortly after birth. They themselves would be mutilated and their viscera excised to halt the inevitable cancers. But they had always been assured, and they believed, that there was "no danger."

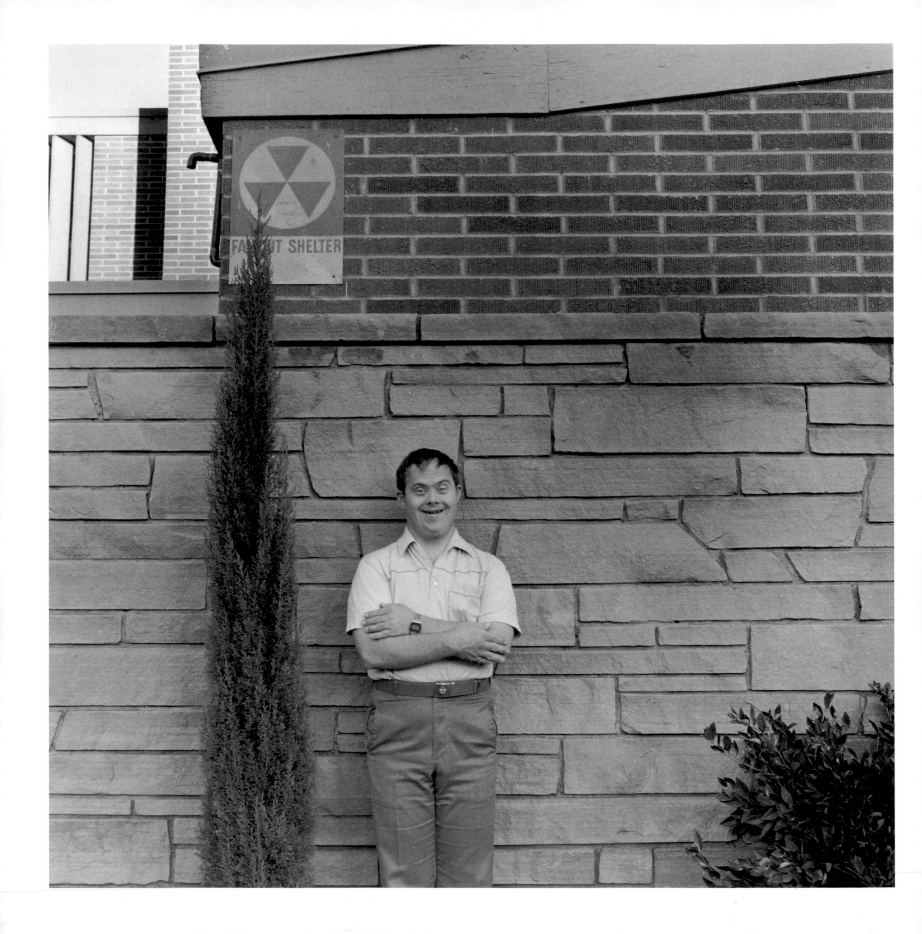

SHELDON AND LEATRICE JOHNSON

May 1988

St. George, Utah

Sheldon and Leatrice Johnson's son, Layne. "We had a lot of mental retardation very apparent in 1956, all of a sudden. Twelve or so in one class. It was enormously different from the proportion you would expect."

Cesium 137 in the fallout, by affecting reproductive cells, will produce some mutations and abnormalities in future generations. This raises a question: are abnormalities harmful? Because abnormalities deviate from the norm, they may be offensive at first sight. But without such abnormal births and such mutations, the human race would not have evolved and we would not be here. Deploring the mutations that may be caused by fallout is somewhat like adopting the policies of the Daughters of the American Revolution, who approve of a past revolution but condemn future reforms.

Causes much less involved than radiation have the effect of increasing the number of mutations. One such simple cause is an increase of the temperature of the reproductive organs. Our custom of dressing men in trousers causes at least a hundred times as many mutations as present fallout levels, but alarmists who say that continued nuclear testing will affect unborn generations have not allowed their concern to urge men into kilts.

Dr. Edward Teller, The Legacy of Hiroshima, *1962*

I was in the South Pacific during World War II. It was really tough. All of a sudden this miraculous thing of an atomic bomb happened. To us, I ought to show you the newspaper clipping, it was this great thing, the atomic bomb. I remember "atomic" and I didn't even know what it was. It probably saved my life, I thought, because we were getting ready to invade Japan at that time. I was next, I was to go there, so from my perspective it saved most of our lives. Suddenly the war ended, big things were happening. I was thankful my wife was safe when I came home, and they say they're still testing atomic bombs. Didn't raise any great alarm to me. It was a good thing, in a way . . . at least they're keeping up with things. We still didn't know about all the radiation problems

with Hiroshima at that time. We didn't know there was such a thing as radiation. We knew nothing that there were harmful effects that would last you a lifetime. Birth defects weren't even thought of in those days.

We had a lot of mental retardation. This had become very apparent early in 1956. We were starting to say, "what is happening around us, and all the cancers around, and all the leukemias, all the experiences people have had within three blocks of us?" All of a sudden. In Washington County School District there had never been even a need for a class, and all of a sudden these children of Layne's age, here were twelve or so in one class. It was enormously different from the proportion you would expect.

If we go back and see the perception of people, it wasn't like now, as far as mental retardation. Retardation was something to hide and to keep away from people, not to mention it. Above all you would not admit it openly to your friends. Now we say they are Down's syndrome, and in those days they were Mongolian idiots . . . there's a difference. Who would want to teach in front of a class, would even want to be seen with them? We had Layne. In a way, I think probably it was a blessing we had him rather than someone else, because I had been appointed to be a member of the school board at that time. All of a sudden we had all these children desperately needing schooling, training. Parents were totally frustrated, really hiding things they couldn't handle. It was fortunate for the community that it happened to us because we really didn't hide it a bit. Then we started investigating it, and we got a class going because of our effort. We were the first ones in the state of Utah to have a trainable class unit in a school. Up to that time they would get a few of them together and hide them in a building someplace where no-body could see them, where nobody could make contact with them. It was a social stigma that was pretty big. We had all these children that needed special education, who were not only slightly handicapped but severely retarded. These were extremely retarded children. It really struck us. We said, they were all born during that time, how come?

We had a lot of trust in the federal government. We really felt like they are really going to take care of us. If there's a danger, they'll let us know, don't worry about that. That was the only thing that we felt bad about, is that we were in a situation where it is more important for them to protect their interests than it is to face the reality.

I'm involved in the school district, and involved in church, government, different ways. Some people are very immoralistic in their approach to other people, in church, government. They really love to rule. Joseph Smith said in the Doctrine and Covenants that as soon as a person gets a little authority, they rule unrighteous dominion on their fellow man. I think it's absolutely a true statement. It is the very nature of man, a natural tendency. And so I say we have to fight that in every aspect of government, in every aspect of anything.

Unrighteous dominion in this case meant premeditated murder, birth defects. It means *many* deaths. What is happening here is not normal.

I agree with you there one hundred percent. I don't think we need to be compensated. I don't think compensation solves the problem. I don't think other citizens in another part of the country need to pay us—they weren't at fault either. Medical bills, that's a minimum requirement, so to speak. To be in apology and acknowledgment, and to clean up the act so

they can be trusted again. I would fight like anything to get that to happen, if I knew what to do. What we really want is morality, we want better decisions, we want more concerned people, that's what we want.

We would be really fighters if we could all unite in the direction we ought to go. We're a little slow. What's the answer to solve it all? There are many people who didn't know any better. There are some that knew better but didn't do better. We are a people who can get on the band wagon and really go. We got feeling strongly about things. Even death isn't going to bother us, we're going to go ahead. Maybe it's the time that we should start thinking more seriously about what did happen. That's the hard thing for us. We'll struggle at it. They really can't tell us what to do. The outside world thinks that all they had to do is do this. They can really lead us in the direction we go, and then we follow. It's a strong, strong feeling inside, so it puts us at a great disadvantage because we can't relate to being stepped on. We can't relate to that very well.

There is a philosophy that Latter-day Saints have, that all will be well, no matter what. Remember that old song they sang as they walked across the plains, "Come, Come Ye Saints?" In spite of all the things that will happen, everything will be okay, the end will be all right. Our challenge is to rise above it.

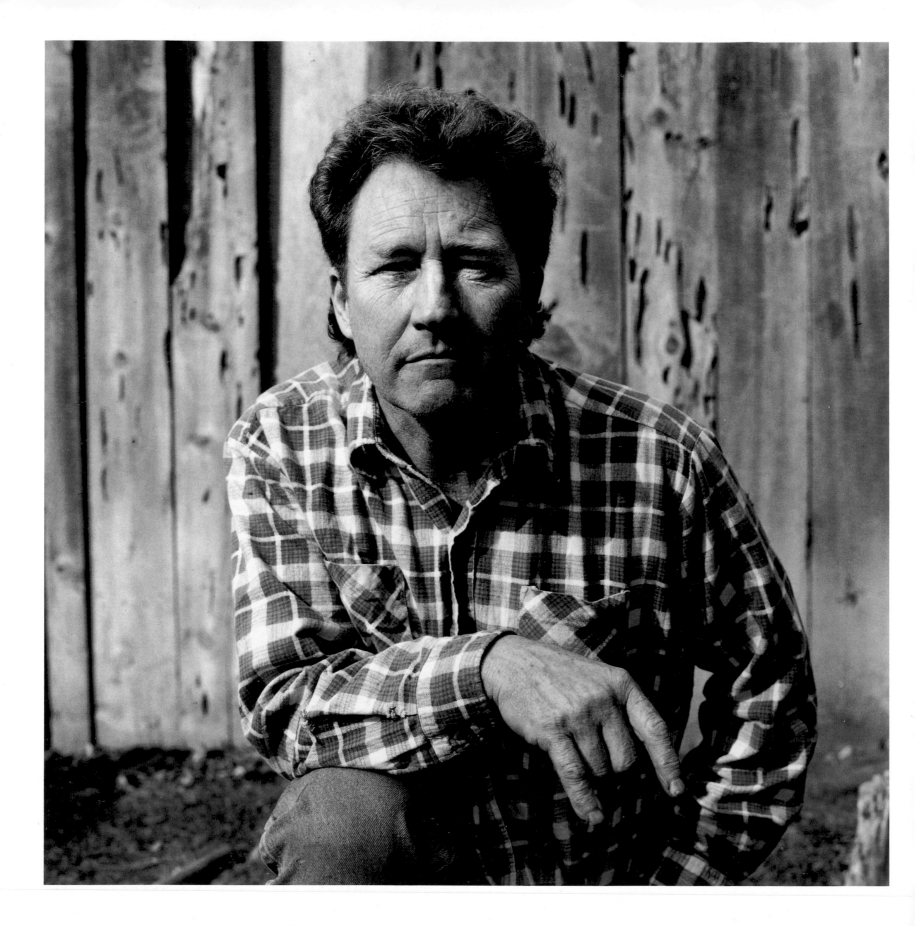

KEN PRATT

March 1988

Salt Lake City, Utah

> **"[When my son] was born, his face was a massive hole. I could see down his throat, everything was just turned inside out, his face was curled out and it was horrible. I wanted to die. I wanted him to die. I thought there was no way he could ever make it."**

I spent all of my time in southern Utah during the 1950s. I started stunt work when the movies started down there, in St. George and Cedar City and Kanab, through a period of five years, '53 through '58. One thing about *The Conqueror* [with John Wayne] was that so many people on that film died. I do remember the fallout clouds coming over. At the time we were told that they were harmless so we didn't pay that much attention to them, but they looked kind of pinkish. They had a kind of glow to them. It was very obvious. They covered a large area. We felt the little pebbles. It settled on stuff, it got on the cars and car windows. I remember the explosions, the shock waves a lot of times. We didn't realize. We were so naive because we trusted the government. If we would have found out, I don't think we would have . . . I remember when my boy was born with a birth defect, right after when all this happened.

[My son] was born in the Panguitch hospital. His face was a massive hole and they had to put all these pieces of his face back together. I could see down his throat, everything was just turned inside out, his face was curled out and it was horrible. I wanted to die. I wanted him to die. I didn't want him to live because I thought there was no way that he could ever make it. I remember going outside the hospital, laying on the grass and just crying and sobbing over it.

When he got in school, there was a lot of problems and teasing. They used to say he didn't need a mask on Halloween. So he went through some really bad times.

While his son gradually adjusted, after many reconstructive surgeries, Ken Pratt was not so lucky. The birth of this child without a face made him suicidally depressed, unable to hold a job. When I first met him, he was taking five different kinds of antidepressant and antipsychotic medications.

Gradually I got worse and worse, and four years ago my wife and I separated, my children wouldn't associate with me because I couldn't hold a job any longer. When I was young I was a really good worker. Not being able to hold a job was traumatic. I got so suicidal that I tried suicide three times and just three years ago I tried it the last time. Every time I get into a car today I think about it, just ramming into a building or bridge or something. It's always on my mind. Because there's nothing to live for. Everything disappears. We don't know our enemy, really.

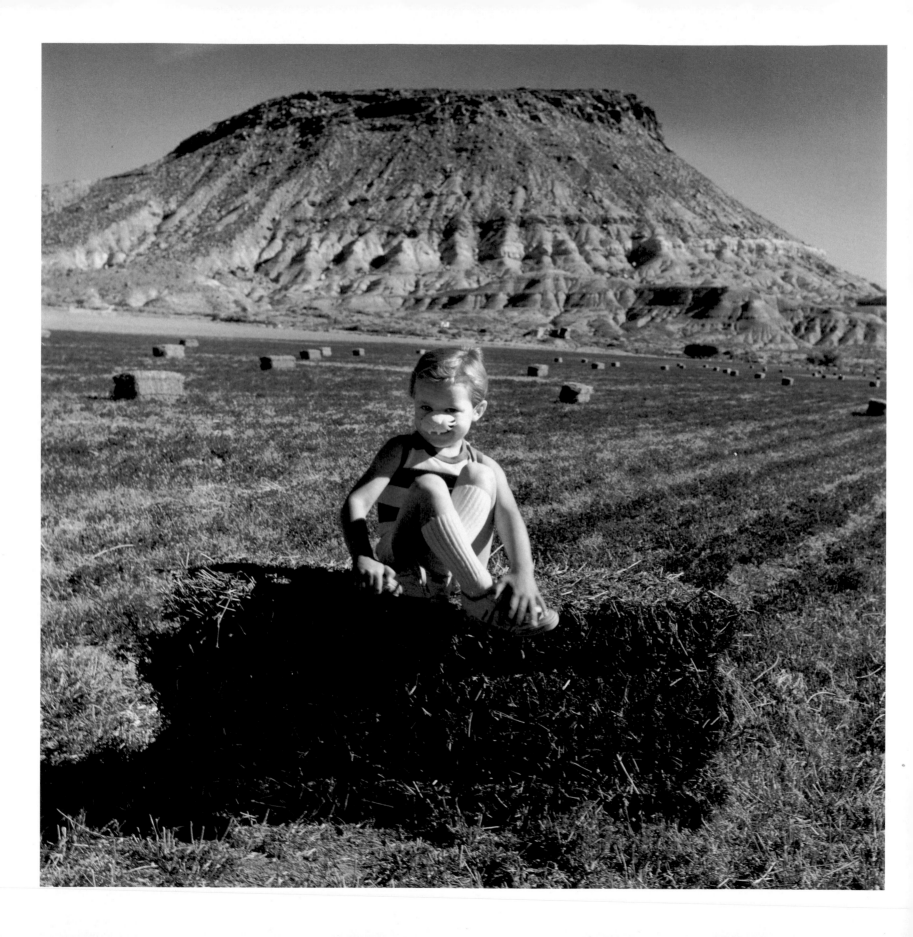

CUBA LYLE

October 1988

Washington, Utah

Cuba Lyle's great-grandson, Tyler Adkin, had leukemia by the age of two. "We had no more idea than the man in the moon what this was. We were dumb enough to think we could trust Uncle Sam. It's the same kind of dirty pool that's pulled off on everybody around here."

In 1952, when uranium fever hit the West, geiger counters bearing such names as Lucky Strike, The Snooper, and Babble Counter would sell for up to $2,000 and prospecting outfits were advertised as "U-235 Suits." A down-at-the-mouth prospector in southeastern Utah hit a mine by accident that was worth $150,000,000 and Salt Lake City quickly became the mecca of uranium stock trading. Robert Bird wrote in the *New York Herald Tribune* that "when Charlie Steen hustles down the street in the little uranium town of Moab, you almost feel the radioactivity in the air."[1] In Las Vegas, where hairdressers advertised "Atomic Hairdos," a chamber of commerce publicity release showed a bikinied woman checking a prospector's beard with a geiger counter.[2]

Cuba Lyle owned the Liberty Cafe on the Boulevard in St. George, Utah.

We had this one little man who stayed in the hotel. I can see him just like yesterday, little old Mac. He died later from cancer, but he would come in, and he had one of these funny little straw hats, like a song and dance man. That darned hat would just about drop off his head, he was so excited, came in and said, "Cuba, I've had that geiger counter of mine on that sidewalk and it is absolutely jumping." That was in front of the Liberty Hotel, where he stayed.

We used to see the flash. We were always up early, had to get up while it was still dark because we had the early shifts at the cafe. The windows would rattle, and you could see that flash through the Venetian blinds. It would light right up, not exactly like a fire would be, but paler than a red cast, more of a golden reddish. Time after time we'd see that. After the children's dad died I worked for Ashley McCoyd's garage. The main showroom was those great glassed-in showrooms

and I'm telling you, the blast swung the front doors of the place open and it almost took those windows right out. You've heard the stories, I'm sure, how they washed the cars off that were coming from Las Vegas, from the desert. I've never forgotten what Elizabeth Bruhn said at the Kennedy hearings, when it was time for her to testify: "You know, we were stupid enough to think that whatever the government did that we could trust them." That's right, that's the way we were. We had no more idea than the man in the moon what this was. When I think back, I don't know how we could have been so dumb.

Cuba Lyle first began to notice her husband's illness after they sold the cafe.

All of a sudden I looked at Roy and thought, "My word, he's a gray color," and he had a funny tight-chested sound as he coughed. He could hardly get his breath. This worried me. We ran into his old ex-boss who used to run the Big Hen Cafe in St. George. He said, "Roy, what in the hell is the matter with you? You better get your fanny in to the doctor's and find out what's the matter." So we put him in the hospital and ran some tests. After a week they still didn't know. I can understand why they couldn't recognize it—nobody knew anything about it and there was very little publicity. A lot of the tests wouldn't have been necessary if that doctor had known more about leukemia. The doctor didn't know what he was looking for. Roy walked in like you and I, and he came out in a wheelchair.

I can remember one time when they called from over the store—not everybody in town had a telephone back in those days—they called to send the message over to the school because the school had no phone. We didn't have over a hundred students at that time in all six grades of Washington Elementary School. They said, "be sure to get the kids off the school grounds," and that great big old pink cloud came waltzing right over and went right over us. It would go up through the valley and drift on over to Kanab.

It was the thirteenth of December that they told us he had four months to live. Well, he made it ten and a half. I had one day a week off from my shift at the Sugarloaf Cafe and I'd take off early in the morning at four o'clock so I could spend some time with him. The next morning I'd be at the hospital again right at six so I could see him for a few minutes to say goodbye, and drive home to work my shift. Six days of shift and then back to Salt Lake, every week. Here I am with seven kids, washing with no automatic washing machine, baking bread twice a week, making dresses for six girls and Lord knows what all else. I was a walking zombie, to tell you the truth.

Friends and neighbors, especially children, were dying of leukemia in Washington and St. George and Cedar City, all over southern Utah. A neighbor lost a husband and a son to leukemia, then her daughter was diagnosed with a brain tumor, and her second husband with colon cancer. Several more children from the 100 families of Washington developed leukemia. The legacy didn't stop with the end of atmospheric testing. Radiation-induced genetic problems have created a wave of illness in the children of those students at Washington Elementary. Tyler Adkin, Cuba Lyle's great-grandson, had acute lymphoblastic leukemia by the age of two. He is "the fourth generation" to succumb, and his mother, Stephanie, admits that in her high school graduating class "we have three kids with children that have cancer, born and

raised here in St. George, and more miscarriages than people really realize, and problems getting pregnant. They're all around 26 or 27. My husband's brother and my aunt on my mother's side have thyroid problems, and I have an uncle, a rancher, that passed away a year ago at 51.

"There were four [new leukemia cases] the same week we took Tyler in. They work with it more than we know. One girl that we went to school with, her daughter is two years older than Tyler and she had a tumor behind her eye and one in her stomach. A friend, a year older than me, has cancer. It's recent—he still has no hair. There is actually a group of all the cancer kids and their parents called the Candlelighters."

[Cuba Lyle concluded:] Most people don't think like you or I do. You can't get them to read. "Oh, I'd just rather not think about it." My home country is up close to Spokane and it was like the dark ages to me when I came here. We were dumb enough to think we could trust Uncle Sam. When the warning came to get the kids into the school, that should have really alerted them, but still nobody did anything about it. They won't make me believe that anything but that caused his death, caused him to have acute leukemia. It's the same kind of dirty pool that's pulled off on everybody around here.

1. Robert Bird, *New York Herald Tribune*, November 1, 1954.

2. Daniel Lang, *From Hiroshima to the Moon* (New York: Simon and Schuster, 1959), pp. 272–273.

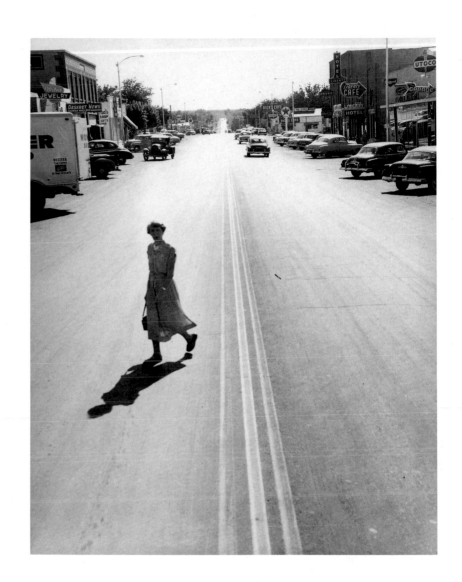

Photograph by Dorothea Lange. 1953. Courtesy of the Oakland Museum. The Boulevard, St. George, Utah, with the Liberty Cafe in the background.

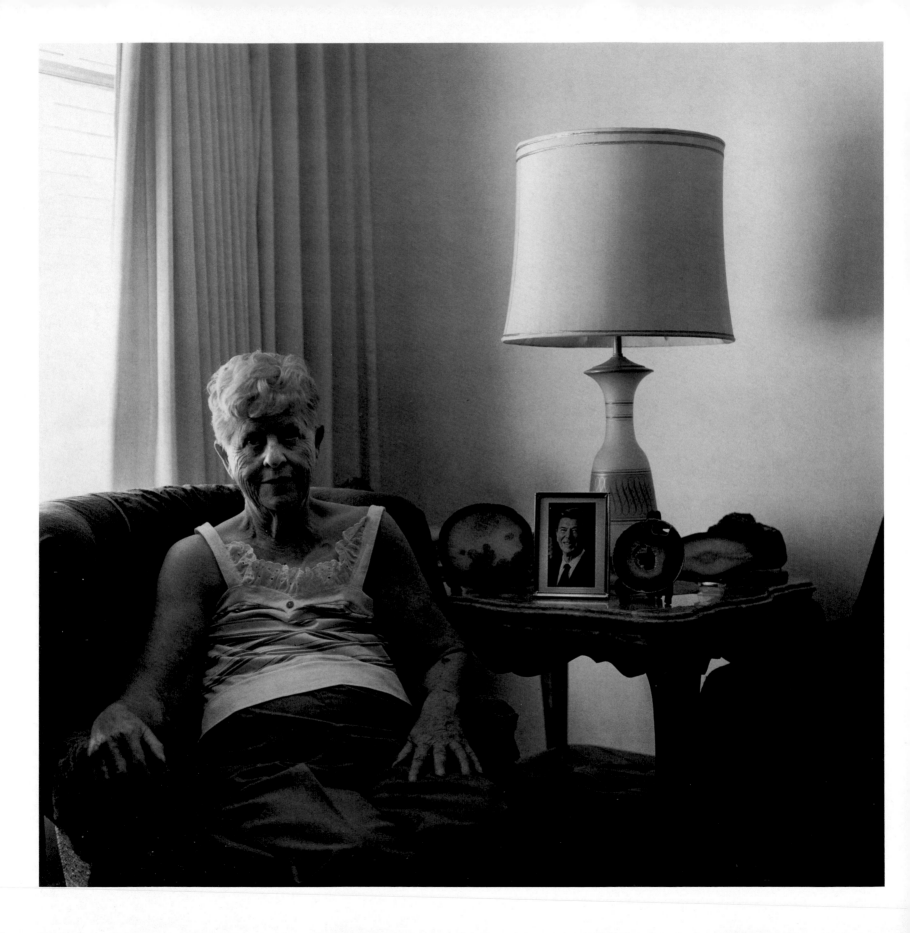

AUGUSTA PETERS

March 1988

Pittsburg, California

"I happened to slip my hand down and I felt a flat, hard lump, the size of a fifty cent piece. I had cancer in the other breast too. They've sawed the bone and took everything they could get under the arm, a radical mastectomy. It's been an awful thing. And I had to have a pacemaker put in after I had seizures when I had one of the breasts removed. When they talked to me about it I thought maybe that would make me look a little breasty to have something there, but then the doctor showed it to me. I thought, 'Oh, that!' and it was the first laugh I had, it was so little."

My husband had been a building and painting contractor in Chicago. He had his heart attack and we came out here. My brother had a silver mine out in Nevada that he was all excited about. My husband got interested and decided to help him. We went out to Ely Springs, Nevada. My husband was born in Sweden and it made him think of the country there. There's an old house there and we ran a camp and worked on that silver mine. I cooked, washed, and did the camp work and we did hit one good payload. He was gambling in that mining business and he wasn't a quitter. Then a promoter in town got hold of him and told him what a great opportunity there was in Pioche, so we lived there in an old mining house way up on the hill. You could look out for 20 miles into the valley from the window. It was too high of an altitude, we didn't know, and his heart began to get bad. After he died, the man that ran the *Pioche Record* newspaper came up to see me and I couldn't get rid of him. He was a very intelligent and nice person, and it was a really isolated place, so we got married.

These agents come around to the newspaper and asked me to wear a monitor for the atomic reading. I went out and stood up and watched every one of them. You've got to get up at 5:30 in the morning, go down and stand on this hill between Pioche and Panaca. I was thrilled. It's only 30 miles direct to where they set it off, not very far away. I stood right under and watched them all. There was a beautiful formation, and then the bomb went over my head, the cloud went right over to Utah. Of course, that's where all the fallout came and everything. Lynn wore his badge constantly. Then they came and collected it, and the agent was wearing one too. They didn't tell him if it read anything or not, and they didn't tell anybody it was dangerous.

When we were in the mining business we were interested in uranium. There was a big demand for it, so we went prospecting over in Utah near St. George. We went with a [geiger counter] wand and found a lot of that petrified wood that was radioactive. It would really make the wand go good so we staked a hundred uranium claims up there, got the people all excited. Then suddenly the uranium went down as fast as it got up. I figured it was a losing game. It wasn't uranium at all.

After her second husband died, Augusta Peters sold their house and moved to California. Many years later while watching TV she heard a public health announcement about breast cancer, mammography, and self-exams.

So I happened to slip my hand down and I felt a flat, hard lump. It was big when I found it, the size of a fifty cent piece. I thought, oh, my goodness, because I didn't know how long it had been there. I had cancer in the other breast too. They've sawed the bone and took everything they could get under the arm, a radical mastectomy. It's been an awful thing. I wouldn't think removing the breast would be so horrible but you don't know what you go through with this scarring after you think you're healed, and the pain from the tissues and the shock of it all. It takes an awfully long time, four years to heal. Now I'm in a great depression with all these awful pains from the healing. I'm depressed terribly and I've developed thyroid, have to take thyroid tablets now. It just stopped acting. I'm very weak and have no strength. And I had to have a pacemaker put in after I had seizures when I had one of the breasts removed. When they talked to me about it I thought maybe that would make me look a little breasty to have some-thing there, but then the doctor showed it to me and it was just a little thing. I thought, "Oh, that!" and it was the first laugh I had, it was so little.

I was out purposely to go see the clouds, beautiful clouds. I saw at least a dozen. I was thrilled to death to see what they were doing. I didn't know you could suffer from the fallout, and now today they say people in Japan that lived through it are suffering. They didn't tell us that, they told us it was harmless. I thought they didn't hurt me because the cloud didn't come down and hit me. They didn't tell the public the truth. Why did it have to come our way all the time? Why couldn't it go toward Las Vegas? No, more people live there, they didn't want that fallout on a big city like Los Angeles, so they did it mostly on deserts and little towns out our way.

It's no little thing to have a breast removed. My mother had nine children and I'm the only one that's been known to have cancer. I tell you, I know less than I ever knew. I've got more questions about everything. It's been so depressing. I would die if I could, I'd commit suicide but I'm afraid I'd make a mess out of it and be worse off. But really, I don't think one should have to live every day just getting ready to cry. I can hardly believe there is a great God. But it's a life. It's a mystery.

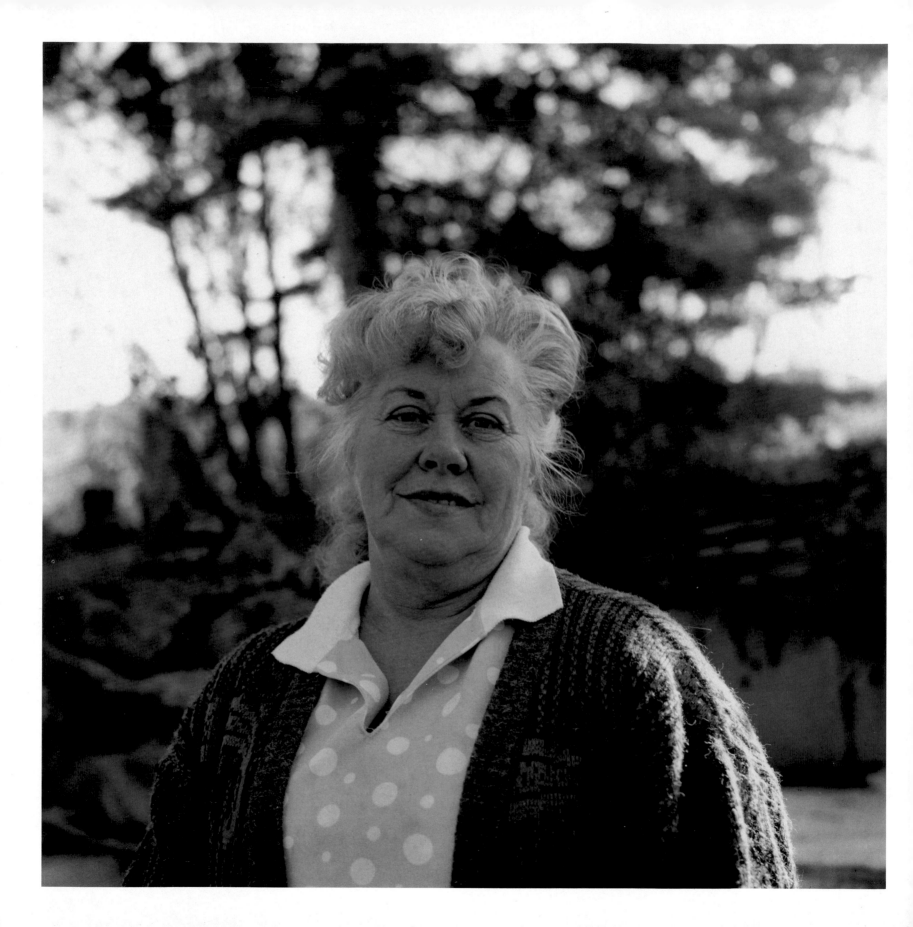

GLENNA ORTON

January 1984 and December 1991

Parowan, Utah

"I'm a person. I'm just as important as anyone in Las Vegas or New York. We've got a Constitution and a Bill of Rights that entitles us *all* to life, liberty, and the pursuit of happiness. We have been used for guinea pigs and I just really resent it."

The house I grew up in was an old adobe, one of the first five adobe homes built in Parowan. It's the mother town of all southern Utah, the first settlement south of Provo. We had seven young people die of leukemia in two years around 1957, and we had never heard of a leukemia death before that time. That's when I think people began to be afraid that it was the radiation that was causing the problems. We're a small family community and a trusting people. We trusted the government. This is what's hurting now because people are furious that the government lied to them. We had seven retarded children born through that time, more than we had ever known in this area in the whole history of Parowan. [These children, called "our row of angels" by the Mormons, were placed at the very front at Sunday sacrament meetings in these tiny southern Utah towns.] We had children who had bone diseases. We were back to nature as much as a people could be. We all grew gardens, do canning, raised our own animals, we had milk, our own cows and chickens. We ate meat and fruit and things growing in the ground and we were being recontaminated with it. This fallout, you were breathing it, you were eating it. They kept on telling you there is no harm and you don't need to worry, so we were all quite fascinated as we watched the pink clouds, big clouds that came up over the west hills. We'd all get our children up out of our basements, where they would have been a lot safer, and took them out to watch this wonderful sight. They didn't want to miss this great thing . . .

The cloud itself was beautiful. It just raised up like a big mushroom. I think it was Dirty Harry, the wind kind of stopped and it just hung right over these west hills for three days. They kept saying it won't hurt you. They brought monitors to put on several people. When the geiger counters started to

go crazy some called and tried to get some of them to come and check, but they would not do it. Ross Hewlett, his was an immediate death and they did sign his death certificate as radiation poisoning. He has had one daughter die of cancer and another who had a malignant kidney removed last year. [Dirty] Harry, the worst one, left a salt film over the cars and everything was tinged a little pink. It was all over the sidewalks. It almost had a salty taste to me. They said, "Wash your cars, the radiation is a bit high." My father said, "How do I wash my barns, animals, farm equipment, and my fields?"

There were 23 cases of cancer in the three-block area where my mother and father lived. It's tremendous, the suffering and the heartache in this town. There's hardly a family that has not been affected one way or another. If my neighbor across the street has cancer it's like my family having cancer. In a small community like this, a lot of people are self-employed and they can't afford insurance, it's become so high. They lose everything they worked a lifetime for.

When they were setting those things off, my dad used to break out in a rash all up his arms and legs. He'd be out in the fields. It would itch real bad. My mother would get really nauseated with terrific headaches, start to throwing up and have diarrhea. She would say, "I wish they'd quit setting that darn cloud off." She died at 51. My father was a farmer and livestock man in the valley. He ran his sheep and cows up on the mountain by Brian Head. He had his farm out west of the valley; there were four good-size farms there. Out of those people, my father, my mother, and my brother had cancer, and Dad's hired man. Earl Bunn who had the other farm has had cancer for quite some time, the two brothers both had cancer, they lost their hired man too and one man's wife had

cancer. She's dead. You should have seen the lambs. They were born like little balls, no wool on them, just deformed pitiful little things. Randall Adams would never eat the mutton that he had in his herd because when he butchered them he said there was a black streak along their spines and he was afraid of them.

My father had never known a sick day in his life. It started in his left sinus and just ate the whole side of his face away. They did really radical surgery and ended up taking his eye and the roof of his mouth. He had to keep a pad over because of the reek of the rotting human flesh. The odors were just unbearable. He lived with us the last seven months of his life. I asked him, "Dad, if you had known how this was going to turn out, would you have let them do all that surgery?" He could hardly eat at all, he couldn't speak so you couldn't understand him very well. He looked at me like I was crazy and said, "Of course I would have. If they haven't learned to save me, they may have learned something to save someone else's life." This tells you what kind of person he truly was, and the doctor told me that he had suffered more than any man he had ever known. The last time we weighed him in 1968 he was 70 pounds, and my mother weighed less than 50 pounds when she died in 1962. The sad thing is you've got to sue the government to get anywhere, to get attention. They cannot bring my parents back, that heartache has already been there. I watched them die by inches. It's grotesque and it's gruesome, absolutely heartbreaking. I still live in terror for my [six] children.

We have been used for guinea pigs and I resent it. Less people would have been affected if they had let the cloud go over Las Vegas because people lived indoors and they worked indoors and they didn't raise their own food. I just

really resent it. They don't know how long that radiation is going to stay; they're telling us forever, five, ten thousand years. Then they say it's going to affect genes. When the genes are altered then there's going to be human defects. My worst horror is that there is no real medical center in this area. People actually have to go to Salt Lake City. What an insult to go up there and get your chemotherapy, and come back down vomiting all the way.

Nearly eight years after my first meetings with Glenna Orton, I returned to Parowan late in 1991 to visit her one last time. The news was not good. Her daughter, Kaydell Mackleprang, had a lump on her thyroid that had caused it to dysfunction, speeding up her metabolism so much that she was suffering heart palpitations. When Glenna took her to the hospital in St. George, the doctor said, "Oh, you have that radiation kids' disease," but wouldn't say whether or not that lump was cancer.

They said her heart would wear itself out, it was going so fast, and she'd have a heart attack. They had to go in and kill the thyroid in order to slow it down because they said that the medication they gave her would give her bone cancer or leukemia by the end of the year. She was just hyper-hyper and her eyes were starting to bulge, I think they call it Grave's disease. She had a lump on her neck. She went to a specialist down in St. George. They're not recommending surgery for that anymore, they killed it with radiation, gave it to her in a fluid. They just took her in and then let her go home. I had a friend who had it done ten years ago and they made her stay in the hospital for a week. I had to take her children back with me so they wouldn't get irradiated. They said particularly the little ones should stay away, or they could get sterile from the radiation from her. She couldn't prepare any food or wash dishes or anything like that, and had to stay home alone. They didn't say anything about her clothing. They advised her not to have any more children, but she already had such tough pregnancies with the three she had that she decided they wouldn't have any more. She just couldn't carry them long enough to get them mature enough that they would live, so she would have to go to bed and stay there for months. My other daughter Wendy has a slow thyroid, so she's taking medication to speed hers up.

Glenna Orton sighed, and a glint of rage in her eyes alerted me that she was not as resigned and passive as many downwind had become during their 35-year-long trauma.

I'm a person. I'm just as important as anyone in Las Vegas or New York. I'm a United States citizen. We've got a Constitution and a Bill of Rights that entitles us *all* to life, liberty, and the pursuit of happiness. I think they've taken some of my freedom away. This is kind of like Russia. Human life is expendable. Basically we expect the government to protect our people. That's one of the things I think we have a right to expect. I'm just as important as someone somewhere else.

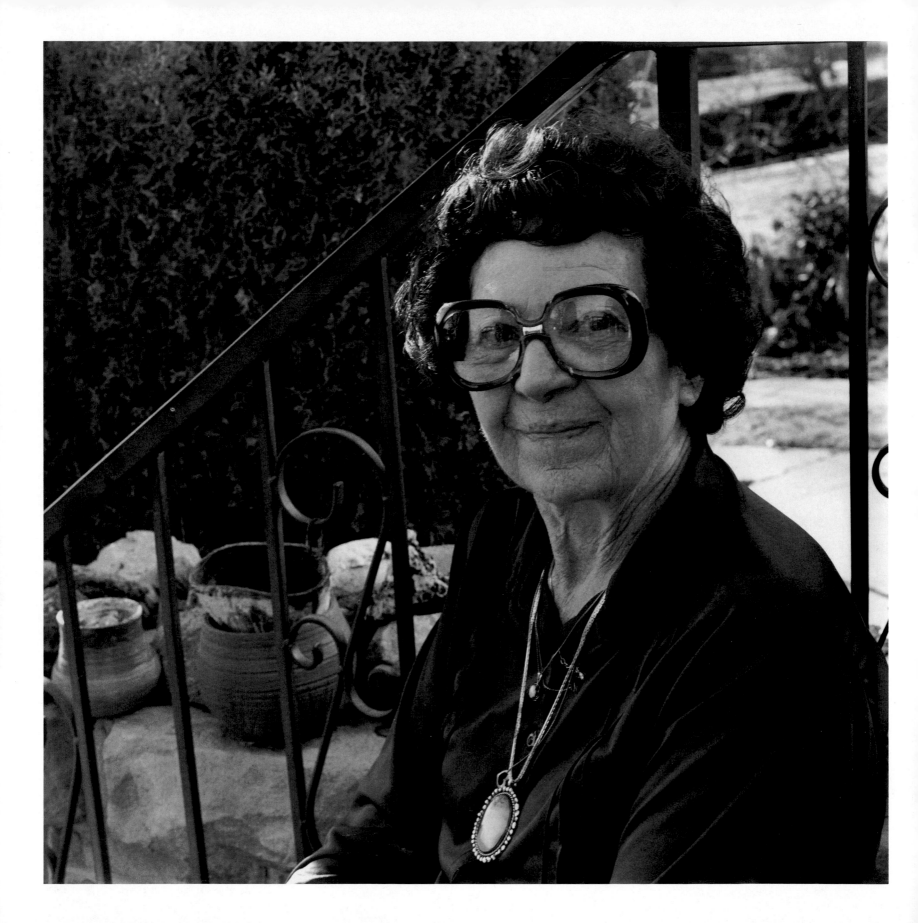

IRMA THOMAS

December 1983

St. George, Utah

"**Wars are made in the minds of men, and that's where they should be fought. We were naive. They told us the fallout was insignificant and minimal, those were the two choice words. I say we've had so damn much insignificant fallout that it's killing us all. We trusted our government, but they considered us expendable, that's for sure.**"

Irma Thomas was a woman obsessed. Uncomfortable from the start with the idea of atomic bombs exploded so close to home, she had bombarded the local paper with letters of protest since the early 1950s. When I arrived at her door in 1983, she was sure to show me within moments a map of her neighborhood covered with dots, one for each friend who had been affected. In just two blocks there were 20 victims, 14 deaths so far. Her "ammunition to carry out this battle" was stacks of studies, reports, and books on the effect of radiation on human health collected over twenty years. "Here, read this," commanded Irma, passing me a 30-year-old Test Site press release: "Some of you have been inconvenienced by our test operations. At times you have been exposed to potential risk from flash, blast, or fallout. You have accepted the inconvenience or the risk without fuss, without alarm and without panic. Your cooperation has helped achieve an unusual record of safety."

I spoke out against it. I don't speak for the [Mormon] church, I only speak for me. Wars are made in the minds of men, and that's where they should be fought. They're pretty powerful when they can reach out and send these young boys to fight and kill other young boys, and boy, I object. I was cussing out an army man one time, up in Salt Lake, I said "Be not proud." I get tired and frustrated and bitter, but not discouraged. I don't give up easily. I've worked hard. My only regret was that I waited as long as I did. I'm going to fight them to the bitter end. But I'm 77, good hell!

My husband has had cancer for many, many years, and I've had cancer treatment myself. I figured it was inevitable. I didn't file a suit because I didn't want to destroy my credibility. I can point to almost every house in the neighborhood

and name names of people who've had cancer. I met a girl in a store the other day, and she was sounding croupy, and I said, "For heaven's sakes, have you got a bad cold?" And she said, "I've just had a cancerous thyroid removed." That's my life. I can't walk out on the street or go anyplace or answer the phone without hearing another story.

I have a little sign over there on the piano, and it says "I'm mad as hell and I'm not going to take it any more." You have to get pretty damn mad before you can do anything. I wondered for a long time about the sterility of my boys, but I didn't ask them about it. And when I saw what was happening to my beautiful talented young daughter, and my young attorney brother who died with cancer, and my sister, oh Lord, don't get me started. I'm so full of stories I make myself sick. My daughters had miscarriages, stillbirths, and hysterectomies, and a lot of my friends have died from it, too. They actually felt the hot radiation raining down on them. One tried to wash it off, but the burning doesn't come off that easily. The children were all out in it, walking to school. Young people were dying from leukemia. And really *young* women with mastectomies!

My mother lived up the street here, and some of her friends used to gather on the porch to watch the cloud go by. I didn't go out and watch. I saw the flash in the bedroom, it came early in the morning just like a lightning flash. It made the room all light up. I was nervous about it, I must admit, from day one. It worried the daylights out of me because my children were small. They were always telling us that it was the Russians that were going to do this to us, that we should build fallout shelters and put in a supply of water, all the instructions that they gave. I didn't know what in the Lord I was going to do for my big family. They said we needed a dirt bag three feet deep in front of every window to keep the radiation out and yet they showered it on us and said it wouldn't hurt us. We should have built those shelters, but we didn't know that *they* were the ones that were going to bomb us. I can't believe that we were so stupid, and they knew it. We were naive. They told us the fallout was insignificant and minimal, those were the two choice words. I say we've had so damn much insignificant fallout that it's killing us all.

They're still blowing off those things, but I'm not going to give up. I'm going to go on with this as long as my breath holds out. We suffered in silence for all these years, too damn long. We trusted our government, but they considered us expendable, that's for sure.

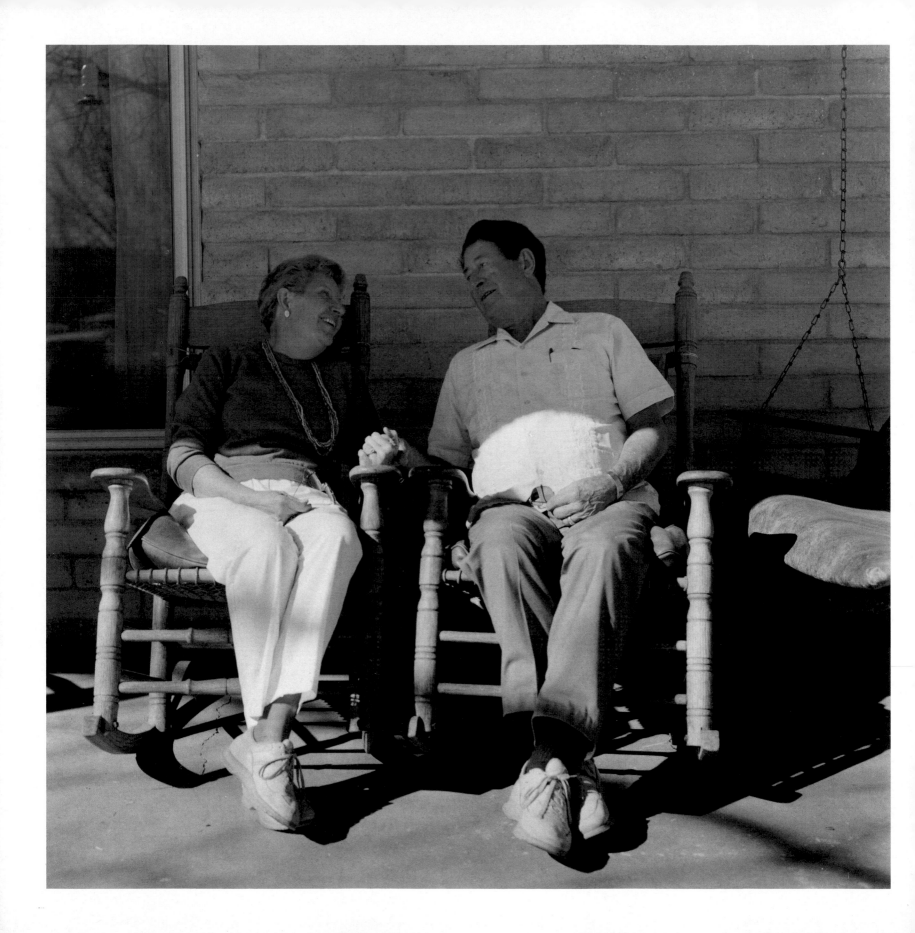

EVAN AND ENA COOPER

March 1988

St. George, Utah

"We had to lower our heads and cover our faces during the blasts, and then we looked up and this huge mushroom was just starting up. The gravel danced a foot off the ground. It started to come right towards where we were, and it rolled right across there, big, huge, gray, the intense color of it, you can't hardly describe it."

Proud of his ancestors, "pioneers, very much so," Evan Cooper explained while seesawing on his rocker that his polygamous grandfather was one of Brigham Young's bodyguards. As he recounted stories of local families affected by the fallout, I found I knew many of the people that he did. I asked him about a man I had interviewed a year earlier, whom I wanted very much to visit again to clarify some details. It had been impossible to get in touch for many months, and I wondered if he had moved. Ernie May was a man starved for affection: weeping, he had told me the story of his wife's death at 49 from leukemia, quite out of control by the time he finished despite how many years had passed. "Has he moved?" I inquired. "His house seems empty and his junkyard out back has been cleared. There are even fresh tractor-tread gullies." Cooper and his wife looked at each other sadly. "He killed himself," Cooper said. Not missing a beat, his wife added, "But before he did, he shot his girlfriend dead. Nobody really knew what happened or why."

Evan and Ena Cooper had also lost their first spouses, but were lucky enough to find each other shortly after. Still, both are conscious of time: so many couples married again, they told me, only to have a second spouse die of cancer. "We are very happy. We have a real good life, and live for each day. Nothing is forever. We count the months instead of the years."

I was working at the Bureau of Mines in Boulder City, Nevada, in 1951. We had four children. The first blast went off about four o'clock in the morning when we were getting breakfast, getting ready for work. The cabin lit up brighter than electric lights, just a flash. The power and hugeness and vastness of

these blasts were quite exciting. Your house would rattle. About ten o'clock the clouds would begin to come through here and they weren't rain clouds. They were more like a sunset cloud, reddish, and they would fan out into the valley. I don't think we ever figured there would be any harm done from the experiments going on down there until people began to die with leukemia, young children. We just had one case after another, and we began to wonder. There was five within a block that died. There is no doubt about it that this fallout had something to do with so much cancer.

I had a young daughter born in 1950. Seventy-two children at the Woodward School were under strict observation and she happened to be one of the eight that had thyroid problems. Two of them they did surgery on. Her mother, Glenna, died of cancer, ovarian carcinoma, and cancer in lymph glands. She was a very husky woman, very active, and she could throw a saddle on a horse as quick as I could. She loved adventure. To see her wither and die, to leave this earth weighing 90 pounds and she fought every inch of the way, it was quite sad. When you begin to look around there is hardly a family that's native that hasn't been touched with one or two or three out of their family with cancer.

It seemed to hit the outdoors people more than the indoor people. If you were out or in, the fallout fell on the ground and we grew our own vegetables. We had our own chickens, pigs, beef, milk and butter. We were sitting ducks because we made our living off the soil. It was a funny thing, you could go out with a geiger counter anywhere and put it down and it would go just wild. You could take your foot and shift the dirt away and it wouldn't do anything. What made us feel like the government was a little bit concerned was that nu-

merous times there was a blockade and they washed every car that came through Santa Clara. They were also stopping them out on the Mormon Mesa and making them change clothes.

Ena Cooper lived with her late husband, Trent Spendlove, at the edge of the Test Site, in very close proximity to the Frenchman Flat detonation area.

We knew when there was going to be a test, so we sat outside of our trailer in Indian Springs and listened to the countdown on the radio. We could even see the planes as they came towards ground zero from Nellis Air Force Base. We had to lower our heads and cover our faces during the blasts, and then we looked up and this huge mushroom was just starting up. The gravel danced a foot off the ground. We watched the cloud as it formed. It started to come right towards where we were, and it rolled right across the air base area there, big, huge, gray, the intense color of it, you can't hardly describe it. The planes from Nellis were spraying it with dry ice. It was really significant that this big cloud had got away and hadn't gone the direction that they thought it would. It did miss our trailer court by probably half a mile, the main body of the cloud. For over an hour it was rolling by our area. There were three women pregnant in the trailer court at that time and all of their babies were born dead. They just deteriorated inside their mothers.

[Evan Cooper continued:] We were all pretty gullible, and I feel the government used us as guinea pigs. I think it was intentional to see what would happen. We have some pretty

smart cookies in the world that did a little research before they began to turn it loose. You can't bring back somebody that's already died, but you could take away a little sting of the cost in admitting it. It has turned out to be quite a serious situation. My theory is the truth shall make you free, and if there isn't any truth we can't be free, can we?

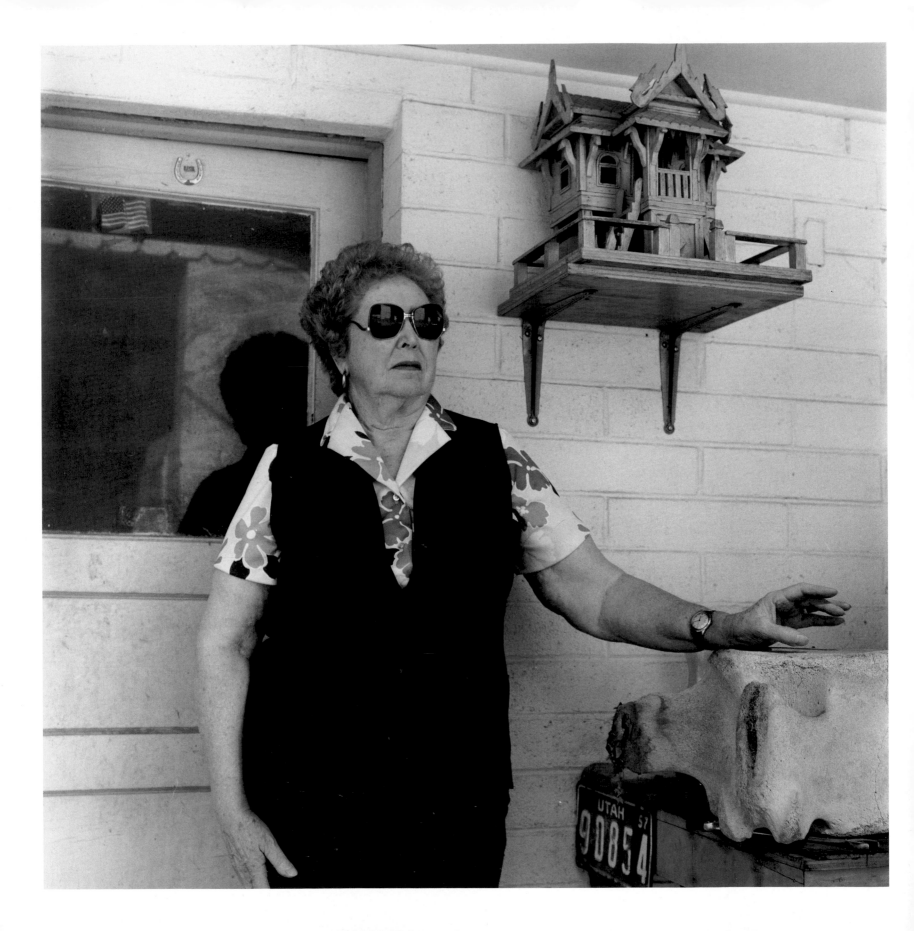

NORMA COVINGTON

February 1986

St. George, Utah

"When there was going to be a blast, everybody opened their doors and windows because the concussion was so heavy. You can hear it go through your house with a shhhhhhhhh. You'd see plate glass windows all over the place snapped out. I sat here one day and just watched my house split right down the middle."

At the time they had this testing I was working for a hardware store. The fallout was so great that we sold hundreds and hundreds of the boards that they use for staking [mining claims]. People went crazy. They staked everything from the east side of the road as far as they could go. There was so much fallout that the geiger counters went absolutely mad. If you were to pick up a rock or kick the dirt, there was no radioactivity underneath the rocks, but they just staked out thousands of acres. My husband, before we were married, owned a motel, and he had one of the AEC men stay there. When they had one of the big blasts Burt said this man took out his scintillator. He was standing right beside him and that thing jumped clear off the graph. He said he turned it upside down and shook it and adjusted it all, this was in the laundry right in the middle of the motel, and the thing went absolutely crazy, there was so much fallout.

In 1954 I went to work for J. C. Penney's. I worked upstairs where we had a window catty-corner from Union Utah Oil station. That day the radio broadcasted they had this blast and the wind turned wrong, and they told everyone to stay under cover. Every car that came through from Mesquite was stopped at that Utah Oil station and washed. They wouldn't let the kids out for recess at all that day because it was so bad. Of course, we believed what the government said, that they didn't know the destructive force of this thing. So when they told us there's going to be a certain blast, people got up there on the hill to see if they could see it, usually at five o'clock in the morning. When there was going to be a blast, everybody opened their doors and windows because the concussion was so heavy. If you didn't, your glass windows would pop out. You can hear it go through your house with a shhhhhhhhh and your curtains would give. You'd see plate glass windows all over the place snapped out. I sat here one day and just watched my house split right down the middle. A lot of people have cracks in their homes.

You could see a great big pink cloud come right over and you could taste it. It was a metallic taste, something awful, like artificial salt. You could see that red cloud go right over the top of this house. We were expendable, the whole bunch of us. When the breeze wasn't right and it was going into Las Vegas or Los Angeles they'd postpone them, but the people in Mesquite got it and the people in western Nevada got it, and eastern Nevada got it bad. Cedar City, we got it bad. they'd bring their people in, the scientists, and they would test the alfalfa; it was radioactive. They tested the milk from the dairies; it was radioactive. You couldn't get away from it. They had lots of kids with thyroid trouble, thyroid cancer, and leukemia. Of course, they say it wasn't the radiation. There's no better stock in people than from Santa Clara [a town 8 miles to the west of St. George]. My cousin married a man from there and while this was going on her 16-year-old

daughter died of leukemia just real fast. Her husband had leukemia, his brother got leukemia, three of them out of that family.

I ended up with this crazy thing, cancer of the larynx, three years ago and I had to have my voice box removed, and they had to cut my vocal cord. It was in my late forties, early fifties that my eyes started dimming, one worse than the other. The operation takes the filter out of your eyes, so on a bright day it's like looking into the sun. Coming back from Mesquite the moon was so bright it even hurt your eyes. You have to learn to live with dark glasses. The opthalmologist said he couldn't understand why I would have cataracts so early in life.

When I mentioned to Norma Covington that early cataracts were common in atomic veterans who were heavily exposed to radiation during maneuvers at the test sites in Nevada and in the Pacific, she was stunned, then angry.

I don't think people back east give a damn. I don't think Washington cared. It might stop some of their programs. They've got some of those high-powered boys in the Pentagon, all they want to do is make a name for themselves. I think what they did to us was terrible. If only they would have accepted responsibility and say, "Hey, we realize what we did was wrong and there is nothing we can do about it now, but we accept our responsibility." But to keep on coming back and saying, "Hell, you guys are crazy. You just don't know what you're talking about," it doesn't help.

Why do people here keep on voting for more military spending, for a "strong defense" and for Reagan, who has built the military up to a dimension many times what we've ever had?

Why would people not make the connection between what's happened here and the insulated Washington Beltway mentality that made it happen?
I guess the charisma of Reagan, plus Utah is definitely a Republican state. Then when you put people in like [Senator] Garn and [Representative] Hansen, you think you're going to have someone that is going to fight for you and they don't do a thing. They go back there [to Washington] and join the pack. The [Mormon] church says it doesn't want to get into politics, which is a bunch of malarkey because when anybody runs [for office] they're right in back of it. I don't know why they didn't take a stand. The Lord has given me a voice, and I say what I think. I'm very much opposed to this nuclear stuff. We need to take care of these people that are laying on the sidewalks. We need more homes. We need more education for the kids. There is so much that the farms need help with. There are so many people that need help. Clean up the water, clean up the environment. Maybe going down the middle of the road is easier. Maybe that's what the government counted on. They [the people of Utah] don't like it, but they don't want to put their name down because they don't want to get involved.

Right now all I can think of is eight in my family who've died. I think people have accepted it as water under the bridge and have the feeling "What can you do about it?" People were affected with it after 30 years. You see so much of it you accept it, just like nudity on television. Twenty years ago, you'd be horrified. Then it just creeps up on you and you absorb it, and it rolls off your back and you don't worry so much. I think we have a tendency to be very upset when it first starts, but if you can't do a darn thing about it, you just accept it.

Photograph by Dorothea Lange. 1953. Courtesy of the

Oakland Museum. J. C. Penney's and the Big Hand Cafe

on the corner of Main Street and St. George Boulevard in

St. George, Utah.

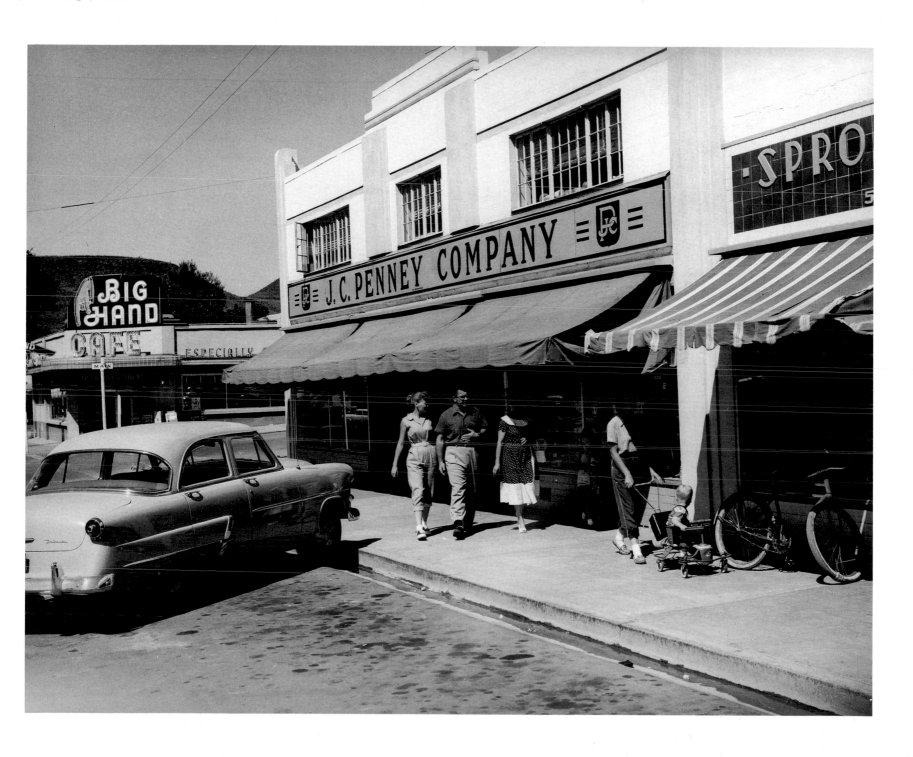

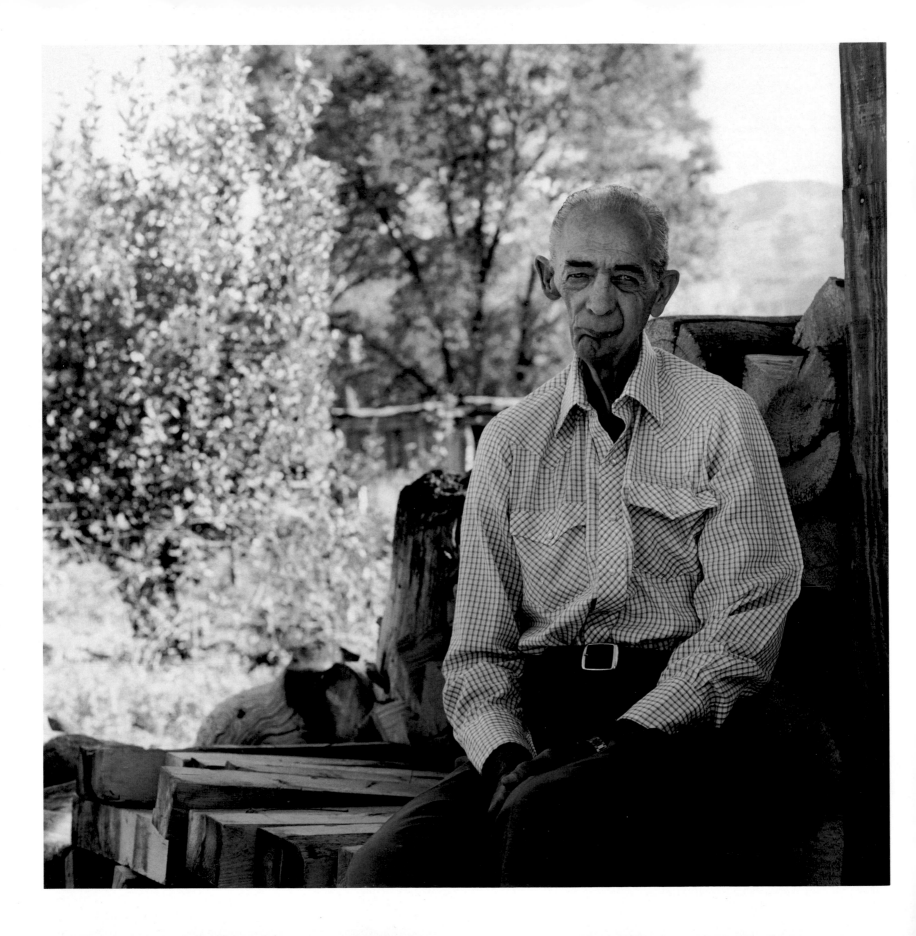

ALDEN ROBERTS

October 1988

Annabella, Utah

"They cleaned out [the cancer] from my heart up into the right side of my head. I could hardly open my mouth. They did plastic surgery so I could open my mouth better."

Alden Roberts, the father of seven children, was a schoolteacher and an outdoorsman who followed the Mormon "Word of Wisdom" all his life: no smoking, no drinking, no caffeine. His family raised their own food in their garden. "We had a cow we milked also." In the town of Annabella there were only about 187 inhabitants, yet out of the six homes within a block of the Roberts house, three were stricken with cancer or leukemia in the space of three years. The usual statistics for leukemia are three cases a year per population of ten thousand in an area not exposed to radiation. Shortly after his neighbors' deaths, one of his sisters died of bone cancer and the other of illness related to thyroid cancer. "It seemed odd to me that three of us so close together would come down with cancer within two or three years of each other. I just can't see why they can't believe it or see it," exclaimed Roberts in his loudest whisper. His wife agreed. "It just doesn't seem normal when you have a healthy body and you get cancer."

In March 1957 I had a lump. I was advised to go to a specialist, which I did, and was operated on. No malignancy showed then. I was teaching school in Richfield, the Ashman School. I went back to teaching and I noticed when I would go outside the air would affect the operation, so I put a scarf over it. My jaw started swelling. It puffed up quite a ways. I went back and had another operation. I came home and the swelling started again. I don't know how long it was but I went back and had another operation. This time it was malignant, [osteo]sarcoma. I had only about three to six months to live, according to the doctors.

Doctor McMurran suggested I go to the Tumor Institute in California. At that time I had two sisters living in Los Angeles, so we made an appointment in August 1957. After a meeting of doctors they decided that all that could be done was to operate. It was terrible. They cleaned out from my heart up into the right side of my head. [That operation paralyzed his vocal cords, permanently, and he can barely speak. The skin of his jaw stretches yellow over the bone. His face on the left is cut away, as is much of his head around the ear and neck.]

After the operations in California I had cobalt treatments for seven weeks, five times a week. That made my bones brittle. While playing football with one of my sons, I broke my shoulder from a fall on the ice, and it wouldn't heal. Three months later I went to California to get this clavicle taken care of. It had to be removed. I got an infection from the scar tissue so bad that I went to Salt Lake. They scraped the bone and cleaned it up. The scar tissue kept increasing and a hole came in the right jaw. I could hardly open my mouth. Dr. Edwards cut part of my jaw bone out when they did plastic surgery so I could open my mouth better.

The intense radiation from the cobalt treatments may have cured the cancer, but they impaired Alden Roberts's immune system so badly that he could not rid himself of an infection of his sternum, which gradually grew through his skin and opened up into a hole in his chest. Future operations would replace with skin grafts those areas of his face, neck and chest that were cut down to the bone to remove the cancer and infection. One could never be sensitive enough in the delicate situation of asking to photograph a man whose cancer had so obviously eaten him alive, leaving an arm hanging uselessly at his side and his face reduced by a third. A man so firm in his belief in God reduced me to thinking of any such deity as a cosmic sadist, yet Alden Roberts was far stronger than I in this situation. He was gracious in granting my request for an image of himself. In forsaking every opportunistic rule of macho photojournalism, I hope I have given him back a portrait that is as generous, if sad, as he is.

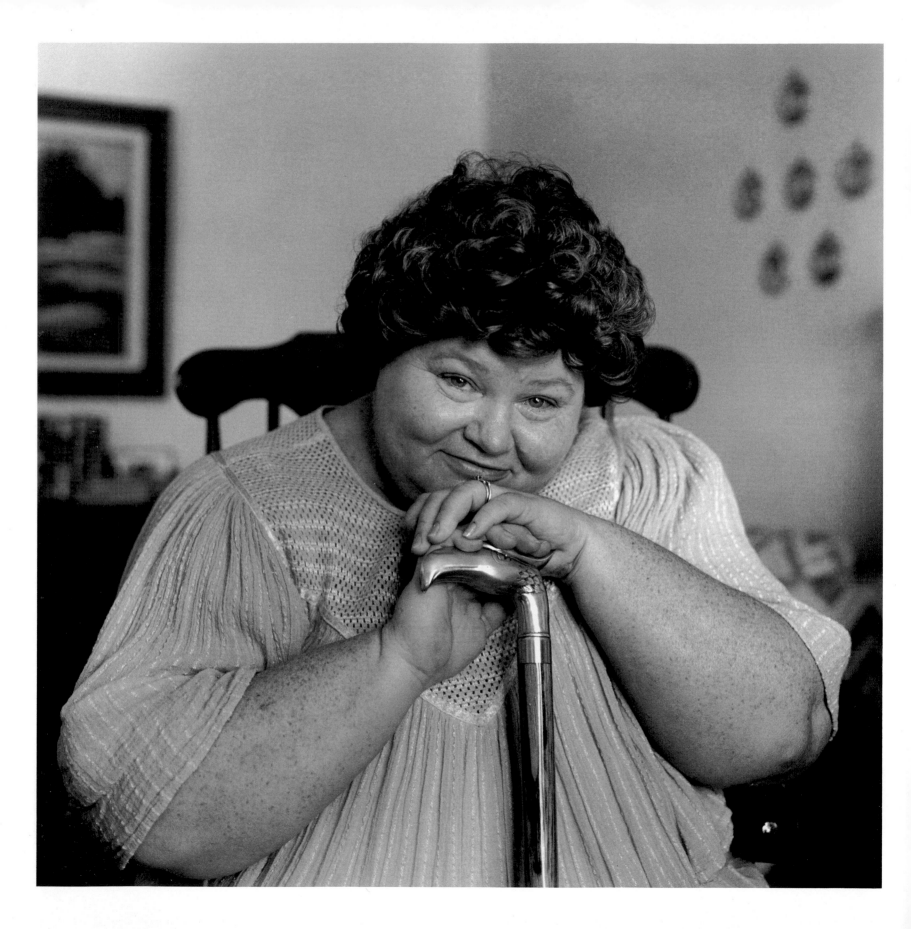

JOANNE WORKMAN

April 1985

San Jose, California

"I kept on having to brush my arms off because these little gritty things had fallen on me. It wasn't like a normal wind, it was awfully awfully hot and I was getting sunburned, I thought. I had these big pieces of stuff in my hair and some right up against my skin. When I went to comb my hair, my scalp started to lift up. It was just really scary."

Born in 1934 in St. George, Utah, in one of the original buildings of that pioneer town, Joanne Workman was a 17-year-old girl in the grips of polio when atomic testing started at the Nevada Test Site in 1951. By 1953, when the testing schedule was in full swing, she had recovered enough from her illness to begin making up the classes she had missed at Dixie College. It was on her geology assignment with Dr. Arthur Bruhn (later the president of the college, who would die of acute leukemia in his early forties) that she received an enormously toxic dose of radiation from the fallout cloud of Dirty Harry, the largest and dirtiest test of the program thus far. They were instructed to meet at Jackrabbit Flats in the desert wilderness many miles west of St. George, and much closer to the Test Site.

I just drove myself out there. I still couldn't go on all those long walks. I had rheumatic fever and polio both. I was watching for a field trip I could take without causing too much illness. It came up that they were going down to watch the bomb explode, and they had written to the captain commander down at the base outside Las Vegas, down on the desert. He [Dr. Bruhn] had a letter saying we were more than welcome. We had to initial it so we could show that we had seen the letter. We went down by the place they call The Summit, which was just off Highway 91.

How far away was it from the Test Site?
I don't know—maybe 90 miles. I drove my own car, no one was with me, parked, and walked up the hill and sat down to watch it. I really didn't want to see it. I didn't particularly want to be there and I don't to this day. In fact, I've always tried to remember if I saw the light first or heard the noise first. We

were there before dawn and sat there and waited. The ground shook and this wind came up, and it was full of little gritty things.

I was waiting to talk to Mr. Bruhn, to leave. I wanted him to know for sure that I was there. I didn't want to stick around, but I wanted him to know I was there. He said, "I want you to come with us—we're going to walk around." I said, "Mr. Bruhn, I can't. I'm not allowed to do that kind of walking, still." "Well, okay, if you can't, you can't. You sit down on that rock over there and you look around you," and he just cast his eyes around. "I want you to write down every geological formation you can see from this spot. Then write in two hundred words what you saw with the bomb and then I'll excuse you and I'll consider that we're even."

That was Dirty Harry. I've discovered that since. Anyway, I sat there and I kept on having to brush my arms off because these little gritty things had fallen on me and the wind was blowing. [They were] kind of gray, and some were red. It had a lot of gray things in it. So it wasn't like a normal wind. It was different, and I noticed those little gray things right away because it was unusual.

The clouds [of fallout] were coming over within a short time after I started writing. Just gray clouds. Then this wind kept blowing up a storm. I was there until ten o'clock, from five until ten. It came fast, like the wind was driving the clouds. It was a hot wind, it was awfully awfully hot and I was getting sunburned, I thought. I went straight home, and I don't remember whether that was the day or not, but one day when I came into town someone had taken geiger counter readings of the car. They pulled my car over and rinsed it off. I went home. I went to comb my hair, and this is why I remember this experience so well, because when I went to comb my

hair, my scalp started to lift up. It was just really scary. I had to peel it up through my hair. A lot of hair came out with it. See, it was burned and I had these big pieces of stuff in my hair and some right up against my skin.

It had blistered in that short a time?

Sure. I had to pull my hair up through, and we thought it was a sunburn. My face was burned, and see this little scar on my nose? It was a place where it burned, it had one of those things lodged in it. My arms are scarred. If you feel you can tell by the different hair. All the places that were bare on me, parts on the sides of my neck and face, all of those were just bright, bright red. Then my hair just continued to fall out as time went past and, of course, I lost it. [Workman has had to wear a wig for all the 35 years since her fallout experience.] I still lose hair. I've had doctors explain to me that my scalp is badly scarred. I had big burn scars from it. The whole thing from here [top of forehead] clear back just lifted right off and then I had places, little spots, that were particularly sore. Everybody teased me. They thought I had been sunburned, and being sunburned in St. George like that in the morning, they laughed! That's what we thought it was. We didn't know.

I didn't know for years until after I had cancer. I began to suspect that might be why I lost all my hair. When I was having babies I was having problems with my teeth, but when the doctor pulled one of them, it didn't have any cavities, so he couldn't figure out why it was bothering me so much. He cut it in two, and the inside was all gone. Nothing was inside the tooth. So he pulled the others and every one was completely hollow. They didn't have blood or anything in them.

I was about 40, and I began to be ill a lot, all the time. My blood pressure went up, a problem with my bowels, infec-

tions over and over. Everything that came along, I got it. I was sick all the time. I was having terrible headaches. It was a mess. I lost weight, about 50 pounds, and I was thrilled that I was losing weight fast until I got down to 125. That's when they began to think I had some form of cancer.

I guess I was 45 when I found out I had cancer of the colon. They found those little polyps, something like 38 of them that were all malignant. They were inoperable because they had the threads like roots that ran all through my intestines. Then they found that they were up in my bladder and in my kidneys and had gone up in my stomach. They told me I had three months to live. A doctor told me there was a team of doctors out of Stanford who were doing experimental treatments for cancer. I knew I wasn't going to die. I knew I would be sick, and sick for a long time, but I knew I wasn't going to die.

Joanne Workman's description of her four-year-long Stanford treatment regime included a course of drugs never used on human subjects before, endless weekly rounds of chemotherapeutic shots, tests, X rays, fluoroscopy, and a bizarre pregnancy, her seventh, that occurred after the doctors had performed a hysterectomy. Peculiar reproductive episodes such as this, strange as they seem to those not living downwind, are not uncommon in populations near nuclear test sites or reservations who are exposed to runaway radioisotopes. A fetus will grow outside its normal place of gestation, or will develop into a hydatidiform mole, which downwinders call "jellyfish babies." While Workman only inferred that many of her medical experiences involved humiliation and extreme pain, and despite the fact that the procedures "looked like Buck Rogers—I had no idea what most of it

was," the most salient feature of her interview was her surprise, almost disbelief, at the success of those years as "Stanford's guinea pig."

I was 48 years old when they started and 51 when they finished. They came to me that day and the doctor said, and he brought his whole crew with him, "Mrs. Workman, I don't know how to tell you this. Everything we've done has been geared to the idea that you have terminal cancer. I don't know how to explain this to you, but you don't have any cancer anymore, you don't have any cancer." They had found a brain tumor, they thought I had polycythemia too. All of that was gone, everything was gone. I want to tell you this because I never even prayed to be cured because I always felt I was so lucky to be alive. I felt the Lord was being kind to let me stay here for that period of time.

You had colon cancer, kidney, bladder and stomach cancer, a brain tumor, and polycythemia vera [a once-rare blood disorder characterized by an increase in total blood volume, particularly red blood cells, accompanied by nosebleed, distension of circulatory vessels, and enlargement of the spleen]. Did the doctors know about your childhood radiation exposure?

Yes. In fact, it was shortly after they started treating me that I went to them and told them about our group of people in Utah filing suit [*Irene Allen et al. v. United States*] and that my mother had put my name on the list. Basically, all I wanted out of that lawsuit was to have the government set up something to take care of the people who are still going to suffer. I had come to look at it like being in a war. It's not fair that those people in St. George, in the downwind area, should be

called upon to fight the war, but that's the way it happened and there's casualties in the war and we're the casualties. It's a sad, sad thing, but that's the way it is. There are no benefits. Worse than that, they won't admit they did it to you. Nobody really believed it could hurt you that bad. We knew it was dangerous until they came and told us it's not dangerous, and then we accepted it as not dangerous. Do you know what I'm saying? They can say what they want to. I know they don't like to think that tumors like mine are caused by radiation, but they were and they are. My doctors were absolutely dumbfounded for one person to have so many kinds of cancer. They couldn't believe it. Anyway, I said that I would need medical evidence and they [the Stanford doctors] told me they wouldn't give me any. They absolutely refused me anything. I signed a paper waiving my rights to my medical records and everything, in order to be treated in this program, which I thought was quite an opportunity, I really did. They were so good to me.

I wouldn't trade my life for a barrel of monkeys. I have nothing but fun. My husband is very supportive. There is very little around the house I can do. He knows I'm not going to be worth a hill of beans. Remarkable thing, he loves me anyway, and it sure makes me happy. Here I am, fat, bald, and toothless and he still loves me. Nobody can have a happier life. Don't you think that's wonderful?

Joanne Workman was a star witness at the Congressional oversight hearings that were convened to investigate the claims of radiogenic health damage by nuclear testing in Nevada. (She and 1,200 other downwinders had already filed suit against the government, the *Irene Allen et al. v. United States* case.) Her postchemotherapy maintenance regimen in-cluded a drug that would turn her skin yellow, blue, green, purple if her stress level would rise—one of the unusual side effects of the experimental treatment program. Indeed, under cross examination, she became a rainbow. Later, she was asked to prove that she was bald from radiation and she removed her wig, good-naturedly. "That was the last time I'd do *that*," Workman mused, because one of the government lawyers behind her snorted loud enough for her to hear, "Well, I guess when I get fifty and start losing my hair I'll ask the government to give me a loan."

Joanne Workman died in 1987.

LORNA BRUHN AND ELIZABETH WRIGHT

February 1986 and January 1992

St. George, Utah

"The tests were exciting. They gave my husband a badge to wear. We were told that the most it can do to you is make you infertile and he said, 'I've got four children,' so he didn't worry about it. We should have known, from Hiroshima."

Lorna Bruhn was born in the small Utah town of Orderville, once the home of the Brigham Young's United Order, an early Mormon vision of socialist communal living independent from the rest of the nation. They were isolated, far from a hospital, and so she was delivered by a midwife. Years later, Arthur Bruhn was traveling around the state, selling coats to put himself through school, when he stopped at the Orderville Cooperative store, a last remnant left from the United Order. "He sold a coat to my sister because she had a job. He thought she might have the money, so she bought one for me. It was a beautiful red coat. When I went to the door, I had an old dress on. It was love at first sight. I hurried to put on another dress, but he never remembered anything about that. He was from Panguitch. He went to the University of Utah. First he wanted to be a doctor and then he decided to be a teacher." The young man not only became a teacher but earned a doctorate in biology and studied geology as well. His career as an educator advanced rapidly and he eventually became the well-loved and much-respected president of Dixie College in St. George. He was teaching geology there when the atomic tests began in 1951.

The tests were exciting. They gave my husband a badge to wear. It would show there was too much fallout. We would see the flash out west and then about ten or fifteen minutes later the sound would come. Everybody was so excited about it. We were told that the most it can do to you is make you infertile and he said, "I've got four children," so he didn't worry about it. He would go out and watch them with geology groups a lot. One night he and I took our station wagon and sleeping bags and camped out there. We got up early the next morning and he set up four cameras on tripods. He was

going to hit the three and I was just going to hit the one. That was the only one that got taken because the reaction made me push my thumb down. That's the only picture we got. He was so astonished that he didn't get them taken. It was unbelievable. The whole sky is alight as you've never seen, a bright reddish-yellow light.

One time when the cloud came over he was warned, but I don't think he stayed in. He had to keep the children in. He went out with friends; they went out on the hill to watch it. People who were out in it that didn't get the news got cancer. Irma Thomas is the one that kept up on that, I didn't. I was home ironing at the time, so I went outside to see the flash and then went back in to finish my ironing. You could hear the sound coming, going into every side canyon, then I could hear it retreating east. When he came back he said they had drove back into town as fast as they could. There was a little service station outside of town, west, with a lot of big windows. He said the glass had actually separated because of the strength of the sound waves. They said it was Dirty Harry, the noisiest one I heard.

We should have known, from Hiroshima. I think my husband did. I think he was aware, but protective. He wrote a poem in church one day that indicated that he may have had some premonition. Just before Christmas 1963 he was ill. He was very, very busy. That was the year they moved out of the college into the new buildings, and they were trying to run the school under those conditions. He said, "I'm just too tired." His face was yellow, I didn't like it, so I made an appointment with the doctor. The doctor didn't tell him anything, but they came and talked to me. He said, "I'm afraid he has leukemia. Everything points towards that. It's best to keep it from the family until we know for sure." I couldn't even tell him. He was a man that had to know. In the meantime his blood vessels were getting big in his legs. Finally the doctor came here. They went into the kitchen and the doctor told him what he had. I think every one of us went quietly to an encyclopedia and read the symptoms. I didn't tell his parents until after Christmas. I'll never forget how his mother screamed.

During that time I began to read the paper more regular of articles on obituaries of men about his age who had died. His bones were causing him a lot of pain. They were deteriorating. I knew one night it was time. We spent the last week and a half in the hospital. I had a bed right there by him. He died July 5th, 1964.

Lorna Bruhn and her daughter, Elizabeth Wright, have been active for years in seeking compensation for those harmed by fallout, and in helping to establish a cancer treatment center in St. George. Elizabeth, born in 1940, was not untouched by the effects of radiation. The testing started as she was entering puberty, and she believes it affected her reproductive system.

One pregnancy dissolved in utero, and the doctor in LA said he had never seen anything like it. It was really bizarre. I would have been about 26. Since that time I've never been able to get pregnant. I've talked to southern Utah women who've also experienced that, you know. It affected all of us. It affected generations to come. We really don't know because there's been no research.

My childhood friend, Judy Neilson, her youngest child was born with most of his internal organs on the outside his body, and has had to have multiple surgeries for that. I was talking

to a woman from Hanford [Nuclear Reservation in Richland, Washington] who said, "Do you know what? We've had seven babies born in the last four weeks. Elizabeth, they were all born with their organs outside their bodies." On Sean's medical records, Judy insisted that they put "mother was exposed to prolonged periods of fallout due to the testing in Nevada."

Ultimately, Elizabeth Wright and her mother were successful in helping to bring a cancer treatment center to St. George, Utah, now administrated by a reorganized health conglomerate, Intermountain Health Care, formerly referred to only as LDS Hospital in Salt Lake City.

I wrote to Intermountain Health Care and said we needed a cancer center here. They wanted us to raise enough awareness that they could proceed and build the center. That was never said until the Bruhn Foundation had disbanded. They never needed us to raise money, they needed us for public relations. Intermountain Health Care reviewed and accepted the policy that the radiation had nothing to do with the cancer they were treating. That's their official stance. Orrin Hatch brought in $3 million [in federal subsidies]. That went to build the research portion of the center, to expand that facility, and paid for mobile screening. It paid for mammograms that women wouldn't have otherwise. The research center was a project with the National Cancer Institute and the University of Utah, a dual project between them, but that's all closed down now. The money ran out.

There are many people who are radiation victims, but there are also many who are radiation survivors. They really do go ahead, go forward, and that's that, isn't that true?

Most of us don't want to consider ourselves victims because "victims" says that you lay down. We've been victim*ized,* but there's a difference between being victimized and being a victim. So we're not only survivors, but those of us who have survived and have begun to fight are visionaries. We're willing to look to the future and say, okay, it happened, but it must never happen again.

JUDITH NEILSON

November 1988

Las Vegas, Nevada

"I remember the earth shaking very hard, it would practically throw you out of bed. And the bombs got bigger, and they got worse. I don't really think you could do this in New York. Number one, there are a great number of people there who would physically attack you. They wouldn't just sit there and say, 'Here I am! Do with me what you will!'"

Judith Neilson, a fresh-faced and lovely woman in her forties, took a photograph of her son, Sean, from the bookshelf. A "sacrifice baby," as such birth-defect children are called in downwind areas, he was born with some of his organs outside his body, and legally blind and deaf. Neilson grew up "under the cloud," exposed throughout her childhood to fallout. By her thirties she had already suffered breast cancer and a collapsed lung. A single mother who refuses to be on welfare in spite of the enormous expense of her child's reconstructive surgeries, other medical costs, and special education, Neilson expresses outrage over a Mormon mindset that Dr. Helen Caldicott had first spoken of as "manic denial," an emotionally self-protective ostrich syndrome similar to the "good German" mentality during the Nazi Holocaust.

"Why can't we just go on?" "Why can't we just put it away?" They wish that Mormon image to be so clean and so fresh and so patriotic. There are a lot of problems which they refuse the outside world to see. To put down in leagues against their own government is something they don't want the world to see them as doing. They are sheeplike. They can be, even to their own, extremely hostile if you do not fall in direct line of whatever they've decided is to be said. If a bishop comes in on Sunday and says "This is the stand we are to take," everybody then must bring their thinking into this line. If you say, "I'm sorry, I disagree," you not only disagree with his thinking, you are disagreeing with an authority in the Church that made a statement. No one has that right. When I told my mother I was going to do this interview, she said, "Will you ever stop getting involved? Will you ever just get on with life? You can't do anything about it, that's just how it is."

In the mid-fifties Atomic Energy Commissioner Lewis Strauss said, "People have got to learn to live with the facts of life, and the facts of life are fallout." Do you think this kind of nonthinking, the Mormon proscription against disagreement, made Utah more likely to be victims of atomic testing and other militaristic situations?

Of course! What are they going to do about it? I don't really think you could do this in New York. Number one, there are a great number of people there who would physically attack you. They wouldn't just sit there are say, "Here I am! Do with me what you will!" Here you have a small community with not very many people, and in those days it was 5,000 in St. George. You have a very strong [Mormon] church center which has made a treaty with the United States government which amounts to "you don't bother us and we won't bother you."

After more than a century of strictly doing what they're told, have Mormons lost the ability to judge for themselves?

Very much so. There are still great prejudices there. The sixties and seventies came and went and it didn't really affect them at all. A great many things came and went, and changed in the world, and they have never changed. Do you read the newspapers here? Finding national news is almost an impossibility. It will change thought, change ideas, it will bring in the world. They don't want it to change.

In St. George and Cedar City I was astounded to find cancer in every house, and often not just one cancer.

Yes. They say there is no direct proof, but if you interview every family, every family will tell you [their] health problems. The percentages are way too high not to be recognized. They don't smoke, they don't drink, they are very health-conscious. I don't know anyone that hasn't had birthing problems that I went to school with. You don't really think about it until you go to class reunions and you're talking to all your friends and everybody is saying, "I couldn't have any kids either" or "The only kids I could have are like this."

I've had a couple of miscarriages, and for both of my eldest sons I had to stay in bed, flat on my back, for almost the whole pregnancy. I had to have shots in order to be able to carry the baby. That was in the sixties. I bled most of the time, threatened to abort. Twelve years later I got pregnant with a son. They kept telling me I wasn't pregnant, but six months along he was born, weighing two pounds, two ounces. He lived, but he dropped one pound eighteen ounces when they did microsurgery months later when his intestines burst. He's deaf, severely nearsighted, has a learning disability with hand-eye coordination. He cost me a quarter of a million dollars, which is why I don't have a big house and a big car. His father took off and left when he was a baby because of all the bills and problems. You pay it off no matter how long it takes.

We were told we could not go outside when the cloud was directly overhead, and there were always great winds after it. They call it a mushroom cloud for a reason: it is very thick, and it is circular. The radioactivity did not leave with the cloud, the cloud just left, so then we were allowed to walk to school, or go out and play. We had our own garden, and we used to pick fresh fruit and vegetables out of the garden and eat it. The people were told everything was fine once the cloud left. They would go out and watch it explode, talk about getting exposed! We weren't allowed all those neat privileges. My mother was very protective of us from the world, from

everyone. I remember the earth shaking very hard, five or six in the morning. It would shake everything. Our dishes would rattle, everything would vibrate. We were down in the basement, and you could feel it, it would practically throw you out of bed. It would be that strong, just jar you right out of bed. As if somebody just came up and shook you good and hard. This happened as regular as clockwork. It happened all the time.

And the bombs got bigger, and they got worse.

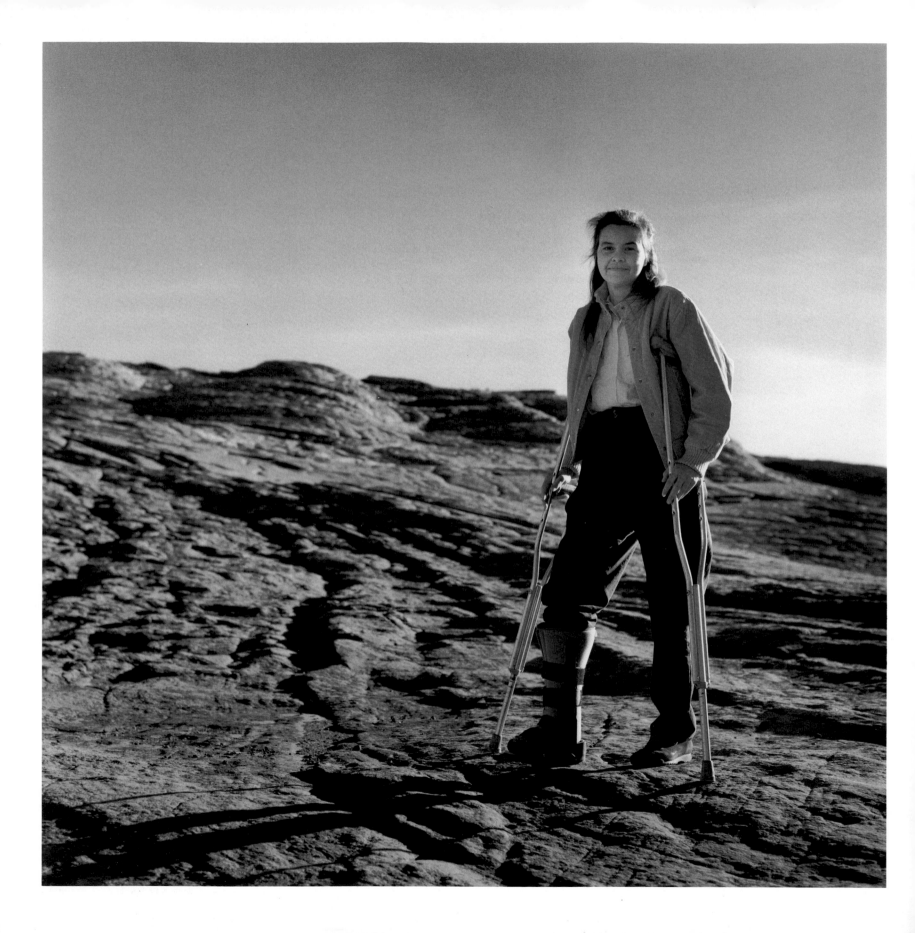

JAMIE STEWART

February 1991

St. George, Utah

"I wasn't even aware that the testing still continued. It was one of the greatest shocks of my life. It was not in the best interest of the church to speak out against testing. They discourage people from becoming politically active. For as long as people can remember the church has been telling them not to get involved. Maybe it's all subliminal, to make people forget what really caused the cancer."

When I visited Jamie Stewart at home, she was partially disabled by a broken foot. As is the case with advanced diabetes, her bones had become so brittle that they shattered, as she told me, from "too much walking around." She was unaware for some time that they had broken because of the numbness she suffers in her extremities, neuropathy, another symptom common to diabetics. Jamie Stewart believes that her illness, and the skyrocketing rates of diabetes in the downwind areas, are due to overexposure to radiation. Indeed, in the Marshall Islands, where a far more powerful testing program of hydrogen bombs in the megaton range took place, the rates of diabetes skyrocketed where formerly there had been only a very small incidence. There have been neither government nor independent studies to confirm or contradict the belief of the Paiute and the Shoshone that diabetes is also ravaging their aboriginal people in much the same way. Stewart, who works with the Paiutes on the Shivwits Reservation west of St. George, is very sure that the diabetes that suddenly manifested itself, without any genetic precedent, in her family in the late 1950s and early 1960s, killing all but her, is radiation-related.

I wasn't even aware that the testing still continued. It was one of the greatest shocks of my life. At the first vigil [for Utah's radiation victims] held up on the Red Hill, 1979 or 1980, Gloria Gregerson affected me tremendously. [Before she died, Gregerson spoke eloquently at every possible Congressional hearing on the effects of radiation from nuclear testing. She would recount her enchantment as a child with the "snow" on the oleander trees around her house near Bunkerville, Nevada. Never having seen snow before in the desert, she would shake the branches so it would fall on her,

but it was a blizzard of fallout from the atomic bombs.] I heard her speak and knew from looking at her, the way she spoke, that look people have in their eyes, I knew she was dying. I knew she was in pain . . . it was cold, and raining. Here we were at a memorial service [for radiation victims] and I remember standing up there and hearing that we were still testing! It had never crossed my mind before. I was really overwhelmed.

When did you develop diabetes?

It was 1962, when I was nine years old. At about the same time, all of the cousins in my family developed it, those in the Utah area, and it had never been in the family before; there is no history of it with my aunts and uncles. My parents were free of it, all my grandparents were free of it. All of a sudden four cousins came down with it within a five-year period, and I'm the only one alive today to tell about it.

My belief that will never change is that my diabetes was caused by ionizing radiation. I think the medical community prepares young diabetics for the inevitable. You realize that if you get it when you're nine, ten years old, by the time you're 30 or 40 years old if it's not the end of your life, it's going to be the end of your active, creative life. It's a unique circumstance, to have all your youth to think about that. It changes your life, it really does. It seems like there's not too much progress on helping the complications, which are blood vessel diseases, and neuropathy is one of those, nervous system disorders, loss of vision. I've already had laser treatment on one eye last fall, and I have neuropathy. Bones become brittle and old. You become old before your time.

The Indian population has a 60 percent diabetes rate, type one. Adult onset is usually over 30, but these people are in their twenties. There isn't even a specialist for these people to go to. The doctors here treat it like they need an aspirin. The oldest person you can find on the Shivwits reservation is in his sixties.

What's keeping people here from getting in and being active? What part does Mormonism play in restraining people's response to this tragedy?

My father's from a Mormon community; my grandparents were polygamists from Kanosh, Utah. But I severed that line during the Vietnam War. That's when I made the break and never looked back. It was not in the best interest of the church to speak out against testing. They discourage people from becoming politically active. They use as a guideline what their church officials tell them, and I guess for as long as people can remember the church has been telling them not to get involved in it.

I feel a terrible, terrible anger at the struggle that I've had, and what still lies ahead of me. It's very probably the fault of my government. My friends and family that I've lost, the fault of the government. They can't even give us a decent health study, let alone the truth. One of the largest populations of diabetics is right here in Washington County, and it's incredibly high in my age group. We're denied even a diabetic doctor, a specialist in this area. You either go to Las Vegas or Salt Lake.

And the only option you have for therapy when you get cancer here in Washington County is treatment with more radiation—there is no chemotherapy offered here, only a cobalt chamber.

What is the point of this, in your opinion, having no chemotherapy in a cancer treatment center located in an area that is called "Cancer Alley"?

Deceit! I don't have any answers. Maybe it's all subliminal, to make people forget what really caused the cancer. You know those old things from back in the fifties when Mr. Atom came on TV? I remember so well! "Mr. Atom, he's your friend. He'll save the future for us!" Mr. Atom with his muscles comes back from my childhood. Back in elementary school we had atom bomb drills, we had to run back home as fast as we could, and then mother would time us as we got in the door to see how long it took, and we'd take our times back to school with us. Maybe the radiation therapy is the same propaganda, all part of what's made me so terribly furious.

I'm angry enough that as I see right now how little progress we've made as we go to war again, the millions and billions of dollars, I really begin to question the nonviolence movement. Have we been traveling down the wrong road? Nothing we seem to have done, demonstrating down at the Test Site, with our peacefulness and our prayer and our love, although it's changed *us,* maybe we've been directing it the wrong way. Maybe we should be resisting this openly. I can't believe that we haven't made any difference in people, that we haven't changed their way of thinking. I have been as naive and stupid as I was 20 years ago.

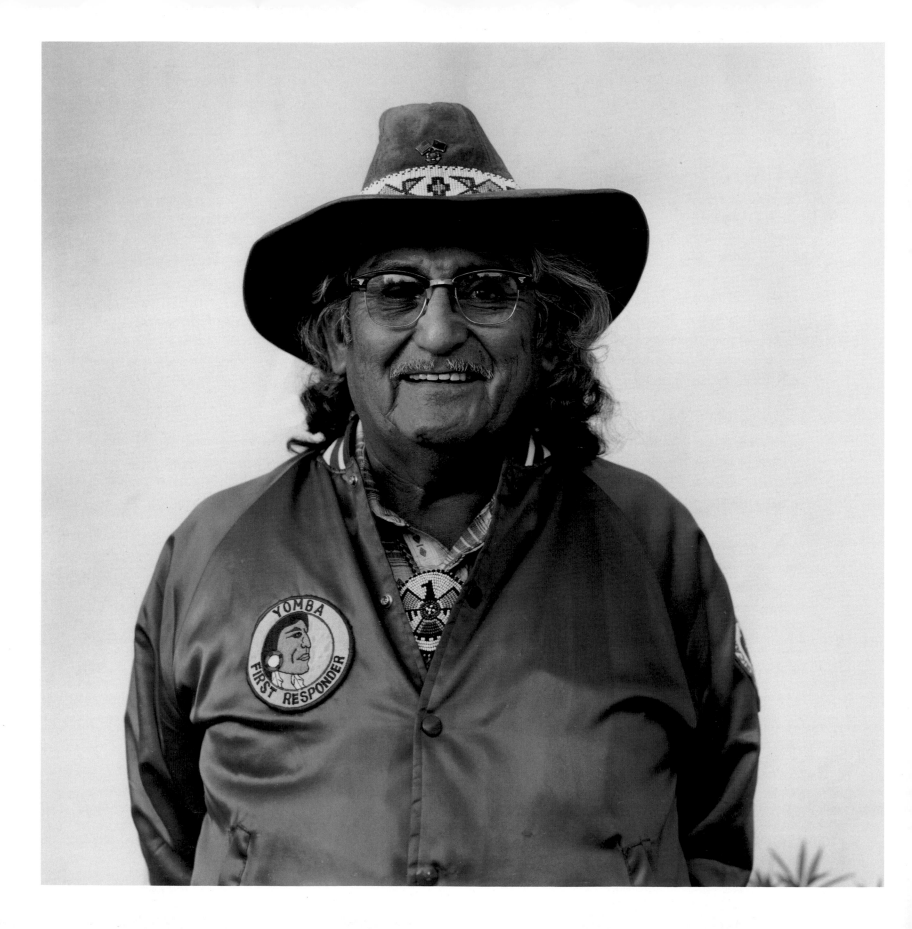

WILLIAM ROSSE, SR.

November 1988

Upper Reese River Valley, Nevada

Spokesperson for the Western Shoshone

"They figure we've been here, native aboriginal people, five or six thousand years. We told the Department of Energy that we do not want the burial sites in the Test Site disturbed. This *land* is [our] church. The whole world is your cathedral. How would you feel if we went into one of your big cathedrals and started running a bulldozer through it?"

The Western Shoshone own the land that the Test Site is on, and they never came to us and said "boo" when they set it up there. By presidential proclamation in 1951, they declared it a test site for the testing of nuclear bombs. They've done quite a few tests in the atmosphere until 1963. The fallout got onto the land, onto the trees. They still are testing here, and they say none of that stuff vents, but they do vent. There was a test recently called Mighty Oak. That time they waited for the fallout to come around from Chernobyl to vent it, and blamed the radiation on that. They call it "controlled venting" but there's no such thing. How they're going to control it, I don't know how. They're going to take the radiation out and let the other stuff go? No way.

Shortly after the Mighty Oak accident, after hearing some accusatory statements by health physicists and other concerned scientists regarding the venting of radiation from the test tunnel to coincide with the Chernobyl cloud, I interviewed on tape the Test Site's public affairs officer, Barbara Yoerg, and asked her specifically about it. Head down, her response was only a stony silence. I asked more bluntly whether the Test Site was concerned with the effects of radiation releases on people living downwind in Utah. She replied, with a contemptuous laugh, "Those people in Utah don't give a shit about radiation."

The truth is that an estimated 15 percent of underground tests leak radiation outside the limits of the Test Site. The Department of Energy admits to this. No studies have been done, however, to examine just how much residual radiation remains from the atmospheric testing era and later nuclear experiments, still an enormous clean-up problem within the Test Site. Over 40 years much of it has been dispersed

downwind by acts of nature such as violent seasonal sand-storms. I was witness to one of these while living in Las Vegas. A dark, roiling cloud suddenly appeared that was more than a mile high, approaching from the direction of the Test Site, blocking out the sun to create a false twilight. Soon the specks of sand were pecking at the windows as the thick brown fog was hurled through town by gale force winds. I had been in other such storms when even closed vents and windows found me sitting in a foot of sand in my truck after it was all over. There is no escape, but there are no plans to pave the highly radioactive areas of the Test Site either.

The Indian people's health is doing very poorly; they have arthritis, and they're diabetic. I have seen very few that didn't have arthritis really bad, some of them so bad they can hardly move. Years ago they used to live until they were over 100 years old and still walk around as good as a young kid 20 years old. My grandmother, when she passed on in 1947, was 113 years old. And our native people never suffered diabetes before.

I've got a granddaughter that was born totally blind. She didn't develop in her mother's womb. When she was born her eyes was just pure white. As she got older her eyes started developing just a little bit, just little pinpoints like pupils, and finally a little bit of coloring started coming in, just a light blue tinge around it. They said she'd never see, all they could do was make contact lenses for her so she'd look normal. She's seven years old now, going on eight. Her family moved to California to find better teaching for her as a blind person. We found out that she had thyroid trouble because she has to take growth hormones, she was too small. I feel possibly her mother or father got contaminated with some of that fallout, living at the reservation. Lot of thyroid problems going on there. Quite a few have died from cancer at a younger age.

Since 1981 I've been fighting the government, first the MX missile system they would place on our land, then testing, now the supersonic planes flying over. First time I went down to the Test Site was June of 1986. Then in November the chief of the Shoshone Nation, Jerry Miller, and a few other native people went down there to be with me at a fairly good-size demonstration, and we was going to issue citations to those arresting officers because they were the ones who were tres-passing, not us. They don't have permission to be there. The government can't tell them to be there because they don't own the land, *we're* the owners. Actually we don't own the land, That Man Up There [pointing to the sky] is the owner. We're just the caretakers.

They figure we've been here, native aboriginal people, five or six thousand years, maybe more. They're finding remnants of native people here in the marshes at the Stillwater Reser-vation, could be Paiute or Shoshone, eight thousand years old. Apparently my dad was a chief—he had the whole thing, the feathers and the buckskin clothes, which were stolen by neighbors when they were living in California. We told the Department of Energy that we do not want the burial sites in the Test Site disturbed. We cannot remove the remains be-cause once you're committed to the ground in that one spot, that's where you stay for eternity. The Indian people don't approve of moving the remains because there are a lot of things that can happen to you if you do. Non-Indian people can't understand this. The power of That Man Up There, they just don't believe. Everybody always thought that the native

people were nothing but savages, heathens, ignorant, because they didn't go to church. This *land* is their church. Anywhere they're at, they worship, they pray, don't make a difference where they go. The whole world is your cathedral.

How would you feel if we went into one of your big cathedrals and started running a bulldozer through it? This is what's happening to us out here. What they're trying to do is run their big bulldozers and equipment through and tear up our church! This is it, this is the way the native people believe, in the land, even in the water. Wherever you're at, it's a sacred area, your cathedral.

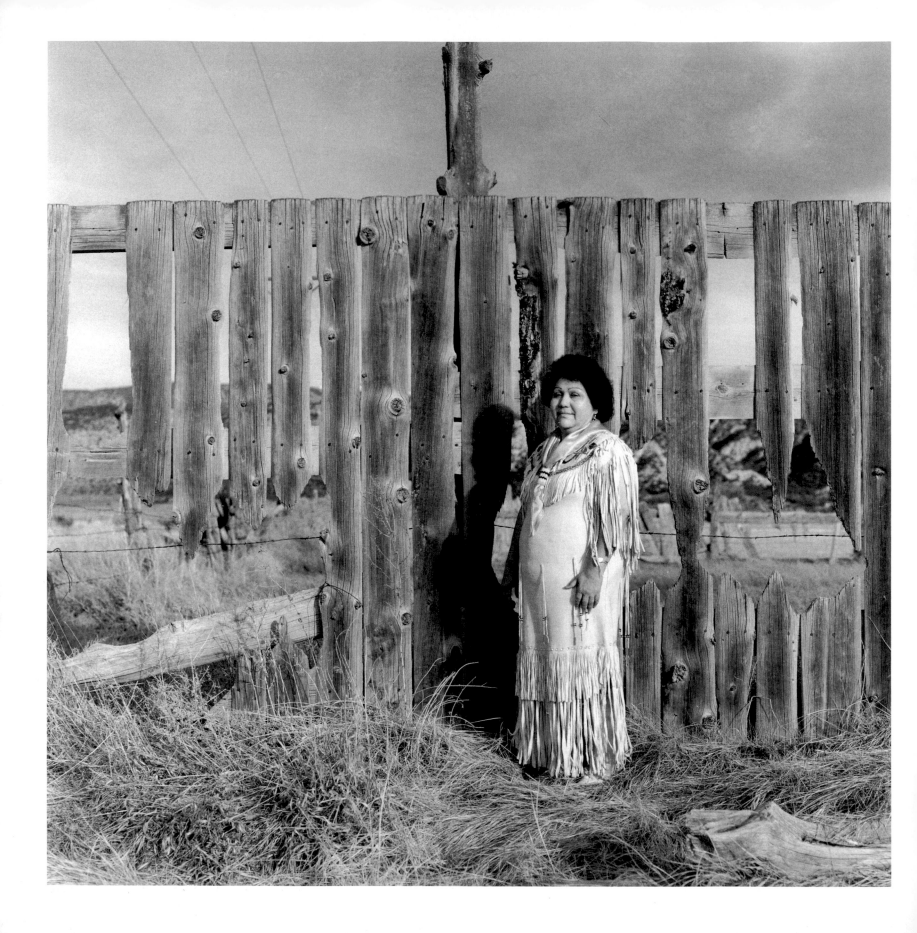

GENEAL ANDERSON

April 1991

Cedar City, Utah

Chairperson of the Paiute Indian Tribe of Utah

"We look at the land as the Mother Earth, and we are supposed to be caretakers. We had our land taken from us. We were pushed aside. We all share a common cause. We want our people to be healthy, but we can't be healthy if nuclear testing continues."

You'd look to the west and there would be pink. Sometimes the sun was red. I remember that, but not knowing what was happening, not knowing about the testing going on in Nevada. I was a kid, born in 1952. You never were told what the pink clouds were. If you're not told, you don't pick up on what's happening.

There's a gap [in our documented history] from 1954 into the late '70s during what I call the "time of termination." The tribe was terminated from the federal government, meaning we were no longer recognized as Indians. During this time many things happened, people were on their own, and there was a void, a gap there. On April 3, 1980, the tribe was reinstated as a federally recognized tribe, and there were a lot of health needs that needed to be met. We notice that now diabetes is at a high rate in St. George, and in the Kanosh area there are more blood-related diseases, some bone cancer. There's been a high rate of arthritis in the tribe. In the 1970s in the Moapa area near Las Vegas, where I was living at the time, I noticed that people did have cancer. I know of a little boy in the '60s, a cousin of mine who used to come visit us all the time, one summer he came up and he was having a lot of nosebleeds. When they went back home to the reservation they found out he had leukemia. That was my first contact with it, in 1963 or 1964. He was four or five. My mom died in 1986. There was a drastic loss of weight, and she was bruising very easily. She had leukemia. She lived over near the Utah-Nevada border near the Indian Peak area when she was a child, and then to Cedar City.

A Shoshone man told me that putting the Test Site on that land was a blasphemy and a desecration of something his people considered holy. Do you feel that your land and your people have been defiled by the radiation that came your way?

Yes. We just live from day to day, not entirely in tune with what's happening on the national level. We say that we're the protectors of Mother Earth, and yet the only way some tribes can make money is to have those types of things on the reservation or, say, an incinerator. We need income. We're a prime target. Maybe it's a lack of knowledge on the part of our tribal people.

Our old reservation used to be out at Indian Peak. We had 8,000 acres, and we were the smallest group of the Paiute Indian Tribe of Utah. It had an effect on the plants, so you know it affects the harvest that you depend on. It affected our pine nuts [a staple in the diets of western aboriginals]. We look at the land as the Mother Earth, and we are supposed to be caretakers. As times change, I suppose everyone has a different opinion, and as the generations go, hopefully we can keep that concern there that we can care for the land. I feel we have been affected by the radiation from Nevada. It may not only be cancer that is a health hazard. We have a high level of arthritis, high levels of blood diseases in one of our areas. In working in the community and being involved in trying to get information for compensation, I feel we have been left out. We've been overlooked, again. We had our land taken from us. We were pushed aside. They say, "They're not interested, they're not concerned." *Yes, we are* concerned. We're concerned with the past, what happened to our families, and we're concerned about what will happen to them in the future again. We're sending out notices to let people know what action needs to be taken. Yes, we need to do something. Yes, we need to be heard. We all share a common cause. We want our people to be healthy, but we can't be healthy if nuclear testing continues.

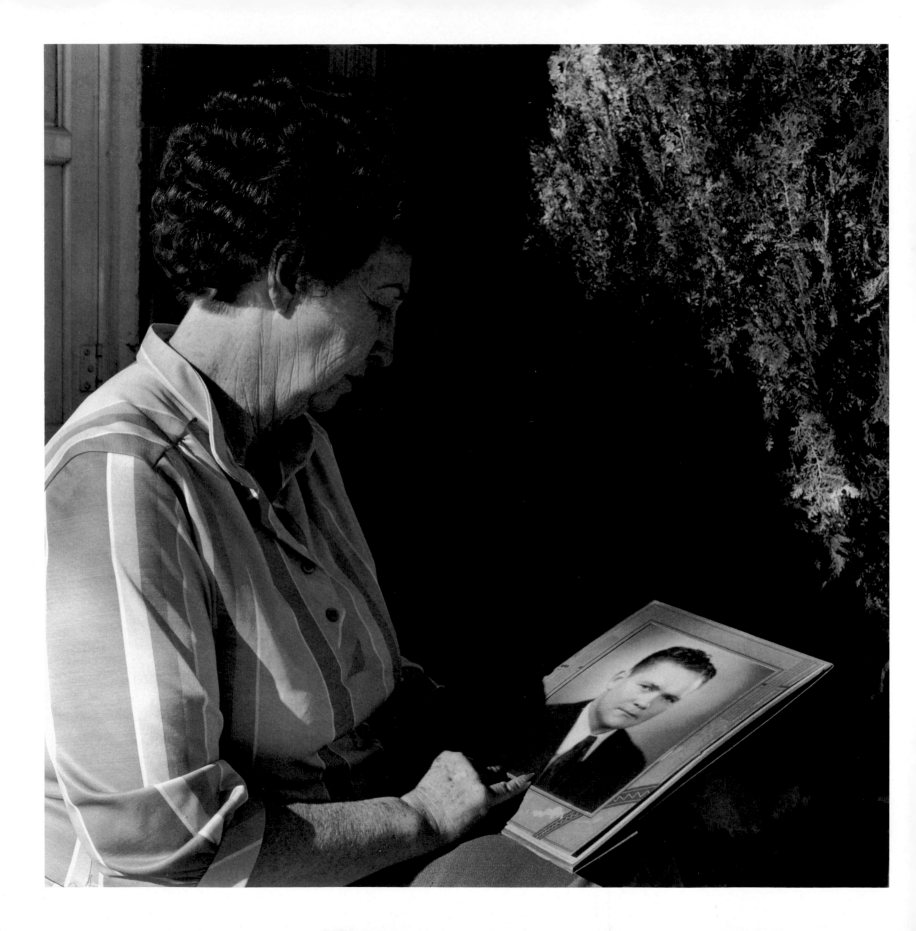

WILFORD AND HELEN NISSON JOLLEY

March 1984 and April 1989

Washington, Utah

"You didn't think your government could do anything wrong. You think it is the strongest and the best. *Our government was just perfect.* Now I've got a different view. They can take care of other countries, the Marshall Islands, Hiroshima victims. People right here it don't make any difference. I don't understand that."

For many years Helen Nisson and Wilford Jolley were next-door neighbors in the small farming community of Washington, Utah, just a leap over a redrock butte north of St. George. "There was only 400 people living here. I guess that's the reason it didn't matter if they let it fall over us. They said, 'It won't hurt you, it won't hurt you.' Funny that it didn't hurt when it came over us, but it would hurt if it went the other way [to Las Vegas and Los Angeles]." The closely knit, often interrelated families were shocked in 1959 to learn that Darrell and Helen Nisson's 13-year-old son, Sheldon, was dying of leukemia.

He was such a lively kid, the healthiest kid. Nothing was wrong with him until Easter. He kind of laid down on the blanket while the kids were playing. He just kept on getting worse. He had hemorrhaged behind one eye and he couldn't see very good. He was getting ready to go hunting with Charles and I said, "You better hurry and get ready," and he said, "I don't think there's any more hunting for me." He must have known he was going to go. We took him to the hospital and had his blood checked and he had leukemia really bad. They sent us to Salt Lake and he only lived six weeks after that. He was so brave. It just breaks your heart you can't do one thing for him. He drove a tractor for his dad, a little Cat[erpillar], he'd drive it around the farm. He was so smart. To know you couldn't do one thing to help him, and to know you have to part with him, it was just pitiful. Way back then there were only 75 kids in our school and leukemia was something that didn't happen to anybody you knew, this disease that turned your blood into water. In that little tiny school two kids died within a few months of each other. There was also a little baby out in Enterprise and a girl in St. George of

16 that died at the same time. About seven people died of leukemia in Washington alone before the years went on.

After Sheldon died I thought, I just can't stand it, I've got to have some more, so I started over. I had two more little darlings in 1961 and 1965. They're still alive, but Bruce is sick all the time. Sick, sick, sick, sick. He was born in 1952. He goes to the doctor all the time. In back of his throat there's a second set of tonsils or something, and they would swell up so big. He just had an operation on his throat a month ago. He went to have it hoping that would make him feel better. They said it was a bad operation, something kept on bleeding a couple of nights, and they had to go back in. It wouldn't stop so they had to do it over, and he has to stay on penicillin all the time.

In 1956 or 1957 everybody was running around looking for uranium. Darrell was a rock man; we had a stone company and he sold building stone. He bought a geiger counter and he said that up at the rock quarry the people said the geiger counter would go crazy. Somebody went up there to stake a claim and was going to get rich because it was so hot. They thought it was uranium there but it was just fallout. Underground a little ways there was nothing. Darrell had bad health for a long time, too, longer than two years. When he first started out his blood was weird, and he had arthritis in his bones. Then his blood got thin. I don't know what did that. He had a lot of blood transfusions and hemorrhages. They didn't say it was leukemia.

Shortly after Helen Nisson lost her husband, Wilford Jolley lost his wife and many of his brothers and their wives.

All I know is I lost a wife and three brothers and two sisters-in-law in a matter of a few years. My wife had it all the way through her body. We used to fish quite a bit together and she had trouble getting up and down the hills. She took more naps and moved slower. I took her to Las Vegas to take some X rays and they couldn't find a thing. She was in the hospital for a week and then she wanted to come home. We brought her home for a week and then took her back for a week and that was it. In two weeks she was dead.

"She was gone like that. It was a shock to everybody," Helen remembered, looking out her window toward Wilford's old house across their lawn and vegetable garden. "All the homes on this block, they've all had cancer." From their common tragedies and their many years as next-door neighbors had grown a new relationship that clearly made them both glow. Wilford Jolley, at the time of our first interview, was a strikingly handsome and rugged man, broad-shouldered, equipped with hands that seemed big enough to pick up a tractor. Helen Nisson Jolley was a new bride for the second time, smitten and feeling once again all that was sweet and girlish about her. When I visited again in 1989, however, Helen was frantic and tearful. Her Wilford, just returned from the hospital days before, seemed no more than a skin-shrouded skeleton lying on their bed in the darkened room. "I can barely think. Don't ask me to talk!" she said, dragging a hand across her forehead. "He's just had most of his intestines removed. Am I going to lose a second husband too?"

You didn't think your government could do anything wrong. You think it is the strongest and the best. They're the one in the right and you look up to them. *Our* government was just perfect. Now I've got a different view. They can take care of other countries, the Marshall Islands, Hiroshima victims. People right here it don't make any difference. I don't understand that. I thought patriotism was just a wonderful thing. A lot of things have happened that makes you not have that feeling any more.

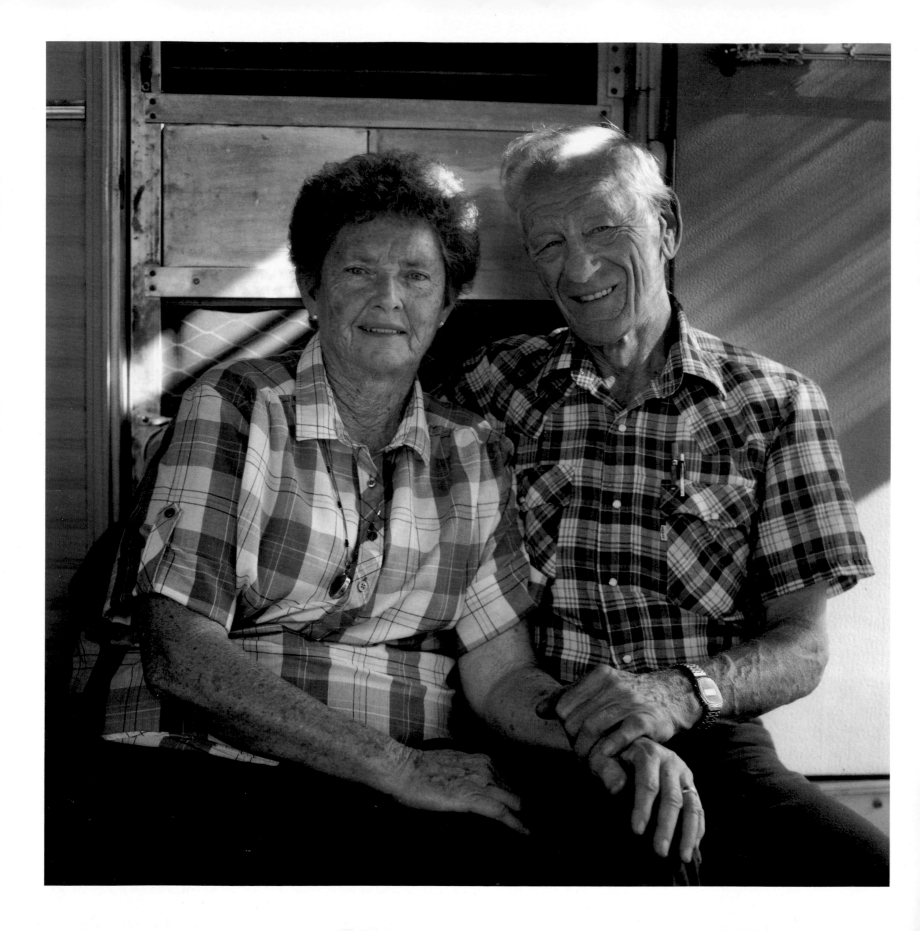

GLENNA BERG

October 1988

Mesquite, Nevada

"I wasn't asking for anything. What I did was write and tell them that if they were keeping a census on kids, we had a daughter with leukemia. When I went to get Mayleen's medical records from the military, they wouldn't give them to me. The legal officer at Hill Air Force Base tried to make me feel like I was un-American. He made one remark, 'Well, when there's a war, it does kill a few people. If the testing has to kill a few people to save the rest of the world, well then that's just a necessary thing.' If we would have been foreigners, why they would have been right in there doing everything for us."

Cliff Berg was a military man, often away from home on a tour of duty in England or in Florida, but based in Utah just north of Salt Lake City.

He chose Hill Air Force Base because from the time he married me he fell in love with St. George. That's where we gravitated to every time we had any kind of a leave. We weren't there for all the blasts but I was there for two of them. That's when she got the radiation, when I was living with my folks there when he went to England.

When her children's tonsils became infected, Glenna Berg, accompanied by her sister, took them to Nellis Air Force Base near Las Vegas to have them removed.

The next day we took them home and the car broke down just this side of Glendale, so we were stranded there for a while, a couple or three hours. It was that day that they let off one of those blasts. There was a little dust on the cars, kind of reddish, ash sort of stuff.

It was April 25, 1953, and 43-kiloton shot Simon had released fallout that "dust[ed] the nearby mesas and rangelands with enough radiation to force the government to throw up roadblocks and decontamination centers in a hasty, unplanned effort to minimize the danger. . . . The shot added immeasurably to the total external exposure for the test series."[1]

One morning I was in the kitchen getting breakfast and [my daughter, Mayleen] came crawling in from her bedroom. She wasn't crying or anything, and I said, "You're being a baby today?" She said, "When I stand up, it hurts. I can't stand

up. It hurts." I took her into the military hospital and they diagnosed her as having acute lymphatic leukemia. She was four and a half, and she died when she was six. She had a complete hemorrhage of her whole system. After they discovered she had it, things started coming out in the paper. My brother Elmer lost his wife first. She had a combination of Hodgkin's disease and leukemia both in her thirties. One of my neighborhood friends, Helen Nisson, her and I were born within one block from each other and played with each other all our lives. She lost her little boy, Sheldon. Then my sister died about two years after that of lung cancer. She never smoked a cigarette in her life. Both sides of my family were long-lifers. The history of our family is to die in their late eighties, nineties, even in the hundreds.

In Glenna Berg's immediate family, eleven people have died of cancer to date. Her daughter Charlotte, now 32, is sterile and her spine is deteriorating. Concerned for Charlotte's health and the rest of her family, she decided to get copies of all the relevant medical information.

I wasn't asking for anything. What I did was write and tel them that if they were keeping a census on kids that was getting this kind of stuff, we had a daughter with leukemia. Then when they first came out saying they were testing all the children that had goiter, why by the time we got back to Hill Air Force Base they discovered Charlotte had a fifty-cent-size goiter. In a two-year-old, no, that's not common. They were testing those children in St. George because so many of them were starting to get it.

I wasn't even going to get into that lawsuit [*Irene Allen et al. v. United States*], but I was curious about it. Cliff said, "We're going to go and sign up." When I went to get Mayleen's medical records from the military, they wouldn't give them to me. They sent me to the legal officer at Hill [Air Force Base] and he tried to make me feel like I was un-American. He made one remark, "Well, when there's a war, it does kill a few people. If the testing has to kill a few people to save the rest of the world, well then that's just a necessary thing." He indicated to me, "When a military man makes waves that's not good for the record." They intimidated me just for wanting my records!

I'm bitter about it. I think if we would have been foreigners they'd have paid us off and it would have been taken care of years ago. We have been easy and a pushover. It's a crime. I'm not anti-government or anything. I don't think there's a better country in the world, but it's easy for *them* to say, just like that attorney for the military said, "Sometimes you've got to invent things to protect 99 percent of the people and if you kill the other percent, that's just war." I think that's the way they probably looked at it, lose a few. If we would have been foreigners, why they would have been right in there doing everything for us.

1. Wendell Rawls, Jr., and A. O. Sulzberger, Jr., *New York Times*, August 12, 1979.

RULEA BROOKSBY
AND ALTA BROOKSBY PETTY

October 1988

American Fork, Utah

> Rulea Brooksby, mother of nine, and Alta Brooksby Petty.
>
> "The same day as my husband's funeral, there was a funeral of a father of eight children who had the same brain tumors, from the same part of Utah."

Rulea Brooksby's husband Victor died of brain cancer in his thirties, leaving her to care for their nine children. His mother, Alta Brooksby Petty, remembered seeing the flash of the bombs from her home in Kanab, a town on the Utah border dubbed the Arizona Strip. I asked if she had heard of Hiroshima and Nagasaki—and hadn't that made her fearful of the atomic bombs so close to home?

I didn't understand enough about it, that they were the same things, I don't think. We figured that it was so far away, and yet we could feel the blast, and we heard it. It just lighted up the sky, and then the big mushroom cloud came up.

By 1960, people on the Arizona Strip had an inkling that something was very wrong.

We hadn't really heard of leukemia. We wondered what could have caused it. Odessa Burch, she was about the first one that we knew of. They sat with her at the last and she just starved to death. She was just a rack of bones. Then my son Kenny not very long after that.

The cancer hit these small communities in hard waves. First, the leukemias. Fifteen to twenty years later the slower-gestating tumors would be diagnosed. Rulea Brooksby's rude awakening occurred at the mortuary.

The same day as my husband's funeral, there was a funeral of a father of eight children who had the same brain tumors, from the same part of Utah. That was really strange to me. I was trying to figure out the possibilities, why something like

this would happen to my husband. He had mentioned that when he was eight years old he had been in the bathroom, looked out the window, and saw the big cloud of smoke that was there from Vegas. If the smoke and dust travels like they say it does, it would have gone all over the place. No warning, that's basically all I really know.

Alta Petty not only lost her son, but she recalled that right afterward her youngest brother passed away, "tumor on the brain, almost the same as Vic's." Birth defects also appeared in clusters.

There was a baby born without a hand, Dale and Teresa Johnson's son. Her baby was deformed. Connie's baby Derrick, all of its little intestines were outside of his body, just laying on his little stomach, my youngest daughter's first child. Five or six families had babies that they lost. There was a cluster of miscarriages at that time. We could tell by the headstones in Fredonia. It was so unusual, because ordinarily we didn't lose babies like that.

Victor Brooksby was described by his wife and his mother as a boy who loved being outdoors, working on the range, being with the cattle, which was characteristic of the lives of most youths in southern Utah and the Arizona Strip.

In 1953 he would have been eight years old. That's when I heard this big bomb hit in Vegas and I just remember him telling me about it, that he remembered seeing it vividly. In August of '84 we realized that his actions were not normal. Handwriting was scribbly, he couldn't remember things, he couldn't say what he wanted to say. He was dragging his right leg, going a little bit paralyzed on the right side. We had him checked with a CAT scan and found out he had two or three little tumors on his brain. We were really shocked. We couldn't figure out where they came from. He had been in the best of health all his life. At first I really didn't think he would be taken from us. It really shocked us, and took him within six months. He was 39.

It eventually got worse. I started to go through a depression. I felt bad because there was no way that he could speak to me. He couldn't even write. I wanted so much to know his feelings. He was hardly able to say a word, ever. That always bothered me a great deal afterwards, because we weren't able to communicate at all and express feelings. We had all the kids here at the time. My children are not real open like their dad. They kept a lot of things to themselves. I know it was hard, but being members of the LDS church we have been strengthened because we know we will be together forever. The gospel has given us a lot of strength, and the teachings of their dad, being as close as he was to the children. I know it's been hard for them to not have a father because they were really close to him. Vic was a very, very caring person. Always willing to do anything he could to help other people, willing to give the shirt off his back for anyone.

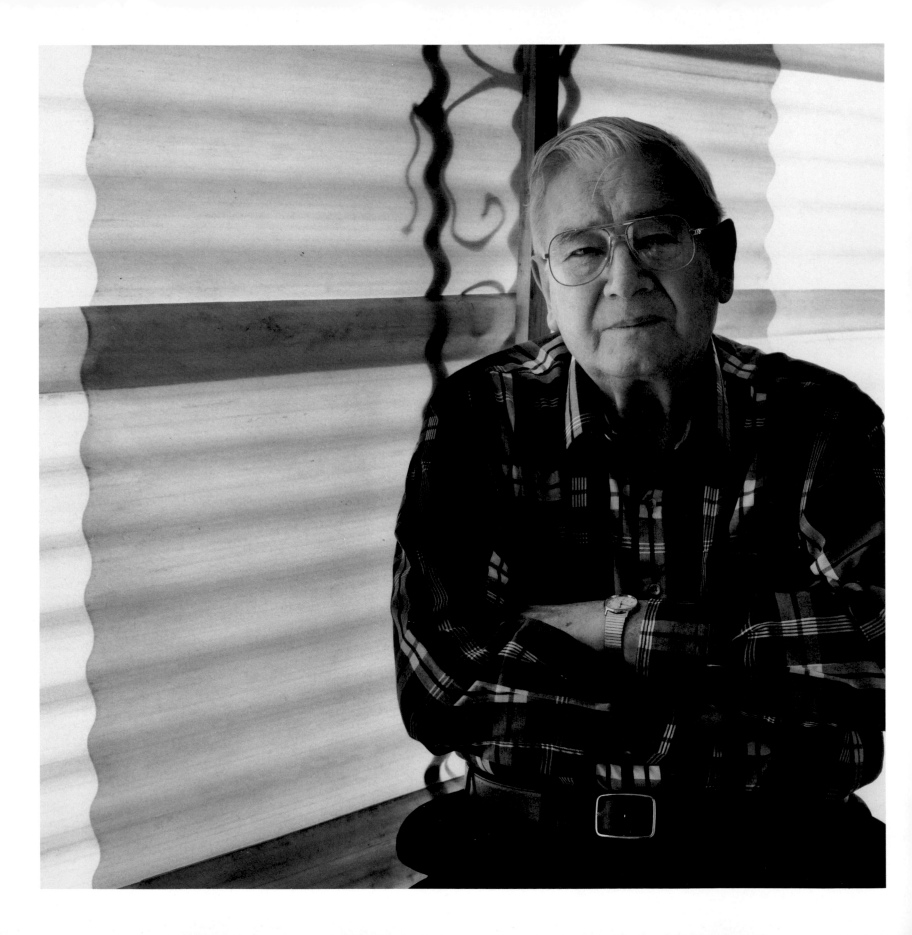

ALFRED ROSENHAN

July 1988

Murray, Utah

"I started tasting a very bad metallic taste in my mouth.
It got quite strong. I couldn't brush it out and I don't
remember how many days before that taste went away.
I went for at least six years, and then a sore appeared on
my tongue next to that filling with the metallic taste. You
could see the cancer with the naked eye, a little yellow
ball with legs going out like a spider and fast-growing.
The doctor took a fourth of my tongue. I had to learn to
talk all over again."

On August 31, 1957, an atomic bomb almost four times the size of the one that destroyed Hiroshima was detonated at the Nevada Test Site. Shot Smoky lived up to its name. According to the ironworkers who built it, the interior of the 500-foot tower on which the bomb stood was loaded with tons of coal. This test, which the AEC knew would be extremely "dirty" with fission products, had been postponed numerous times because the winds were blowing toward more heavily populated Las Vegas and Los Angeles. The prevailing winds blew its fallout cloud through Nevada into northern Utah and southern Idaho. Alfred Rosenhan, 45, was spreading out the fixings for his lunch on a flat rock near Preston, Idaho, during a noon break from uranium prospecting when Smoky caught up with him.

It had to have fallen on my lunch as I was preparing and eating it. The others in the group had brought sandwiches wrapped in wax paper but I brought the raw ingredients to make my own because the rough ride up the mountain generally shook our lunches to pieces.

We were on the south shoulder of Mt. Oxford, in the northwest corner of Franklin County, Idaho. We had been prospecting there for 40 years so we knew the country pretty well. At first we were after silver, but then the uranium boom came along. We had taken a scintillator and a geiger counter with us. At noon I took out my bread and butter and opened a can of tuna fish. I sliced me some tomato and had it all spread out on this rock. I poured some milk out of my thermos and took about 20 minutes to prepare and eat. Right beside my leg I had a counter, but it was set off. When we got through eating I told my nephew to take the counter and go back where he left off. He turned it on and signaled a very high

count. I went over and looked, and the needle was against the pin. I thought something was for sure wrong because that would be awful hot because the instructions on the counter said if you have an ore that counts *halfway* up the scale, don't carry it on your body because it will kill the nerves where you're holding it. I switched the counter to the highest scale. The needle still went against the pin. I went to some ground that had just been cleared by the bulldozer, set the counter down and it went to normal.

Then it hit me: they set off this bomb at six in the morning in Las Vegas. I ran around the hill here and there and there was nothing that wasn't red hot. We knew there was no use prospecting because if we would have had a claim that hot we would have been millionaires. We spent three hours getting off that hill because there were a lot of switchbacks; on this road you had to go really slow. We checked the hill as we went down and everything was hot. I checked the farmer's garden at the foot of the hill and the whole thing was hot, tomatoes, carrots, corn. Anything with moisture on it you couldn't even hear the separate clicks [of the geiger counter]—they were just a steady roar. The green foliage was picking it up almost like a magnet. Actually, all we had to do was hold the counter out of the car window as we drove home [to Salt Lake City] and when we got to the middle of Willard [Utah] it shut right off, right back to normal just like at the edge of a rain cloud.

About that time I started tasting a very bad metallic taste in my mouth near one of my upper silver fillings. It got quite strong before we came home. When I got home I couldn't brush it out and I don't remember how many days before that taste went away. The next day there was a headline in either the *Deseret News* or the [Salt Lake] *Tribune* about an inch high clear across the paper, "Northern Utah Hit By Fallout Cloud." We never went back up to Idaho until after there had been a big rainstorm, and everything was down to normal. The farmer at the foot of the hill said five of his cows dropped dead as they were being brought in for the evening milking. He said that one of them dropped down in the field, and then one dropped dead a little further on. One dropped right in the middle of the road. All of this area sent their milk to the condensing plant at Preston, Idaho, Sego Milk, which shut down shortly after. [This part of the Cache Valley is Utah and southern Idaho's prime dairy production area.]

Within five weeks I noticed a general weakness, and a loss of feeling in my pelvic area, from my crotch right on down the legs. It came on gradually, but I was sterile and impotent. I didn't know what was happening to me, since I was still in my forties. I have found out since at meetings I've attended with veterans that this is the first thing radiation does, and it does it to women too. I already had eight children, and we would have had more because I love children, but that was the end of it. I'm sure glad for the ones I've got. Then my feet started getting numb. Within six months they were completely numb, and I had some real bad spills. I have a hard time keeping my balance. All I've had is loss of feeling. I don't get hungry and I can't sleep.

I went for at least six years, and then all of a sudden a sore appeared on my tongue next to that filling with the metallic taste. I remember we went to a drive-in movie that night and the next morning my tongue had swollen up, I could hardly close my mouth and it was sore on that side. The doctor said, "It looks like you're getting cancer," and cut a strip off my tongue about a half inch wide and an eighth inch thick, the whole length of the tongue. That seemed to settle

it for a while, but six weeks later it was back the same way, so bad you could see the cancer with the naked eye, a little yellow ball about an eighth of an inch in diameter with legs going out like a spider and fast-growing. The doctor cut another strip off. I thought, boy, it keeps coming back next to that filling. I went to the dentist, had him dig it out and a new filling put in, and that made a difference. The operations stretched out almost 30 years, about two or three years in between each one of ten operations. I've had them pull my tongue out with an instrument, me laying conscious on the table, and they skinned it like you skin a rabbit. Of course they deaden it first, but it's miserable. The last operation I had was way down deep at the root of the tongue. He took a fourth of my tongue off and I could hardly talk. I had to learn how all over again. I still get caught on some words. I had never had any trouble until after I got this radiation. There is so many things that has happened to me because of that, diabetes, these sores on my legs that don't heal, well, my life has been a hell.

But I couldn't prove it. I heard that you couldn't sue the government so I just thought, well, as long as I don't get any worse, I can handle it myself. I called Las Vegas and asked who the big man was in Washington who was in charge of all these atomic explosions. They gave me a man's name and a phone number. I talked to him and I explained to him just like I'm explaining to you. When I got through he just laughed a big belly laugh. I said, "What can I do?" He said, "Not a damn thing," and I'm quoting word for word. I thought at least they could refer me to some medical source, or tell me something I could do. They've been fooling around with it long enough and here I was, abandoned. I feel stonewalled with this fallout and I feel like I've been denied my civil rights. And there's not a damn thing you can do.

RULON "BOOTS" COX

December 1991

St George, Utah

Rulon "Boots" Cox supplied milk and cows to the AEC for radiation monitoring. "I had a calf born without a tail during that time, and one cow had a three-legged calf! I couldn't believe it when I saw it. I asked them a lot of times, and they told me that they would tell me if they ever found any traces of radiation. The only time that they ever did was when China let off their first explosion, and they told me then that they got a slight trace, only on the China deal."

My name is Rulon B. Cox, Rulon Barney Cox, but I went by the name of Boots all my life. My dad used to come home with rubber boots on when I was a little two-year-old kid, and they used to say I'd play with them by the hours to try to get into them like he did, so my older sister started to call me Boots.

I dairied for 42 years starting in 1937. We sold the herd off in 1979, wasn't it, Grandma? I could be wrong; Grandma [his pet name for his wife, who sat nearby] says I've been wrong before. I took care of this testing for two or three years afterwards, though, the atomic deal, did stuff for them for thirty-some odd years. When they first started out I'd take a gallon of milk, and they sent me containers to put it in, and I'd ship it to St. Louis. Then they started doing a little more thorough when they got right into testing [in 1951]. They'd come pick up that gallon of milk, and they would go out in the corral and get a sample of green fresh manure, a sample of the dry manure, a sample of the water, a sample of every kind of feed that I was feeding. They'd even go into the pasture and take a sample of the grass and the soil the grass grew in. Sometimes they'd come weekly, sometimes once a month. You never knew when they was comin'. We bottled it and everything, sold gallons and gallons of raw milk right from our dairy here.

Then every few months, they'd buy a culled cow from me. They would give me five cents a pound more than the going rate for him. They'd take that cow, and I used to kid 'em about having their own steaks, y'know, but that guy told me that they cut that cow up from A to Z, every part in her, and they'd test that cow. The blood, the tissue, the meat, everything. He said you'd never seen such a cut-up mess in your life when they got through with her. I never seen it. They just come get it.

That went on for several years in the early part of the testing, maybe ten years. All I done is take the readings and send it in. I didn't know what it meant, or nothing. I didn't keep any record, I just filled out their papers and took the readings off this machine [which measured radiation from fallout]. The numbers would change every once in a while. I asked them a lot of times, and they told me that they would tell me if they ever found any traces of radiation. The only time that they ever did tell me was when China let off their first explosion, and they told me then that they got a slight trace. They never did come right out and tell me, "Yes, we found some stuff," only on the China deal.

I remember that first explosion. I'd bring the cows into a holding corral, and then they'd go into the milking barn, and when that first explosion went off, I thought they's going to take the corral, barn, and all out. Boy, they just went wild. It scared 'em, exploded and sounded like it was right amongst 'em. It was a bugger. And the whole sky light up down here just like daylight. It was before dawn, but it would light up just like a big flash, and then you'd get the aftershock of the explosion and boy, you'd think it was going to knock your buildings down and the cows went wild. Sounded like it went off right in the room where you was, y'know. They didn't tell us anything about it, that first one. When they shot 'em off the other times, it would startle 'em but not as bad as the first one.

I tried to get out of taking those readings, I'd done it so long, y'know. I'd gone to an auction, and the guy'd come and told her, "He can't quit, don't let him quit, he's got the best records in the whole western United States." He was from the testing place down there [in Las Vegas]. He'd come clear to the auction [in Cedar City, an hour north of St. George] to look me up. So I went on for a few years more. Then they finally got it set up near the [high] school, and now it's up near the college.

Both the high school and Dixie College, where radiation monitoring equipment is now located, are a few blocks away from Boots Cox's home. An explanatory statement is posted near the complex of machines, listing on a graph and in numbers the radiation readings for all the small towns in Nevada and Utah where the other monitors are located. Only for St. George is the graph and number column blank except for the legend "No data available."

The children of Boots Cox with their three-legged calf.

Date unknown. Photo courtesy of Rulon Boots Cox.

People blaming this onto the cancer, they would be people that was outside, like Fred Ward, the dairyman next door. Our oldest daughter has taken thyroid medication for a while, and I was on it for a short time, and I've had all these skin cancers. But I was inside milking; I had a roof over me. By the time I got done, that [fallout] cloud would be gone. Some of those blasts would come early in the morning, just when I'd barely get the cows in, and it would be two or three hours before I'd be out of that building. I think some of these people like cattlemen out with their cattle, it could do it to them.

I had a cow that had a calf once born without a tail during that time, just no sign of that tail at all. One cow had a three-

legged calf! I couldn't believe it when I saw it. I thought, there's something wrong with that, what is it? Then I saw it only had one front leg. It grew up and run with the other calves, and when it run and play you couldn't even tell. But it had to hopscotch when it was just walking, y'know. She grew up to a full-grown cow and had calves of her own. One cow had five calves, very unusual, but they was all born dead. Another had three and they lived.

If they had told us the milk was dangerous, maybe we would have had to dump it a few times, and we would have. You wouldn't want to have something in the milk that would be detrimental to your customers, y'know. I think I should have been told more. I asked quite a few times, but they always said no. I didn't know enough about it to know whether to suspect anything. After they started to complaining here about the fallout you start to wonder. No way I could tell, I just took the reading, put it in an envelope and sent the paper in. I didn't have a geiger counter, but they had the machines runnin' all the time.

Knowing what I know now and read and everything, I don't see how they could have helped but know that there was fallout in it. I'm sure they did, they knew more than they ever told me. It would be hard to test anywhere without hurtin' people, testing anywhere or some of these nuclear plants that go wrong. Any part of the government you get that underhanded stuff in it. Knowing how the government acts and operates, they don't tell you somethin' they don't want you to know.

SCOTT AND ELAINE PRISBREY

March 1986

St. George, Utah

Chad Prisbrey's grave in the St. George cemetery. "We were never concerned about the fallout dust in the mid-fifties when the St. George valley was covered with fallout dust. We were never warned that the dust could be hazardous. After his death, we began to wonder why our son, a healthy boy, should die from cancer, as there were no records of cancer in our family. We feel exposure to cancer-causing radiation caused his death some 20 years later."

Except for three years in the army, 1970 to 1973, Chad Prisbrey lived his entire life at 431 South Main Street in St. George, Utah. His parents recounted what they thought to be the idyllic childhood of their son, playing "cowboys and Indians" in the backyard with his friends, doing the things that boys do. When asked about their first clue that the atomic tests in Nevada might be more harmful than downwind residents were being told, the Prisbreys remembered:

School children were given tests for radiation problems, but only a one-shot test [February 15, 1955], not a long-range program. If these same children were tested 20 to 25 years later they would have come up with a better answer to A-bomb tests effects. [In truth, the cancer studies are ongoing to this day.] We were never concerned about the fallout dust as there were no warnings to the potential danger, except in the mid-fifties when the St. George valley was covered with fallout dust. On one particular day the noon news on the radio warned people to stay indoors and later on they announced that cars coming in on U.S. 91 from the south were being stopped at a roadblock by the Atomic Energy officials and being washed to eliminate the contamination of A-bomb dust. Many of the blasts 135 miles away at the Nevada Test Site sent dust clouds over our neighborhood during the 1950s. We were never warned that the dust could be hazardous to younger children or adults if enough exposure was encountered. Our child spent considerable time playing in the yard at this point in time, and we feel exposure to cancer-causing radiation caused his death some 20 years later. We were unaware that there was a problem.

Chad took good care of his health, exercised with weights and jogged every day. Being LDS he never smoked or drank.

He served in the army in Georgia and Germany from 1970 to 1973. While at Ft. McPherson in Georgia he was operated on for a small growth in the roof of his mouth. He visited us on leave several times and mentioned he had a little back problem. I noticed he had a small cough, winter and summer.

After his army discharge he worked for the city as a police dispatcher, and joined the Jogging Club. He believed in being in good physical condition. In May and June of 1975 he complained of headaches and nosebleeds and then the loss of feeling in his fingers, feeling like sandpaper. He was unable to lift small objects with ease, unable to do typing on his job, and visited his doctor several times. About the first of July he came in one evening and said he felt terrible. He said he just couldn't work in his present condition. His doctor suggested that he go to a blood specialist, Dr. Cecil at the Holy Cross Hospital in Salt Lake. He received many tests and returned home August 17, our thirty-fourth wedding anniversary. He had multiple myeloma bone cancer.

From a normal boy of 160 pounds he lost weight and dwindled down to 85 pounds. He never returned to work and his condition worsened from day to day, using a cane, coming down with virus pneumonia, had a lung biopsy. They told my wife he could live 2 1/2 months to 2 1/2 years . . . she went through agony. Our prayers were answered for the Lord to take him. He died November 13, 1975, just a short 18 days before his twenty-eighth birthday.

After his death, we began to wonder why our son, a healthy boy, should die from cancer as there were no records of cancer in our family. Father, mother, grandparents lived to a good age, 90 years, and no cancer. The rumors began to filter down to our area that radiation was a very dangerous

material and would take a number of years to produce cancer. Several of our neighbors died though they were fairly young in age. In my discussions with other local people I found an alarming number of people with the same problem in our area.

Our medical bills were around $30,000 for the three months our son was ill. The insurance companies paid for part of this, but it was still a large burden to our family. We had great faith that he would be saved by proper medical treatment. We joined the group in a suit against the U.S. government to bring attention to our problem. *Life* magazine came down and produced an article about the "downwinders" for the June issue of 1980. A lady in the East seen the article and sent us copies of government reports for 1956 or 1958 which indicated that they had developed charts to show how soon a person would die from certain amounts of radiation exposure up to 20 years of elapsed time after the actual exposure. I understand that these records are now classified to the public.

In the A-test hearings here in St. George with senators Kennedy, Hatch, and others, testimony was given by many people who are dead today of cancer. A school board member indicated we had two full classes of handicapped children from during the A-tests and that normal numbers from before the tests were five or six children. I asked Senator Hatch if he was aware that the present underground tests were still based on "favorable" weather conditions, that the wind must not blow towards California or Las Vegas. The wind must blow towards "uninhabited" Utah and eastern Nevada or "sparsely" settled areas. They must know that radiation venting from underground tests can kill.

A week or so ago the so-called Star Wars test of 150,000 kilotons was delayed for several days *due to adverse weather conditions.* The downwinders are still guinea pigs to the test program.

DR. BILLINGS BROWN

March 1988

Holladay, Utah

"Nobody ever dies of radiation poisoning. The vital statistics of the U.S. only allow you to die of one of 73 causes. Radiation poisoning isn't one of them. The computer won't take it. When the government doesn't want things out it suppresses them with vigor. They put enough money into lawsuits and cover-ups so they always win. It's them against us."

Billings Brown, originally from Seattle, moved to northern Utah in 1952 where he opened the Department of Chemical Engineering at Brigham Young University in Provo. After six years there he went on sabbatical and never came back, joining the Cold War military effort instead. "Missiles were my line, working on rockets and rocket fuels at Hercules [Missile Motors plant in Magna, Utah]. I went on to Boeing, then in 1968 I went to the Pentagon for a couple of years, working in the Institute for Defense Analysis." As a scientist, Billings Brown became concerned about the integrity of government-sponsored cancer studies administered through the University of Utah Medical Center that considered northern Utah to be an area of low fallout, and thus used it as a "control" group against which to compare rates of cancer in southern Utah. This juggling of statistics would make it appear that there is less cancer downwind. His many experiences with radiation at home in Utah during the atmospheric testing era, in his efforts to clean up the enormous Vitro uranium tailings site in Salt Lake City, and as a technician at Hanford Nuclear Reservation and Lawrence Livermore Laboratory, have convinced him that the government will always "put enough money into lawsuits and cover-ups so they always win. It's them against us."

One of the courses I taught at BYU was nuclear engineering, so I did have some equipment. A geiger counter is quite inefficient, but it does work. In March 1955 I wrote to the *Los Angeles Times* and complained that they only set off tests when the wind wasn't blowing towards California. It went toward Salt Lake City. Dust settled over northern Utah like the old-timers had never seen before. With that clue I took the geiger counter and went outside. We counted the dust settling on cars, on the windows, and so forth, and found it very radioactive. Very hot. In fact, my estimate was that it was above the tolerance level for children, though not for adults. My basis for that *LA Times* letter was seeing all that dust everywhere, and knowing my four kids were out playing in it. I called home, had them brought into the house, bathed and their hair washed. I took the geiger counter home and measured their clothes. They were hot. What I want to point out was that fallout wasn't just in southern Utah. It was just as severe in northern Utah.

Dr. Joseph "Lynn" Lyon, Chief of the Division of Epidemiology of the Department of Family and Community Medicine at the University of Utah and codirector of the Utah Cancer Registry, headed cancer studies of southern Utah residents that, to his surprise, showed that there was a three-fold increase in leukemia. Press attempts to interview him

after a second study was released were unsuccessful; he said that the Department of Energy had placed him under a gag order.

I didn't know Lyon, only his impudence. If Lyon hadn't gotten into the act and spoiled the statistics, I think somebody could have proved that his division between northern and southern Utah fallout was wrong. I did talk to one of his graduate students [a research assistant] until he ordered that she not talk to me anymore, so we did get some facts before she clammed up. The problem was he drew a line through the state and used northern Utah as a control group, but that's wrong because the north had plenty of exposure. He should have used someplace that wasn't exposed [to radiation].

I did a sampling on one day, three days after a test. I had the figures on the geiger counter written down and sent them to the *LA Times* [which, in the March 24, 1955, issue, described atomic tests as "nuclear puffballs"], who forwarded my letter to the AEC. The AEC wrote back that they were genuinely interested in my figures, which I then sent them. They sent back rather a nasty letter, as the government is prone to do, saying it [the radiation] was 18,000 times below the maximum permissible concentration, and you'd have to inhale or eat 70 tons of this dust to get up to the permissible burden. This was absolutely false, wrong, misleading, and I don't know where they got their figures, but I just let the matter drop. The AEC letter said, "we appreciate your personal concerns, but would you please try to separate them from the facts." I was 35 then, relatively young and innocent. Nowadays 35-year-olds are more active, but then I just saluted and let it drop.

As far as I know, only myself and Bob Pendleton [Utah's first full-time director of the Department of Radiological Health and a persistent critic of the AEC whom Dr. Lyon characterized as "very noisy"][1] made measurements in northern Utah at that time, and he made far more than I did. He went to the mountains and measured radioactivity in deer and brown trout. He said, for example, he would not eat those trout because they were too hot. I discussed the results of my spot checks with Pendleton off and on, and we were two crying in the dark. He had much more data than I did. He went after the thing with vigor, I did not. He carried the ball in the fallout, but he didn't get anywhere. [In 1963, after publication of his radioiodine study was held up by the AEC, Dr. Pendleton wrote, "I wonder if those in power in the Atomic Energy Commission realize that it is one thing to err and admit it, but that it doubles the guilt when you err, refuse to publish it and then deliberately go contrary to all the democratic principles by suppressing release of information which is vital to the nation."][2]

Snow was collected on March 2, 1955. You might want to zero in on that date. [This was the day after shot Tesla, 7 kilotons.] There was a second test a couple of days later. There was a dust storm on March 7 [the date of shot Turk, 43 kilotons, almost three times the size of the Hiroshima bomb]. There was a previous dust storm in my notes on February 23 [shot Moth was February 22, measuring 2 kilotons].

In 1956 I spent the summer at Hanford. [Hanford Nuclear Reservation in Richland, Washington, where the plutonium for the first atomic bombs was processed during the Manhattan Project, remains an environmental dead zone" to this day. The area downwind is often referred to as a "national

sacrifice area" by its residents.] I was exposed to radiation and my coworker, a professor of physics, died of leukemia shortly thereafter. We were working in the basement on one of the reactors. My job was to examine the Purex process separating uranium from plutonium. It wasn't the best way of doing it. I think there was a leak. My son Russell worked on a cancer study of dogs [at the University of Utah]. The research he was doing was feeding beagles small amounts of radium and plutonium and comparing the incidence of cancer death in the dogs. So we had some notion as to the relative toxicity of radium versus plutonium, and the fact that while civilization has built up some tolerance to uranium, there is no such tolerance to plutonium. We were exposed without knowing it—we wore film badges, but they're only read after the fact. We wore no masks, just some protective clothing. There was a minor flap at the time, testing of urine and blood samples, but no report back to us at all. So again, we had no way of knowing what was going on. Nothing was ever said. Nobody said a word to us, not my supervisor, nobody.

I had a tired, ill feeling and the blood tests showed the platelets and everything messed up. It stayed like that a very long time. The Veterans Administration hospital here [in Salt Lake] admitted to me that I had radiation sickness. To give you an idea of how bad it was, about ten years ago I had an annual physical with one of those physicians out at Hercules. On this one occasion he sat me down and poked into my file and looked at me and said, "You're dead." Well, I knew by that time that it was a game. I said, "But Doc, I feel particularly good today." He said, "Doesn't matter. You're dead." I'd like to put in here that nobody ever dies of radiation poisoning.

The government has a very good case. The vital statistics of the U.S. only allow you to die of one of 73 causes. Radiation poisoning isn't one of them. The computer won't take it.

When the government doesn't want things out it suppresses them with vigor. And you have to understand that anybody in a university may not talk to you at all, the reason being that all the money comes from Washington. If any researcher dared to chip away at the stonewalling of the government, he just need not apply for any further grants. Without grants at the university, you starve to death. Or you're let go. Publish or perish. It's as easy as that. There were a few people who brushed up against the AEC, as I did, and got them mad at them. I'm a survivor . . . this house was torched, my children were threatened, my job was threatened, and when we had a boy spending the summer in Dallas, Texas, I remember being called and the voice said, "you wouldn't want anything to happen to Tom, would you?" It's all the same thing: shut up or else.

1. Philip Fradkin, *Fallout: An American Nuclear Tragedy* (Tucson: University of Arizona Press, 1989), p. 44.

2. Ibid., p. 217.

STEPHEN BROWER, PH.D.

February 1988

Provo, Utah

"I asked what was the process by which the sheep men could get some kind of redress. At that point he was very firm. He said there was no way they would allow this precedent to be set, or a claim to come against the AEC. He said it would jeopardize the testing program. I came to understand that that's what you're dealing with. I felt used and violated."

I was in Iron County as the agricultural agent employed by Utah State University primarily to link the knowledge and research from the experiment station at the university, make it available to the people of the state in Iron County. We could hear and feel the tests when they started testing in Nevada in 1951. We became aware of it then. I was living in Cedar City. The AEC made contact directly with me and provided me with a geiger counter, a radiation meter that I carried with me all the time. There was no formal agreement. I was in touch with the livestock men and was traveling all the time in that western desert area.

We were regularly exposed to fallout whenever the winds from the test came to the north and east. I was called on a couple of occasions, and I talked to Joe Sanders, the acting field manager from the AEC in Las Vegas. I talked to him about the fallout and they notified me that there would be some fallout from the tests, to kind of be aware of it and do some checking with the meter. They made a point of reassuring me that there was no problem, and encouraged me to reassure the local people that there would be no danger, that the levels of radiation would be negligible, and compared it to X rays.

Our daughter Teresa had some thyroid problems, and by the second grade David had enough so that for three years he didn't grow. The doctors finally found that it was thyroid and gave him thyroxin so he started growing. In 1974 when I came back from overseas, a number of people from southern Utah made contact with me and were telling me the problems they had with cancer and deaths in their family. In 1953 when the first court case was held until 1974 or '75 I was away and not aware of what was going on.

I would check vegetation primarily in the west desert and the Escalante valley, and I'd find from double to triple the readings on plant vegetation compared to if you wiped the dust away and took a reading on the ground. The background readings were 3 and 4 and the vegetation were between 10 and 12, two and three times as high. The AEC didn't set up any formal reporting procedures. Other than providing the instrument and occasionally talking about what was happening. I remember one day they had announced on the radio that all the cars had been washed down, actually stopped traffic on the highway, and I guess that happened three or four times. Probably the most dramatic experience I had was a meeting with the county commissioners one day. I overheard a group of men in the courthouse talking excitedly about uranium claims they were making in the west desert. I went out there and checked. What they'd been doing was picking up the radiation off the vegetation.

I went with a U.S. Public Health Service doctor to collect case data from a family that had been with sheep in Hamblin Valley during the tests. They told of one atomic cloud in June of 1954 that had moved in low like a fog over the valley on a day of high humidity. The wife, a young woman in her late twenties, had lost all of her hair, had experienced lesions on her ears and nose that were extremely slow in healing, and she lost her fingernails. The men did also. She had developed some serious emotional problems from nervousness and was unable to take care of her children, which resulted in a divorce. The official explanation that was reported to me afterwards was that she had undergone hysterectomy and this explained the symptoms. The report of Monroe A. Holmes, DVM [a veterinarian] from the Dept. of Health, added that her symptoms were "complicated by neurosis."

As the sheep men were bringing their sheep off the winter range in Nevada, they were beginning to report to me and to Dr. A. C. Johnson the veterinarian of lambs being aborted on the trail, which is quite unusual, and sheep dying on the trail. Then during the lambing time they were losing a large share of the lambs. They were concerned enough that I made contact with the state vet, the agricultural experimentation station, and we were suspecting it had something to do with the fallout but we had no experience. Dr. Johnson said he had never seen anything like it before, and he was approaching retirement, long years of experience there. Of the sheep he said "You could pick wool off like dry asbestos." He was perplexed. At that point the AEC came in, particularly when the Bullochs and one of two others described their experience of being told by the AEC to get out of an area, but there was no way they could evacuate because they had to stay with the sheep.

We collected samples of the sheep that had survived. I took readings with my geiger counter with Dr. Thompson and Dr. Veenstra, one was a private veterinarian from Los Alamos and the other was an AEC man. On the low scale the needle on my meter went clear off scale. We picked up high counts on the thyroid and on the top of the head, and there were lesions and scabs on the mouths and noses of the sheep and the wool was beginning to come off. In some cases it was falling off in big chunks. We helped collect samples of fetuses and dead animals. Unfortunately the people from the slaughteryard had already collected most of the dead animals from the desert trails for processing into oils and sold for meat and chicken feed before the AEC came in to do an active investigation. My guess is the meat was consumed primarily in the local markets down there. Very few of that lamb crop

survived; the herds were decimated. Seventy percent or better were lost. I took pictures of the animals that survived. We found regrowth of wool that was in some cases black, it was a different color. You could actually see on the backs of the animals the retarded growth of the wool, and the skin on their faces where the lesions were was leathery, different.

One of the things that was most striking to me was that each time we pressed the AEC experts they'd say to us, "We don't have any experience with radiation on sheep." In fact, a man named Leo Bustad from Hanford talked to the livestock men and very specifically indicated, with Paul Pearson, chief of biology and medicine with the AEC, that they didn't have any experience with radiation on sheep. Yet Bustad in 1950, three years before this time, had conducted extensive radiation experiments and had produced these kinds of results with sheep and with lambing of ewes. I didn't know that until 1976. My major AEC contact at that time was with Dr. Pearson, a Utahn who agonized about it. His family was in the livestock business. Thompsett, a private consultant at Los Alamos with AEC, told me that in his experience with livestock this was definitely radiation-related, and promised to give me his report. When I didn't get it I called Pearson for it and he hedged. After two months he said it was picked up, every copy, and "I've been told to rewrite it with no reference to radiation." I had a thorough talk with Pearson and asked him if it was radiation, what was the process by which the sheep men could get some kind of redress. At that point he was very firm. He said there was no way they would allow this precedent to be set, or a claim to come against the AEC. He said it would jeopardize the testing program.

The sheep men moved towards litigation. All the data I'd had, and the attempts I'd made to get copies of reports they'd made, finally after six of eight months of waiting I was told it was classified, not available. When we finally did get this case into court, none of the technical data from experts was allowed to be used, and of course the Iron County sheep men could not make a case that would stand up in court without this data. The original, preplanned strategy of the AEC worked because they had the indiscriminate power to intimidate, to withhold, screen, change, and classify any and all information, reports, and data. The Justice Department blocked the case to the point that it was impossible legally to move any further.

During one of the Congressional hearings in 1978–79, a report came out. I picked up a statement from Dwight Ink, the general manager of the AEC at that time, now one of the most respected professionals in public management, in which he said, "Although we do not oppose development of further data, performance of the public health service studies will pose potential problems to the Commission: adverse public reaction, lawsuits, and jeopardizing the programs at the Nevada Test Site." That became the policy statement which guided all these people. The AEC strategy for accomplishing the central goal? Classify any data that appeared damaging to the AEC. They were able to neutralize any surveillance of what they were doing as an agency. There was no such thing as moral or ethical behavior except that behavior which supports the policy of the organization. Just as good-intentioned Germans followed Hitler, even to killing people, that same behavior is common in these bureaucratic organizations, public or private. I came to understand that that's what you're dealing with in these kinds of systems. I felt used and violated.

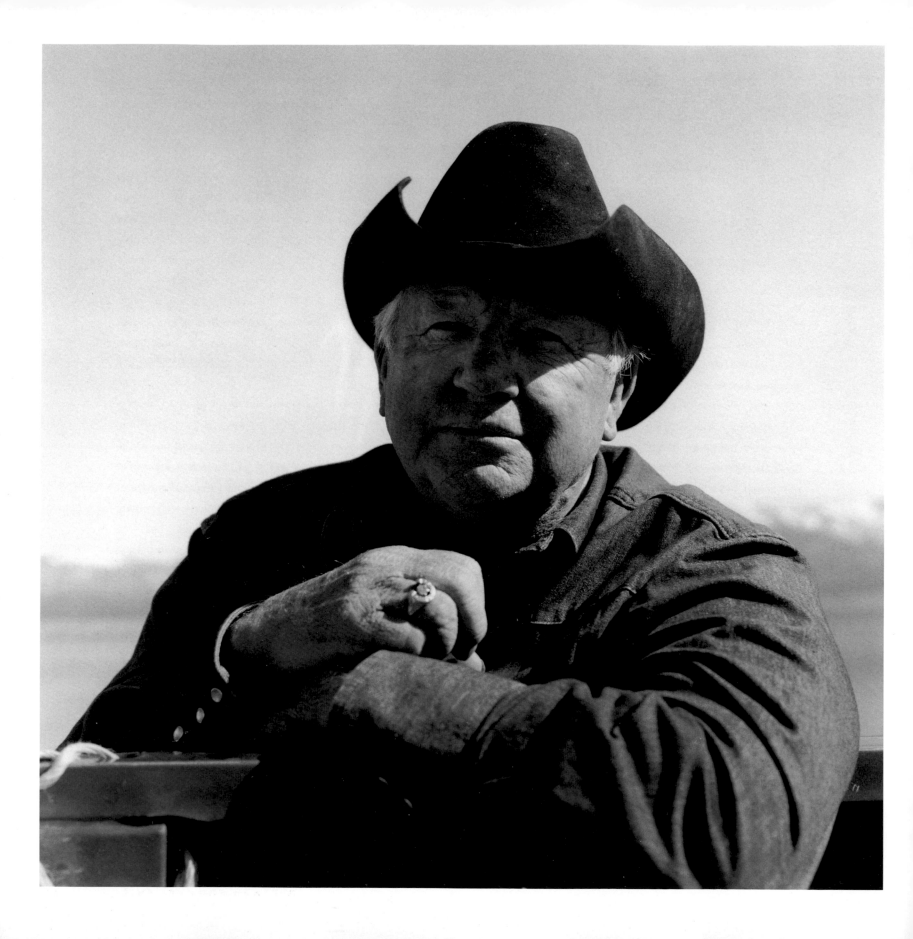

McRAE BULLOCH

March 1986

Cedar City, Utah

"They took the geiger counter and put it down on these sheep and that needle would hit the post. I remember the guy saying, 'Is it hot?' and the other guy would say, 'Is it HOT? It's so hot this needle just about jumped the pole!' This was months after they died and he put the counter by that pile of bones."

A part of my interview with McRae Bulloch took place in his truck, driving out to the range west of Cedar City, Utah. We talked about the months he would spend with his brother and father living in a sheep wagon on their winter range due east of the Nevada Test Site. Each spring they would trail them back east to Cedar City, more than a hundred miles over a 30-day period. "It was a lonely life, but there was something about it, it just gets in your blood." Bulloch has finally sold off the last of his herds, keeping just 200, almost as pets, "to keep me out on the range and out of my wife's hair." Back at the lambing sheds, I understood at once the enormity of his loss. He pointed to the roofs of the sheds, looked at me hard, and said, "some of those lambs would be born with their hearts outside of their bodies, skin like parchment so you could see right inside to their organs. They died, so many of them that they were piled up right up to the roofline every day."

It was a clean and healthy life. One thing about it, you wasn't breathing the air someone else was breathing. It was fresh air. But not when the bomb was there, it wasn't fresh then. We didn't even know! We'd be out there on the range and the sky would light up. At first we didn't even know what they were doing. Then we heard that it was an atomic bomb test at the Test Site, because we were right there adjoining the Nevada Bombing Range, near Alamo and Hiko. We were close to it. Lots of times we would be eating at the breakfast table and the whole sky would light up. You could see the mushroom cloud come up and the gray haze up the valley, all over us. Saw a dozen or more. I think in 1953 they dropped Dirty Harry from an airplane. I wasn't out there that day but my brother was. The army personnel came up to camp. They had gloves on their feet and on their hands and told them, "You guys are in a hot spot here. You better get these sheep out of here, you're in a hot spot."

They had no idea of how much time it takes to drive sheep out of there, did they?

Sure didn't. They finally radioed back to base and said, "There's two sheepherders with a herd of sheep in an awfully hot spot. What are we going to do about it?" Dan Sheehan [who lived nearby] heard them say this. They were told, "How many guys are there?" And they said, "There's just two." "If there's only two there forget about them and go up to the mine," which is Tempiute Mine, two or three miles away, and there was two or three hundred people up there. "Forget about the two sheepherders and get up to the mine and put those people under cover." That's where they went. We stayed there a little while longer, and then it was about time for us to head home. It took us 25 days [for the herd to walk

150 miles] to come in from out there with the sheep. As we got closer to Cedar City, we noticed the ewes were aborting their lambs, miscarrying. We didn't know why, we just started to notice it. Then we got in and had them sheared, and we had about 700 or 800 yearling ewes that wouldn't have lambs, you know. And the little lambs started to die. And one day Ashton came down and said, "Gal, you better come down and look at your sheep—there are a lot of yearlings dying." I went down there, and the ewes were dying out in his field. My dad was beside himself because so many sheep died, most of our lambs and a fourth of our ewes. We trailed them to the mountain and we took our cattle truck to pick up the sheep that couldn't go. We had just all we could take, and all those sheep we picked up that day died.

We dumped them out in a pile. The AEC came to that pile of bones later. The scientists came to investigate after we decided it was something really wrong and other ranchers who had been out in Nevada close to where we were, their sheep were dying too. We got the county agent [Stephen Brower] and the vet [Dr. A. C. Johnson]. Those sheep had burns on their faces and on their lips where they had been eating the grass, and blisters on the ears, on the nose, I noticed that out in Nevada before we started to come in. The black sheep had white spots come in the black wool where the fallout would land on their back. We had a black horse, black as coal, and pretty soon he started to have white spots on his back. They took the geiger counter and put it down on these sheep and that needle would come over there and hit that post. I remember the guy saying, "Is it hot?" and the other guy would say, "Is it HOT? It's so hot this needle just about jumped the pole!" This was months after they died and he put the counter by that pile of bones.

What was the attitude of the officials?

At first they did say this could be radiation, and then they got kind of sarcastic with Doug Clark because they told him, "You're just a dumb sheepherder. You wouldn't have understood it if we explained it to you." Doug was a city councilman and a very prominent and bright man. He was no stupid man.

Did you see the clouds actually come over your herd?

Oh hell, time and time again it would come up. It would mushroom out and pretty soon it would be a kind of smoky haze come up in the valley. Matter of fact, I had my sleeves rolled up one day and it left a rash on my arms. The thing is, the sheep slept in it and ate it and drank it in the snow. They ate the vegetation, rolled in it.

What happened to the wool?

We sheared it, sometimes you could pull it right off the sheep, but we sold that wool. We had no idea. Those lambs went to market too, in the fall. I don't know who ate them but somebody did, I guess. I think there were seven of us who were in on that lawsuit [*Bulloch v. United States,* filed in 1955] but there were plenty others who didn't go in on it. The government had two attorneys, one of their names was Finn, and he was a sharp attorney. They lied in court, none of them told the truth. They said it was malnutrition, that it had nothing to do with radiation. Poor management is what they said killed the sheep.

We lost that case. A lot of years went by, and our lawyer, Dan Bushnell, called to say he got some more information and wanted to know if we wanted to go on with it. He found out they had covered up some letters. One scientist was really for us, and his name was Harold Knapp. [Dr. Knapp

was employed by the Fallout Studies Branch of the Atomic Energy Commission's Division of Biology and Medicine.] He really believed it was the radiation. He lost his job because he told the truth.

How did you recover from the original sheep loss? When you lost all those sheep, what happened?
We sold our Nevada ranch, and we sold property here in town. Actually, we never did completely recover.

After many secret Atomic Energy Commission documents were released to the public through use of the Freedom of Information Act in the late seventies, District Court Judge A. Sherman Christensen ruled that in the original trial there had been fraud perpetrated on the court by the government. What the AEC studies did *not* investigate were the large doses of radiation that internally irradiated the thyroid glands of the lambs (measured at 20,000 to 40,000 rads—a 600-rad whole-body dose is considered fatal) and the dead sheep's gastrointestinal tract (1,500 to 6,000 rads). The external doses were estimated by the AEC to be only 4 rads from "all the fission products present in the fallout particles which were ingested along with the open range forage." Judge Christensen wrote of AEC officials during the early fifties, "I can't help but believe that those gentlemen were conscious of the implications; [untruths about the sheep deaths would] jeopardize every one of us, because the general pattern could extend to humans."

In a brief submitted in court in 1979 by Dan Bushnell, attorney for the sheep men, it was recounted that during the original trial, the government attorneys suggested that it might have the discretion to use the sheepherders as human "guinea pigs" in experiments to assess the effects of radioactive fallout. Judge Christensen had asked whether it would be within the discretionary function of the test manager to delay the shot, even though there might be sheepherders in the area, in the interest of learning the effects of beta rays on them. Finn, the attorney for the United States, said that it might be. The judge was astonished by the answer, saying that he had understood that such an attitude had existed in concentration camps, "but to say that would be within the discretionary function, *it shocks me.*"[1]

For each district court decision granting justice to the sheep ranchers, a successful government appeal has denied it to them. In 1986, the case went to the Supreme Court, but the Justices in a 5–3 vote refused to hear it. A few months later, Chernobyl became a household word, and the sympathy of the world went out to the Ukrainians, Byelorussians, eastern and western Europeans downwind, and for the Laplanders whose reindeer were dying from ingesting radioactive fallout while foraging for food in the wilderness.

Lost in the fog of forgotten history is the fact that *each* of the atmospheric tests in Nevada released many more curies of radiation than Chernobyl. The ranchers of southern Utah asked for only $250,000 total in compensation for all their sheep losses. When I asked Dan Bushnell, their attorney, for his estimate of the federal attorneys' fees, he laughed darkly and sputtered, "Hell, they're spending a quarter of a million dollars a day now, and just to fight *me!*"

1. An excellent description of the sheep deaths, AEC cover-up, and the litigation that followed may be found in a government-issued publication, *Health Effects of Low-Level Radiation*, volume 1, 1979. Congressional Oversight Hearings, Washington, D.C. The material quoted here is selected from passages on pp. 530–595.

DELAYNE EVANS

October 1988

Parowan, Utah

"Have you ever seen a five-legged lamb? I did. Have you ever seen a one-eyed lamb? I did. We got blasted. Then they tried to tell us that our sheep were dying from mal-nutrition!"

Have you ever seen a five-legged lamb? I did. Have you ever seen a one-eyed lamb? I did. The bombs that hurt us, one was in March and the other one was in May of 1953, I was about 30 years old. One of them they called Dirty Harry.

In fact, four atomic detonations from the Upshot-Knothole series of tests were responsible for the sheep losses that spring: shot Annie on March 17 at 16 kilotons, Nancy on March 24 at 24 kilotons, Simon on April 25 at 43 kilotons, and Harry of May 19 at 32 kilotons. By June with shot Climax the kilotonnage was up to 61, but the lambs and sheep were quite dead by then.

We would have a prevailing wind from the southwest all the time, and it brought it right over where we run our sheep, just over the fence from the atomic range. The Atomic Energy Commission drove up in a station wagon and said, "You better get the hell out of here, it's hotter than a firecracker out there," then drove off. They wouldn't stay there five minutes. I said, "Where the hell am I going to move two thousand head of sheep?" They'll only go two miles an hour, that's as fast as a sheep will walk, and where could you go? The thing of it was, they stayed there for another thirty days and ate the shrubbery with all that stuff on it. That's how the ewes got it in their thyroids and that's what killed the lambs. Those sheep of mine had scabs from it on their ears and noses and their feet. They were burnt, and every spot on those sheep that didn't have wool over it had radiation burns on them.

We got blasted. The fallout would settle in different pockets, and was more intense in some spots than others. It came over this valley here and it hung for twelve solid hours, a pink cloud of dirt and dust. You can't imagine. Those ewes

were heavy with lamb, and they'd walk along and then just stop, and wouldn't move. I had to take my truck out and haul them in. They had so much radiation in their thyroid glands they just give up. I bet there wasn't one sheep that was out there in '53 that didn't die within two years because I was buying sheep all the time to replace them. They kept on going down and down and down. It breaks you. It broke me. I had to mortgage my home to buy more sheep to start out again. It took me 15 years to pay it off. It completely broke my brother-in-law Randall Adams. He never was able to crawl out of it after that, and finally he died of cancer in his fifties. The Clark boys finally got out of debt but the Bullochs never did. They just couldn't work hard enough to get out of it.

One day I went over to where Randall was lambing his sheep. He had a two-ton truck with three-foot beds on the side, and we loaded that completely with dead lambs and hauled them off. Every day or two I'd take a pile of lambs 8 feet tall from outside my lambing sheds and haul them to the lower field to dump them. Then the ewes would die and I would drag them onto the tractor because they were harder to load. Have you ever seen a young animal that was born completely rotten? I did. They'd be bare. I had little lambs born that absolutely didn't have one speck of wool on their bodies. They were transparent and you could see their little hearts a-beatin' until they died. I never seen anything like that in my whole life until then and I've been in the sheep business from the time I was a little boy on the farm.

Now Doug Clark, the Atomic Energy guys visited him one day and called him a liar until he had a heart attack and died right on the spot. They told him, "You're dumb, you don't know what you're talking about." He knew just exactly what he was talking about, he was the County Commissioner at the time and an outstanding citizen. We knew it caused it, hell, we're not stupid. They thought we were a bunch of old stupid sheepherders but there's nothing stupid about us. They stopped Doug from coming in from Nevada, stopped his pickup and made him take all of his clothes off and washed him down and washed his truck before they'd even let him come home. Now was that man irradiated or what? Why a geiger counter would go absolutely crazy out there, it would go off of the peg.

Then they tried to tell us that our sheep were dying from malnutrition! Hell almighty, we were feeding them every day, hauling water to them to keep them in good shape, and they were *fat!* I was putting choice hay in my mangers and rolled barley on top of it twice a day!

I figured I lost a third of my operation within three months. I know Mac and Kern [Bulloch] and Randall [Adams] lost more than that. They would never admit that they had killed thousands of head of sheep because it would cost them maybe as much money as they'd send down there to Nicaragua in one day. It's just that simple, they could have paid this whole bill and compensated all the people in southern Utah, eastern Nevada, and northern Arizona. That government of ours will spend billions of dollars, Mexico, Nicaragua, and all over the world but they won't take care of their own people. That's what bugs me. They took care of the Japanese and that bomb they dropped out there done us as much damage as it did them, and over in the Marshall Islands and all over. And when they treat you like that, and lie to you like they lie to us, it don't make you feel very good. They knew and we knew they were lying. This country ought to be taking care of their own people instead of worrying about somebody else. Don't you think the same way I do?

Everybody that worked out in the open is affected by it one way or the other. You could see the flash from here and then later you'd see the stuff come, and they never told us to stay indoors. We'd go out and watch it come. Right to this day they won't touch a bomb off even underground if the wind isn't blowing right toward us, and there's nothing you can do about it. I'm sure the radiation affected [my daughter] DeeAnn so she couldn't have children. She was just a little girl then. These little kids in here are adopted children. And you can go up in that cemetery and see the headstones of the little children that died of leukemia about five years after 1953, that tells you everything right there. There are people there that died in their forties and fifties, and most every one of them are people who worked outside with livestock. Why would they all start to die of cancer at the same time, I'd like to know? Now it's hitting everybody, bone cancer, cancer of the glands and the breast. That was unheard of years ago. I'm going to have it in my throat before long, you wait and see. If I hadn't been so mean and ornery, I would have been dead before this!

I love the country and I love my government but I think they sure done us wrong. We've fought them for years. Everything I say is the truth and I don't give a damn who hears it.

MARJORIE BLACK

November 1988

North of Delta, Utah

"The government was telling us on the radio, don't let your children eat the snow. This one morning when we got up, our truck was sitting quite close to the house and a light snow had fallen. When that snow melted off the truck, the paint peeled off. Just curling off and there's the bare metal. I told my husband, I said, 'Are they telling us that if the children eat the snow, that's the only danger?'"

When I first met Marjorie Black, my first thought was that she was a kind of woman one would hope to become with age. She looked so strong, yet she was gentle with me, solicitous, clear-eyed with bushy black eyebrows, and she packed a pistol in her truck. Yes. She had lived alone since her first and second husbands each died of cancer 30 years too soon, supported by her spittin'-image daughters who were also affected by the radiation of their childhood: thyroid problems from milk loaded with radioiodine. Her ranch on the south slope of Sheeprock Mountain had been in the family for a century and was one of those out-of-the-way treasures in an area that the AEC designated "virtually un-inhabited." During the open-air tests there had been a hot spot or two on their land with enough high-level radiation to kill a man within a few hours, but not a single federal or state bureaucrat she called lifted a finger to help her or her husband. We talked in her truck as she drove me to the ranch on the old Pony Express Road, then onto other, more jarring terrain.

I've been on the ranch since 1930. It was just exactly the life I loved. My husband was born out there. His father homesteaded that ranch in 1887. We had our own meat, grew our own garden, fruit trees. We *worked!* One day we heard the calves bellowing and crying. You would never hear that, because they were contented. In the daytime the cows would go out to the southwest corner of this pasture. There are some big cottonwood trees down there. We had a water pipe there and a little trough, and there was also a spring at these cottonwoods. We went down and there were no cows. We found all twelve of them dead. The strange thing was, and that's why I contend that it was concentrated fallout from the

bomb testing in that one area, because outside the fence the cows were fine. Inside, not only were the cows dead, but there were rabbits and magpies dead.

My husband, Richard Ekker, went down to fix a fence. He was down there for maybe an hour and he came home, and his face was just purple like a fever. He was nauseated and sick, and I said, "You've got to go to the doctor." Our doctor was in Nephi, 50 miles away. He said, "I would die on the road, I cannot go anywhere," and so he laid on the bed. His lips cracked and he broke out with blisters. He was nauseated, all the symptoms, because I have read a lot about fallout and the dangers of bomb testing, whatever the government put out. They didn't necessarily say there was much danger, but he had every symptom of exposure to radiation. I really truly believe that if he had stayed there, he would have died like the cows. He died in 1973. The doctor said it was massive cancer, that's how he put it. In his liver, and he was passing blood clots in his urine, and his lungs were terribly bad.

My second husband was a rancher just west of us. He died in '84 with bone cancer, it was all through him. The doctor told us it was even up in his chest. His brother also died with cancer. Betty has problems, my oldest daughter, thyroid problems. She would have been twenty when testing started in '51.

That was in the uranium boom days. We had a scintillator, testing for uranium. Something went wrong with it, and a man from Richfield had it fixed. I met him in Delta, about 50 miles south of the ranch. He said, "I wish we had some uranium to test it. I'd like to show you it was working fine," and I said, "Turn it on and put it on the hay in the back of the truck." You couldn't have tested as high with pitchblende uranium, that hay was so radioactive. I took the scintillator and went back with it. In our area everything was so radioactive you couldn't hunt for uranium. It was the early spring of 1955, March or April.

I called the county agricultural agent in Nephi, Ray Burtonshaw, and asked him if he could come out and check where those cows had died. He called Dr. Don Thomas from the Agriculture College in Logan and they both came out. I went down into the field where the cows had died with them and said, "Can you check for fallout?" They said, "All we're going to do is check the water. Maybe the water is poisoned." "It isn't the water. This has been a water hole for the cattle for years and it isn't the water." He said, "Well, we can't check for anything else." When they left, I couldn't see them drive away, I had such a pain in my head. My other daughter fixed dinner because I had to go to bed, and I was in bed for three days with this pain in my head. I couldn't eat. I was nauseated. It was such a severe pain that it affected my eyes—I didn't want any light in the room. I wasn't burned. I had talked to our doctor and he told me to call Dugway [Biological Warfare Laboratory, which is nearby]. A fellow came out, they landed the helicopter down below the corrals. I told them about the cows and asked if they'd go down, and they wouldn't go down into the area. I called again and made an appointment with Captain Scott. I said, "I want you to check on your records to see when that helicopter came out," and he said, "We don't have records."

Another thing that happened, the government was telling us on the radio, don't let your children eat the snow. This one morning when we got up, our truck was sitting quite close to the house and a light snow had fallen. When that snow melted off the truck, the paint peeled off. Just curling

off and there's the bare metal. The truck was about five years old, a '49 Chevy. I told my husband, I said, "Are they telling us that if the children eat the snow, that's the only danger?" There are young fellows of a certain age group, maybe between 30 and 40 years old, that have adopted children in the Delta area. It's amazing that a certain age group doesn't have children. I was talking to an attorney down in Delta and had mentioned it and he said, "My brother is one." I talked to another attorney in Provo and he said, "I'd like to investigate that—all my children are adopted."

I saw when they set some of those bombs off one morning. I was by the window, looking to the southwest, and it went up like a fan of colors. It spread way out, and then later it shook the windows in the house until I thought it was going to break them. Some friends of my daughter, one lady, her health was really bad. She stopped out to see this lady and she had these burns on her face. Jeannie asked what was the matter, "What have you done to your face?" She said, "Oh, these are burns from the bomb testing. You ought to see our cattle." The hair was burned off in strips. Her husband was out riding to check the cattle, and within a few hours he just dropped off his horse dead. It seems to me it would have been west of Gold Hill, west of Ibapah, close to the Nevada line. It's a frightening experience, and it was amazing how you come up against a blank wall when you go to them for information on what was going on. We had no answers. They said a lot of things were harmless when they weren't. There didn't used to be near the cancer there is now. It wasn't the word you heard all the time, everywhere you turn. My goodness, it's unbelievable the ones that have died. And it's cancer, cancer, always cancer.

RUTH COLE FISHEL

May 1989

Belle Fourche, South Dakota

"We've been expendable, a sacrifice area. It's a cover-up job . . . dirty politics, in fact. Why don't they do this to the New Yorkers? Why don't they do this to all those street people that haven't got enough gumption to get a job and make an honest living?"

She definitely did not look happy to see me when I knocked on her door for our appointment. I didn't know why she was irritated, so I donned my most meek attitude and sat down quietly at the kitchen table. Ruth Fishel was making the most perfect strawberry-rhubarb pie I'd ever seen, but as she narrowed her eyes to size me up I knew I'd never taste even a crumb. I found out an hour or so later what the problem was: when I first spoke to her on the phone I had said I was from New York. Out west, that usually does it. I was, as I would discover again and again, just a whipping boy for the pent-up rage that radiation victims (and survivors) feel toward anyone from the East. After all, the decisions for the testing program were made, they were certain, in Washington, D.C. (Actually, the situation was more collaborative; some life-threatening choices were being made in conjunction with scientists at Los Alamos and at Lawrence Livermore Laboratory.) Above all, New York is, by my experience, the city that rural people most love to hate, being quite sure that many metropolitan types haven't a clue about how to do an honest day's hard work. Nevertheless, there was something compelling about Ruth Fishel's strength and very obvious intelligence. No matter what she thought of me, I had a hunch I was in for an interesting if combative day, with or without the pie.

I think we've been expendable, a sacrifice area. It's changed my idea about how much you can believe. It's a cover-up job . . . dirty politics, in fact. I don't know how high up this went but different guys were trying to save their hides, those responsible for the testing in Nevada. I have no respect for "politicians" because that's all they are, the senators and representatives making a life job out of it. Government workers, there's a lot of them who are not very pure. Why don't they do this to the New Yorkers? Why don't they do this to all those street people that haven't got enough gumption to get a job and make an honest living? Stuff doesn't come for free and sometimes you do a whole lot of work. I worked in the hayfield, I ran every piece of machinery we had. I could plow, I could drill, I could harrow, I could disk, I could mow, rack, bail, stack hay, all those things I did. I worked right along with [my husband] Floyd in order to make a living all right, and the kids helped too.

One afternoon, the last Sunday in August 1957, we had a very hard rain and a severe hailstorm and it reduced the third cutting of hay from a crop that was about three feet tall to a bit of stubble within less than a half hour. Our barn is sided with corrugated aluminum siding and there's pockmarks there still from the hail. The next morning the hail was still six or eight inches deep on the north side of the barn. I had a garden, and all of it was left in ribbons. Floyd and Charles were not home at the time, but my daughter Jean, who was 10, and son Dan, 7, were with me. We all felt sick for several days. At the time I thought it was my reaction to seeing our garden and other crops destroyed.

Next December we lost three calves for no good reason. Floyd thought maybe they were poisoned from some weeds. Our cattle was always well taken care of and we weren't in the habit of losing them. More calves got sick and we lost them. Dr. Peleski came out and did a post mortem. He opened up the calf from its mouth all the way through the alimentary canal. There were lesions in the mouth and down the canal into the stomach, the intestines were badly eroded, and the green hay the calf had eaten the night before was still there, not decomposed, not digested. Now that stuff was hot. The lesions were thick in there and the other calves' stomachs too. Some of them ran a high temperature, 106 to 107 degrees. The veterinarians couldn't figure it out. The calves kept dying. In the morning they would be standing there with their heads hung down, their ears down, and they wouldn't eat another mouthful, wouldn't drink, nothing. They lost great big gobs and patches of hair. Any bruise caused them to bleed, and the blood was light pink. They just stood there till they dropped. The dead ones we drug out to a wash down north of the house and piled them up. Well we'd lost over a third, 33, by the end of December, and Floyd says, "I'm going back down there, there's something funny about that." It was January and the temperature was 12 or 14 degrees below zero in the day, and minus 20 at night. He had stepped out onto these dead critters we'd hauled in the day before and they didn't freeze, they were still hot. The crows and magpies found the dead critters and were eating them. Pretty soon they were just hopping around and couldn't fly, and soon there weren't any magpies at all, or coyotes either. About that time we heard this news report on the radio about somebody flubbed up and sent radioactive wheat to England. We looked at each other and we thought, gee, if the wheat is radioactive, bet the hay and straw is too. It started making sense.

[After that hailstorm] my son Chuck had come home. He had a geiger counter, a Sears Roebuck model, not very big but it did the job. [My neighbor] Lucille had one. They were rockhounds too back in those days. She checked in their front yard and Floyd checked out our place and found out it [the fallout] came in the hail. The ground count at the house was 12 and at the feed lot 97. The hay stack at the barn was 98. When we found that out, we started feeding the cows hay from another area, and we didn't lose a cow or a calf.

An old white truck came out from Rapid City. They heard we had these dead critters so they wanted to take them "to make into dog food." That sounded like a lot of baloney to us but Floyd said, "well, we've got to get rid of them some way. If the water washes through here it can contaminate the whole hay creek all the way to town." Dan being a young rascal, he got his sister's camera, got smack dab in front of them as they were coming through the gate and took a picture, really close. Do you know what they did? They got out and took the camera away from him and took the film out of it. They gave the camera back but took the film. Now talk about destroying the evidence! The government sent some guys out to check the milk, and we gave them some vegetables from the garden. They said that the milk was reactive but the vegetables, they never told us. They told us "you might soak them in a pail of salt water before you fix them to eat." It was a sorry mess, a cover-up job.

I didn't know hailstorms were pink until Jeannie told me. The reason I found out afterwards was the fact she thought those hailstones were so pretty she ate some of them. They were pink. They were loaded with radiation, of course. The next thing that happened was I got a call from the school superintendent. She said, "Do you know that your daughter Jeannie has to go to the bathroom every fifteen minutes?" I

didn't know, we were so busy doctoring the sick calves. I took her to be checked and her thyroid had just plain quit. She quit growing tall and started widening out, her kidneys were affected and her thyroid had completely shriveled up. The doctor asked, "When did you have radiation treatment on that thing?" She was just a child of ten, born in '47. She was put on thyroid medication and still is on medication. It has caused many more complications since.

The next spring as Floyd was dragging and harrowing the alfalfa field he became ill. He didn't know why. He felt good before he went out in the field, it was just north of the barn. The alfalfa dust caused a rash on Floyd's arm, so I put a cloth around my face to keep the dust out and I went down and finished harrowing the field. Floyd had the lining of his nostrils swelled up so he could hardly breathe. I felt sick to my stomach, my throat was raw, and I felt so tired and weary. I had a rash on my face. Floyd had prickly pains diagonally across his right lung. Dr. Willard told us to go for a check up. We had X rays and blood tests and so on. When the doctor said, "There's a shadow across there like a scar tissue," Floyd said, "That's funny, that where I had the chest pain when I was working in the hayfield." The kids and I were very anemic so they put us on medication. I felt just kind of sick and weak; I didn't have hardly strength enough to walk across the street when I went to town to get groceries. I always felt sick but I couldn't lay a finger on it.

Anyway, Floyd's lungs were still bothered, and he'd had numerous heart attacks. One day I was getting bales off the top of the stack and one ended up hitting him in the chest and about knocked his wind out. He hadn't told me before that he was having chest pains again. The doctor said pleurisy but he hadn't been sick. We sent him to another doctor for a second opinion. He didn't like the looks of it and sent him for a biopsy. It was malignant, the festering kind. He started having trouble in '58 and '59 and he died in 1964. The cancer came where the shadow was, diagonally across his right lung.

Ruth Fishel had solicited the help of a local scientist, Dr. John Willard, when she and her family discovered the fallout problem. An AEC consultant who had, years earlier, worked on the Manhattan Project, Willard was a professor of chemistry at the University of South Dakota's School of Mines in Rapid City. He realized the acute danger from the rainout of radiation and alerted all the state authorities, including the Department of Health. For his efforts he was called on the carpet by the AEC and summoned to Las Vegas for an accounting. According to Document 29691, dated August 16, 1957, from the Department of Energy Archives, "Considerable time and effort was expended in *cooperating* [italics mine] with Dr. Willard. He has been very receptive, and time being taken are believed to be well spent." So chastened, he returned home powerless to help any further. The matter was finally put to rest two years later by the State Health Officer, Dr. G. J. Van Heuvelen. In a letter dated February 24, 1959, to Dr. Francis J. Weber, Chief of the Divisional of Radiological Health of the Public Health Service, Van Heuvelen wrote: "Enclosed are two copies of a report entitled 'Investigation of a Reported Radiation Incident at Belle Fourche, South Dakota' . . . prompted by the death of cattle located on a ranch near Belle Fourche. . . . We are quite happy to report that the findings did not justify the contention that radiation was responsible." The AEC had once again taken measures, as written in the report, "sufficient to prevent the development of what might have been another highly publicized radiation episode."

DR. JOHN WILLARD, SR.

May 1989

Rapid City, South Dakota

"We quarantined all the milk. We brought in milk from Denver and Sioux Falls, but the AEC got wind of it. They were really threatening me with Leavenworth, that I had no authority and I had identified a test that was highly classified. I did. Boy, they were going to nail my hide to the barn door. They had me under house arrest. They told me what a traitor I was. Even the head of the Atomic Energy Commission in Washington got on the phone."

Dr. John Willard was working in military intelligence when he was called to work on the Manhattan Project in a group under the direction of Glenn Seaborg. Their goal was to "devise a plant to separate plutonium and at the time we didn't have a milligram of plutonium to work with. Whenever I went [for consultation], there was an FBI man to pick me up and he never left me. There were 6,000 scientists from the free world on that program and if you'd be walking and happened to see somebody that you knew, you'd start over to shake hands and the Fed would just say, 'we won't allow you to talk,' so each separate unit was so no one could ever get the whole picture. We were in Chicago at the Manhattan Project, and we devised the Hanford plant." That plant supplied the enriched uranium and plutonium for the bombs that destroyed Hiroshima and Nagasaki.

Willard woke to a jangling phone at five in the morning on July 16, 1957. Twenty-four hours earlier a bomb named Diablo had been detonated in the Nevada desert 850 miles away, a nuclear explosion larger than Hiroshima by half. North of Willard's home in Rapid City, South Dakota, a uranium prospector in Belle Fourche had discovered un-usually high readings of radioactivity with her geiger counter. It had rained during the night: she checked the soaked garden and the gutters. "That counter just jumped right up, like you were in an area of ore." Dr. Willard and a team of Civil Defense experts tracked down the fallout pattern. "It was hotter than hell," Willard contended, and he quickly alerted the governor, Joe Foss, and the Civil Defense headquarters in Denver. Milk from local dairies was dumped, and farmers were alerted that their hay was contaminated. Much of it was burned. For the most part, the incidents of fallout were always kept secret because, Dr. Willard said, "We could have

panicked all the citizens, the children and the ranchers. We took all the safety precautions, did everything we could to minimize it." Two days after the incident, FBI agents arrived at Willard's door to escort him to the Test Site, but he was already on a plane to Nevada to seek help from the AEC in dealing with the Black Hills fallout episodes. Willard, who had lost a stomach, kidney, gall bladder, and one eye as a result of a serious radiation accident during his tenure in the Manhattan Project, was word-whipped by Test Site officials for being so "alarmist."

From your first days in the Manhattan Project did you have any inkling of how damaging the effects of fallout would be? **Not really at first. I had seen classified movies on the Alamogordo test. The first time I saw one actually go off I bet my mouth was down near my belt buckle because I had visualized and made calculations about $E = mc^2$, the energy that was to be expected. But until you actually saw it and felt the effect of it you just couldn't comprehend it. And those were the so-called "baby bombs," ten thousand tons, twenty thousand tons of TNT equivalence.**

As big as Hiroshima, basically?
Yes. From the effect of it I would say quite a bit bigger. I saw about 12 or 14 of them. The most outstanding was the first bomb that I witnessed. They always test just before dawn so nobody could really spy on them. We were in position 12 miles from ground zero, up on a knoll. There was a table made of two-inch planks and anchored concrete underground, and wooden seats. [This was called "News Knob" and was located at the south end of Yucca Flat.] You'd sit there, looking. I had worn welding goggles because Dad was

a mechanic. These goggles were so dark, but when that bomb went off, even with my glasses on I could have seen a jackrabbit run across the desert floor, the light was that intense. Then you would feel the pressure wave. Actually, you felt the shock wave come through the earth first. If you had been standing up, you probably would have been knocked down.

Now you asked about the fallout. My own opinion was that Civil Defense would never work. I became engaged in the fallout—we started testing with airplanes and balloons, sampling the air for these radioactive particles. I had two years of intensive training. We were trying to take the weather information before we set the bombs off, and then we tried to project. We never were able to be even 50 percent right because it generates so much of its own wind. Because of the prevailing winds, it would take the atomic bomb [fallout] up to about the 80,000-foot level, way up in the stratosphere. Sometimes the fallout would go twice around the earth. Due to the topography, the mountains and things like that, there are natural fallout zones. South Dakota was one of them. Our code name for South Dakota was Sunshine, meaning that there was what we call a rainout or fallout that was natural. I think the Black Hills have a lot to do with that, because this is an area that goes up to about 7,000 feet, rather compact and plains on all sides.

Any bomb that was set off in the United States, the odds were pretty great that a large portion of the fallout would be in Russia. That might account for the fact that they so quickly ratified [the Atmospheric Test Ban in 1963]. In fact, there was a project that was highly classified to see if we couldn't increase the fallout over Russia. We couldn't, incidentally.

What precisely was your capacity as a consultant to the AEC at the time when you discovered the fallout in South Dakota? When the fallout came over Belle Fourche, how did you first come to know there was a problem?

I was out of the AEC then, working for the Air Force and for the governor of South Dakota, Joe Foss, as an advisor to him on radiation fallout. I received a phone call, about five o'clock in the morning. It was a captain of the security. "Doc, we're getting some abnormal high readings." When we got to Belle Fourche she was hotter than a two-dollar pistol. I got in trouble with the AEC. They had a standard test procedure which I never paid attention to anyway because it's ridiculous to measure waist high. That's the way for the AEC to cover up. For example, if you had alpha radiation you had to get right down on the ground before you could detect it. At waist high the beta particles would have lost all of their energy. Belle Fourche had had a rainout and that's what brought the fallout down. Along the gutters were some very fine sand particles and they were just hotter than hell. It would have been very serious for young children.

Of course, no publicity about it. We quarantined all the milk. We brought in milk from Denver and Sioux Falls, but the AEC got wind of it. We warned some of the ranches that their pastures and their hay was contaminated. The fire department took their hoses and slushed every damn gutter down into the river. Sometime later the AEC were really threatening me with Leavenworth, that I had no authority and I had identified a test that was highly classified. I did. I took some of the damn stuff back to the laboratory. Every radioactive material has what we call its own fingerprint. I relayed that to Denver and to the Air Force out here. Boy, they were going to nail my hide to the barn door. They had me under house arrest. They told me what a traitor I was. Even the head of the Atomic Energy Commission in Washington got on the telephone.

Weren't they concerned with safety?

Lip service. They actually flew a team in there and monitored from the air. They said yes, there was above-normal radiation. I said, "Did you land that airplane?" "Oh, no, we couldn't land there." They were probably monitoring up a thousand feet. What you have to know, girl, you have to realize there are people in these big government projects that are growing six-figure salaries. They have the most sophisticated instruments because the government is paying for it and most of them aren't held accountable. Eisenhower warned us about the military-industrial complex when he was president. They've got assistance and a very contented life. It takes a pretty big individual that would speak up and say, "What I'm doing should be stopped." I spent 30 years at what we call the dark side of science, which means your work is classified and top secret. I've seen much power. Generals and senators, even presidents of the United States buckle there.

I've read that Eisenhower said of those living downwind from the Test Site, "We can afford to sacrifice a few thousand people out there in defense of national security." And you're quoted as saying that the public should not know.

I agree. My philosophy of life is there is no free lunch. No pain, no gain. The media, they blow something way out of proportion, and it bothers me. Grandpa Willard had a saying, the more you stir shit the worse it stinks, and that's true.

DONALD CARTWRIGHT

May 1988

Parowan, Utah

This radio station manager "didn't want to make a fuss" by broadcasting news of approaching fallout clouds. "We were given some information that we couldn't understand fully what it could be, even though we had witnessed the results of the bomb in Japan. But I think in that time we were probably better journalists than some of the people today who are out to do anything for a story. There were some journalistic reports that did cover the fact that there were questions that were still not being answered. And that some of these questions had been, shall we say, covered up. I think our news department had a little more integrity than to try and sensationalize that type of thing. We tried to keep it within our proper scope of good journalism."

Shortly before I visited Don and Iris Cartwright, Utah had been in an uproar over an article in the *Los Angeles Times* that gently ridiculed its deservedly ultraconservative image. "A Perry Como kind of place" was the reporter's very lenient description of a rather bland state proud of its squeaky-clean and self-righteous Mormon fundamentalism. The very first moment I walked into the Cartwrights' home I couldn't help but notice, with a grin, some well-worn record albums: Mantovani and Perry Como. Don Cartwright, a Mormon as are most Utah downwinders, had been the manager of a radio station in Cedar City during the fallout years. He was also the public communications director for the county, working with the Civil Defense authorities. A victim himself of radiation exposure, he developed cancer of the throat and tonsils. When asked about a journalist's responsibility to notify the public of the approaching fallout clouds during those dangerous times, he responded that he "didn't want to make a fuss" because "we have not been brought up that way as a people. We talk about it and we're concerned and we're knowledgeable, but I don't think we're a demonstrative people." What, I wondered later, would become of a radio station manager in New York, Chicago, Los Angeles, who arbitrarily followed such a policy of non-notification if even one nuclear bomb had been dropped a similar distance away? During the fifties and sixties, the infancy of the nuclear age, what exactly was "the proper scope of good journalism"?

My community is all a neighborhood. Originally we were excited. [Atomic testing] was interesting. There were days when I wouldn't go to work. I'd actually take my family and go west of town here and be able to watch the explosions. I'm well acquainted with people who were radiation victims. People

all around me, friends and neighbors, loved ones, have had serious repercussions from it. There are just too many factors to put together to make it an accident. [The AEC was] probably making the greatest effort in being reassuring that they were on the spot, were watching it and monitoring it. They weren't making an issue of any effects. The AEC did make provisions to take the media people out, and there were some spectacular tests down there. I mean, they constructed a model town down there, for one thing, about one mile from zero. They went through the town to see what it was like before, then saw the shot, then went back through the town to see what had happened to the people and structures and so forth. Just the media, a special provision for the media. We had in our KSUB files some rather graphic pictures of this. It took a little while for it to build on us what was happening, I think. I do remember some statements being made in Cedar [City] of people living in a two-block area—almost every household had been affected. You find that there are too many cases that have similarities and that's the only thing they have in common.

The first one was Randall Adams, a good friend of mine, whose reaction was immediate. He was out in the fallout bringing the sheep in. He got that heavy dosage of radiation and had an immediate effect of discomfort in his lungs and some facial and skin discomforts. A lot of his sheep were listless, their heads were hanging, just an obvious thing. You don't see sheep in the corral with their heads down. They had been trailed in from the desert but they had been given the opportunity for feed and water. There was no excuse for them to be fatigued or in any undernourished condition. You could see the ewes aborting lambs. The wool was slipping back away from their eyes and their faces. You could see

lesions around their mouths. I think it kind of grew on us. The longer the thing went on the more we became aware of the compounded probabilities of the effects of it and I imagine when we first saw the sheep, we didn't see that effect on the people right then. There was one exception: Randall definitely began to complain immediately. Then we saw other people developing other symptoms. We began to ask some questions. They started to add up. We became alarmed.

We began to feel that there were some things that we had concern to worry about and we should be having more information than we did, probably in the late fifties, early sixties. We had four teenagers in our high school die within probably two years' time from leukemia or brain tumors. About 1960 it just came on them and wham! they were gone. These youngsters were schoolmates of my children. It strikes home pretty close. I just don't feel that people in a metropolitan area can comprehend how close this is to us, because first of all the people of this area are descendents of a pioneer stock. We have a small tight-knit community. If someone was to break their arm in Kanarraville 40 miles down the road it would be news here in Parowan. It became a very traumatic situation.

I thought maybe we had been used a little bit. They recognized that there had to have been some chances taken, and when they took chances it was better to take it with a small population 145 miles away from the Test Site than it would to take chances with the big population of Las Vegas at a much closer range. Somebody had to take some chances. In this case, we took the chances of what might have happened.

They were doing the best they could, maybe. I have to be a little lenient—let's not judge. We were given some infor-

mation that we couldn't understand fully what it could be, even though we had witnessed the results of the bomb in Japan. But I think in that time we were probably better journalists than some of the people that we have today who are out to do anything for a story. We just didn't try to sensationalize it. We wanted to get the story out but not to build it out of proportion. I do think there were some journalistic reports that did cover the fact that there were questions that were still not being answered. And that some of these questions had been, shall we say, covered up. I think our news department had a little more integrity than to try and sensationalize that type of thing. We tried to keep it within our proper scope of good journalism.

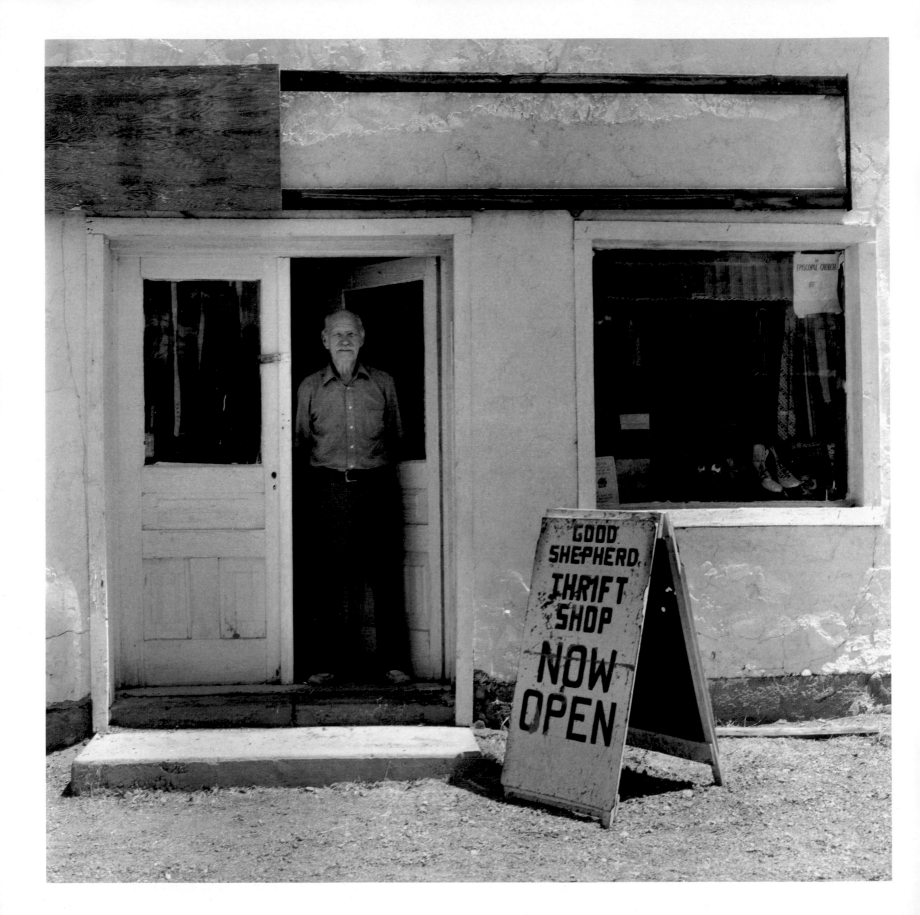

KEN PRIEST

July 1988

Beatty, Nevada

"Eisenhower told us, 'Beware of the military-industrial complex or they'll take you over,' and he was a militarist. We are being influenced way beyond our needs. We need to find ways to feed people, house people, give them employment. All we do is make things to blow people up."

The town of Beatty, Nevada, is located on the southwest corner of the Nevada Test Site and is proud to be called "The Gateway to Death Valley." It has little to offer but a quick commute to Mercury, the gateway to the Test Site's interior, a few casinos, restaurants, whorehouses, an Episcopalian church, and a senior citizens' center. The interviews I conducted in Beatty were with two people from opposite ends of the spectrum, but service providers both. I visited Ken Priest, the minister of the town, at his Good Shepherd Thrift Shop, and madam Fran York at Fran's Star Ranch Brothel.

Ken Priest, an Episcopalian minister, has for 30 years attended to the more spiritual needs of the residents of a large territory that includes Beatty, where he lives, and he travels some distance to the towns of Goldfield, Round Mountain, and Tonopah to hold services. During the years of atmospheric testing, he even held services at Mercury, where some of the Test Site's administrative and operations offices, the cafeteria, and nests of trailers, temporary homes for some of the workers, were located. "They opened up a chapel there and then they closed it after the army got through with it. Now it's an auction hall." He is a small, reticent man, doing the best he can in a town where too few people care about their heavenly destiny. He works for the poor folk in town, supplying them with whatever old clothes and appliances he can find. Widows of Test Site workers can rely on him for spiritual support.

I received a much warmer welcome from Fran York, met her girlfriend, and took a tour of the establishment. Fran was good pals with many Test Site workers, frequent visitors to the Star. She had heard a lot of stories about the Test Site over the years, and beds had often shaken wildly in the early

morning hours, but by the shock waves of open-air and underground nuclear blasts. A call girl herself since she was 13, she thinks out loud that she has "seen it all."

My questions to both were similar. Beatty is located on the side of the Test Site that would rarely receive fallout, since bombs are never detonated unless the winds are blowing in the other direction, toward Utah, to avoid endangering Los Angeles and Las Vegas with fallout. I asked Ken and Fran whether they knew that people were dying downwind in Utah, northeast Nevada, and Arizona as a result of the radiation from the Test Site. Were they aware that the jobs of their clientele created dangerous living conditions not just for livestock but for children? Did they know that the Soviet Union was observing a unilateral test ban then in its eighteenth month? Didn't they think U.S. nuclear testing should be stopped?

Not a moment's hesitation. The man of God and the woman of the flesh gave identical answers: the Test Site is necessary for the health of our town's economy. Ken Priest seemed troubled by it, though, and remarked quietly, thoughtfully, "I don't think downwind has had any influence here, really. It's not their problem."

What was your experience when the atmospheric testing was going on at the Nevada Test Site? It's a pretty intimidating neighbor, isn't it?

I can remember one time when the wind shifted. They hadn't expected it to, and that pink cloud came over here and sat for several hours. They had a whole fleet of buses down the road here for about two miles waiting to find out if they were going to evacuate us or not. There were guys running around with scintillators, just holding them in the air, going tick, tick,

tick. It wasn't a cumulus cloud. It wasn't in a cloud shape in the sense we see a cloud blown by the wind. It was just that the whole sky up there in the high altitude was pink. It stayed about twenty-four hours. I think it was three days later that the pink cloud got down over Los Angeles.

What was the feeling in the town? Did you get any directions from the radiation monitors?

There was only about 260 people living here then, 1958, and they didn't know what to think about it. [The monitors] didn't know what to do either.

Have you heard of any people in town who worked at the Test Site who have severe illnesses from it?

Only one. When they opened up a tunnel to see what had gone on with the [nuclear] explosion, as the oxygen in the air hit the air in the tunnel it blew, just an explosion. If it hadn't been for the fact that a rock fell down below the door and jammed it, they wouldn't have been able to get out. I know they had the special clothes on to go in there to check out this thing. There was one man here in town that didn't go back to work for six to eight months. They figured he had enough [radiation]. That's the one case where I know there had been some real problems, but they checked him out well enough so that they knew he had more than he should accept. Whenever anybody gets more counts than they should have, they lay them off until what they had assimilated had passed on. Like if you're out in the sunshine too long, you've got to get out of it. You can go back into it after a while but you want the burns to heal up first. Some of these boys like himself, the Test Site had been pretty good to them as far as work is concerned and they aren't interested in being in-

volved in your talking about it. They don't want to be brought out and quoted, you see, because their job depends on it.

What is the general attitude in town . . . is there fear of health effects from testing?
Maybe for a few, but it's political more than anything else, about money and employment.

If people who work for the Test Site thought there was a problem downwind from what they were doing, how do you think they'd deal with that?
What they are doing: nothing. Eisenhower, before he retired, told us, and I've heard it quoted only once, "Beware of the military-industrial complex or they'll take you over," and he was a militarist. That's my answer. We are being influenced way beyond our needs for our own protection. We've got enough to blow up every person in the world, kill everything that lives already. What else is operating in this country? Most of the rest of our industry has gone to Mexico, Japan, or somewhere in Asia. We've been paying so much attention to the military that Japan is ahead of us. All we do is make things to blow people up. We don't need that. We need to find ways to feed people, house people, give them employment. People who were laid off in industry, they thought they were entitled to employment that would give them retirement, and they were laid off with *nothing.*

In a town where people work at the Test Site and are rather pro-nuke, do you have any trouble with being labeled as a liberal? As a man of God, do you find all this a little upsetting?

No, I don't make a lot of noise. I sometimes preach about it, but there isn't very many people who will listen. I don't know enough about what went on on the east side of the Test Site to give an educated opinion of what people here should think. I don't think downwind has had any influence here, really. It's not their problem.

Madam Fran York, proprietor of Fran's Star Ranch

Brothel, Beatty, Nevada. "I've seen it all."

DARLENE PHILLIPS

December 1991

Bountiful, Utah

"My change of religion is focal to the way I am, focal to the problem of why the state which was receiving most of the fallout didn't complain. When I left the Mormon church I claimed back for myself the right to make my own decisions, even if they were bad ones. My mother disowned me. My sisters wouldn't speak to me. My neighbors wouldn't have anything to do with me. It was not an easy decision, but I chose life over tyranny."

On a beautiful day after a winter storm, the branches of the trees bent and groaning under the weight of the heavy, salty snow, I drove north of Salt Lake City to its neighboring town of Bountiful to visit Darlene Phillips. Her home on the bench of the Wasatch Mountains looked down toward the Great Salt Lake, which had given these snowflakes their characteristic briny taste. When she opened the door, I instinctively reached out to shake her hand in greeting. "I don't do that," she said, "my immune system can't handle the germs that could be on your hands." Her legacy from a lifelong exposure to radiation from childhood was an immune system that had collapsed completely. She had had absolutely no defenses against illness for many years, making her virtually a shut-in, unable even to touch her children, until she participated in a government study that supplied her otherwise unaffordable medications. Federally funded studies on the effects of radiation on the immune system have been ongoing since the mid-fifties.

As a child she had spent much of her time in southern Utah where her father, a photographer, loved to take photographs of Bryce Canyon and other spectacular geological formations for which the state is much beloved by naturalists. She would satisfy herself by painting and writing, spending as much time as she could outdoors throughout her teens and into her adulthood, working during the summers at Bryce. Everyone was excited about the atomic tests that were going on at the time and, being a visually pleasured soul, Darlene Phillips wouldn't miss a single one.

I was raised in a Mormon family, raised always to be patriotic, always to be obedient, and never to question at all. And so when we started testing bombs out in Nevada I was excited

about it. I was thrilled with the idea that I was down in southern Utah and I would be able to watch the bomb blasts. We would always be notified when there was going to be a blast because it was patriotic hoopla to get out there and watch them. Everybody in the dorm in Bryce Canyon would get up early, before dawn, and get on the catwalk which faced west. It would be kind of chilly, and we would count down with it because we knew what time it was to go off. Then you would see the whole sky light up as if the sun were coming up backwards, and even the shadows of the trees would be wrong, casting their shadow in the other direction. And I should have known then that the world was upside down, that it was wrong, but I didn't.

Just as I'm curious about the birds that live in this area, I was curious then and I don't think I ever missed watching the blast. I wish I still had the paintings of the clouds because we had *such* interesting clouds after. When we would have a test, quite often we would have rain afterward, but that was not so unusual because it rained in Bryce Canyon somewhere every day because of the elevation. Bryce was a cliff that caught all the clouds that came across, and then the canyon amphitheater would fill up like a bowl with ground fog, and I used to love to walk out there when it was like that because it was so magical. The fingers of the formations would stick up through the fog and it would just be like soup.

There was one time we had had a test in the morning, so my mind was focused on it, and it had not had much of a cloud that I could see because it was an overcast day. Still, you could see the flash when they set it off. I was puzzled by the fact that we had not had a cloud from that test. But in the late morning, the sun came out and everything cleared away, my favorite time to hike down into the amphitheater [which is the shape of Bryce Canyon's rock formations]. I had been in the dining room, and I looked out into the canyon, and there was a cloud down there to the east, over Tropic. I grabbed my paintbrushes and went down, and the cloud, it was like a mushroom cloud, like what we'd see to the west. I never saw that kind of cloud again. It was pink, that's what attracted me, with kind of an orange tint to the top of it. Being an artist I did paint it, and spent the afternoon in it.

Years later my husband and I were in southern Utah at Arches National Monument. We pitched our tent in a rather primitive area, and there were stakes all around us with little cans on them—they were uranium claims. They were all through the park, right up to the edges of the park, everywhere. I think of us laying our sleeping bags down on the ground. The next year all of those claims were denied because they would scrape down two inches and there was nothing. What they were making a claim on, what they were picking up with their geiger counters, was fallout. We were camping right in the dust of a big fallout cloud.

Our family had another experience with fallout in the fifties. Right after my husband and I were married, his two uncles were prospecting in Nevada, looking for uranium. They were in a place they thought was safe, camped overnight, and were caught in a dust storm. When they came back they were stopped by the military. There were check points on every road. They had geiger counters. Their car was radioactive, they were radioactive. Everything was radioactive. They were told outright, "You were caught in some fallout, but you're not in any danger. Just go back to St. George and wash the car, wash all your clothes, take a good shower. Clean the car out and you'll be okay." Five years later both of them were dead of leukemia. And there was no

follow-up. This is the thing I resent. It was known that these two men and the young boy they had with them had been exposed to fallout, it was known how much landed on them, and they were just sent home.

At that time I was Mormon, but I have to clarify this for you, I am not Mormon now and haven't been for some years. I chose a different way. Because of how I was brought up with a notion of blind obedience, and having asked for some guidance about the issue of fallout and political issues related to it, being told "We're just good citizens and we're lucky to have these tests near us and we should be honored. This is our chance to prove that we are loyal citizens of the United States," I feel that everybody in Utah has paid for that. I think Utah was the one state where they could have done this. There were some demonstrations when the milk was becoming perceived as a problem from strontium 90 in the late fifties, early sixties, people who were connected with Dr. Linus Pauling and the Utah Council for Constitutional Liberties. At any given demonstration there might be 25 people. My girlfriend, who has never been Mormon, asked me if I wanted to go to the demonstration and take our kids and make an issue of it. I asked my bishop what was the proper role for a good Mormon woman to take. He said "No, you stay away from it, those people are Communists," so I didn't go. To Mormons, the first law of God is obedience.

By my last pregnancy, in '59, I was probably already in trouble then, but I didn't have any visible symptoms except that I was severely anemic. One day I was brushing my hair and a huge hunk of hair came out, and the scalp was attached. All through that year, '61 and '62, I lost more until I thought I was going to go bald. I was never ever strong again after that, but it was such a gradual decline. It was the time of the final atmospheric tests, the grand finale, the fireworks when they set off everything and didn't care which way it blew. As a mother of five young children, catching all their infections, I didn't recognize it for what it was until I collapsed with hepatitis in '62. There was an epidemic and even after everyone in the neighborhood got well, I didn't. I have seizures too, controlled by medication now, that started at the same time. It was just more of Darlene being "a bit nutsy." I had a doctor who treated me for one of my pneumonias and he put on my chart "housewife syndrome." That diagnosis followed me from doctor to doctor, and everybody saw it so they'd say "This lady's just making up symptoms," even though I'd had hepatitis twice, for nine months, and started making arrangements for my mother-in-law to take custody of the kids because I was so sick I couldn't care for them.

I probably had been losing my immune system for some time, if I check all the medical history, the strep throats, the ear infections, the pneumonias, one complicated by a pulmonary embolism, the pleurisies, they increase, and finally I got to the point where I couldn't get over an infection. As soon as I quit taking an antibiotic I got it again. I missed the middle of my life, it was taken away from me, because from '63 on I lived a very abnormal life. Finally a new doctor ran a test. He said, "It was just what I thought. You don't have an immune system, basically, any more. You had one once or you wouldn't have made it this far. You don't produce any gamma globulin." It's called gamma globulin anemia. If you don't have it, you can't manufacture your own antibodies. That explained the hepatitis. I got rid of it because we moved from the house where the virus resided. If we hadn't moved I probably would never have gotten over it.

In August of '64 I would have been 34. (My birthday is on the 4th of July, so the idea of being unpatriotic . . .) When I recovered from the hepatitis, I knew I had to make a change. Not just change how I lived or worrying about testing in the desert, I knew I couldn't stay in the Mormon church. I was not willing to live under that tyranny. I knew I couldn't listen to that doctrine of obedience day after day, and I couldn't see my children indoctrinated with it. I was faced with a decision where my physicians had said to me, "Darlene, if you have one more child we don't think we can save you because this last one was hard enough." But I was locked into a system which forbade me from making any decision about it. I was supposed to take whatever God handed out to me. If I was going to survive, I was going to have to get myself away from the church and make my own choices. One of those choices involved having no more children, which is going against the Mormon value structure. It was against the law in Utah for a doctor to even discuss contraceptives with a Mormon woman.

I don't mind discussing my change of religion because it's focal to the way I am, focal to the problem of why the state which was receiving most of the fallout didn't complain. Of all people, we should have been the ones complaining, and we weren't. We were discouraged from it. We were more able to be victimized. Utah is rather well known for fraud, and it's because as a structure, as a society, Utah is filled with people who will believe just about anything, and who go along with anything. If the person who brings the idea to you says "I'm Brother So-and-so" or "I'm Sister So-and-so," *of course* they're responsible, *of course* they're decent people. It wouldn't occur to you to question *them.* When I left the Mormon church I claimed back for myself the right to make my own decisions, even if they were bad ones. My parents were angry. My mother disowned me. My sisters wouldn't speak to me. My neighbors wouldn't have anything to do with me. It was not an easy decision, but I chose life over tyranny.

When I was first diagnosed, nothing much was known about it. It was a new disease. The theory was that it was something you would get over. The Red Cross furnished my gamma globulin free of charge, but they required that every six months I would go for six weeks without it on the grounds that they needed to test to see if my body had recovered and was able to produce its own gamma globulin. During those six weeks I would really try to be in isolation, to keep away from the children, not to be involved in the neighborhood, not to go to church, but somehow a germ would always get into the house and by the time the six weeks was up I was in intensive care. I had some pretty hideous years there where my life was always in the balance. It reached such a point that in 1973 I again ended up in the hospital thinking I wasn't going to be able to finish raising my family. The same doctor, who had worked so hard to find answers for me, told me of a purer form of gamma globulin from the Centers for Disease Control and a program at the National Institutes of Health in Washington, D.C., but with the same six weeks without it, in isolation, to test. They were trying to get together a study group of about 45 people with spontaneous immune failure, and I fit their criteria. I know now that to them I was like gold because I was still alive. Most people die before they are diagnosed or shortly afterward.

The original program was looking for people whose immune systems had failed. It was part of a project to study

transplants because they knew if they wanted to do a transplant the best thing to do was to knock out the immune system. That was the original plan, but a year later I was transferred to the National Cancer Institute to a different project which was an immunology study, the metabolic branch. I know I'm a guinea pig.

In a really confining way, I was isolated in my house for ten years. That's the sentence I paid, I guess, for having watched the nuclear blasts. I've also paid for it with my eyesight. Cataracts were diagnosed at NIH in 1975. They sent me to a neuro-opthalmologist from Japan. He asked me if I had ever been to Japan. Japan? I was lucky if I could get out of my house! I asked why. He said, "Well, you have a type of cataract that we see in the people I treat from Hiroshima and Nagasaki who have witnessed nuclear blasts." I said, "Bingo! You got it." When I got back to my room everybody asked what the neuro-opthalmologist said. "He said I have, basically, radiation cataracts." Everybody got *very* excited and said, "He didn't really say that, he didn't *tell* you that, did he?" and they went through my chart. Everybody was really upset that he had told me this because only three times at NIH have I been told that my research project might involve radiation victims. The first time was when I first came and I was told that people from Utah were given preference at NIH in the immunology department. The second time was when my husband was talking to the doctors and said, "What is this? Did she have a virus? Did she work too hard? What is it?" and they said, "Our best guess is that she was exposed to too much fallout but if I had to write that down, I wouldn't stand behind it." There was another reason I was told that people from Utah have preference is that we're stationary, we don't move around too much, and we have great genealogical records.

Our family spent as much time in southern Utah as if we were residents, due to my father's photographic expeditions. This is what makes me angry about this compensation bill. I always hate to make the distinction that only if you went into southern Utah did you get the fallout because I *know* that the fallout was high here. My girlfriend's father had a geiger counter, she herself is ill now, and he would go out with it to measure fallout and it was off the scale. All of us at that time had sore throats. The interesting thing about Orrin Hatch's compensation bill, and his involvement, is that for years I had been contacting him regularly—I'm stuck, he is my senator—and I have never had any feedback. I find it ironic because I'm willing to testify about immune disorder related to radioactive fallout and continued exposure to low-level radiation. My medical history is catalogued, well-documented, because from 1973 onward I have been a patient of the National Cancer Institute, and I was brought into it under this program where they were looking for people with spontaneous immune failure not just from Utah but from all over the United States and some from Canada. It's so sad to see him taking credit for something when he's actually fought to minimize the [perceived] damage.

I consider myself part of the problem. I didn't demonstrate, and I didn't complain. I think there's a very good chance that the tests would have stayed out in the Pacific if we had. We said nothing. I call us "the dispensable citizens of the United States." We have Dugway Proving Ground, all kinds of bacteria testing out there, and a population exposed to radiation. We are the dumping ground of the United States. I want testing stopped. It's gone on long enough.

JAY TRUMAN

November 1987

Salt Lake City, Utah

"I remember in school they showed a film once called *A is for Atom, B is for Bomb.* I think most of us who grew up in that period, we've all in our own minds added *C is for Cancer, D is for Death.* In my own life I try not to think about the future in a sense because I don't know that the future is ever there. The realization comes that you don't really have a future."

Preston Jay Truman was born in Enterprise, Utah, on the Utah-Nevada border, eleven months after the inception of the atmospheric nuclear testing program at the Nevada Test Site in 1951. Throughout his childhood he witnessed the detonations of atomic bombs and watched the fallout clouds pass over his home, damaging vegetation with brown burn spots and decimating wildlife. When older, he noticed that neighborhood children became ill and died of leukemia, other children were born with birth defects and Down's syndrome, there were miscarriages and sterility and cancer among his parents' friends. At 15 he became very ill with a type of lymphoma, Waldenström's disease. He recovered but has suffered various radiogenic health effects to this day, thyroid problems in particular, as is the case with so many baby-boomers in Utah, Nevada, and northern Arizona. We spoke of what would satisfy him, what might vindicate the years of illness, and the death of his mother and others like her. "There is only one justice that we could really get, and that's to put a padlock on the Nevada Test Site, and take away their death machine. The people downwind are the immediate victims, but humanity is going to be the ultimate victim of that continual madness."

I was born in December of 1951. Testing started in January of 1951. I can remember one of the earliest memories of life: my mother and father would drive me out on the farm and watch the bombs go off. It was kind of weird in the sense that they were always there and they were very much a part of life. Not only did you have the bomb tests going off all the time, you also had the government's monitors and their PR shows going on in those areas. I can remember really well right after kindergarten had started, this would have been in

1957, we had a general, he had ribbons all over his chest, talking to the school kids about testing and how it was necessary, and how the Russians would be here in the morning, that type of thing. How it was perfectly safe, we shouldn't worry about it. He did say little kids shouldn't go outside and play when the cloud was overhead, and he tried to explain a principle called "cloudshine" to the kids. I remember very distinctly when he explained that cloudshine was the stuff in the cloud radiating onto the ground. Once that was gone there was no danger.

We also saw films all the time, like *Target: Nevada,* and *Nuclear Tests in Nevada,* and *A is for Atom; B is for Bomb:* PR movies. There were a lot of attempts to get the public involved in the test program to keep the chance of opposition down. They had a "sky watch" program where they had volunteers from the little communities watching the skies different hours of the day, looking for Russian spy planes. Women would volunteer to do that, and they were given a roll of dimes and a phone number to call.

I personally never really enjoyed watching the bombs go off. It was a sight to see the whole sky light up, and all of that, but to me they always sent cold chills up my back and scared me a great deal. Also, as time wore on they served as a kind of a focus point for anger, in the sense that by 1960 rumors were beginning to circulate that testing was the reason for the leukemia cases. In a town that extremely small, you hear about everybody's problems, everybody's tragedies. When you have someone dying from leukemia or from progressive wasting away from other types of cancer, each new problem the person has is almost instantly transmitted throughout the whole community.

Did anyone suffer hair loss or nausea from exposure to some of the clouds? Were there any signs of intense lethargy such as one has after exposure to radiation?

Yes. And in one year, fall of 1958 and spring of 1959, there were a large number of miscarriages in town, I remember that. My mother lost a child and some others did. There were stories about the sheep all the time, and I remember seeing cattle—it was obvious that there was something wrong with them. I also heard of people talking about the fallout and the burning of their eyes from the clouds, tingly sensations, mild sunburns, people who had cattle or sheep in Nevada who were out working all the time. The clouds that brought the fallout were distinctly different and very obvious to everyone what it was, every time it happened. It looked dirty, but it had a kind of pink tint, or pale red glow to it. The bombs would go off about five in the morning, just barely before dawn, and by ten o'clock the cloud would be overhead. The closer you were to the Test Site, the more the cloud looked like a big wall of fog that would roll into the valley. The air seemed to have a certain ozone, a tingliness to it that was similar to what you get around large electrical apparatus. Sometimes there would be a slight metallic taste in one's mouth. The cloud, from where we were, had some resemblance to a mushroom, but it had kind of a long tail or stalk to it. From a vantage point on top of a large mountain, you could see the cloud trailing back toward the Test Site.

I remember also going to California with my dad, hauling potatoes and hay, before I was in kindergarten. We were twenty or thirty miles north of Las Vegas when we had to pull off, and they did the fireworks. I could see the typical mushroom shape, and I've seen it from Las Vegas, the cloud

rising at the end of the Strip. The Atomic Energy Commission and the Department of Energy went to great lengths to make sure they never got fallout over Las Vegas, but most of the dairies that produce milk for Las Vegas got their hay and alfalfa trucked in from the high fallout areas of southwestern Utah and eastern Nevada. Most of the fallout damage people received came from drinking raw milk and eating vegetables from our own gardens. An old prospector was talking to my dad about how we shouldn't be drinking raw milk. He pulled out his geiger counter and put it right on the middle of a cow's back. Nothing out of the ordinary. Ran it across the mouth where the cow had been eating in the pasture and the needle went off the scale.

What was the psychological effect on people, as you look back, in thinking there's danger, there is no danger, there's danger, that kind of ping-pong in their minds?

It was very confusing because on the one hand there were statements by Linus Pauling about the possible harmful effects of fallout, and the fact that everybody knew that all those herds of sheep had been killed by radiation. I think the most difficult thing for people was the fact that they knew on a personal level, a visual level by going to the church and cemetery for leukemia cases and others, they knew something wasn't right. In order to accept that, they also had to accept that the government not only did it to them, but was carrying on an extensive con job to show them there was no danger. How do you admit your government is lying to you and is putting you on the receiving end of discretionary genocide?

This must have been devastating in Utah, since Mormons believe that our government is divinely inspired.

That's it! The people were extremely patriotic and had that Mormon aspect to it, but they also had been subjected to the PR road shows and I think people underestimate the impact those had, when you were constantly informed that those tests were the only things that were standing between you and the Russians in the morning. It was the kind of thing that added to that patriotism, so you were damned if you did, and damned if you didn't. You knew inside. I remember as a child being afraid the same thing was going to happen to me that was happening to these other kids with leukemia. One of the frightening things I can remember, extremely frightening to me, was when they showed *On the Beach* in Enterprise. That was the talk of the town for three or four days.

In the late sixties you had a lot of opposition to testing in Nevada simply because Howard Hughes didn't like the Nevada Test Site so there was a lot of news stories generated as a result of his efforts. He thought it was going to poison everything. He'd see the things go off in the wee hours of the morning, those were the times he was always up, wining and dining his starlets and his business clients. I think he felt a personal remorse and personal fear because of what was happening to the cast members from *The Conqueror,* the last film he ever directed. It was filmed north of St. George a year or so after the Dirty Harry shot. It was done on the sand dunes, which was known as a hot spot. [More than two-thirds of the cast and crew died of cancer.] The AEC was monitoring it at the time. Hughes moved to Nevada and attempted to buy the state. One of the prime reasons was to shut down the Test Site.

So he would be up in his penthouse watching the bombs go off, having a mild seizure of emotion?

More than a mild seizure, yes. [Truman alleges he was often employed as a courier for Howard Hughes, and he described a scene in Hughes's penthouse apartment at the top of the Desert Inn Hotel in Las Vegas, in which a pendulum had been installed to measure the severity of each atomic detonation.] Also, you have to realize that the ground motion from those big tests they were doing in the mid to late sixties was the only thing from the outside world that was capable of penetrating the penthouse atop the Desert Inn. [Hughes had become extremely reclusive by this time in his life, and had gone to great lengths and expense to see that he would never be disturbed. His apartment was a tightly controlled environment with many maids but mostly aides about.] Once it shook, and he yelled and he panicked and crawled under the bed. It took his aides and some science advisors quite some time to convince him to come out.

The fallout debate more than anything else, the test ban debate of the sixties and late fifties indelibly left in the minds of a good share of the downwind residents the suspicion that it was testing that caused the problems. Growing up I remember in Enterprise, I again want to mention that in a small town [between 600 and 800 people during that period] everybody knows everybody else's business. It was way low in cancer incidence rates from the past that you heard about, and then all of a sudden there was this person and this person and this person. Women with three liver cancer cases within a year and a half, and that was, of course, very rare. The leukemia cases, skin cancers, stomach cancer started to show up. Pancreatic, lymphomas, that type of thing. Cancer then became one of the prominent causes of death in the general

vicinity. You heard about it all the time. We had a science fair in school and one girl from Modena for her project brought the head and neck of one of their cows they had to do away with. They cut it open so you could see the cancer all over the neck of it. That was kind of impressive.

Right along the same period of time we all got marched into the auditorium of the gymnasium, and none of us had been told, there was no note sent home asking for parental consent, and they had all kinds of doctors set up. The last test we went through was that we drank two different kinds of fluid and you were supposed to tell if you tasted it. While you were swallowing it, someone was feeling your neck. The doctor stood right in front of us and told us, and I was about ten feet away from one doctor in particular when he made the remark, that they were there from the Mayo Clinic and they were there because we didn't have adequate nutrition or medical care. It was a survey. There was not one mention made that they didn't have anything to do with the Mayo Clinic. They were not there because of sparse medical care. They were there from the Atomic Energy Commission as part of the thyroid program that they did. They checked all the thyroids of all the students in Washington County and compared them with a county in Arizona that supposedly didn't get any fallout.

Was it true that their study's "control" county in Arizona didn't get fallout?

No! [Declassified AEC fallout maps indicate that many fallout clouds drifted over Arizona.] After that there were a bunch of people who weren't allowed to go back to class and they had blood tests drawn again, with no parental consent. I was fourteen years old at the time. One girl in the valley had her

thyroid removed, was out of school for about six weeks. When she came back she had a scar on her neck and it was mutilating. My parents' friend's daughter had a check for medical care and it was from the AEC. While that was going on my mother was called down to St. George where they were checking adult thyroids. She had a small nodule on her thyroid. They didn't even bother to tell her what they found or what they didn't find. It eventually killed her, one of the prime factors in her death years later. [Mrs. Truman died of a heart attack induced by a thyroid storm, a sudden and severe quickening of the metabolism and related body functions that can cause heart palpitations and even cardiac arrest.]

When was it that you started feeling ill?

Two years later, in 1966. The first time I really noticed it I kept on waking up really sweaty and clammy in the night, and have chills by morning. I was out target practicing and I shot a couple of shots and my nose started bleeding, I guess from the concussion of the shots. Then I had a growth removed from the bottom of my foot and it was a month before the damn thing finally stopped bleeding. I had nosebleeds all the time. I was very frightened of it for two reasons. Number one, I thought it was leukemia. If you had those symptoms, that's what you thought. My mother was extremely sick at the time and I had a fear of what my own problems would cause regarding her.

One of the doctors in St. George had quite a bit of experience with this kind of situation, and found Walderstrom's disease, a type of lymphoma where the blood becomes extremely thick, has the tendency to bleed easily. It can range from almost no symptoms to full-blown lymphoma that would result in someone's death; it was what the Shah of Iran had. I was having blood vessels break in the joints all the time and spent a lot of time on crutches. I had dark under my eyes and blotches of bleeding all over the place. A kid from St. George that had something very similar died with it about that time. It was a very frightening experience because in my heart for some strange reason it did not surprise me. My mother provided a good model of how you handle chronic illness and those kinds of problems, that you ignore them and full speed ahead. That your attitude and your determination has so much to do with your eventual demise or recovery. It did crystallize in my own mind that something was awfully wrong with the testing program and it caused some severe problems.

We had one guy come in with some AEC nonsense, he was also doing a survival course, the twelve-hour civil defense instruction course in the high school. He always had a book in front of him, something like *The Book of Atomic Facts.* I kept asking him questions, like why does it cause leukemia in the Japanese but not in Americans. He didn't answer the question so I stole his book. In the survival course we had a film about blowing bombs off and going to the fallout shelter. The next day we were going to wander around the town, where potato cellars had been converted to bomb shelters. The guy was telling us that if the Russians bomb Los Angeles, we'll have to stay in the fallout shelter for two weeks. I think people that are *that* blatantly stupid logically ought to be confronted, so I raised my hand and he called on me, and I said, "I don't understand. You say if they bomb southern California some seven hundred miles away we'd have to spend two weeks in a fallout shelter yet they blow off bombs in Nevada and we don't do anything. Now what's

the difference, what's the deal?" "Oh. Well, we're talking about Russian bombs." I kept pinning him down and it was obvious that I struck a raw nerve, it was causing excruciating discomfort. I was in the seventh grade. There was a big conflict there. When he couldn't answer my question, I think that was the strongest single point that made me doubt the government's entire story. It was because I knew there was no logic in going to a fallout shelter for an LA bomb and something only a hundred miles away we were supposed to go out and roll around in it and watch history being made.

So during the times when there would be a wave of death, what was the human accompaniment in terms of the emotional pitch of the town?

It was *the* topic of conversation, a wave of whispers, for a better term. If the same thing had happened in New York they would have hung the bastards. The people out here were taught not to do that. The Mormon upbringing had a lot to do with it. Also, the feeling of helplessness, what the hell can you do? The government has all the facts. The anger, the feeling of being lied to, hopelessness and despair, and a deep down personal feeling inside of "when's my turn, am I next?" And I think this is as important, as far as victimization goes, as the cancer itself. People wrote themselves off anytime the symptoms came, whether those symptoms were cancer or not, and for that reason I think there were a lot of needless cancer deaths. I knew women who, for instance, put off having pap smears, breast examinations, and others that have bleeding, put it off for long enough that in essence they signed their death warrant. That is something that I don't think people have any grasp of. I think that fear, that uncertainty, that mystery, that unknowing what's going to happen

to you, that internal resignation, I guess, that it's going to get you too, one of these days. That fear is to me as big a burden to the people downwind as the cancers themselves. It's psychological torture.

Was sterility becoming prevalent in the people of Enterprise?

Yes, there were people having those problems and then, of course, the year after Dirty Harry there was a whole class of severely retarded, severely damaged birth defect children born in Washington County. I don't know if you saw the *Life* magazine article where it showed them all. There were quite a lot of people. There were considerable discussions of miscarriages. Dirty Harry happened in May of 1953. I wasn't very old when I heard about those tests that year. They did a whole bunch of rather large tower shots which were extremely dirty in '53 and, of course, that was what got the sheep. I was old enough in '55 to remember hearing the discussions around the dinner table and the anger about the sheep case being thrown out of court. So I heard about those tests, how people had to stay indoors and how they wouldn't let the kids go home from school for a couple of hours. Harry was the single worst test that they did as far as downwind residents go. The winds changed direction and it went straight over St. George and stayed for most of the day. Test Simon and others during that period went heavy across northern Arizona, Colorado City, Fredonia, Bunkerville, Mesquite, and it rained out over Toronto and New York two days later.

If you had a class reunion, what would be the percentage of people who had health problems?

Thirty percent if you put thyroid, problems with weight, sterility and skin cancers in. A big share of them are on thyroid

products, a lot of them have joint pains, muscle weakness. I think a lot of people, when they talk about radiation problems, they look at cancers, thyroids, some birth defects, and that's where their feelings of radiation damage comes to an abrupt end. There are a lot of other problems associated with radiation. When a person is repeatedly exposed, it comes to a point where they simply don't work. The best way I ever saw it put was in the movie *Half Lives* [a documentary of radiation effects at the Pacific Nuclear Test Site by Australian film-maker Dennis O'Rourke]. At the end of the movie an elderly woman, Senator Anjain's mother, says, "Well, we were all right before the bomb came. After the bomb we haven't felt very good." They get tired easy and they don't tolerate stress very well. If there is anything going around, they get it and it hangs on longer than it should. I don't see radiation survivors living too awfully long.

I think it's very important to realize about the downwind residents that these are not isolated personal tragedies. They are a cultural tragedy, a part of everyday life. We've all lost loved ones, friends, and we've all been lied to and we've all been expendable. Everyone says a nuclear war is impossible. The downwind residents, the atomic veterans, the Test Site workers, we are the casualties of the Cold War, the casualties of the opening round of World War III. I think we always stand by looking into the endless graves of the not-yet-dead. It's like some graffiti I saw sprayed on a rock, "When the big one comes, our long nightmare will be over and yours has only begun."

The public needs to realize that until they hold their public officials accountable, until they take more of an active interest in matters of security, until they learn to take everything the government says with a grain of salt, a large one at that, that they and their families could be murdered and destroyed and wiped out by tomorrow afternoon by the government. And there's not a damn thing they do can about it.

What do you foresee in your life?

I think I see in my life what a lot of other people see regarding their favorite cars or favorite outdoor vehicle, something which they got a lot of use out of and enjoyed a lot. It's just simply going to fall apart, that's what I think. I talked about earlier that this psychological trauma is just as much a part as the helplessness, the despair, the fear. I understand that really well because deep down inside there isn't any question that eventually the Big C is going to get its way. I remember in school they showed a film once called *A is for Atom, B is for Bomb.* I think most of us who grew up in that period, we've all in our own minds added *C is for Cancer, D is for Death.* I think that's what I see for the future. In my own life I try not to think about the future in a sense because I don't know that the future is ever there. The realization comes that you don't really have a future.

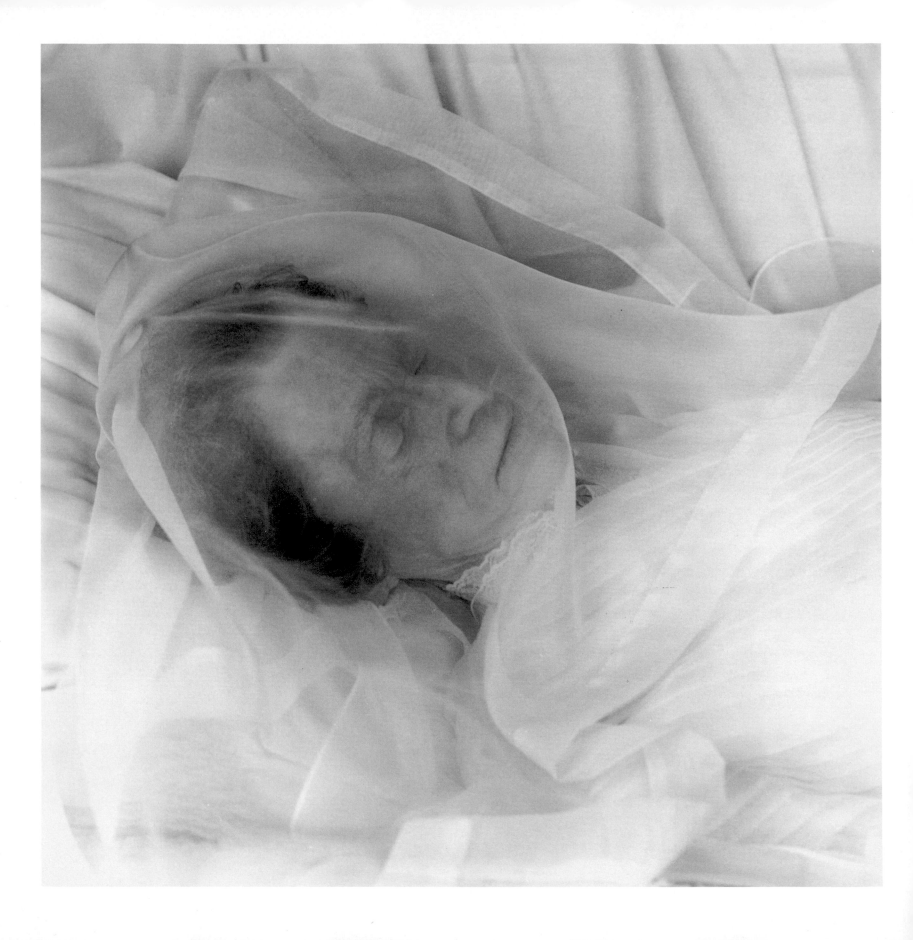

| **Della Truman at rest, West Jordan, Utah.**

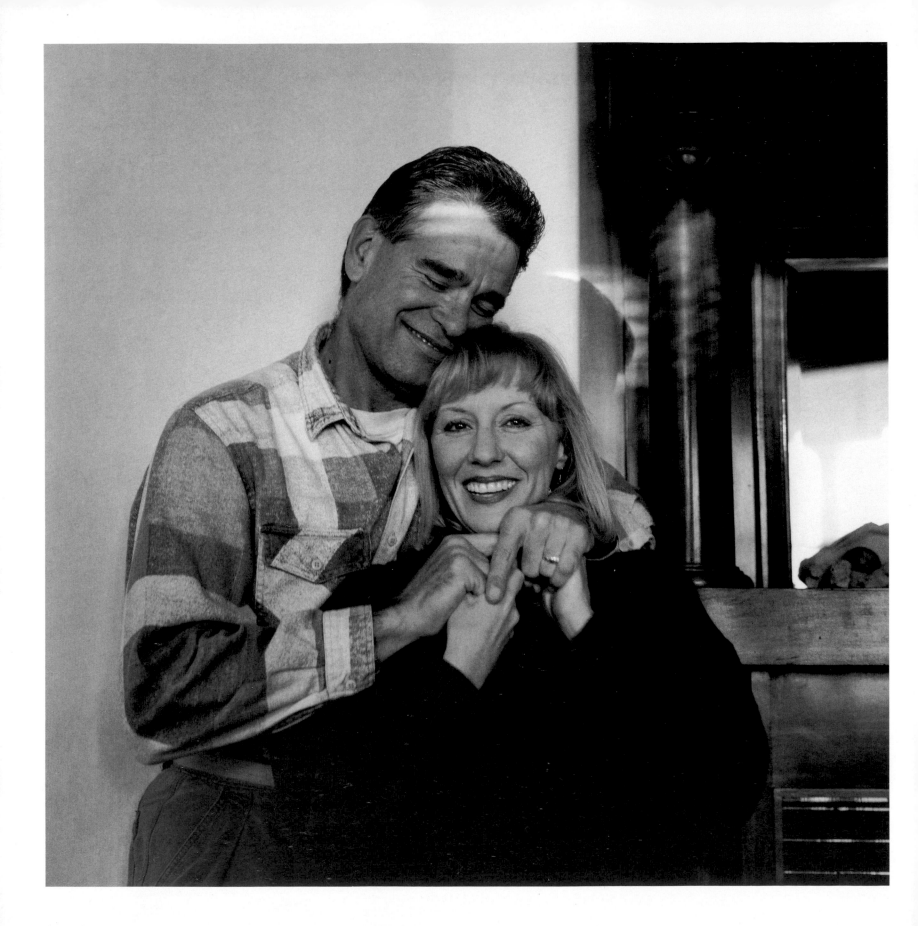

MARY DICKSON

December 1991

Salt Lake City, Utah

"A quote of Dostoyevski was used often after the Jim Jones massacre in Guyana: 'There are none so desperate as those who need someone to tell them what to do.' Mormons believe that the Constitution and the government is divinely inspired, part of God's divine plan! This is why it was so easy to conduct testing here for so many years and not have people make a fuss about it. A divinely inspired government doesn't poison its own people."

In the community of interested people that has sprung up around the issue of the health effects of nuclear weapons production and testing, there has always been a dialogue as to how we regard people adversely affected by exposure to radioactivity. Are they to be called radiation victims or radiation survivors? So many have died. Many more will certainly leave us as we work with them and for them. They will die of cancer, complications from diabetes, heart disease, severe birth defects, and other radiogenic problems: the victims. They are the majority. But there are those who are very obvious survivors, those whose cancer was diagnosed in time and also those who struggle valiantly through all manner of cures, valid or otherwise, against the odds. Others will cope with diseases related to immune system deterioration, diabetes, lupus, severe allergies, crippling arthritis, nerve and muscle disorders. After my decade of documenting a small portion of the problems associated with nuclear testing at the Nevada Test Site, a depressing assignment if there ever was one, it worked out that my last interview with Mary Dickson renewed the hope in me that all the previous years in Utah had ravaged. Mary is the quintessential survivor, a thinking, twinkling, vigorous achiever who overcame her cancer with beauty and grace to spare. Her clear-eyed appraisal of the cause and effects of cancer in her life and in her homeland was a refreshing change from the malignant mix of repression, delusion, and denial that surround her. I thank Mary Dickson and her husband, Keller Higbee, for a hope restored.

A funny thing, growing up in Salt Lake we never really heard about the testing that much, never really knew it was going on down there. I don't remember hearing about it until I was an adult, which to me was amazing. I came from a really educated family, my father was a scientist, a meteorologist, and yet I never heard about it. He knew all about those air currents, all of it, but I don't think any of us had any awareness. You know what it is, there's a lot of denial that goes on here, a lot of "I'm living my life right, I'm a good person, these things don't happen to us." Even if they were aware of it, it was something that happened in the *southern* part of the state, far away, and we felt safe up here so it was never an issue that we really discussed.

We lived on the canyon rim of Salt Lake, right up against the hillside [a natural trap for any fallout clouds approaching the west edge of the Wasatch Front of the Rocky Mountain range]. Growing up we always drank milk. It was good for you, they said, but we never knew. [Milk from downwind cows carried radioactive iodine, which lodged in children's thy-

roids, and strontium that mimicked calcium, seeking out their bones.] When I was growing up, anyone would always tell you what a low cancer rate Utahns had because of the Mormon influence, because of our good clean living, that people didn't do things here that would give them cancer. And yet, there were all these people getting cancer. PBS documentaries got people's awareness up, and then [Governor Scott] Matheson called Congressional Oversight Hearings [held in Salt Lake City in 1979] so he was a real catalyst, and worked really hard to get people what they deserved. And later *he* got cancer himself, and died last year.

There was still a lot of skepticism. People couldn't really believe that could happen or refused to see a real connection between the testing and so many people getting cancer. I think it's part of the denial. They're led to believe that if they do what they're told, they'll be taken care of, not just by the government, not just by the church but by God. They'll be protected, they'll be immune from this, so it's really hard for them to believe that something could go as wrong as that, and affect so many people when they didn't do anything to deserve it. There's a real feeling here that what brings on bad fortune is bad behavior. It's part of the theology. Bad things don't happen to good people, but when bad things do happen to good people, it's God's will and something to build their character. Things happen for a reason, they don't believe in the randomness of bad luck. Everything is always God's will. So many times people die in this community and you'll hear the comforting line, "Well, God wanted him to come home," when it was really just damn bad luck, you know?

This kind of "magical thinking" also makes people inactive in doing anything about bad circumstances. They're passive because of their belief in God. It keeps them down. They have a really blind obedience to authority and they always think that somebody else knows better, whether it's the government, the doctor, their bishop, and it's always a man in authority. "They wouldn't lie to me." It makes them passive, submissive, subservient, and trusting, which makes them incredibly vulnerable.

I was lucky. My father would always say, "Having the answers is nothing; it's asking the right question." He was a scientist, so of course he would have to say that. He always taught us to question, which didn't make him very popular in the neighborhood. I was always told not to have so many questions. They don't like questions here, especially questions that make people uncomfortable, that insinuate that something is not quite right.

There's a real facade of "niceness" here and it's a Mormon thing, I think. People don't say what they really feel, they don't ask questions that might embarrass someone or make them uncomfortable because you're supposed to be "nice" above everything. You end up having, as a population, a very dishonest people. They're "nice."

What you'll find here too, in small towns where everyone is a lot alike, is that when you have someone who's aberrant or does something they shouldn't be doing, you'll find the whole town protecting him or her and buying into the lie. Almost a conspiracy develops to protect their system and their own. They'll do what they have to. It's true. It's ultimately very dangerous.

What are they so afraid of that they encourage people not to think?

What they're afraid of is that somebody will find out the truth. The Mormon church and the government is afraid of people asking questions because you might find out something they don't want you to know. They're always worried that if you find out one thing they didn't want you to know, it's going to make you question *everything,* and then they lose their power. They lose their control. For them, it's a matter of staying in power, a matter of survival to have people believe what they're told and not ask too many questions. Look at the Soviet system, or any system that depends on people blindly following them, won't allow questions, won't allow you to explore, be curious, and discover because you'll find out something they don't want you to know.

They treat people like children. The government did this with nuclear testing, and the [Mormon] church does it as a matter of course. "We know what's best for you. Just trust us. We'll tell you all you need to know. What we don't tell you, you don't need to know." Here people are so used to being given instructions, people are so desperate not to have to make decisions for themselves, not to have to think for themselves, that it's easier just to turn all that over to a source outside yourself that you view as more intelligent and more powerful than you are.

Once somebody in college said to me, "Well, if you don't believe in God, then what?" And I said, "Well then I have to decide everything for myself, don't I? I'm responsible for myself." And he said, "That's pretty scary." A quote of Dostoyevski was used often after the Jim Jones massacre in Guyana: "There are none so desperate as those who need someone to tell them what to do." And Mormons believe that the Constitution and the government is divinely inspired, so there you have it again. Not only do you have them saying that they are the one true church and that they have a monopoly on the truth, but it's part of their doctrine that the American government was part of God's divine plan! All this is background as to why it was so easy to conduct testing here for so many years and not have people make a fuss about it. A divinely inspired government doesn't poison its own people.

When I first got [thyroid] cancer in 1985 [at the age of 29] it didn't occur to me that testing caused it until a radiobiologist I met at the university said that it's the most common form of cancer caused by radiation. Then I would tell that to people and they would just laugh at me. See, it's interesting how it works because even I, a questioning person who *knew* what had happened from testing, didn't put it together at first. It could happen to any of us. I was lucky because it was an easy kind of cure, not that bad of a surgery or recovery, but it does make you realize how vulnerable you are and you don't know who you can trust anymore, and you don't know what *else* went into the air that can hurt you.

What were the procedures that cured you?

There was a nodule on my thyroid that was cancerous. Luckily, it hadn't spread. They took that out, and some lymphs around it and the parathyroid. After that they gave me an "iodine cocktail" which is radioactive iodine that you drink, and it kills off any thyroid tissue that is left. When the nurse wheeled me back to my room the back of the chair was real high, and it was *leaded* so that she wouldn't get any radiation from me. On the door of my room there's a radioactive sign, "Caution, Radioactive Material," and on my bracelet it had

the same symbol on it and *I* was the radioactive material! That's pretty overwhelming. I had to stay in that little room alone for a few days until the reading on the geiger counter was low enough that I could be around people. I kept thinking, this doesn't just go to your thyroid, it goes through your system, goes through everything. I did nothing in that room but drink water and pee because I just wanted to flush it out. My clothes were radioactive. The nurses would open the door and just scoot the food in, and a little man would stand at the door with his geiger counter and aim it at me to see how much radiation I was giving off. Even when I got home they told me not to be around small babies for another week. My husband was so afraid he'd sleep in the back room. I remember being nervous. I'd ask my doctor, "But isn't this going through other parts of me? Doesn't radiation cause it?" and he'd just say "No, no, the dose isn't high enough," but you know they *always* say that. They did tell me after that treatment that I shouldn't get pregnant for a year.

I remember saying to the doctor, "Now that I've had this kind of cancer, does that mean I've had my bout with it and I won't get it anymore?" and he just laughed.

I went to hear a doctor speak who said that cancer is now an epidemic. You never know where it's going to strike next, who's going to get it or where you're going to get it. It's like a wild animal stalking you in the dark and it's frightening. To me it's just overwhelming how many people here get cancer. Six months before I had my surgery, a man in my office had his thyroid removed, cancer. What's so hard about getting compensation for people is that only certain cancers will be compensated, and only in *southern* Utah. I'll believe it only when they get a check.

Are people here shunned when they get cancer, or are they supported through their illness?
I think anywhere, not just here, you get shunned somewhat. I found that, and it's weird. There were some people I just didn't want to tell, and others I knew could handle it. Some people treated me as if they could catch it if they got close to you. I would enjoy telling people just to see what their reaction was. I was at a writers' conference where a woman came up to me that I hadn't seen in a while, and she asked me what I'd been doing. I said, "Well, I had cancer surgery." She physically stepped farther away from me, said "Oh" and walked away from me as if she could catch it. It's a real test. One friend, when I told her, started to laugh because she thought I was kidding, she couldn't believe me, but then when she realized I wasn't she got real upset. She immediately went out and bought everything she could to read up on it. At the office they were really supportive. But generally, people just heard that word "cancer" and it just panics them.

Also, there is a certain false mythology, the way many think that people with cancer should look.
Right, they think you should look like you just came out of Auschwitz. My old professor came up to me and said, "Well, I guess you won't be having kids now." I thought, God, what does he think they cut out? I said, "Why?" and he said, "Well, you don't know how long you've got." Then I said, "Well, you don't know how long you've got either!"

I always thought I had a charmed life, that things always went my way. Then something like cancer happens and you realize you're just as vulnerable as everyone else.

Photograph by Dorothea Lange. 1953. Courtesy of the

Oakland Museum. Sister Higby, Toquerville, Utah, 1953.

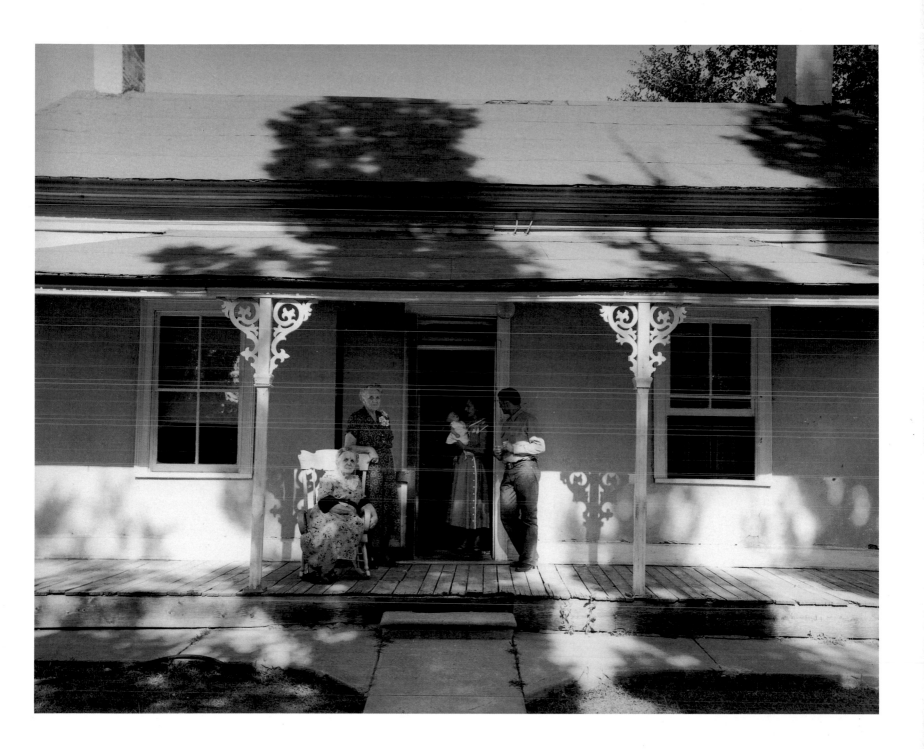

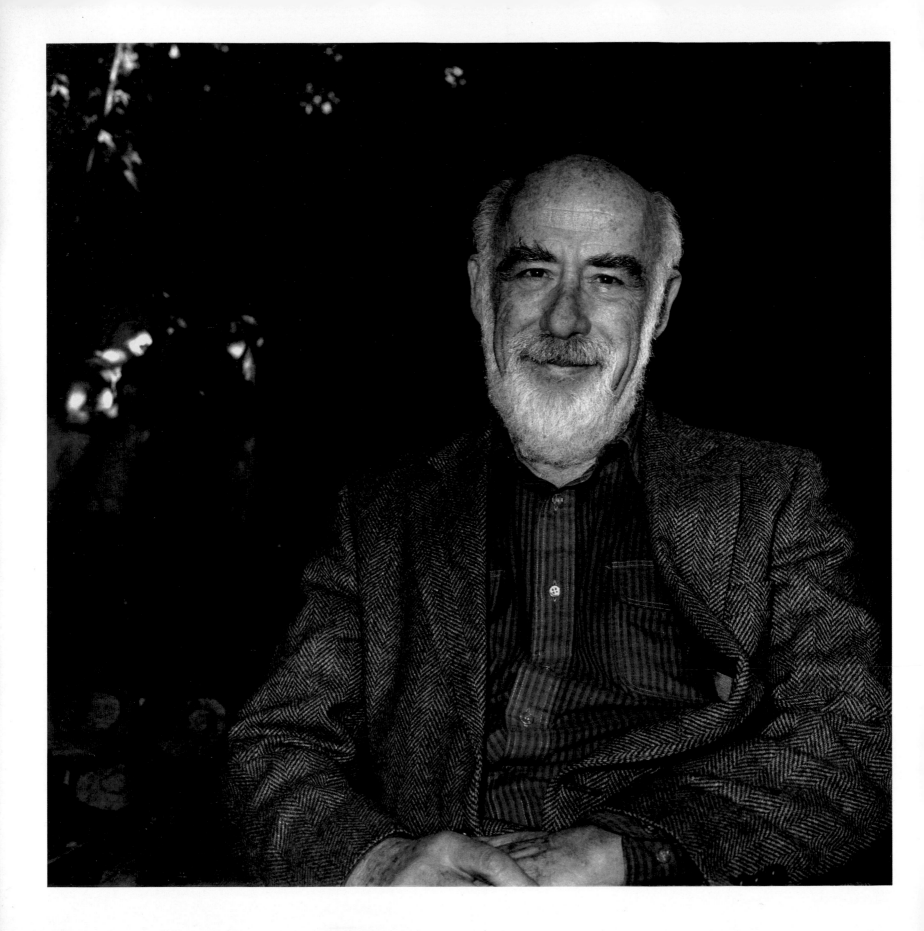

JOHN GOFMAN, M.D., PH.D.

March 1992

San Francisco, California

"The nuclear establishment will not tolerate that nuclear radiation is dangerous, and that's not limited only to the United States. It's true in the Soviet Union, France, Great Britain. At every opportunity you see them struggling to make it safe on paper. i wouldn't give you two cents for any of them. They're the scoundrels of the earth."

John Gofman codiscovered uranium 233 and isolated the world's first milligram of plutonium for J. Robert Oppenheimer during the Manhattan Project. The author of *Radiation and Human Health* and *Radiation-Induced Cancer from Low-Dose Exposure*, definitive works on the effects of exposure to radiation, three other books on the subject, and many important articles, he has recently written an estimate of the damage caused by the accident at Chernobyl. These books were written in response to nuclear-protective studies financed by the United States government. Apart from the work of Gofman and very few other independent scientists, the Atomic Energy Commission, its successor the Department of Energy, and the Department of Defense control all nuclear-related scientific operations, including the study of the effects of radiation and radiation-related illnesses such as cancer, birth defects, immune system failure, and heart disease. It was Gofman who first used the Nuremberg Principles, the most important war crimes document of the twentieth century, as the standard by which the morality of the worldwide nuclear military-industrial complex might be judged.

The nuclear establishment will not tolerate that nuclear radiation is dangerous, and that's not limited only to the United States. It's true in the Soviet Union, France, Great Britain. At every opportunity you see them struggling to make it safe on paper. I wouldn't give you two cents for any of them. They're the scoundrels of the earth.

What is your estimate of the cancer risk per unit dose of radiation, in contrast to the government-funded estimates?
Per rad, overall, the children being at least two or three times more sensitive than adults, my published number based on

the most up to date Hiroshima/Nagasaki evidence is 26 fatal cancers expected for every 10,000 persons, each of whom received one rad. You must multiply that number by two if you want to take into account that for every fatal cancer there will be one additional nonfatal cancer, so that would be 52 per 10,000 people per rad. That's for bomb-energy radiation. For medical X rays it would be twice as bad. They're more hazardous, and nobody argues with that factor of medical X rays versus the bomb radiation. The BEIR [Biological Effects of Ionizing Radiation] Committee [a government-funded organization that analyzes radiation risk] has come up a bit, almost approaching the real world but not quite, they've suggested a number of 8 fatal cancers per 10,000 per rad. Their numbers come out of thin air. There's no logic for it.

You know, of course, that I have a fundamental, big, big difference with them on the legitimacy of their new dosimetry [the figures upon which, for example, the Radiation Exposure Compensation Act are based]. [In the Hiroshima/Nagasaki dosimetry study] they changed all the groups, threw out some people from the study, and you can't do that after the fact. So I regard mine as more correct. It may be totally innocent and without any bias, but what they've done would suggest to any shrewd and careful observer is a procedure that would *introduce* the possibility of bias. It's not the same as being accused of cheating, but you have laid the door open to question as to whether your reasons are objective, and so everyone knows the way you eliminate the question of accusations is never to do anything that introduced a possibility of bias. I don't accuse anybody of anything, but I do say, "What in the hell did you do this for? You've just made yourselves subject to question."

What did you think of the radioepidemiological tables in Orrin Hatch's original Compensation Act?
Absolute lies. I've written a very strong critique. Basically, I wouldn't believe anything written by the Department of Defense or the Department of Energy. And the North American Radiological Association is worthless. The government holds [in all of its major radiation compensation acts] that only 13 cancers are radiation-induced and therefore there's no compensation for the other cancers, but I consider that nonsense. I regard all cancers to be virtually equally inducible by radiation so I would consider that bill [the Radiation Exposure Compensation Act] as erroneous.

I've written that a favorite technique used by the establishment to confuse things is to take small studies, divide them into a hundred cancers, and then they can say "We saw no pancreas cancer at all, so it's not radiation induced. We can't prove anything significant." They knew what was important *not* to study. What you must absolutely insist on is to add up all the cancer deaths and not separate them. But 50 cancers have occurred where 20 were expected, and that's damn significant! You would think that the people who have the responsibility to collect the data and to analyze it could at least be able to tell us if cancer in the United States is rising, or falling, or staying constant over time.

Given the skyrocketing increase of breast cancer, for example, are the federal health institutions just discounting entirely the effects of radiation from nuclear testing and nuclear pollution on the health of the entire planet?
Not entirely. If you look at the Department of Energy reports on Chernobyl they say, "Well, we have to say there's some effect from the radiation that's been released but we want

you to know that the true number may be zero. We're not sure there will be any cancer at such low doses." They use what they call our zero risk model, that at low dose radiation doesn't have any effect. They like that best. Actually, in proportion, the exact opposite is true.

Low-dose radiation is more harmful than high-dose?

Per rad, you get a bigger cancer effect from low doses than from the rads you get later, but that should never be interpreted that 100 rads is less harmful than 50 rads. It's just per rad that low doses are a little more effective. The evidence itself shows in the critical region of the cell: it only takes one track going through it to produce whatever effects it's going to produce. When you look at mental retardation in infants, it's also consistent with one track.

What percentage of all scientific research in this country is funded by the government? How many non-government-funded, unbiased independent studies of radiation-related effects have there been?

If you leave out production plant matters like General Motors and General Electric, research on products, the rest must be about 80 to 90 percent government-funded. Very few are independent. Just my studies, and Dr. Karl Morgan [considered the father of health physics]. [Other scientists of integrity, Dr. Thomas Mancuso and the late Dr. Carl Johnson, either had their research funds cut or were fired when their studies revealed a large number of radiation-related cancers.] Dr. Alice Stewart gets a lot of government funding but she's largely independent. I think her work is good and she's an honest lady. But there are very few independent studies,

almost nonexistent at this point. Almost nonexistent! Money buys many things. It will buy people. Just like buying oranges.

Think about it. Where do all the grants come from that support medical schools? The U.S. government, vested interests. And who are the editors of scientific journals? People with grants, who have government-funded research going on. They're not going to bite the hand that feeds them. The fact that we have the government as almost the sole source of research funds is a disaster. When you look at the large number of scientists they produce, a whole stable full, from their brothel. People think they're giving a scientific opinion. Baloney! They're giving the opinion that will guarantee that their job continues, or their scientific research grants. It's that simple. The history of whistleblowing tells you that you'll get clobbered if you don't go along with it.

What do you think the effects of testing were?

The effect is to produce cancers in proportion to the [radiation] dose. If I knew the correct dose I could tell you how many cancers. We don't have a good handle on what the dose was and to how many people. [Even though the Department of Energy has conducted ongoing biannual meetings of the Dose Assessment Advisory Group for many years, packed entirely with their own scientists, they have never issued conclusive results to the public. They will admit only to not having sufficient evidence of high radiation levels downwind, but data collection during the open-air testing years was largely inept, with figures underestimated or falsified.] We could have had a rainout on a major populated center that would change the picture a lot. If you look at an accident like Chernobyl as an example, if the weather had

been different, the wind had been blowing in the direction of Kiev, and if the explosion was a little less mighty so that the cloud didn't get so high and it drifted southward to Kiev and it had rained, I don't believe anyone would be living in Kiev today, a city of 1,600,000. It gives you an idea of how important the wind direction, the height of the cloud, and rain would be.

What is hormesis? Is it real?

Hormesis is the suggestion that low doses of radiation are stimulative and high doses are harmful, and Thomas B. Luckey in Loveland, Colorado, who wrote a book about it in 1982 has come out with a 1992 version. I have not yet found any evidence that hormesis is real, but he's very enthusiastic. He thinks we're all suffering from radiation deficiency disease, and he says we have to get after these people who say radiation is harmful because that's going to slow up the government from taking steps to find out what dose ought to be given to everyone so they could have optimum health. He's working hard on that. He said Chernobyl was one of the best things to happen to Europe and Russia because it's going to save so many people from having cancer because it's protective. That's in his book, by the way. It's an Orwellian rewriting of history.

Does mental retardation occur as a result of radiation damage to the chromosomes of the parents before conception or during pregnancy?

There are two potential ways it can occur, and let me talk about the place where we got lots of real evidence, and that's from the women who were irradiated with children in utero in Japan [at Hiroshima and Nagasaki]. There was a rash of these children, some 30 cases out of 1,500 women. The analysis of the data which they agree with is that for 100 rads you're going to have 45 percent of children exposed in utero between the eighth and fifteenth week mentally retarded. That's very, *very* bad, roughly one out of two. I don't know if you know what their designation of mentally retarded is. It's children who can make no conversation, cannot take care of themselves, or tie their shoes, or ever learn to do so. They're *not* Down's syndrome. They just can't get along without being taken care of. In recent years they've put out data they had and hadn't looked at, and made a grading of the children and their performance in school. There's a sliding mental scale, a regular decline in their school performance with increasing dose of radiation, so everybody who's exposed suffers in proportion to the dose they're getting, and I'm sure the effect of that is chromosomal. Now in terms of looking for mental retardation in children of people who were irradiated pre-conception, they've not been able to observe anything yet in Japan. However, there would be a number of things that could produce very serious mental retardation that could occur because of a mutation of the chromosomes or genes in either the sperm or ovum, but we don't have enough data to say. If you have that mutation in all the cells, a large part of the abnormalities won't ever come to term, they'll be aborted.

Why is the central nervous system so sensitive to radiation? Why are the atomic vets and Test Site workers having nerve and muscle disorders and seizures?

There are many statements by the physicians and people in Byelorussia and Ukraine that there's an awful lot of that in people who were exposed to Chernobyl, nervous disorders.

Whether those have been objectively looked at, I don't know. One Russian physician who came over said there was a study of some soldiers who had been involved in the clean-up, and he showed me these hand-drawn graphs indicating that there was a rise in nervous system disorders directly proportional to the dose. I'd like to know more. In utero exposure nervous disorders, I'm sure, are due to multiple chromosomal injuries [from radiation].

How did you begin to study the health effects of radiation? Your original research, for which you received the Stouffer Prize and so many other awards and honors, was for your work linking lipoproteins with heart disease. What made you change your field?

After I worked on the Manhattan Project I finished my medical work, and then after my internship I got a position at University of California at Berkeley as assistant professor of medical physics. My teaching was on artificial radioactivity and radiation methods, but my own research was almost *all* on heart disease and in fact that's what I got my major awards for. I had gone out to help Ernest Lawrence at Livermore in the mid-fifties. He was worried that someone might do something silly and hurt themselves, so I set up the medical department and served as the industrial medical officer for Livermore Labs a couple of days a week. In 1963 when the AEC suggested to them to set up a biomedical division, the Livermore director, John Foster, talked me into the job of forming the division and becoming associate director of the Lab. That's when I shifted my work towards radiation and health. After I accepted the position we had to go to Washington to see the five Atomic Energy commissioners. Glenn Seaborg [with whom Gofman codiscovered uranium 233, and

who would later be awarded a Nobel Prize] was the head of the Commission. I could only tell you this about the meeting: I said to Glenn Seaborg, "I've been requested to do this job. I would like to say that I think you ought to think twice about accepting me for this position. Frankly, if I think a program is going to hurt people because of the effects of radiation I'm going to say so. My only devotion would be to the health of the public, not to the Atomic Energy Commission." And in memorable words, Glenn Seaborg said, "Jack, all we want is the truth."

When did things begin to sour?

Everything went fine through late 1969 when I was invited to give a plenary address, in San Francisco at the Institute for Electrical and Electronic Engineering. They were going to talk about nuclear technology. In preparation, Art Tamplin and I had put together our estimates of the cancer risks of radiation, how many cancers you get per 10,000 people per rad, and it was a much higher number that anyone had anticipated, and I said so. The address was titled "Low Dose Radiation, Cancer and Chromosomes." I presented what Tamplin and I had found, that the risk of cancer had been underestimated at least 20 times. That was when we predicted the now infamous fact that if everybody got the "permitted" dose there would be something like 16,000 to 32,000 extra cancer deaths per year in the United States. Some newspaper people asked officials at the AEC what they thought of my work, and they said "Nonsense." That was when the trouble started.

There used to be a standard way to destroy people who said the wrong thing, to invite you to come to hearings before the Joint Committee on Atomic Energy. I was invited for

January 28, 1970. It was a set-up. They would get all the other AEC flacks to come to the hearing, see one in the audience and say, "Oh, I see Dr. So-and-so. What do you think of what Dr. Gofman is saying?" and they'd all dive in for the kill. So we decided we wanted to put a lot on paper. Within four weeks we put out 13 papers, all published for the hearings, 250 copies. We wanted to be sure that scientists around the country knew about this hearing. We distributed about 100 copies to everyone at the hearing too, so nobody at the hearing questioned us. We got over that hurdle. They realized we weren't that easy to knock over. They didn't do anything about it. [Nevertheless, the chairman of the JCAE, Chet Holifield, confronted Gofman after the hearings. "Just what the hell do you think you're doing, saying the amount of radiation we're allowing is causing cancer? I've been assured by the Atomic Energy Commission people that a dose of a hundred times what they're allowing won't hurt anybody." He continued, "Listen, there have been others who have tried to cross the AEC before you. We got them and we'll get you."]

You know, Edward Teller's favorite project was to use the bombs to dig canals, to divert rivers, to move mountains. [This was the Plowshare Program, successor to Eisenhower's "Atoms for Peace."] One of the chief projects, and I was supposed to evaluate the biological hazards of it, was to dig a new Panama Canal with 350 megatons of hydrogen bombs. That was one time that I got into a little trouble at the lab. I presented my findings in 1965 concerning that, and I'd spoken before the directors at Livermore Lab. I said, "My view is that building a canal with hydrogen bombs would be biological insanity." Edward Teller was beside himself. I then heard, just joking but only half joking, "John Gofman is the enemy within."

In 1972 Roger Batzel, then associate director of Livermore, came to me and said, "We have a problem. The AEC came to us last year and said 'Cut John Gofman's research money off.' We told them that we disagreed with your view on radiation standards, but we thought your work in the lab on chromosomes and cancer was very fine work, and why should we cut that off? They went away and said nothing. However, they've just come to us this year and said 'Cut Gofman's $250,000 off. If you won't do that, then we'll just withdraw $250,000 from your budget and you can lay off whoever you want.'" So Roger said, "What should I do?" And I said, "I'm not going to have anyone else suffer for what I have done." So I considered moving the program with about 12 people to Berkeley where I was teaching. The National Cancer Institute was considering funding it, but after the original optimism a third-echelon deputy wrote a letter that said, "The work you propose is not in the main line interest of the National Cancer Society."

Is the National Cancer Institute part of the brothel too, willing to study cancer from the point of view of anything but radioactivity?

I'm afraid that what I have to say about that is yes. It is a single point of view throughout the U.S. government to support that radiation is wonderful and don't interfere with the programs. The actual evidence about radiation is very damning. You're not going to get any better action from one branch of government than another. If you take responsibility [for scientific studies] away from the Department of Energy and put it into another department, it's just fingers on the same hand.

I'm just pointing this out because for seven years I'd been their fair-haired boy with a budget of three and a half million dollars a year and 200 people under me. Within two weeks of criticizing Teller's Plowshare project the AEC began attacking me as "personally incompetent." Why the hell didn't somebody say so before? It doesn't take seven years to find that out.

Then I discovered that some of the most vicious attacks were coming from the electric utility industry, and I wondered why because I said nothing about nuclear power. I didn't even have a position on it. I started looking in magazines and found that all the ads were saying that the radiation emitted will all be below the harm level. In other words, they were saying there's a "safe" level and what I was saying was there is no evidence for a "safe" dose.

In the fifties, did you know when Utah, on the state level, might have begun to react to the suspicion that it was being plastered with fallout?

By 1962 they had installed throughout the states near the Test Site a much wider milk [monitoring] network for radioactive iodine [which causes thyroid cancer]. When the Russians reneged on the voluntary moratorium of their test program the U.S. responded by firing up new tests in Nevada and in the Pacific. What they didn't count on was that this milk network was in place, and they discovered that in Utah the radioiodine was three times the so-called tolerance limit. That was '62 and early '63. The so-called Federal Radiation Council promptly solved that by suddenly announcing that the safe level was three times higher. I think that it was that more pervasive milk monitoring network that got the information to people in Utah and elsewhere that they were being clobbered with fallout. I am firmly of the opinion, as were the people in Livermore, the directors, that the reason why they came to Livermore with the suggestion of setting up a biomedical division was that the Atomic Energy commissioners were catching hell from the state of Utah about the radioiodine in the milk from the '62 tests.

Did the mainstream of people in Utah know that was happening, or not?

They knew it after those tests in 1962. They really awoke with a bang at that point. When Johnny Foster asked me if I would consider to come out to Livermore to form the biomedical division I asked just what in the hell the AEC needed another one for. They already had 20 labs doing biomedical research for the [Atomic Energy] Commission. Donner Lab, where I was, was one of them. He said, "Frankly, the reason they want a biomedical division is that somehow if there were biologists here along with the weaponeers they could prevent another flap from happening like what happened in Utah from the milk." I said, "Johnny, if you blow off bombs in Nevada and the winds are blowing in that direction, how are biologists going to stop that fallout?" "Well," he said, "do you think the fallout problem is important?" I said yes, but I didn't think the AEC wanted to know the truth about fallout, or about radiation. That was based on my observations of the tremendous attack on Linus Pauling for his radiation calculations in the fifties. He brought it to public attention. Johnny then said that maybe the biologists could look at the bombs' construction and make the bombs less radioactive, so I had my biomed people looking at that with the weaponeers. "Cleaner" bombs.

They're smart. They learned something the anti-nuke people never knew, the lesson of Joseph Goebbels. He had it right. Tell a lie. Tell a very big lie, and you'll be believed if you tell it often enough.

I consider the whole idea of subjecting people to a toxic influence without their consent is an outrage whether it's done for weapons testing or nuclear power, nuclear medicine. You have no right to do that to people. And I don't think this stuff is benign at all. It's about one in three people in the United States now that will have a brush with cancer. The latest figures that I last worked with were about 16 percent to 18 percent that would die of it. Pretty close to one out of six. And that's *aside* from skin cancer. Sam Epstein is now saying one out of four will die of it, that the fraction of those who have a brush with it who will die of it is getting bigger. [Samuel S. Epstein, M.D., the author of *The Politics of Cancer* (Sierra Club Books, 1979), is Professor of Occupational and Environmental Medicine at the School of Public Health, University of Illinois at Chicago. He believes that the effort to exonerate carcinogens from the chemical industry and radiation from the nuclear industry are both deplorable and very real trends. Gofman's characterization of Epstein is that he is "as knowledgeable about carcinogens and prevention of cancer as anyone in the world."]

Is there now a cancer epidemic?

I think it's one hell of a thing when one out of six people die of a disease and you can't really say that this disease is just part of growing old. You'd have to say it's a serious epidemic.

How would the radiation have visually and physically manifested itself in exposed populations during the atmospheric testing era?

Any symptoms or signs at all, reddening of the skin or blood count changes, come at about 25 rads. At 50 rads it's more prominent. At 100 rads you're going to start to lose hair, nausea and vomiting, further blood count changes, and maybe the beginning of some of the lesions in the intestinal tract, bone marrow depression, the red blood count starts to fall, maybe some bleeding. That will all get worse at 200 rads and a small proportion of people will die from it. At 300 to 500 rads you have about 50 percent of people dying in the first couple of months.

By those measures, I've interviewed a number of people who apparently got 100 rads from just *one* of the bomb tests in the fifties, and there were at least 106 blasts. I tried to track down people to interview from each downwind town, at least in Utah. I sent out about 3,000 letters asking people to participate; about 2 percent answered with a yes. There were many other sources too. I tried to find each kind of illness and manner of exposure, but this evidence is clearly anecdotal—how could it be otherwise? These are quite simply the oral histories of the people exposed to the atomic bomb. I hate to see people's lives and deaths reduced to what critics might call "only an anecdote," but that was the best that could be done, along with photographing their lives, to create a credible document. There will undoubtedly be the inevitable scorn of "it's not scientific" as a way to disqualify the very valuable experiences of the victims of testing, which always concerned me greatly. One had to think about how

this book would be received by Big Science and keep the research pristine.

What do you think, as a scientist, a Manhattan Project scientist, about the validity of such a study?

Big Science won't believe any of it, no matter what, but you don't have to worry about that. You're not expected to do a scientific job. You're trying to get their story of what happened the way they saw it. As I look at the whole situation, I've seen so much that I know is untrue that's stated by officials, and so much cover-up, I honestly don't know if the things I've been working with is really all of it or just the tip of the iceberg. Maybe these people who are telling you these things are closer to the truth than the sanitized stuff I get to see. I honestly don't know how much to trust what's officially reported, even from Japan. I have said on the record that if the Department of Energy impounds data, even if they release it ten years later, I personally will not believe a damn thing that comes out of it one way or the other. I make my mind up in advance of any studies that come from it. You make up your mind that this is credible material or it isn't. I don't consider the Department of Energy a credible agency. I don't see how you could, for example, from the lies you know they told back in the time when they were called the Atomic Energy Commission. Frankly, Carole, you may be seeing people who are telling you things that are far more important than any of the official rhetoric.

Remember, Edmund Burke said at least a couple of hundred years ago that all that is necessary for the triumph of evil is that good men do nothing.

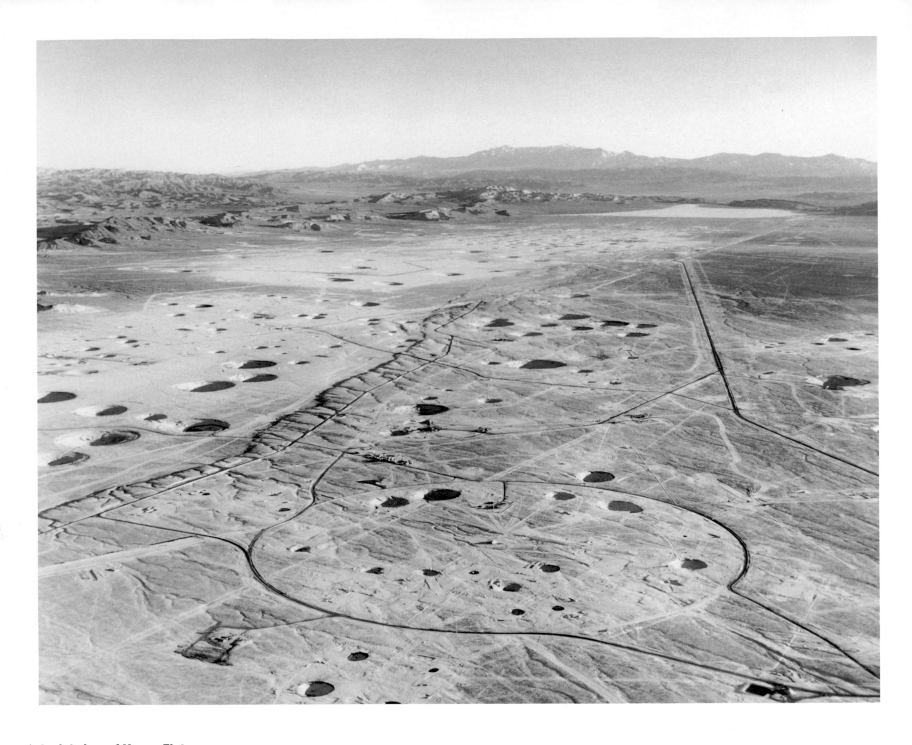

Aerial view of Yucca Flat.

Photo Courtesy of the Department of Energy.

CONTAMINATED LIVES AND LANDSCAPES OF THE WEST:

"A DAMN GOOD PLACE TO DUMP USED RAZOR BLADES"

Sedan crater at the north end of Yucca Flat. 1990.

Although testing went underground in 1963 after the signing of a Test Ban Treaty, a program called Plowshare was experimenting with nuclear explosives on a grand scale to see if mountains could be moved, rivers diverted, canals dug, and so forth. Shot Sedan on July 6, 1962, was a hydrogen bomb of 104 kilotons, nine times the size of the atomic bomb that destroyed Hiroshima. It dug a crater that was 320 feet deep and released such enormous amounts of radiation into Utah that scientists at the University of Utah reported in an issue of *Science* that from that one shot alone, children's thyroids were exposed to far more than the permissible dose of iodine 131. The *New York Times* reported that President Kennedy "expressed a cautious skepticism about the report. Although the report is 'a matter of concern,' he asserted that there was 'some controversy about it.'" It was estimated that children in southern Utah were receiving as much as 700 rads to the thyroid from shot Sedan alone. A 600-rad whole-body dose is fatal.

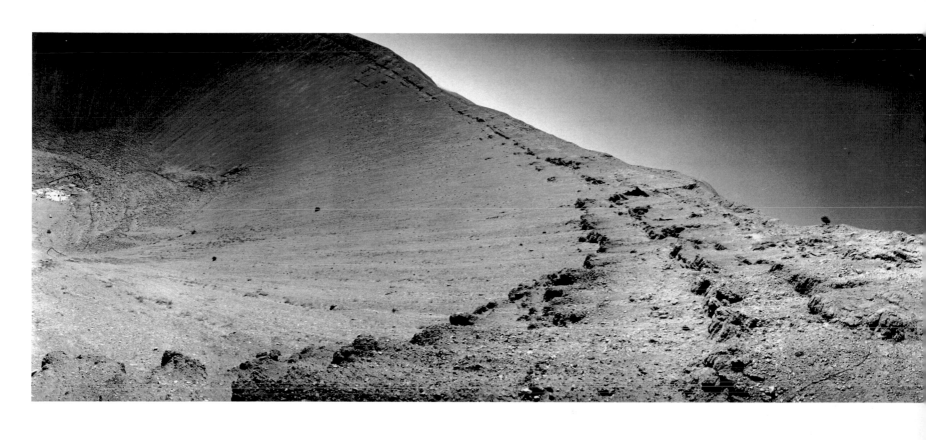

Yucca Pass, gateway to Yucca Flat to the north. 1990.

Yucca Flat is the site of 99 atmospheric detonations and

hundreds of underground tests. The craters made by the

caving of the surface into the caverns deep underground

created by the bomb explosions have transformed Yucca

Flat into a lunar landscape.

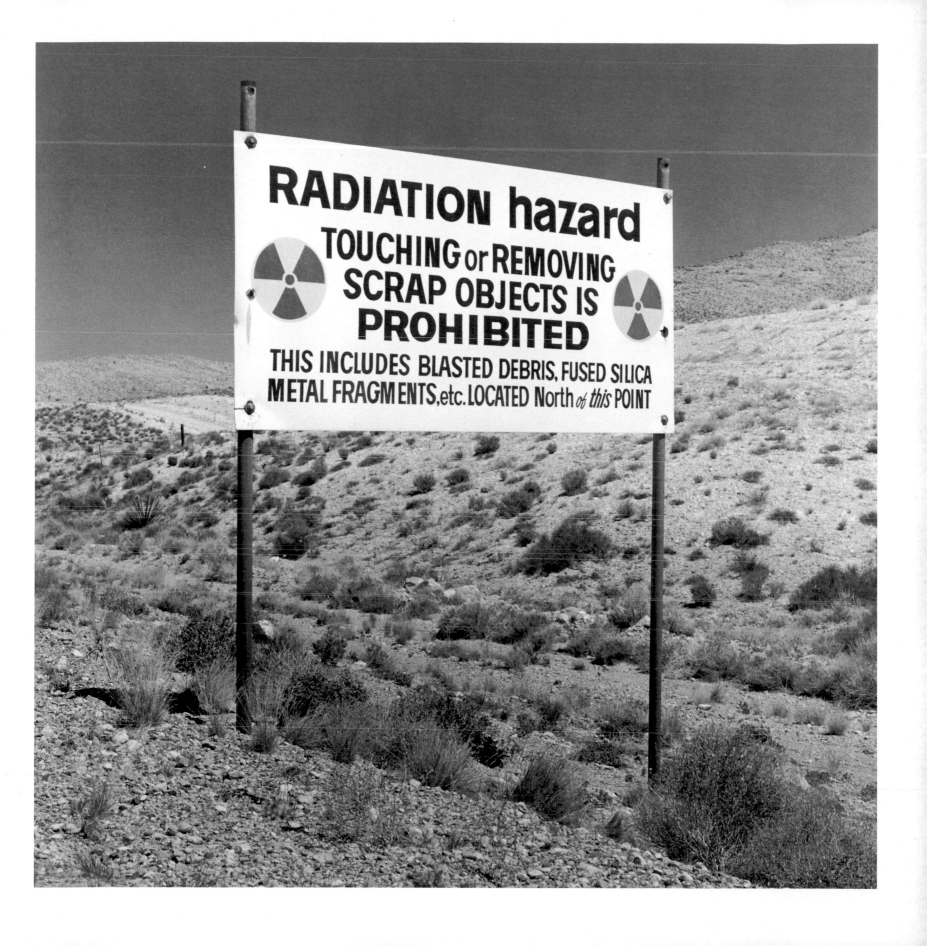

Animal cages near ground zero, Frenchman Flat. 1990.

While officials of the Department of Energy denied on my

public bus tour of the Test Site that there was any animal

experimentation during the atmospheric testing era,

atomic veterans testify that they saw both animals and

humans chained in cages close to ground zero. French-

man Flat was the site of 27 atmospheric detonations and

was littered with the detritus of motel units, experimen-

tal fallout shelters made of various materials, bank

vaults, tanks, trucks, portions of bridges and highways

. . . and cages.

Crushed aluminum fallout shelter and other ruins at

Frenchman Flat. 1990.

CONTAMINATED LIVES AND LANDSCAPES

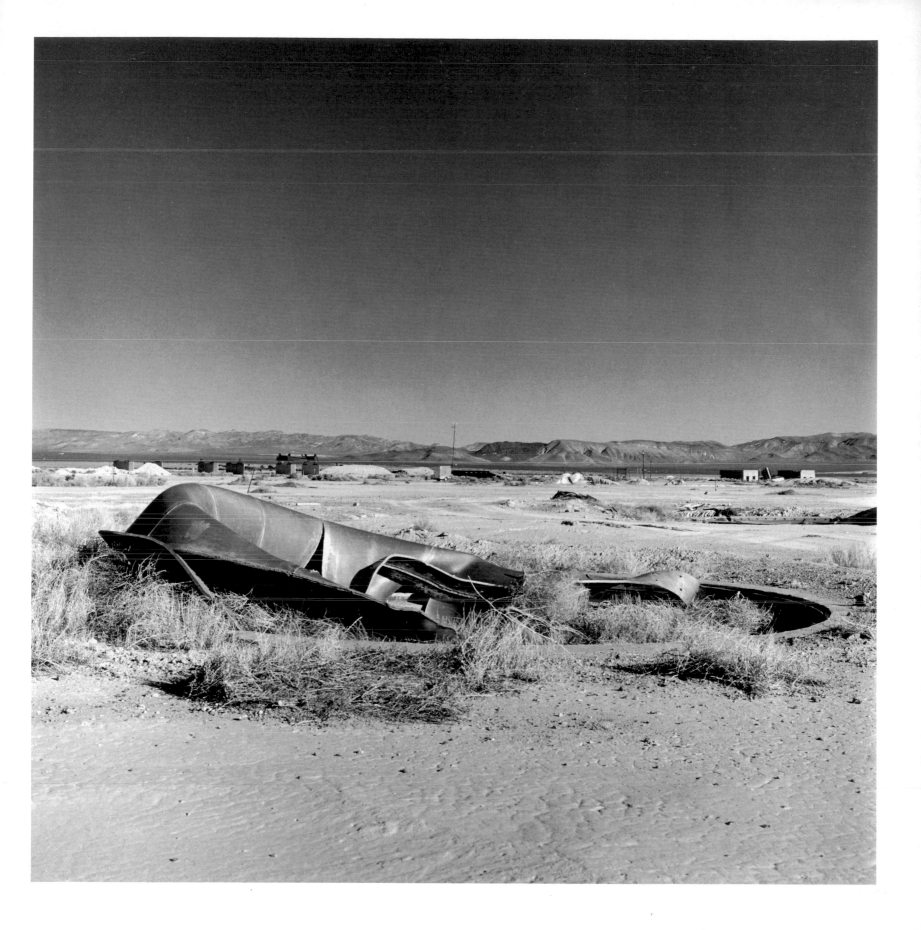

Crushed cement fallout shelter and other ruins at French-

man Flat. 1990.

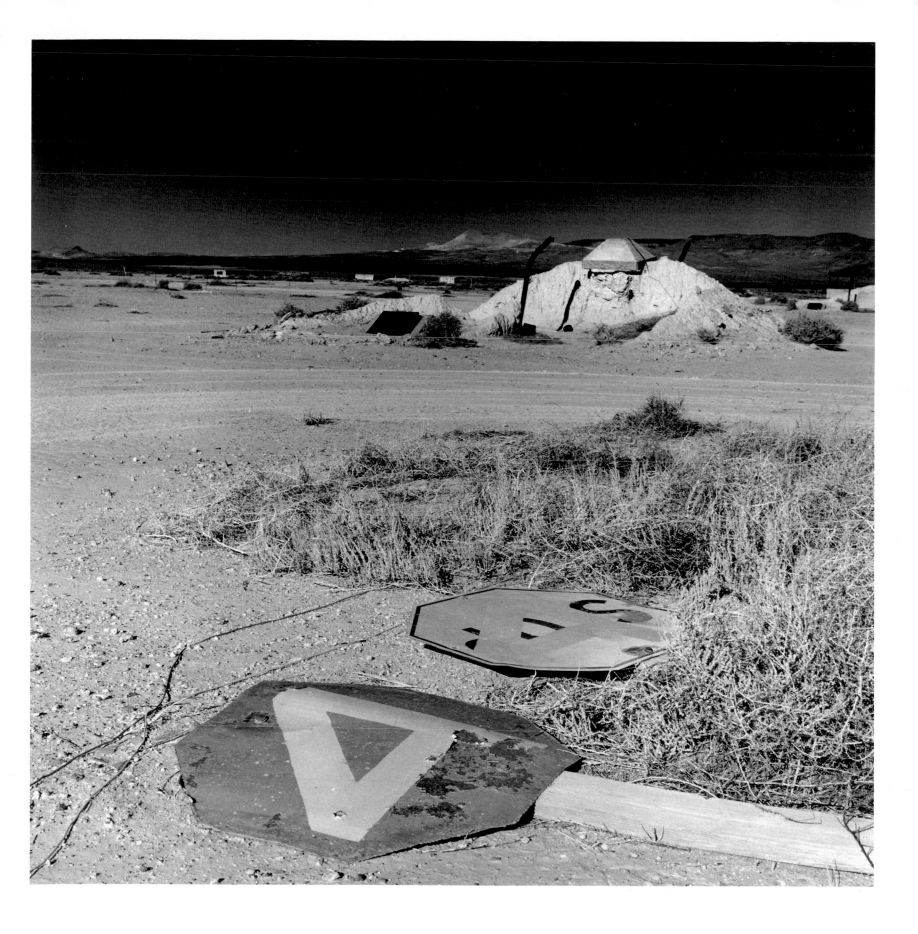

| Moon over St. George, with Mars and stars. 1989.

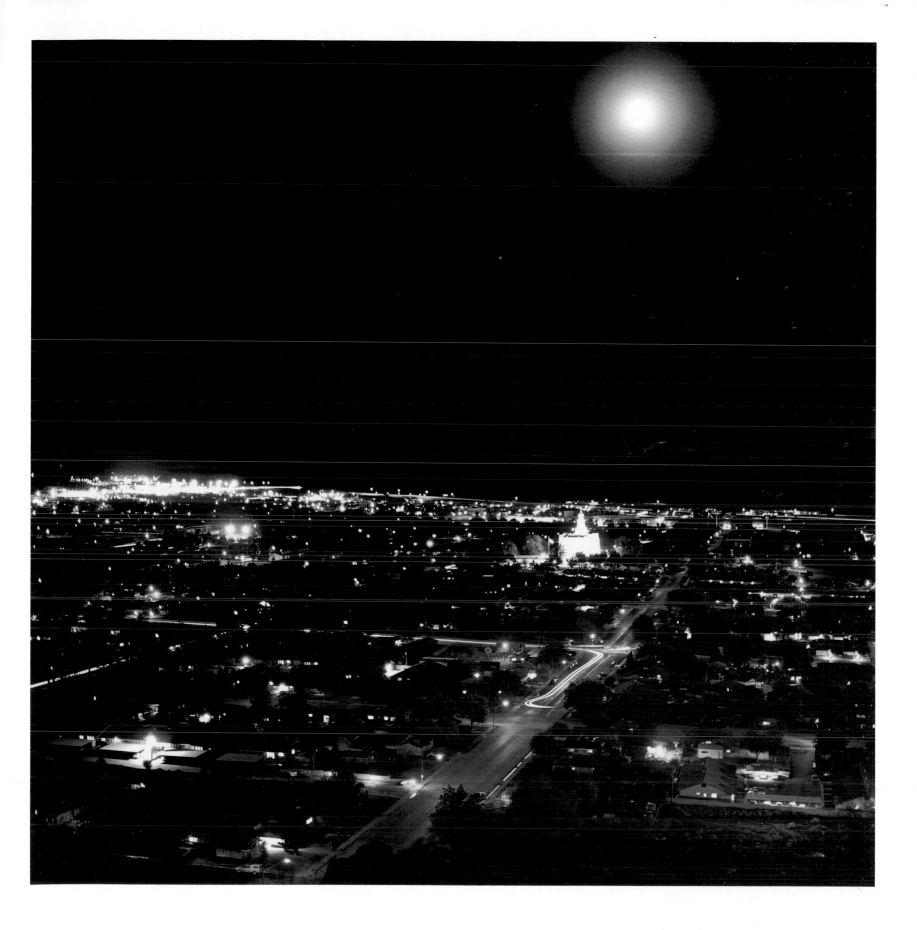

Thunderhead over Ivins, Utah, south of Snow Canyon.

1987.

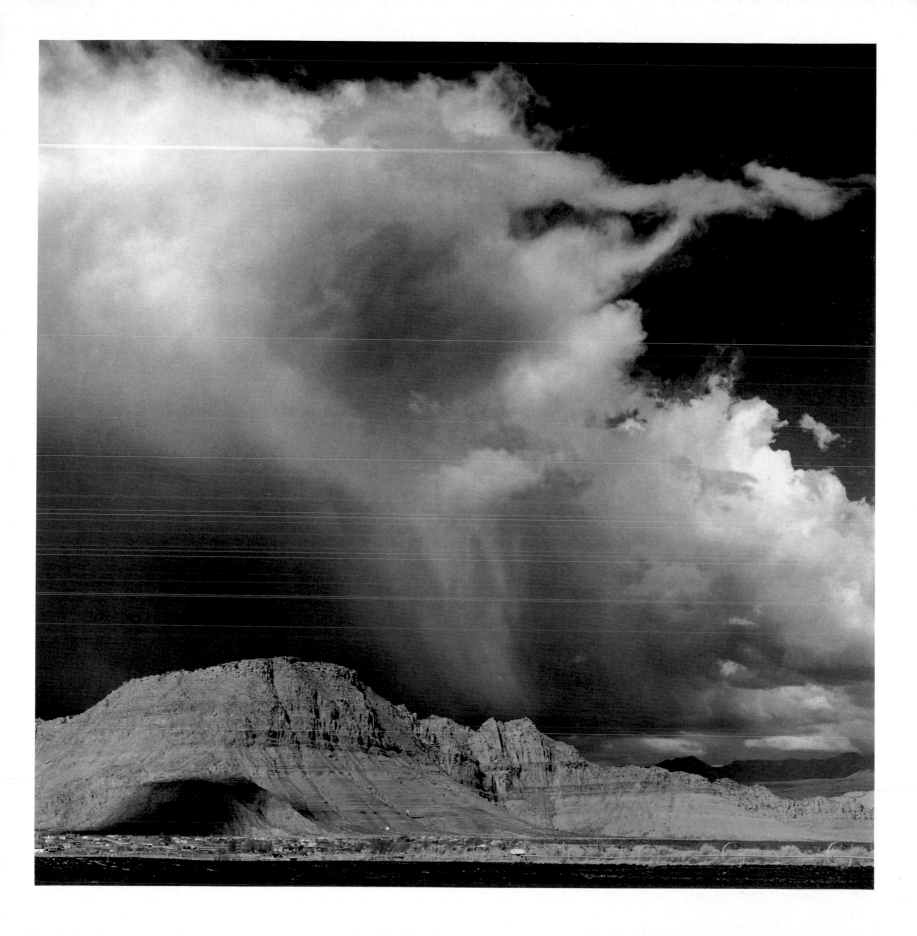

Deserted schoolyard in Amargosa Valley, 10 miles south

of the Nevada Test Site. 1988.

McRae Bulloch on the range near Cedar City, Utah. 1986.

When Bulloch was in his salad days as a sheep rancher,

his herds would stretch out into the Cedar Valley as far

as the eye could see. The sheep loss hurt Bulloch and his

wife. She went to work in the library, he struggled to

rebuild the herd. "We sold our Nevada ranch, and we sold

property here in town. Actually, we never did completely

recover."

McRae Bulloch's sheep sheds, Cedar City, Utah. 1986.

When Bulloch's herds of sheep were exposed to fallout

on the winter range just east of the Nevada Test Site, it

was right before the spring roundup and the 200-mile trek

back to Cedar City for lambing. Many ewes were too sick

to make it home and just stood motionless on the trail

before falling down dead in their tracks. What ewes did

make it back to Cedar either aborted or gave birth to slick

lambs without wool, or with three legs, or hearts beating

outside their chests. Most of them died, and were piled

up to the roofline of these sheep sheds each day before

being trucked off to be sold as food for humans or dogs.

McRae Bulloch's dress hat. 1987.

Snoozing cowboy waiting for a haircut in the barber shop

on North Main Street, Cedar City, Utah. 1984.

Cecil Garland, Rancher for Peace, Callao, Utah. 1987.

Cecil Garland worked in the Las Vegas casinos during the atmospheric testing era, and his daughters are living testament that fallout did cover the town, despite the protestations of the AEC. They suffer thyroid problems from drinking the milk hauled in from the dairies in southern Utah but, like many downwind, were unwilling to talk about it and profess not to care.

| Downwind grain silos. 1987.

Thelmer Stratton rescues a lost lamb, Cedar City, Utah.

1984. When I first met the Stratton boys, the sun was

setting and they were leading their herd home across the

railroad tracks on Cedar City's north side. I returned the

next day and met his father, who had a grapefruit-sized

tumor on the back of his neck. It was hard to say whether

their suspicion of me as a stranger or just the patriotic

climate in general kept them from talking about what

they so obviously knew about the sheep deaths in the

fifties. "Well, I just ain't gonna say. Who told you that?

You been talkin' to the Bulloch boys?"

Old sheep wagon, Cedar City, Utah. 1984. These wagons were the only shelter a sheep herder would have on the winter range, where he would spend months away from home with fellow herders and thousands of sheep. Strong range coffee and open sky were the most appreciated staples of this existence. "It was a clean and healthy life. It got in your blood. One thing about it, you wasn't breathing the air someone else was breathing. It was fresh air. But not when the bomb was there, it wasn't fresh then."

| Mormon child, St. George, Utah. 1983.

"Atomic" street sign, Amargosa Valley, Nevada, 10 miles

south of the Nevada Test Site. 1988.

CONTAMINATED LIVES AND LANDSCAPES

| **Truck stop Americana on I-80 in Nevada. 1987.**

Sand dunes north of Route 59, Nevada, "The Loneliest

Road in America." 1989.

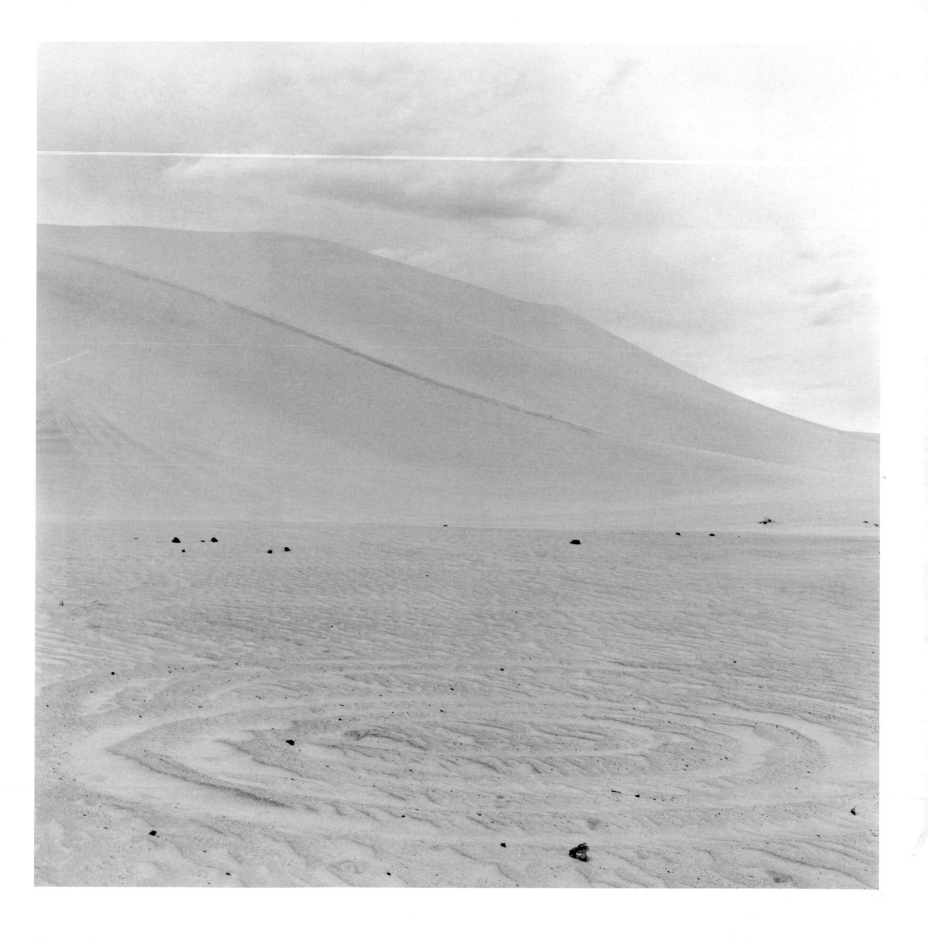

A road to infinity, between Cedar City and Minersville,

Utah. July 16, 1984.

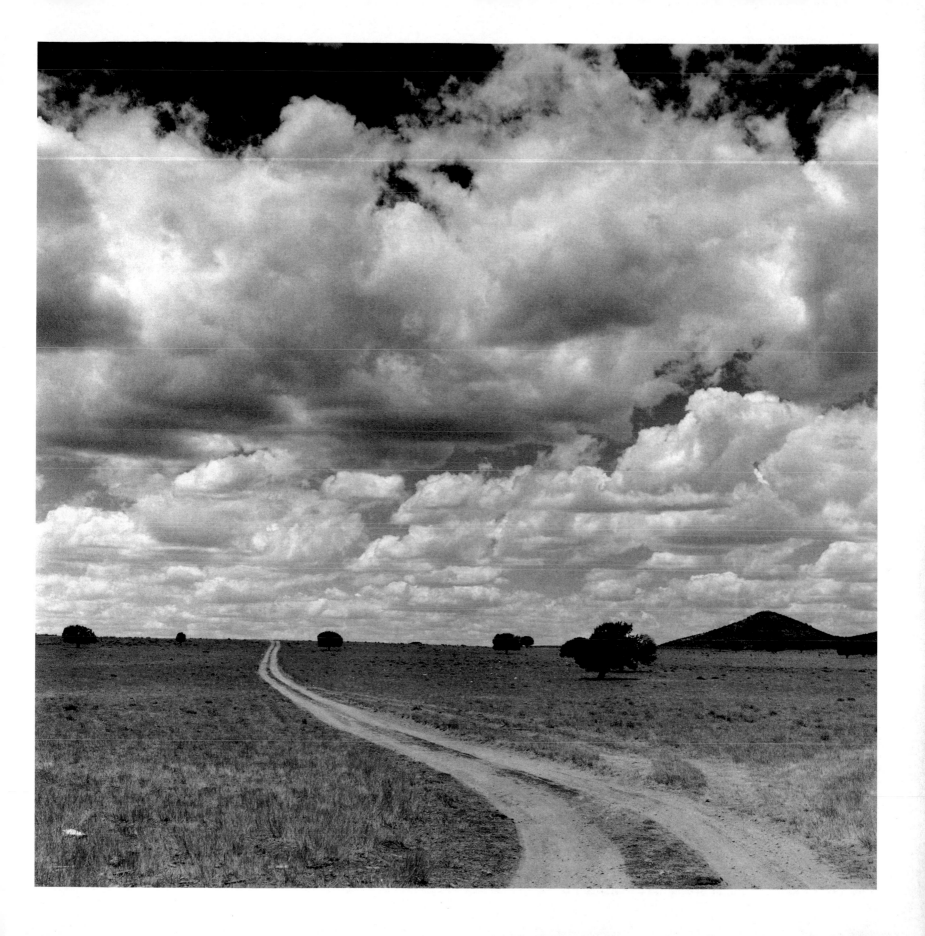

| Desert hot springs near Gandy, Utah. 1987.

CONTAMINATED LIVES AND LANDSCAPES

Twilight on the Rosebud Reservation, South Dakota.

1984.

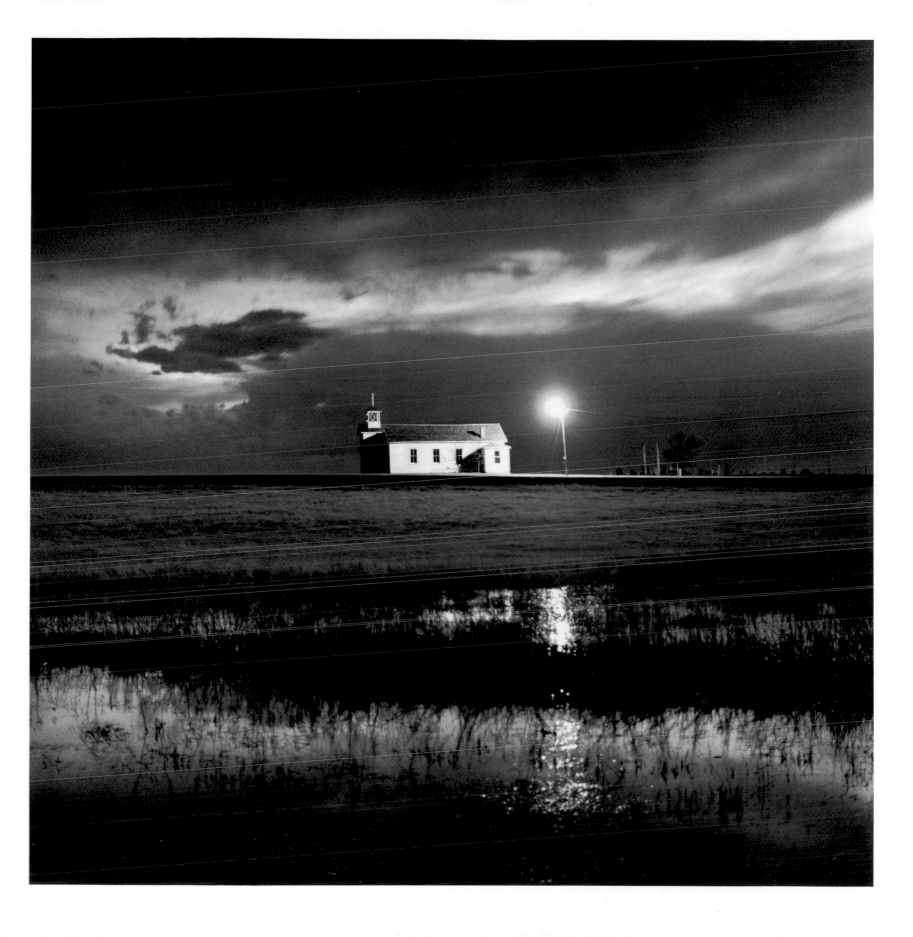

A cross in the atomic breeze, Pine Ridge Reservation,

South Dakota. 1984.

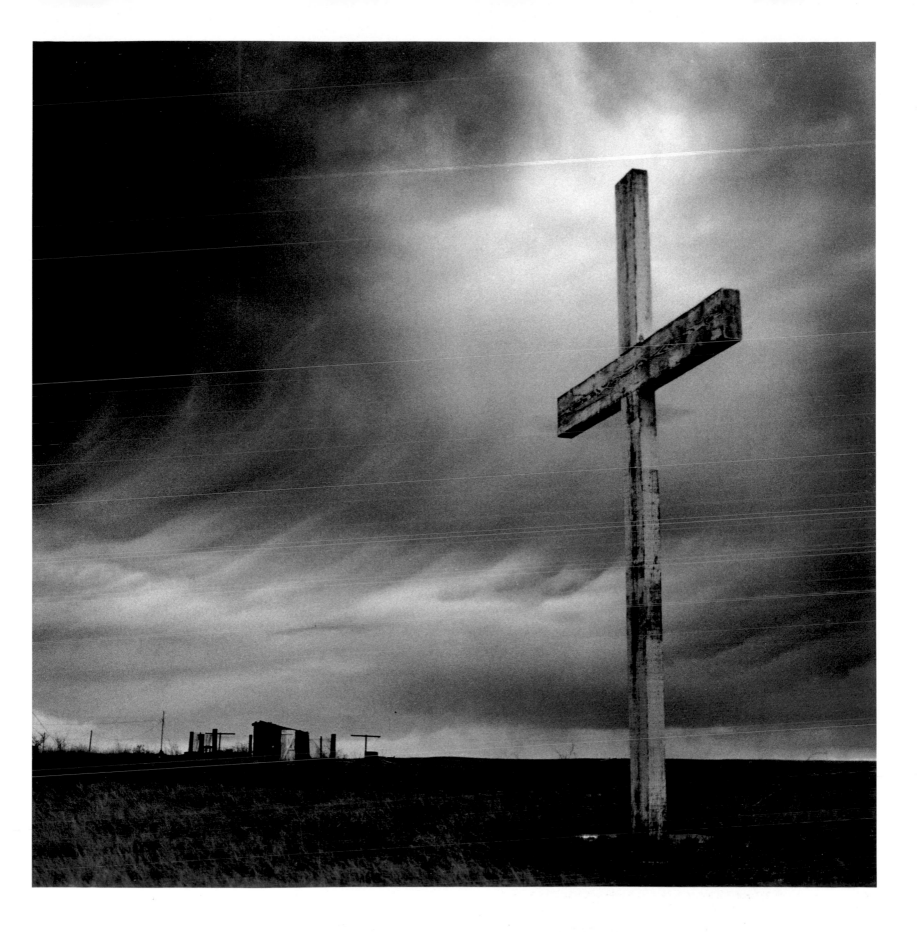

A missile silo under an ominous cloud near Wall, South Dakota. 1989. Missile silos such as these dot the landscape in much of the West and some midwestern states too. Only a chain link fence encloses the 110-ton concrete pad that Strategic Air Command believed would protect the missile below from a first-strike nuclear attack. Underneath in the vault that protects both the missile and the workers at their "missile away" control panels, even the chairs are bolted to the floor in the event of an enemy "near miss" of their target. Despite its strategic importance in a "strong defense" network protecting the United States, each missile silo was a certain American ground zero in the event of an enemy attack. Now that the Cold War is over, ranchers are protesting military plans to blow up these silos after the missiles are removed, disassembled, and destroyed, claiming that the explosions will contaminate the precious desert aquifers beneath them.

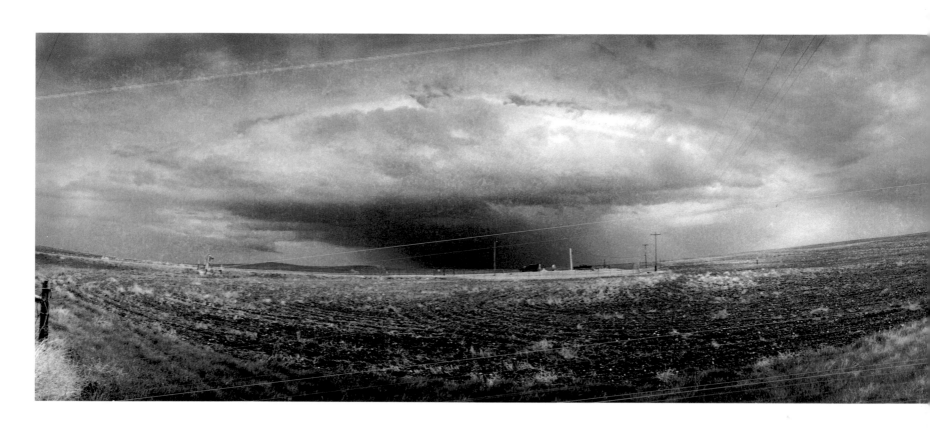

| "Wrong Way." 1986. The Great Salt Lake at Saltaire.

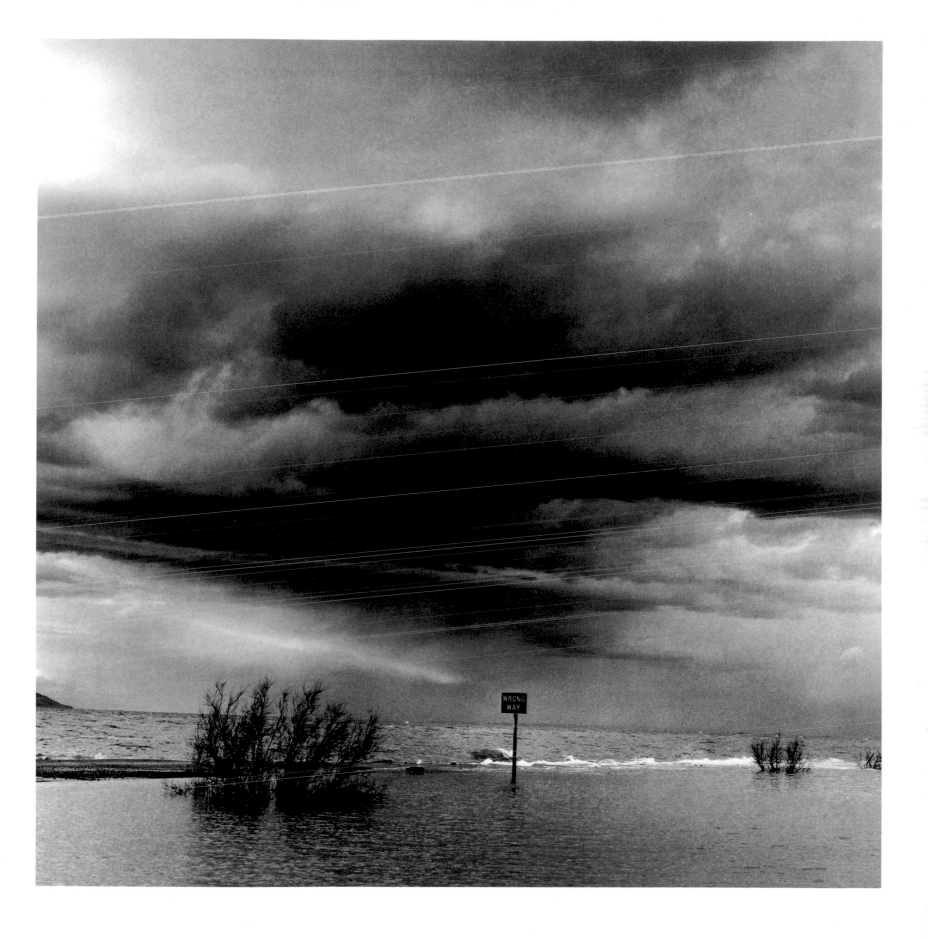

Bloody hands, sharp knife, the heart of an antelope. 1990.

"Home, home on the range

Where the deer and the antelope play,

Where seldom is heard a discouraging word,

And the skies are not cloudy all day."

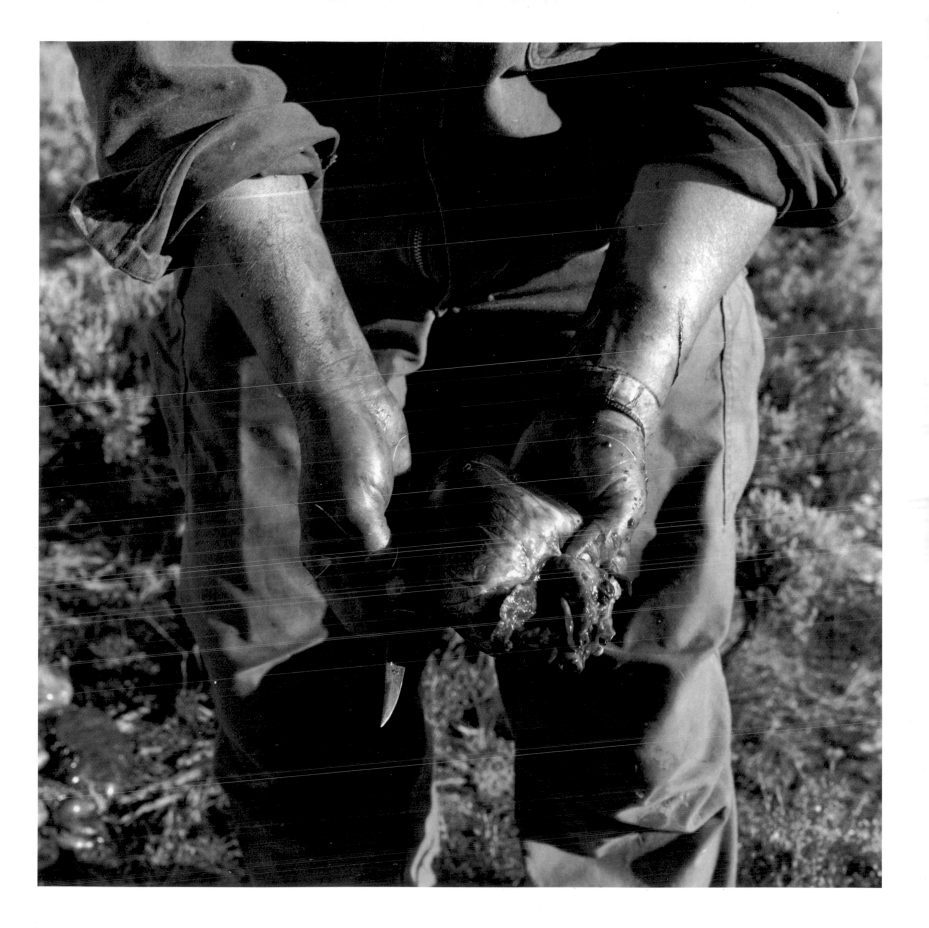

| **Bowed but not broken. 1991.**

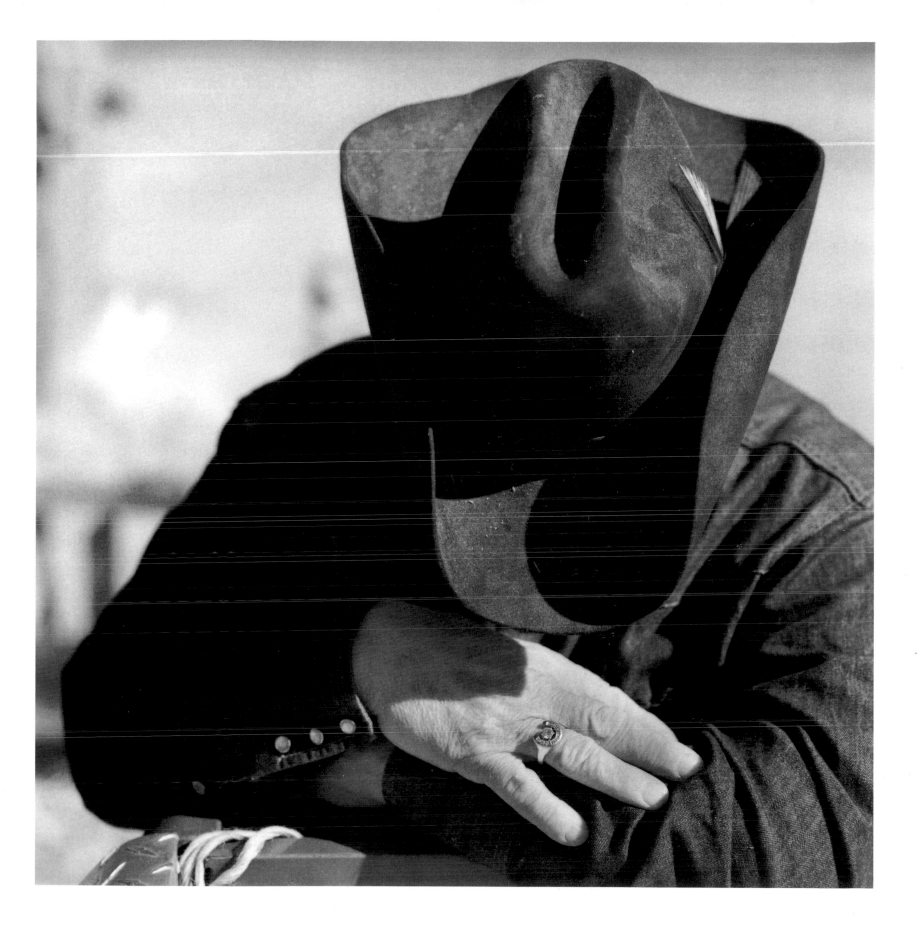

ACKNOWLEDGMENTS

Between its lines every book contains a story behind the story, and in my case the decade of researching and creating *American Ground Zero: The Secret Nuclear War* produced a profound transformation. I would like to thank all the close friends, supportive colleagues, and venerable elders who stood by me during those tenuous years. Special thanks to Studs Terkel, Robert and Kerstin Adams, Bill Moyers, Susan Silk, Steve and Elizabeth Marshall Thomas, W. H. and Carol Bernstein Ferry, Ann Price, Jan Andrews, Deb Vase, Hank Kandler, and Edgar Carpenter. And I thank Turner Browne . . . for everything.

For the first four years of work on this book, it seemed as if there would never be any financial support for its expenses, and so after that drought it was heartening to receive the help of the following foundations: the CS Fund, the Columbia Foundation, the Program for Research and Writing in International Peace and Cooperation of the John D. and Catherine T. MacArthur Foundation, the Deer Creek Foundation, the LEF Foundation, the Ruth Mott Fund, the Utah Arts Council, the Puffin Foundation, the New York Foundation for the Arts, and the Fund for Investigative Journalism. The hardcover publication of *American Ground Zero* by The MIT Press was subsidized in part by the Nevada Humanities Committee, the Charles Stewart Mott Foundation, the Lucius and Eva Eastman Fund, the Columbia Foundation, and Maryanne Mott. Many thanks to the Pope Foundation for honoring this book with their first Award for Investigative Journalism.

A companion exhibition of *American Ground Zero* will premiere at the International Center of Photography in New York and travel to other museums nationally and internationally. I wish to thank Cornell Capa, ICP's founding director, for his continued commitment to "concerned photography" and his support of documentarians. My admiration and gratitude to Charles Stainback, the curator of the exhibition, for his grace, competence, and kindness during the time we worked together, and to all the staff of ICP for their work.

After eight years of effort to find a publisher for this book and countless rejections because its contents were "too depressing—would never sell," I am relentless in my gratitude to The MIT Press, to Frank Urbanowski, its director, and to Roger Conover, my advocate, editor, and friend, for their courage in acquiring it. The hardcover edition was perfection, and for this I thank the designer, Yasuyo Iguchi, the production coordinator, Terry Lamoreux, my text editor, Matthew Abbate, as well as Gita Manaktala, Brooke Stevens, Cristina Sanmartin, Elizabeth Gunderson, Cindy Lordran, David LePere, and all at The MIT Press who make it "the publisher made in heaven."

A smile, a cheer, and infinite gratitude to my editor at Random House, Ruth Fecych, for her tireless campaign to bring this book "out of the shadows."

I would like to thank one person in Utah, a true beacon of compassion and light, for all he did to help me complete this documentary: Dr. J. Boyer Jarvis, professor emeritus of the University of Utah, and his family provided a safe harbor for most of my years in this very dark state.

In the last years of my documentary marathon, the late Dr. Dorothy Legarreta blessed me with an introduction to atomic veteran Walter Hooke and his dear wife, Caroline, who gave me all the love and support I needed to complete my work and who provided a real family to call my own. I dedicate this book to them with all my heart and with the deep gratitude that gives us life.